SACRAMENTO PUBLIC LIBRARY 828 "I" Street Sacramento, CA 95814 02/14

ArtSpeak

Robert Atkins

ArtSpeak

A Guide to Contemporary Ideas, Movements, and Buzzwords, 1945 to the Present

3rd Edition

Abbeville Press Publishers New York London

This book is dedicated to numerous artist-friends who have passed away over the last quarter-century, before reaching their creative primes.

For the first and second editions
EDITOR: Nancy Grubb
PRODUCTION EDITORS: Laura
Lindgren and Meredith Wolf
PICTURE EDITORS: Robin Mendelson
and Laura Straus

For the third edition
EDITOR: David Fabricant
COPY EDITOR: Patricia Bayer
PICTURE EDITOR: Missy H. Dunaway
COMPOSITION: Angela C. Taormina
DESIGN: Misha Beletsky

Text copyright © 1990, 1997, 2013 Robert Atkins. Compilation, including selection of text and images, copyright © 1990, 1997, 2013 Abbeville Press. All rights reserved under international copyright conventions. No part of this book may be reproduced or utilized in any form or by any means, electronic or mechanical, including photocopying. recording, or by any information retrieval system, without permission in writing from the publisher. Inquiries should be addressed to Abbeville Press, 137 Varick Street, New York, NY 10013. The text of this book was set in FF Tisa. Printed in Hong Kong.

Third edition
10 9 8 7 6 5 4 3 2 1

Library of Congress Cataloging-in-Publication Data Atkins, Robert. Artspeak: a guide to contemporary ideas, movements, and buzzwords, 1945 to the present / Robert Atkins. — Third edition.

pages cm
Includes index.
ISBN 978-0-7892-1150-7 (hardback) —
ISBN 978-0-7892-1151-4 (paperback)
— ISBN 978-0-7892-6036-9 (e-book)
1. Art, Modern—20th century—
Dictionaries. 2. Art, Modern—21st
century—Dictionaries. I. Title.
N6490.A87 2014
709.04'5—dc23

For bulk and premium sales and for text adoption procedures, write to Customer Service Manager, Abbeville Press, 137 Varick Street, New York, NY 10013, or call 1-800-Artbook.

Visit Abbeville Press online at www.abbeville.com.

INTRODUCTION	10
HOW TO USE THIS BOOK	14
TIMELINE	15
'85 New Wave	51
Abject Expressionism	53
Abstract/Abstraction	55
Abstract Expressionism	57
Academic Art	58
Action/Actionism	59
AIDS Art	61
Allegory	64
Alternative Space	64
Anti-Art	65
Antipodean Group	67
Appropriation	69
Art and Technology	70
Art Brut	71
Arte Povera	73
Art Informel	74
Artists' Books	74
Artists' Furniture	77
Art Market	78
Art World	79
Assemblage	80
"Bad" Painting	82
Bay Area Figurative Style	82
Biennial	85
Black Arts Movement	85

Body Art	87
Ceramic Sculpture	89
Chicago Imagism	89
CoBrA	92
Collaborative Art	92
Collage	95
Color-Field Painting	97
Comics Art	99
Commodification	100
Computer Art	101
Conceptual Art	103
Concrete Art	106
Constructivism	106
Contemporary	107
Contemporary Indigenous Australian Art	109
Content	110
Copy Art	111
Crafts-as-Art	112
Culture Wars	112
Cynical Realism	113
Dada	116
Dau al Set	117
Documentation	118
Düsseldorf School of Photography	118
Earth Art	120
East Village	121
El Paso	123
Existentialism	124
Expressionism	125
Fashion Aesthetic	126
Feminist Art	127

Figurative	130
Finish Fetish	131
Fluxus	132
Formal/Formalism	134
Found Object	134
Funk Art	135
Gesture/Gesturalism	136
Graffiti Art	137
Gutai	139
Happening	141
Hard-Edge Painting	142
Installation	143
Intermedia	145
Junk Sculpture	146
Kinetic Sculpture	147
Kitsch	
Light-and-Space Art	150
Mail Art	151
Manipulated Photography	153
Media Art	154
Minimalism	155
Mission School	158
Modernism	160
Mono-ha	161
Mülheimer Freiheit	163
Multiculturalism	164
Multiple	165
Narrative Art	166
Neo-Concretism	168
Neo-Dada	170
Neo-Expressionism	171

Neo-Geo	173
New Image	174
New Leipzig School	176
New Media	178
New Realism	178
New Wave	180
Nouveau Réalisme	181
Online Art	182
Op Art	184
The Other	186
Outsider Art	186
Painterly	188
Pathetic Art	189
Pattern and Decoration	191
Performance Art	192
Photo-Realism	194
Picture Plane	196
Pictures Generation	196
Pluralism	198
Political Art	199
Political Pop	200
Pop Art	202
Popular Culture	204
Post-	205
Postmodernism	206
Primitivism	208
Print Revival	209
Process Art	211
Public Art	212
Realism	215
Regionalism	215

Representation	216
Saint Ives Painters	216
Scatter Art	217
School of London	218
School of Paris	220
Semiotics	220
Shaped Canvas	221
Simulation	222
Situationism	223
Snapshot Aesthetic	224
Socialist Realism	226
Social Practice	226
Social Realism	229
Sots Art	229
Sound Art	231
Space Art	232
Spatialism	235
Staged Photography	236
Stars Group	238
Straight Photography	240
Street Art	243
Style	245
Surrealism	245
Transavantgarde	246
Tropicalism	248
Video Art	250
Young British Artists	252
Zeitgeist	255
INDEX	257
DUOTOCDA DUV CDEDITS	287

When the first edition of *ArtSpeak* was written twenty-five years ago, the world was a different place. The cold war was winding down, but the Berlin Wall had yet to be breached or the map of Eastern Europe redrawn. China's economic liberalization was proceeding more rapidly than its tentative progress toward democracy, which would soon be squelched in the brutal crackdown on the Tiananmen Square demonstrators. Outside of scientific communities, e-mail was not yet in use, and mobile phone subscribers numbered between five and ten million worldwide. Today that number stands at more than six billion, or 90 percent of the world's population.

At the end of the 1980s many officials in China, the United States, and the USSR regarded contemporary art and artists with suspicion: In China, the officially sanctioned exhibition of "unofficial" art, China/Avante-Garde, would open and close the same day. In the U.S., legislators would respond to art about gender, sexuality, and AIDS with constitutionally questionable legislation barring so-called "obscenity" in art. In the USSR, some unofficial artists were personae non gratae, allowed to exhibit (and sell) work abroad in order to generate hard currency but not permitted to show at home.

The art world has also changed dramatically. A quarter-century ago, New York had only recently relinquished its mantle as the center of postwar art production, exhibition, and sales. By the end of the 1980s European artists, galleries, and museums had attained more or less equivalent status and economic clout. This multi-centered—but indisputably Western—art world was the foundation of today's international art system. Characterized by a global network of galleries, collectors, art fairs, and franchised (Western) museums, it mirrors the globalized economic system of our day, with its multinational banks and corporations.

This shift has occurred with astonishing speed. Twenty-five years ago China had no commercial galleries. In 2011 it became the largest art and antiques market in the world. In contemporary art, the realignment is even more pronounced. In 2008 eleven of the world's twenty top-selling contemporary artists were Chinese, and in 2009 the single largest buyer of contemporary art in the world was Qatar, the Persian Gulf state with a population of less than two million. The same year, French president Nicolas Sarkozy attended the groundbreaking for the Louvre "branch" in the neighboring emirate of Abu Dhabi.

The globalization of the art world is reflected in this new edition of *ArtSpeak*, which features expanded coverage of the production of art in China, Japan, and Brazil, and of its distribution through art fairs, biennials, and museums. Globalism is also reflected *upon* throughout

these entries, since its implications extend far beyond its visible manifestations. For example, while the consequences of adopting an almost entirely Western model of cultural development throughout Asia cannot yet be determined, the protection of cultural pluralism might turn out to be as critical to our future as the preservation of biological diversity.

The nature of the language we use to talk about contemporary art has changed, too. The biggest difference between the vocabulary of the late-modern era of a quarter-century ago and that of the current postmodern period is the shift away from the division of art into short-lived styles or movements. Each of the modern movements or "isms" of the past 150 years—characterized by artists of a particular place and time, sharing a common style and thematic concerns—followed hard on the heels of its predecessors: after World War II, abstract expressionism was followed by Neo-Dada and Pop, Op, then Minimalism, process art, earth art, Conceptualism, and so on. This stylistic turnover reflected the modern industrial age and its burgeoning middle class, attuned to novelty and consumption. Buoyed by a belief in technological progress and the utopian social goals of both the political right and left, these societies were guided by a faith in the future that we no longer share in our era of environmental degradation and recurrent factional hostilities.

The first of the modernist movements was Impressionism, whose name was coined by the French critic Louis Leroy in 1874, as a term of derision. The spread of the term Impressionism was gradual and haphazard, helped along, surprisingly, by its sometimes ironic use by the artists involved. By contrast, the few movements that emerged during the last decade of the twentieth century—such as the Young British Artists and the New Leipzig School—were named by dealers or publicists and greeted with cynicism by critics and artists as marketing tools. (The accelerated pace at which Chinese artists have, since the 1980s, absorbed decades of previously forbidden Western art makes the naming of contemporary art movements in China a different matter.) The twenty-first century has seen the disappearance of art movements as the basis of a descriptive language of art.

Although the "star system" continues to elevate a select few artists to critical and usually financial success, its nature has changed: today, artists are less frequently recognized as exemplars of a particular medium or stylistic approach, as Lee Krasner was for abstract expressionist painting, or Roy Lichtenstein for Pop art. Instead, since the proliferation of Conceptualist art during the 1970s, artists have increasingly worked in varied media and styles. This makes them primarily artists, rather than photographers or painters or video artists. Put another way, the artist's signature style has in many cases been replaced by a signature thinking, invisible to the eye but apparent to the mind. This anti-modernist trend

away from the separation of media is reinforced by the encouragement of eclecticism and experimentation in art education. Today most young artists who produce video works also create installations or performance art, perhaps even incorporating all three within a single production.

When it comes to the relevance of *ideas* and *buzzwords* as tools for understanding, time has had little effect. (A *buzzword* may be a slangy stand-in for an *idea* or its hollowed-out shell.) We continue to associate art with the ideas that inform it and are given form by it. To ignore the realistic style, bourgeois patrons, and Protestant themes of seventeenth-century Dutch painting would be to miss what makes it different from art produced anywhere else. We similarly associate abstract expressionism with a constellation of ideas and stylistic characteristics that include existentialism, authenticity, abstraction, and the picture plane. Likewise, postmodern appropriation art brings to mind the ideas of deconstruction, authorship, and—variably—digital reproduction, semiotics, or queer theory. To decipher the sometimes complex meanings embodied in works of contemporary art and stimulate an appreciation of its production is *ArtSpeak's* purpose.

Unlike propaganda, cartoons, or advertising, contemporary art can be difficult to understand. In fact, art is the most complex form of awareness or knowledge. It simultaneously engages our left- and right-brain faculties, sense and intellect, soma and psyche. It is this engagement with all of our apprehending faculties—our ways of taking in and making sense of the world—that accounts for visual art's richness and complexity. The process of making art is also rigorous, involving analysis, decision-making, and self-criticism.

Art is also a language. This is meant in two senses: First—and literally—it is a vocabulary of visual forms from which the artist can make a work that speaks to an audience, somewhat as words can be assembled into a text. In the second, or figurative, sense, art is the materialization of an artist's individual "voice." Most artists produce art not simply to make a living, but to express themselves and to catalyze communication. Some artists believe their work is "completed" by the responses it receives, whether from viewers, friends, or critics. The "conversation" about art has existed since the origins of modern art in mid-nineteenth-century Paris, where numerous reviews of the Salon were published and often heatedly debated, and careers made and unmade.

How, then, to join today's rather different conversation? Whether at an exhibition opening or on a gallery crawl, it is natural to want to exchange ideas and opinions with your fellow viewers. There is, of course, a basic vocabulary required for understanding and discussing contemporary art, as there is for every vocation or avocation, be it biochemistry or

viniculture, scuba diving or sonnet writing. Despite the complexity of contemporary art, mastering its language is not all that onerous. The new ArtSpeak remains an essential and easy-to-use guide to this basic vocabulary, one that is perhaps most usefully consulted while in the presence of art. In addition to explaining current art, ArtSpeak places it within the context of the transition to postmodernity that has taken place over the past quarter-century. Despite the epochal shift from modern industrial production to postmodern digital production, from the limited edition to the infinitely reproducible, and from the individually to the collaboratively authored work, postmodern art might seem the last bastion, even possibility, of genuinely personal expression. Yet the means of its distribution—especially the now-dominant art fair—are no less specific in their demands for certain kinds of art (and content) than a designer commissioning a mural for the lobby of a modern office building, or a medieval patron ordering an altarpiece for a cathedral.

The new ArtSpeak features twice as many entries as the original. Many of the digital art forms discussed—from online art to virtual reality—did not exist in 1989, and the majority of contemporary Chinese art was then either below the radar screen or difficult to place in context. Hence ArtSpeak is no longer simply a dictionary of the new, but an encyclopedic account of twenty-five years of it. It is also an alternative to the abundance of online information provided by the collaboratively authored Wikipedia and search engines like Google. We may well wonder how we got along without these research tools in the twentieth century, but it must be said that accuracy, clarity, and context are not their strong suits. ArtSpeak, by contrast, remains a concise and reliable distillation of art-historical information, enriched by decades of looking, thinking, and writing about contemporary art. Whether in print or the new e-book format, I hope you will find it a useful and welcome addition to your conversations and thinking about contemporary art.

San Francisco June 2013 ArtSpeak begins with a timeline of important or symptomatic world and art-world events from 1945 to the present.

The main body of the book identifies and defines the terminology essential for understanding art made since World War II. This terminology consists of art movements, art forms, critical terms, and cultural phenomena, which are explained here in short, alphabetically arranged entries. A few prewar terms that are essential for understanding postwar art, such as *Dada* or *biennial*, are included as well. Many, but not all, of the entries are divided into the journalistic categories of who, when, where, and what.

- ▶ WHO is a list of the principal artists involved with a movement or art form. Names in bold type indicate the pioneers or virtuosos of that approach. Certain artists appear in several entries; for instance, the prodigious German artist Joseph Beuys is listed under Action/Actionism, assemblage, Conceptual art, Fluxus, installation, media art, and process art. In some cases, such as that of video art, more emphasis is placed on the pioneers who established an art form than on the many twenty-first-century artists who incorporate it within a broader multimedia practice. The nationality and dates for each artist are provided in the index.
- ▶ WHEN signifies the moment of greatest vitality for a particular attitude toward, or method of, art making. Pop art, for example, is associated with the 1960s, but many Pop artists continued making Pop art well after 1969.
- **WHERE** identifies the cities, countries, or continents in which a movement was centered.
- **WHAT** defines the nature, origins, and implications of the art movement or art form. Cross-references to other entries are CAPITALIZED.

What's the best way to use this volume? That depends on who you are. ArtSpeak has been designed for different kinds of readers. The expert can use it to find specific facts—say, the name of the curator who coined the term New Image painting or the location of the first feminist art program. The student, collector, or casual art buff may find it useful to read the book from beginning to end and then return to it as needed.

Timeline

Q.

Franklin D. Roosevelt dies; Harry S. Truman becomes U.S. president.

U.S. drops atomic bomb on Hiroshima and Nagasaki.

World War II ends.

United Nations (UN) Charter signed in San Francisco.

U.S. Federal Communications Commission (FCC) sets aside twelve channels for commercial television.

Roberto Rossellini directs *Open City*, establishing neo-realism in film.

French war in Vietnam begins.

Nuremberg trial ends in conviction of fourteen Nazi war criminals.

Winston Churchill delivers a controversial speech in Fulton, Missouri, warning of the threat that lies behind a Communist "iron curtain."

Xerography is invented.

'46

Jean Dubuffet coins the term ART BRUT.

The Dutch painter Hans van Meegeren is convicted of forging paintings by the seventeenthcentury Dutch artist Jan Vermeer.

Influential Henri Matisse retrospective, Paris.

Salvador Dalí designs the dream sequence for Alfred Hitchcock's film Spellbound.

The term ABSTRACT EXPRESSIONISM is first applied to contemporary New York painting, by Robert Coates.

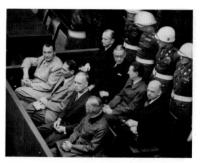

DEFENDANTS IN THE DOCK AT THE NUREMBERG TRIAL, 1945-46

India becomes independent from Great Britain and is partitioned into India and Pakistan.

Jackie Robinson becomes the first African-American to be hired by a major league baseball team. Marshall Plan is passed by U.S. Congress, providing \$17 billion in aid for European economic recovery.

Truman is elected U.S. president.

Organization of American States (OAS) is established.

Mahatma Gandhi is assassinated in India.

State of Israel is founded.

Transistor is invented.

47

'48

Institute of Contemporary Arts is founded in London.

Georges Braque receives first prize at Venice Biennale.

Boston Museum of Modern Art renamed the Institute of Contemporary Art.

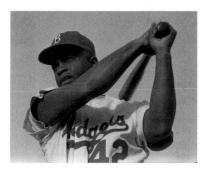

JACKIE ROBINSON, WHO JOINED THE BROOKLYN DODGERS IN 1947

ART WORLD

North Atlantic Treaty Organization (NATO) is established.

Mao Zedong proclaims People's Republic of China.

USSR tests its first atomic bomb.

Apartheid is enacted in South Africa.

Simone de Beauvoir publishes *The Second Sex*.

George Orwell publishes 1984.

49

Korean War begins.

Senator Joseph McCarthy charges that the U.S. State Department has been infiltrated by Communists.

FCC authorizes color television broadcasts in U.S.

China annexes Tibet.

'50

First COBRA exhibition, Amsterdam.

Chinese Nationalists transport to Taiwan the most important artworks from the imperial collections in Beijing.

The Irascibles, a group of AVANT-GARDE New York artists, protest the conservative policies of the Metropolitan Museum of Art.

Arshile Gorky, Willem de Kooning, and Jackson Pollock represent U.S. at Venice Biennale.

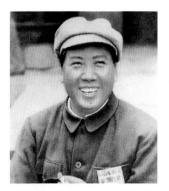

MAO ZEDONG, PICTURED IN THE EARLY YEARS OF THE PEOPLE'S REPUBLIC OF CHINA

Churchill becomes British prime minister again.

Julius and Ethel Rosenberg are sentenced to death for espionage (executed in 1953).

First transcontinental television broadcast, San Francisco to New York.

Rachel Carson publishes *The Sea* around *Us*, which spurs environmental awareness.

Dwight D. Eisenhower is elected U.S. president.

Elizabeth II assumes British throne.

U.S. explodes first hydrogen bomb.

Chinese Premier Zhou Enlai visits Moscow.

Samuel Beckett publishes Waiting for Godot.

'51

'52

First São Paulo Bienal.

Last COBRA exhibition, Liège.

The influential *Dada Painters and Poets*, edited by Robert Motherwell, is published.

Jean Dubuffet spreads the ART BRUT gospel with his "Anticultural Positions" lecture at the Arts Club of Chicago.

Festival of Britain signals postwar cultural renewal in London.

Michel Tapié publishes *Un Art autre* (Another Art), which popularizes the term ART INFORMEL.

Harold Rosenberg coins Action painting as a synonym for ABSTRACT EXPRESSIONISM.

Independent Group is formed at Institute of Contemporary Arts, London; it will be instrumental in the development of POP ART.

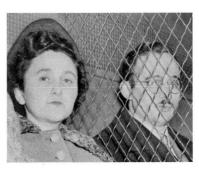

JULIUS AND ETHEL ROSENBERG AFTER THEIR 1951 CONVICTION FOR ESPIONAGE

Soviet premier Joseph Stalin dies, succeeded by Georgy M. Malenkov; Nikita S. Khrushchev is appointed first secretary of the Communist Party.

Korean War ends.

Dag Hammarskjöld becomes UN secretary-general.

Double-helix structure of DNA is discovered.

Alfred Kinsey publishes Sexual Behavior in the Human Female; Hugh Hefner founds Playboy magazine. Gamal Abdel Nasser seizes power in Egypt.

Algerian War begins.

U.S. Supreme Court rules segregation by race in public schools unconstitutional.

U.S. Senate censures Joseph McCarthy.

The French are defeated at Dien Bien Phu; Vietnam is divided into the Democratic Republic of Vietnam and the Republic of Vietnam; U.S. involvement begins.

'53

'54

Museum of Modern Art, New York, sends Pablo Picasso's *Guernica* to the second São Paulo Bienal.

GUTAI GROUP is founded in Osaka by Jiro Yoshihara, who, two years later, issues *Gutai Art Manifesto* urging artists to seek a new relationship to their materials.

Peter Voulkos establishes ceramics center at Otis Art Institute, Los Angeles.

AMERICAN POWS REPATRIATED AFTER THE END OF THE KOREAN WAR

African-Americans boycott segregated city buses in Montgomery, Alabama.

President Juan Domingo Perón is ousted in Argentina.

Warsaw Treaty Organization is formed to counter NATO.

Commercial television broadcasts begin in Britain.

Eisenhower is reelected U.S. president.

Nasser is elected president of Egypt and nationalizes the Suez Canal, which results in war with England, France, and Israel.

USSR crushes resistance in Poland and Hungary.

Japan is admitted to the UN.

Transatlantic cable telephone service is inaugurated.

Elvis Presley makes rock and roll a household phrase.

Allen Ginsberg publishes Howl, is tried for obscenity, and is acquitted.

John Osborne's play Look Back in Anger is produced in London, marking the debut of Britain's Angry Young Men.

'55

'56

First Documenta, Kassel, Germany.

The Family of Man, an exhibition of 503 pictures from 68 countries at New York's Museum of Modern Art, is the photographic event of decade; its message is "We are all one."

Richard Hamilton's collage Just What Is It That Makes Today's Homes So Different, So Appealing? (regarded as the first POP ART work) is shown at the Institute of Contemporary Arts, London.

Construction begins on Frank Lloyd Wright's controversial Solomon R. Guggenheim Museum in New York (opens in 1959).

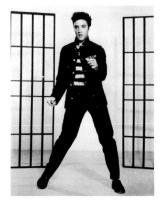

ELVIS PRESLEY IN A PUBLICITY STILL FOR HIS MOVIE JAILHOUSE ROCK

Common Market (European Economic Community) is established.

USSR launches Sputnik I and II, the first man-made satellites.

The first large nuclear power plant in the U.S. opens in Shippingport, Pennsylvania.

Mao initiates the Hundred Flowers Campaign, designed to "let a hundred flowers bloom, [and]...a hundred thoughts contend"—and punishes more than a half million citizens for ensuing criticism.

Jean-Paul Sartre coins the term *anti*novel to describe a non-narrative AVANT-GARDE form. Charles de Gaulle is elected first president of France's Fifth Republic.

Pope John XXIII, a liberal, succeeds Pius XII.

Race riots in Notting Hill, London.

Mao launches the Great Leap Forward, which results in reduced agricultural and industrial output, leading to thirty-eight million deaths, mostly in the countryside.

National Aeronautics and Space Administration (NASA) is established in the U.S.

Xerox produces first commercial copying machine.

Claude Lévi-Strauss publishes Structural Anthropology.

Soviets pressure Boris Pasternak to retract his acceptance of Nobel Prize in Literature for *Doctor Zhivago*.

'57

'58

Tatyana Grosman founds Universal Limited Art Editions in West Islip, Long Island, New York, triggering the PRINT REVIVAL.

SITUATIONIST International is founded in Paris.

Contemporary Bay Area Figurative Painting, Oakland Museum, California.

ZERO group is founded in Düsseldorf to stimulate dialogue between artists and scientists.

The term NEO-DADA first appears, in Artnews magazine.

Jules Langsner coins the term HARD-EDGE PAINTING.

Lawrence Alloway first uses the term POP ART in print.

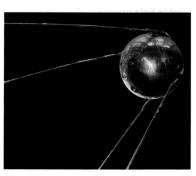

REPLICA OF SPUTNIK 1, LAUNCHED OCTOBER 4, 1957

G I G O W T G

Cyprus is granted independence; Archbishop Makarios is elected its first president.

Fidel Castro overthrows Fulgencio Batista regime in Cuba.

China consolidates its control over Tibet, forcing Tenzin Gyatso, the 14th Dalai Lama, to flee to Dharamsala, India.

Saint Lawrence Seaway opens.

French New Wave cinema becomes a force in international film.

U.S. Postmaster General bans D. H. Lawrence's *Lady Chatterley's Lover* on grounds of obscenity; trial results in enhanced protections for literary expression. Nixon-Kennedy debates demonstrate importance of television in politics.

John F. Kennedy is elected U.S. president.

Belgium grants freedom to the Congo; UN forces intervene to keep peace.

Optical microwave laser constructed.

'59

'60

Robert Frank's book The Americans introduces the SNAPSHOT AESTHETIC.

18 Happenings in 6 Parts, Reuben Gallery, New York.

First Biennale of Young Artists, Paris.

Daniel Spoerri founds Editions M.A.T. (Multiplication Arts Transformable) to produce MULTIPLES, Paris.

Peter Selz organizes New Images of Man exhibition at Museum of Modern Art, New York, devoted to figurative imagery by American and European artists.

The term POSTMODERNISM appears in sociologist Daniel Bell's book The End of Ideology.

Pierre Restany coins the term NOUVEAU REALISME.

June Wayne founds Tamarind Lithography Workshop, Los Angeles.

First exhibition of Frank Stella's SHAPED CANVASES, Leo Castelli Gallery, New York.

Groupe de Recherche d'Art Visuel (GRAV) founded to encourage art-science interaction. Paris.

Yves Klein uses nude women as "brushes" in a public performance at Galerie Internationale d'Art Contemporain, Paris.

Jean Tinguely's Homage to New York self-destructs at the Museum of Modern Art. Yuri Gagarin (USSR) orbits Earth in the first manned space flight.

Alan Shepard makes the first American manned space flight.

U.S. President Kennedy acknowledges responsibility for Cuban exiles' failed invasion of Cuba at the Bay of Pigs.

Berlin Wall erected.

Birth control pills become available.

Henry Miller publishes *Tropic of Cancer* in U.S. after a nearly thirty-year ban for obscenity.

Dancer Rudolf Nureyev defects from USSR.

Cuban missile crisis triggered by American discovery of Soviet missile bases in Cuba. President Kennedy demands their removal and orders a blockade; Soviet Premier Khrushchev agrees to remove them and dismantle bases.

Pope John XXIII opens Vatican Council II in Rome to promote Christian unity.

U.S. Supreme Court declares mandatory prayer in public schools unconstitutional.

First transatlantic television broadcast via Telstar satellite.

Georges Pompidou is appointed prime minister of France.

The sedative thalidomide is linked to thousands of birth defects worldwide.

'61

'62

The term FLUXUS first used by George Maciunas.

ASSEMBLAGE named by William Seitz and Peter Selz for the exhibition *The Art of Assemblage*, Museum of Modern Art, New York.

Exhibition of POP ART, The New Realists, Sidney Janis Gallery, New York.

POP ART appears on the covers of Time, Life, Newsweek.

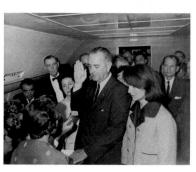

LYNDON JOHNSON SWORN IN AS U.S.
PRESIDENT AFTER ASSASSINATION OF
JOHN F. KENNEDY, NOVEMBER 22, 1963

ART WORLD

John F. Kennedy is assassinated in Dallas; Lyndon B. Johnson becomes U.S. president.

Pope Paul VI succeeds Pope John XXIII.

U.S. Congress passes Civil Rights Act and begins the "War on Poverty."

Nuclear test ban signed by the U.S., USSR, and Britain.

De Gaulle blocks Britain's entry into the Common Market.

Michael DeBakey first uses an artificial heart during surgery.

Betty Friedan publishes *The Feminine Mystique*.

Khrushchev replaced as Soviet prime minister by Alexei Kosygin and as party secretary by Brezhnev.

Johnson is elected U.S. president.

U.S. Congress passes Civil Rights Act and begins the "War on Poverty."

People's Republic of China (PRC) explodes its first atomic bomb.

Free Speech movement begins in Berkeley, California.

Music becomes international language of youth; the British beat is exemplified by the Beatles, the Motown sound by the Supremes.

Martin Luther King, Jr., receives Nobel Peace Prize; Sartre declines Nobel Prize in Literature.

Marshall McLuhan publishes Understanding Media: The Extensions of Man.

'63

'64

First exhibition of television sculpture by Nam June Paik, Wuppertal, West Germany.

Soviet authorities begin campaign to suppress "artistic rebels."

Andy Warhol establishes his studio, the Factory, and shoots his first film, *Sleep*.

Walter Hopps organizes Marcel Duchamp: A Retrospective Exhibition, Pasadena Museum, California; marks postwar emergence of widespread interest in DADA's eminence gris.

Japan begins prosecution of artist Akasegawa Genpei for his use of realistic-looking—but one-sided—copies of 1000-yen notes in his works.

The term OP ART is coined by the sculptor George Rickey.

Robert Rauschenberg receives first prize at Venice Biennale.

Vatican sends Michelangelo's Pietà to the New York World's Fair.

Critic Clement Greenberg coins the term Post-Painterly Abstraction, for exhibition at the Los Angeles County Museum.

ART WORLD

India and Pakistan fight for control of Kashmir.

U.S. bombs North Vietnam; students demonstrate in Washington, D.C.

The Black Muslim leader Malcolm X is assassinated in New York.

Race riots in Watts district of Los Angeles.

Indira Gandhi becomes India's prime minister.

National Organization of Women (NOW) is founded by Betty Friedan and 48 others; Black Panthers is founded by Huey P. Newton and Bobby Seale.

2,000 Madrid University students clash with police in demonstration.

Mao publishes Quotations of Chairman Mao and initiates the Great Proletarian Cultural Revolution, which targets intellectuals, artists, and well-to-do peasants, as well as universities and temples, leading to massive dislocation and demoralization.

Riot by transgendered youth at Compton's Cafeteria in San Francisco presages Stonewall riots and gender conflict throughout Western society.

'66

The term MINIMALISM comes into common usage.

First artist's VIDEO by Nam June Paik shown at Café au Go Go, New York.

National Endowment for the Arts (NEA) and National Endowment for the Humanities (NEH) are established, Washington, D.C.

William Seitz organizes exhibition of OP ART, The Responsive Eye, Museum of Modern Art, New York.

The assassination of Malcolm X and Amiri Baraka's move from Manhattan's Lower East Side to Harlem help catalyze BLACK ARTS MOVEMENT.

Kynaston McShine organizes Primary Structures, devoted to MINIMALIST art, Jewish Museum, New York.

Experiments in Art and Technology (E.A.T.) is founded in New York.

Robert Venturi publishes his influential POSTMODERN treatise, Complexity and Contradiction in Architecture.

Exhibition of Edward Kienholz's Back Seat Dodge '38 creates furor over sexual content; Board of Supervisors nearly closes down Los Angeles County Museum of Art.

Opening of the Asian Art Museum of San Francisco, largest such institution in the U.S.

FLUXUS artist Dick Higgins coins term INTERMEDIA.

The Los Angeles Artists Protest Committee, an anti-Vietnam War group, constructs a six-story-high "Peace Tower" on the Sunset Strip. Six Day War between Israel and Arab countries.

Bolivian troops kill Cuban revolutionary Ernesto "Che" Guevara.

China explodes its first hydrogen bomb.

Widespread anti-Vietnam War demonstrations in U.S.

Race riots break out in U.S.

Christiaan N. Barnard performs first heart transplant operation.

Rolling Stone begins publication.

USSR invades Czechoslovakia.

Student uprisings in Europe and U.S.; general strike in Paris.

Robert F. Kennedy and Martin Luther King, Jr., are assassinated.

Pierre Trudeau becomes prime minister of Canada.

Richard Nixon is elected U.S. president.

Tet offensive by North Vietnamese army and the Viet Cong; My Lai massacre.

'67

'68

The term ARTE POVERA is coined by Germano Celant.

The term CONCEPTUAL ART is popularized.

Funk exhibition, Berkeley Art Museum, California.

Center for Advanced Visual Studies opens at Massachusetts Institute of Technology, Cambridge.

NEA establishes Art in Public Places program.

Summer of Love in San Francisco's Haight-Ashbury neighborhood marks zenith of hippie subculture.

Cybernetic Serendipity: The Computer and the Arts, Institute of Contemporary Arts, London.

The Machine as Seen at the End of the Mechanical Age, Museum of Modern Art. New York.

POP ART dominates Documenta 4, Kassel.

Andy Warhol is shot by Valerie Solanas, founder and sole member of SCUM (Society for Cutting Up Men), and nearly dies.

Earth Art, White Museum, Cornell University, Ithaca, New York.

Marcel Duchamp dies; his last work, Etant donnés (1946–66), will be permanently installed in the Philadelphia Museum of Art. Riots in Northern Ireland between Protestants and Roman Catholics.

U.S. troops begin to be withdrawn from Vietnam.

Golda Meir becomes fourth prime minister of Israel.

U.S. spacecraft Apollo 11 lands on moon; Neil Armstrong steps out onto the moon.

Human ovum is successfully fertilized in test tube.

Woodstock and Altamont music festivals.

Native Americans seize Alcatraz Island, San Francisco, occupying it for three years.

Stonewall rebellion in New York triggers Gay Liberation movement. U.S. bombs Communist strongholds in Cambodia.

Antiwar demonstrations in the U.S.; the National Guard kills four students at Kent State University in Ohio.

Marxist Salvador Allende is elected president of Chile.

Nigerian civil war ends.

Twenty million Americans participate in first Earth Day.

Kate Millet publishes Sexual Politics.

Communist Angela Davis is arrested on murder charges (acquitted two years later).

Exhibitions of PROCESS ART: When Attitudes Become Form, Bern Kunsthalle, and Anti-Illusion: Procedures/Materials, Whitney Museum

First FEMINIST ART program founded, at California State University, Fresno; moves to California Institute of the Arts a year later.

First ALTERNATIVE SPACES open in New York.

of American Art, New York.

First entirely CONCEPTUAL exhibition, Seth Siegelaub gallery, New York.

Pontus Hultén organizes The Work of Art in the Age of Mechanical Reproduction at Museum of Modern Art. New York.

Art Workers' Coalition founded in New York to protest the underrepresentation of minority artists in museums and the lack of institutional opposition to the Vietnam War.

Exhibitions of CONCEPTUAL ART: Information, Museum of Modern Art, and Software, Jewish Museum, both New York.

Happenings and Fluxus, Kölnischer Kunstverein, Cologne.

Museum of Conceptual Art is founded by Tom Marioni in San Francisco.

Exhibitions of sound art: Sound (1969–70), Museum of Contemporary Crafts, New York, and Sound Sculpture As, Museum of Conceptual Art, San Francisco.

Conceptual Art/Arte Povera/Land Art, Galleria Civica d'Arte Moderna. Turin

200,000 march on Washington to demand end of Vietnam War.

Idi Amin seizes power in Uganda.

East Pakistan achieves sovereignty and becomes Bangladesh.

U.S. Lt. William Calley convicted of premeditated murder of civilians at My Lai.

New York Times publishes the leaked Pentagon Papers.

Women are granted the right to vote in Switzerland.

Astronomers confirm the "black hole" theory.

Cigarette advertisements are banned from U.S. television.

Germaine Greer publishes The Female Eunuch.

The PRC wins the China seat from Taiwan at the UN.

Watergate scandal begins with apprehension of Republican operatives in Democratic National Headquarters.

President Nixon visits China and USSR.

U.S. Supreme Court rules the death penalty unconstitutional.

Nixon is reelected U.S. president.

Arab terrorists kill two Israeli Olympic athletes in Munich and take nine others hostage, all of whom are killed in shoot-out with police and military.

Gloria Steinem and others found Ms. magazine.

The military draft is phased out in the U.S.

Moog (electronic music) synthesizer patented.

71

'72

ART AND TECHNOLOGY program (1967–71) culminates in exhibition, Los Angeles County Museum of Art.

Robert Pincus-Witten coins the term *Post-Minimalism*.

Hans Haacke's exhibition about New York real estate ownership is canceled by Guggenheim Museum, New York.

RICHARD AND PAT NIXON IN CHINA, 1972

First exhibition of ARTISTS' BOOKS, Nigel Greenwood Gallery, London.

Retrospective exhibition of photographs by Diane Arbus at Museum of Modern Art, New York, so disturbs viewers that some spit on the pictures.

Documenta 5, Kassel, offers international survey of new art, including PHOTO-REALISM.

Exhibition of CONCEPTUAL ART: "Konzept"-Kunst, Öffentliche Kunstsammlung, Basel.

SOTS ART named by Komar and Melamid in Moscow.

Chilean President Salvador Allende is overthrown by military junta and either commits suicide or is assassinated.

Arab oil-producing nations embargo shipments to the U.S., Western Europe, and Japan in retaliation for their support of Israel.

U.S. Supreme Court rules a state may not prevent a woman from having an abortion during the first six months of pregnancy.

Martin Cooper of Motorola makes the first telephone call from a handheld mobile phone. On the verge of impeachment, Nixon resigns; Gerald Ford becomes U.S. president.

Worldwide inflation and recession.

Author Aleksandr Solzhenitsyn is deported from USSR.

India becomes sixth nation to explode a nuclear device.

'73

'74

The term ARTISTS' BOOKS is coined by Dianne Vanderlip for the exhibition Artists Books, Moore College of Art, Philadelphia.

Auction of Robert and Ethel Scull's collection signals meteoric rise in prices for contemporary art, New York.

International conference on VIDEO ART, "Open Circuits," is held at Museum of Modern Art, New York.

Soviet officials mow down an openair show of unofficial art in Moscow, which becomes known as the "Bulldozer" show.

SIGNING OF THE PARIS PEACE ACCORDS, JANUARY 27, 1973

Civil wars in Lebanon, Angola, and Ethiopia.

Generalissimo Francisco Franco dies; Juan Carlos I becomes king of Spain in return to democracy.

Phnom Penh falls to Khmer Rouge troops; U.S. Embassy closes and Americans leave Cambodia. First functional synthetic gene constructed at Massachusetts Institute of Technology, Cambridge.

Mao Zedong and Zhou Enlai die.

North and South Vietnam are reunited after twenty-two years of separation; renamed the Socialist Republic of Vietnam.

Jimmy Carter is elected U.S. president.

'75

'76

First exhibition of GRAFFITI ART, Artists Space, New York.

Body Works, Museum of Contemporary Art, Chicago.

Christo and Jeanne-Claude's twenty-four mile (39 km) Running Fence in northern California catapults them to fame.

Linda Nochlin and Ann Sutherland Harris organize Women Artists: 1550–1950, Los Angeles County Museum of Art.

Robert Wilson and Philip Glass first present the operatic PERFOR-MANCE spectacle Einstein on the Beach at the Festival d'Avignon, France.

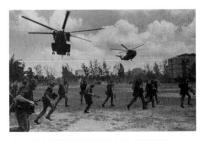

U.S. MARINES EVACUATE PHNOM PENH, APRIL 12, 1975

ART WORLD

Egyptian president Anwar Sadat flies to Israel on peace mission, the first Arab leader to visit the Jewish state since its founding in 1948.

U.S. signs treaty to relinquish control of Panama Canal to Panama.

Military deposes Zulfikar Bhutto in Pakistan.

Nobel Peace Prize is awarded to Amnesty International; the 1976 Nobel Peace Prize is belatedly awarded to the Irish women Mairead Corrigan and Betty Williams.

Disco craze popularized by the film Saturday Night Fever.

Former Italian premier Aldo Moro is kidnapped and killed by Red Brigade terrorists.

Reverend Jim Jones and over 900 American followers commit suicide at People's Temple, Guyana. California Congressman Leo Ryan and others are killed shortly beforehand in attempted intervention.

San Francisco Mayor George Moscone and Supervisor Harvey Milk are assassinated by Supervisor Dan White in city hall.

Civil war begins in Nicaragua.

First "test-tube baby" is born in Britain.

Karol Cardinal Wojtyla becomes Pope John Paul II.

'77

'78

Exhibition of EARTH ART, Probing the Earth, Hirshhorn Museum and Sculpture Garden, Washington, D.C.

Susan Sontag publishes On Photography.

Centre National d'Art et de Culture Georges Pompidou (popularly known as the Beaubourg) opens in Paris.

U.S. tour of *The Treasures of* Tutankhamun, the biggest of the so-called blockbuster exhibitions.

Pictures, curated by Douglas Crimp at Artists Space, New York, features artists of what will later be called the PICTURES GENERATION.

Marcia Tucker organizes "Bad" Painting, New Museum of Contemporary Art, New York.

New Image Painting, Whitney Museum of American Art, New York.

I. M. Pei's East Building, for modern art, opens at the National Gallery of Art, Washington, D.C.

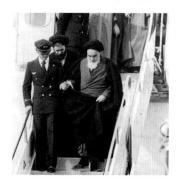

KHOMEINI RETURNS TO IRAN TO LEAD THE 1979 REVOLUTION

Israel and Egypt sign peace treaty.

Margaret Thatcher becomes Britain's prime minister.

USSR invades Afghanistan.

Seven-year war ends in Rhodesia (now Zimbabwe).

After the shah flees Iran, the Ayatollah Khomeini establishes an Islamic government; American hostages are held.

Major nuclear accident at Three Mile Island, Pennsylvania.

Pioneer II photographs Saturn's rings.

Christopher Lasch publishes *The Culture of Narcissism*, about the "me generation."

Ronald Reagan is elected U.S. president.

Green Party is formed in Germany to politicize ecological issues.

Voters in Quebec reject separatism.

Indira Gandhi becomes prime minister of India in dramatic political comeback.

Archbishop Oscar Romero is assassinated in El Salvador; civil war rages.

John Lennon is shot and killed in New York.

'79

'80

Frederic Edwin Church's *Icebergs* (1861) is auctioned for \$2.5 million, a record price for an American painting.

Judy Chicago's Dinner Party opens at San Francisco Museum of Modern Art.

Hara Museum of Contemporary Art opens in Tokyo.

First exhibition of the STARS GROUP in Beijing.

Venice Biennale features major survey of international POSTMODERN architecture, The Presence of the Past.

Exhibition of NEW WAVE art, Times Square Show, New York.

Picasso retrospective at Museum of Modern Art, New York, receives more than one million visitors.

Willem de Kooning's Two Women (1955) is first work by living artist to fetch \$1 million at auction.

RLD

ART WORLD

François Mitterand becomes president of France.

Pope John Paul II and President Reagan are wounded in assassination attempts.

President Sadat is assassinated by Muslim extremists in Egypt.

Martial law is declared in Poland, suspending operation of the new Solidarity trade union.

Massive nuclear-disarmament demonstrations in London, Paris, Brussels, Potsdam, and Amsterdam.

MTV debuts on U.S. television.

Yuri Andropov succeeds Brezhnev as leader of the USSR.

Falklands War fought by Britain and Argentina over British possession of south Atlantic islands.

Equal Rights Amendment, prohibiting discrimination on the basis of sex, fails to be ratified by a sufficient number of U.S. state legislatures.

AIDS (Acquired Immune Deficiency Syndrome) is named by the U.S. Centers for Disease Control; 1,208 AIDS deaths are reported in U.S. by end of year.

Mexico defaults on international bank loans, triggering Third World debt crisis.

'81

'82

Picasso's Guernica returns to Spain following resumption of democracy there, in accordance with the artist's wishes.

Robert Arneson's monumental ceramic *Portrait of George (Moscone)*, commissioned for the San Francisco convention center named for the slain mayor, is rejected by the city.

Fun Gallery opens in the EAST VILLAGE, New York (closes 1985).

Exhibition of NEO-EXPRESSIONISM, A New Spirit in Painting, Royal Academy of Arts, London. Transavanguardia, Italia-America: Mostra, Galeria Civica, Modena.

Completion of Michael Graves's Portland Municipal Services Building, generally known as the Portland Building, draws attention to POSTMODERNISM in architecture.

Dan Cameron organizes Extended Sensibilities: Homosexual Presence in Contemporary Art, New Museum of Contemporary Art, New York. Rául Alfonsin is elected president of Argentina, a rejection of the military government and the "disappearance" of thousands.

U.S. invades Grenada; overthrows Marxist regime.

241 U.S. troops, most of them Marines, killed in Beirut by truckbomb driven by pro-Iranian Shiite Muslims.

Lech Wałęsa, Solidarity leader, receives Nobel Peace Prize.

Reagan is reelected U.S. president.

Massive rioting and school boycotts begin in South Africa; Anglican Bishop Desmond Tutu receives Nobel Peace Prize for nonviolent campaign to end apartheid.

Rajiv Gandhi becomes prime minister of India after the assassination of his mother Indira Gandhi.

Gas leak from Union Carbide chemical plant kills some 2,500 in Bhopal, India.

Famine in Ethiopia threatens the lives of six million.

'83

'84

Exhibition of GRAFFITI ART at Museum Boijmans Van Beuningen, Rotterdam; Post-Graffiti, Sidney Janis Gallery, New York.

Museum of Contemporary Art, Los Angeles, opens.

Kate Linker organizes Difference: On Representation and Sexuality, New Museum of Contemporary Art, New York.

Neue Staatsgalerie opens in Stuttgart.

Havana Biennial inaugurated.

Artists Call Against U.S. Intervention in Central America organizes exhibitions and events in thirty cities protesting military incursions in the region.

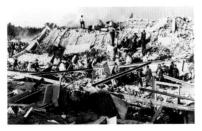

AFTERMATH OF THE 1983 TRUCK-BOMB ATTACK ON THE U.S. MARINE CORPS BARRACKS IN BEIRUT

GAS PLUME RESULTING FROM THE EXPLOSION OF THE SPACE SHUTTLE CHALLENGER, JANUARY 28, 1986

Mikhail Gorbachev becomes general secretary of the Soviet Communist Party; initiates campaigns for perestroika and glasnost.

1.6 billion people watch the *Live Aid* concert by satellite from London and help raise funds to alleviate African famine.

Philippine President Ferdinand Marcos is overthrown by "People Power"; Corazon Aquino becomes president.

The illegal diversion of funds to Iran for the release of hostages and the arming of Nicaraguan contras—known as the Iran-Contra scandal—comes to light in U.S.

U.S. bombs Libya in response to terrorism in the Middle East.

Accident at Chernobyl nuclear plant in USSR results in evacuation of 135,000.

The U.S. space shuttle *Challenger* explodes, killing entire crew.

Olof Palme, prime minister of Sweden, is assassinated.

'85

'86

Robert Rauschenberg exhibits his work in China, exerting major influence on contemporary art there.

Philosopher Jean-François Lyotard co-curates Les Immatériaux exhibition, a highly CONCEPTUAL, POSTMODERN exploration of technology and the contemporary self at Centre Georges Pompidou, Paris.

Exhibition of NEO-GEO, Sonnabend Gallery, New York.

Maurice Tuchman organizes *The Spiritual in Art: Abstract Painting,* 1890–1985, Los Angeles County Museum of Art.

Sots Art, New Museum of Contemporary Art, New York.

"Artisco" trend of artist-produced INSTALLATIONS at nightclubs peaks at Area, New York, with temporary works by Jean-Michel Basquiat, Francesco Clemente, Keith Haring, Julian Schnabel, Andy Warhol, and others.

Museo Nacional Centro de Arte Reina Sofia opens in Madrid.

Museum Ludwig opens in Cologne.

ART WORLD

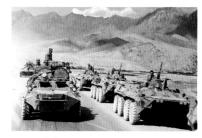

WITHDRAWAL OF SOVIET TROOPS FROM AFGHANISTAN, 1988

Palestinian uprising (or Intifada) protesting economic and social inequality begins in occupied territories and West Bank of Israel.

U.S. congressional Iran-Contra hearings are televised.

Stock market crashes in New York.

Largest gay-lesbian demonstration for civil rights in history, Washington, D.C.

James Gleick publishes Chaos: Making a New Science. George H. W. Bush is elected U.S. president.

USSR begins to pull its troops out of Afghanistan.

Iran-Iraq war ends.

'87

'88

NAMES Project Quilt, devoted to those who have died of AIDS, is first shown, on the Mall, Washington, D.C. Art against Aids is launched; raises over \$5 million in first two years.

Andy Warhol dies; his assets, auction, retrospective exhibition, foundation, diaries, museum, and possible forgeries keep him in the news for the next two years.

Hispanic Art in the United States, Museum of Fine Arts. Houston.

Vincent van Gogh's Irises (1889) auctioned for record \$53.9 million, New York.

National Gallery of Canada moves into Moshe Safdie-designed building, Ottawa.

"Unofficial" Soviet art begins to be widely exhibited in U.S. and Western Europe.

New York City Department of Consumer Affairs forces art galleries to post prices.

Museum openings: Instituto Valenciana de Arte Moderna (IVAM) in Valencia, Spain; Luigi Pecci Center of Contemporary Art in Prato, Italy.

Freeze exhibition, London, puts the YOUNG BRITISH ARTISTS on the map.

The Aboriginal Memorial is dedicated in the National Gallery of Australia in Canberra.

O.W.

Oil spill from tanker Exxon Valdez causes ecological disaster in Alaska.

Pro-democracy demonstrations in China are violently suppressed.

Momentous shifts in policies and governments throughout Eastern Europe (symbolized by the opening of the Berlin Wall) signal the diminution of Communism and a new balance of power in Europe.

U.S. Supreme Court narrows abortion rights; pro-choice demonstrations are held throughout the country.

Battle against the worldwide AIDS epidemic is being lost; more than 66,000 dead in U.S. (a greater toll than the Vietnam War).

Abortion pill developed in France.

U.S. invades Panama.

Samuel Beckett dies.

Iraq invades Kuwait, prompting U.S. threat of war if January 1991 deadline for withdrawal is not met.

Worldwide recession begins.

Jean-Bertrand Aristide becomes first democratically elected president of Haiti but is forced into exile.

John Major becomes prime minister of Britain.

Helmut Kohl is elected chancellor of newly reunited Germany.

'89

'90

On the Passage of a Few People Through a Rather Brief Moment in Time (on SITUATIONIST art) and Les Magiciens de la terre, both at Centre Georges Pompidou, Paris.

Richard Serra's PUBLIC ART work, Tilted Arc, is removed from its New York site after years of legal wrangling.

Corcoran Gallery of Art, Washington, D.C., cancels exhibition of Robert Mapplethorpe's photographs; U.S. Senate bars public funding of "obscene" art.

Willem de Kooning's Interchange (1955) is auctioned for \$20.7 million, setting a record for a work by a living artist.

Visual AIDS organizes first annual "Day Without Art: A National Day of Action and Mourning in Response to the AIDS Crisis."

China/Avant-Garde exhibition opens (and promptly closes) in Beijing.

The Decade Show opens at multiple venues in New York, focusing attention on identity politics and MULTICULTURALISM.

Ryoei Saito pays \$78.1 million for Pierre-Auguste Renoir's Au Moulin de la Galette and \$82.5 million for Vincent van Gogh's Portrait of Dr. Gachet, making them the two most expensive artworks ever purchased at auction.

Kathy Halbreich and David Ross assume directorships of Walker Art Center and Whitney Museum of American Art, respectively, signaling a generational change.

Thirteen works of art from Isabella Stewart Gardner Museum in Boston, then valued at \$200 million, stolen in biggest-ever art heist.

Cincinnati's Contemporary Arts Center and its director, Dennis Barrie, are acquitted on obscenity charges related to Robert Mapplethorpe exhibition. U.S.-led Gulf War forces drive Iran out of Kuwait.

Soviet president Mikhail Gorbachev is ousted in temporary coup; Boris Yeltsin rallies anti-Communist forces as USSR collapses. Yeltsin is later elected president.

Civil war rages in former Yugoslavia; Slovenia and Croatia declare independence.

Mount Pinatubo erupts in Philippines, taking 330 lives and affecting global weather conditions.

Ötzi the Iceman, 4,800 years old, is discovered in Austrian glacier.

Race riots in Los Angeles follow acquittal of four policemen accused of beating Rodney King, resulting in 58 dead, \$775 million in property damage.

Hurricane Andrew is costliest natural disaster in U.S. history: sixty-one dead, \$22 billion in property damage.

Brazilian president Fernando Collor de Mello is impeached for influence-peddling.

Bill Clinton is elected U.S. president.

'91

'92

Hitler's Entartete Kunst (Degenerate Art) exhibition of 1937 is remounted by Los Angeles County Museum of Art.

Museum openings: Museum of Modern Art, Frankfurt; Irish Museum of Modern Art, Dublin; Museo de Arte Contemporáneo de Monterrey, Monterrey, Mexico.

Christo and Jeanne-Claude's The Umbrellas, Japan–USA unfurls at cost of \$26 million and two lives.

Places with a Past, organized by Mary Jane Jacob, brings twenty-three artists to Charleston, South Carolina, for year-long SOCIAL PRACTICE collaborations with residents.

APPROPRIATION artist Jeff Koons is found guilty of copyright infringement in federal appeals court.

Walt Disney Company forces owner of a Los Angeles building to remove Dennis Oppenheim sculpture incorporating Mickey Mouse and Donald Duck.

Museo de Arte Thyssen-Bornemisza opens in Madrid.

Art Taipei is first art fair held in Asia.

WORLD

WORLD

World Trade Center in New York is bombed.

Ultranationalists make gains in local elections in Russia, Italy, Austria, France, and Germany.

Nobel Peace Prize goes to South African president F. W. de Klerk and African National Congress leader Nelson Mandela.

E-mail begins to be widely used.

Jonathan Demme's Philadelphia is first major Hollywood movie about AIDS.

Mandela is elected president of South Africa

Hundreds of thousands of Tutsis slain by Hutu-led army in Rwanda.

Russia invades Chechnya, following its secession.

General Agreement on Tariffs and Trade (GATT) approved by 117 nations.

U.S. National Center for Supercomputing Applications develops the pioneering Web browser Mosaic.

Kurt Cobain of the rock band Nirvana commits suicide.

Twenty-fifth anniversary of Woodstock draws 350,000 to Saugerties, New York; Rod Stewart draws more than 3.5 million to Copacabana Beach in Rio de Janeiro on New Year's Eve, making it the largest concert ever.

'94

Museum openings: Carré d'Art, Nîmes, France; Galicia Center for Contemporary Art, Santiago de Compostela, Spain; Yerba Buena Center for the Arts, San Francisco; Arnulf Rainer Museum, New York; United States Holocaust Memorial Museum, Washington, D.C.

Actress Jane Alexander is appointed chair of the beleaguered NEA.

The Whitney Biennial, devoted to INSTALLATION works on the theme of identity politics, is reviled by many commentators.

China's New Art since 1989 opens in Hong Kong.

Ai Weiwei publishes first of his *Black Books* in Beijing.

Organizers of the Cologne Art Fair stir controversy by initially refusing to show paintings by CONTEMPORARY INDIGENOUS AUSTRALIAN ARTISTS because the works are "folk" rather than "authentic" art.

Japanese Art after 1945: Scream against the Sky, which travels throughout U.S. and Japan, is the largest survey of postwar Japanese art to date.

Museum opening: Andy Warhol Museum, Pittsburgh.

The File Room, an interactive archive of censorship by Antonio Muntadas, is first major artwork on World Wide Web.

Presidents of Bosnia, Croatia, and Serbia sign treaty in Paris, to be enforced by NATO troops.

168 killed in domestic terrorist attack on the Alfred P. Murrah Federal Building in Oklahoma City.

Three-week-long general strike protests social welfare cuts in France; government makes concessions.

Trial of former football star O. J. Simpson for the murder of his ex-wife, Nicole, and Ronald Goldman ends in acquittal.

Yeltsin is elected president of Russia.

Clinton is reelected U.S. president.

Benjamin Netanyahu becomes prime minister of Israel.

Lee Teng-hui is the first directly elected president of Taiwan.

"Unabomber" Theodore Kaczynski is captured in Montana; two years later sentenced to life imprisonment.

Federal appeals courts strike down state laws in New York and Washington that ban physicianassisted suicide.

'95

'96

Museum openings: Museu d'Art Contemporani, Barcelona; Museum of Contemporary Art, Tokyo; Memorial to Indigenous People, Brasília; Wolfsonian, Miami Beach.

Kwangju (South Korea) Biennial debuts; Venice Biennial celebrates its 100th anniversary.

Peter Ludwig establishes Fundación Ludwig de Cuba in Havana.

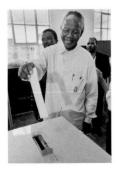

NELSON MANDELA VOTES IN SOUTH AFRICA'S 1994 ELECTIONS

Museum of Modern Art, New York, opens *Picasso and Portraiture*, its third blockbuster devoted to the artist since his death in 1973.

Traffic, curated by relational art theorist Nicolas Bourriaud, at Museum of Contemporary Art, Bordeaux, France.

Institutional interest in electronic art is signaled by opening of Ars Electronica Museum in Linz, Austria, and new galleries devoted to digital art at the Guggenheim Museum Soho in New York.

Museum openings: Ludwig Museum, Beijing; National Gallery's Contemporary Art Museum, Berlin; Museum of Contemporary Art, Niterói, Brazil.

U.S. federal appeals court rules that the government cannot require the NEA to consider "prevailing standards of decency" in making grants to artists. Tony Blair becomes prime minister of Great Britain.

Madeleine Albright is first woman appointed U.S. Secretary of State.

UN adopts the Kyoto Protocol, an international treaty for the reduction of greenhouse gas emissions (later ratified by 191 nations, but not the U.S.)

Princess Diana is killed in auto accident in Paris; millions of mourners gather outside London's Westminster Abbey, where her funeral is held.

World's first surviving septuplets born.

Scientists in Scotland announce the first cloned mammal, a sheep named Dolly

Military coup in Zaire (which is renamed the Democratic Republic of the Congo).

Historic agreement brings peace to Northern Ireland.

India resumes nuclear testing in violation of international ban, prompting Pakistan to do the same.

President Clinton admits to affair with Monica Lewinsky. He is impeached in House of Representatives, acquitted in Senate.

Viagra, the male impotence drug, is approved by U.S. Food and Drug Administration.

James Cameron's Titanic becomes highest-grossing film ever.

'97

'98

Continued institutional interest in electronic art reflected in openings of ZKM (Zentrum für Kunst und Medientechnologie, or Center for Art and Media Technology) in Karlsruhe, Germany, and Eyebeam Art + Technology Center in New York.

Guggenheim Museum Bilbao, Spain, opens in spectacular building designed by Frank Gehry. Inside Out: New Chinese Art, organized by Gao Minglu and featuring post-1984 art, is seen at the Asia Society, New York, and the San Francisco Museum of Modern Art.

TAXIDERMIED REMAINS OF DOLLY, THE CLONED SHEEP INTRODUCED TO THE WORLD IN 1997

ART WORLD

Pervez Musharraf takes power in military coup in Pakistan.

Falun Gong—a spiritual discipline emphasizing meditation and compassionate action—is outlawed in China (a move later censured by UN as a human rights abuse).

Euro monetary zone created in Europe.

Two high school students gun down fifteen, including themselves, at Columbine High School in Littleton, Colorado; Larry Ashbrook kills seven in Fort Worth church.

John F. Kennedy, Jr., killed in crash of small airplane he was piloting, off Nantucket Island.

George W. Bush attains U.S. presidency in election decided by Supreme Court.

Vladimir Putin is elected president of Russia.

Vicente Fox Quesada is elected president of Mexico, ending seventyone years of single-party rule by the Institutional Revolutionary Party, or PRI.

Yugoslav president Slobodan Milošević is overthrown, captured, and turned over to UN tribunal in The Hague for war crimes trial.

Mad cow disease causes jitters in Europe.

Y2K bug fails to cause widespread computer trouble.

'99

'00

Forty-eighth Venice Biennale features work by twenty artists from China, underlining prominence of Chinese art.

Twenty-fourth São Paulo Bienal, on the theme of *anthropophagy*, or cultural cannibalism, is applauded for its cosmopolitanism.

The 2000 Sydney Olympic Arts Festival, *Harbour of Life*, the last of four annual festivals, features some fifty exhibitions of European and CONTEMPORARY INDIGENOUS AUSTRALIAN ART.

BRAIN TISSUE OF A BOVINE WITH MAD COW DISEASE, THE CAUSE OF WIDE-SPREAD CONCERN IN EUROPE IN 2000

ART WORLD

On September 11, al-Qaeda terrorists, under direction of Osama bin Laden, ram hijacked jetliners into the World Trade Center and the Pentagon, and crash another jet outside Pittsburgh; more than three thousand killed.

U.S. and British forces launch bombing campaign in Afghanistan against al-Qaeda training camps and Taliban regime, forcing its collapse.

Population of India reaches one billion.

Earthquake in the Indian state of Gujarat kills 20,000 and injures 167,000.

First self-contained artificial heart successfully implanted in a human in Louisville, Kentucky.

Wikipedia is launched.

International Criminal Court in The Hague ratified without U.S. support.

Venezuelan president Hugo Chávez ousted in coup, reinstated two days later.

U.S. and Russia sign landmark arms agreement to cut nuclear arsenals by more than half over a decade.

Terrorist attack by violent Islamist group kills more than two hundred in Bali; more than one hundred dead in Moscow after Russian forces attack theater in which Chechen rebels are holding 763 hostages.

East Timor is recognized as an independent state.

12,000-year-old, 500 billion ton Larsen B ice shelf, part of the Antarctic Peninsula, disintegrates in just five weeks.

'01

'02

Milwaukee Art Museum opens addition designed by Santiago Calatrava.

Artist Carolee Schneemann appropriates newspaper photos of victims of 9/11 terrorist attacks jumping from World Trade Center towers for her work *Terminal Velocity*, which is defaced with obscenities when shown at Elga Wimmer PCC, New York, in October 2001. Eric Fischl's similarly themed bronze sculpture *Tumbling Woman* is removed from Rockefeller Center in 2002.

Afghan Taliban destroys the Buddhas of Bamiyan, two monumental sculptures dating to the sixth century AD.

Documenta 11, on the theme of globalism, features didactic work in five "events," staged on four continents over eighteen months. The last is the traditional exhibition in Kassel.

Critic Glen Helfand coins term MISSION SCHOOL.

U.S.-led coalition launches war in Iraq, despite millions protesting throughout the world.

500,000 march in Hong Kong over a bill expanding government power to monitor citizens, which is withdrawn.

U.S. space shuttle *Columbia* disintegrates, killing entire crew.

Mars makes its closest approach to Earth in nearly 60,000 years; NASA launches the Spirit Rover to begin exploration of the "Red Planet."

350,000-year-old footprints of an upright-walking human are found in Italy.

Recording Industry Association of America files lawsuits against hundreds who illegally swap music online. Apple Computer opens iTunes Store, making music downloading cheap and easy.

9.3 magnitude earthquake and resulting tsunami kill 230,000 in Sri Lanka, India, Indonesia, Thailand, Malaysia, and the Maldives.

U.S. media release graphic photos of American soldiers sexually humiliating Iraqi prisoners at Abu Ghraib prison.

251 people are trampled to death at the Hajj pilgrimage in Saudi Arabia.

San Francisco Mayor Gavin Newsom directs city clerk to issue marriage licenses to same-sex couples; gay New Jersey governor James McGreevey comes out and resigns.

Singer Janet Jackson's breast is exposed during Super Bowl half-time show, prompting the euphemism wardrobe malfunction.

Facebook is launched.

'03

'04

Alors la Chine? (Well then, China?) at the Centre Georges Pompidou, Paris, is the first officially sponsored foreign exhibition of Chinese AVANT-GARDE art.

FISHING BOAT WASHED ASHORE IN BANDA ACEH, SUMATRA, BY THE 2004 TSUNAMI

Millennium Park opens in downtown Chicago. The world's largest rooftop park at 25 acres (10 ha), it features a bandshell and a bridge designed by Frank Gehry.

Museum of Modern Art, New York, reopens after two-year renovation project led by architect Yoshio Taniguchi.

Two paintings by Edvard Munch, *Madonna* and one of four versions of *The Scream*, are stolen from the Munch Museum in Oslo.

U.S. artist Mitch Benoff wins competition for a light-based artwork for the 2004 Olympic Games in Greece with Athens Olympic Meteor. Its fifty-four strobe lights fire in rapid succession, leading the eye up Mount Lycabettus to the newly relit Parthenon.

Pope John Paul II dies, Joseph Cardinal Ratzinger of Germany succeeds him as Pope Benedict XVI.

Angela Merkel becomes first woman chancellor of Germany.

Evo Morales becomes first indigenous president of Bolivia.

Hurricane Katrina claims 1,840 lives, floods 80 percent of New Orleans, and causes \$100 billion in damage.

Fifty-two killed in July 7 terrorist attacks on London trains and buses.

Former Lebanese prime minister Rafic Hariri is killed in bomb blast.

YouTube is launched.

Sadam Hussein is hanged after two years' imprisonment.

Stephen Harper becomes first Conservative Party prime minister of Canada.

The China-Tibet railway line is completed, symbolizing Tibet's annexation by China and its new status as an "autonomous" Chinese province.

China overtakes the U.S. as the largest emitter of carbon dioxide.

Pluto is demoted to "dwarf planet" status.

Twitter is launched.

05 '06

In San Francisco, the de Young Museum reopens in a new Herzog & de Meuron-designed building in Golden Gate Park, and the Contemporary Jewish Museum opens in a landmark 1907 power substation redesigned by Daniel Liebeskind.

Peter Eisenman's Memorial to the Murdered Jews of Europe, comprising 2,711 concrete stelae of different heights, opens in Berlin. Sotheby's New York holds its first auction of contemporary Asian art.

Gustav Klimt's Adele Bloch-Bauer I (1907) changes hands in a private sale for \$135 million, an apparent record. A few months later, Jackson Pollock's No. 5, 1948, sells privately for a reported price of \$140 million.

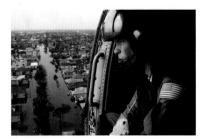

U.S. COAST GUARDSMAN SURVEYS FLOODING IN NEW ORLEANS AFTER HURRICANE KATRINA, 2005

Benazir Bhutto is assassinated in Pakistan while campaigning for 2008 election.

Nicolas Sarkozy is elected president of France; Gordon Brown becomes prime minister of Great Britain.

In the second-deadliest terrorist attack since 9/11, multiple suicide bombers kill 796 in Yazidi communities in northern Iraq.

Arctic sea ice hits a record low, enabling ships to traverse Northwest Passage without icebreakers for first time.

Apple releases iPhone.

Barack Obama is first African-American to be elected U.S. president.

Violent anti-Chinese protests in Tibet lead to a tense standoff between the Chinese army and Buddhist monks.

Maoist parties win first democratic elections in Nepal.

Fidel Castro resigns as president of Cuba after nearly a half-century in power. He is succeeded by Raúl Castro, his brother.

Sichuan earthquake wreaks havoc on southwestern China, resulting in some 70,000 deaths.

U.S. subprime mortgage crisis leads to worldwide economic recession.

Summer Olympic Games held in Beijing.

'07

'08

Baron Guy and Myriam Ullens open the Ullens Center for Contemporary Art in Beijing, the first such venue established by foreigners.

Damien Hirst completes For the Love of God, a platinum cast of an eighteenth-century human skull encrusted with 8,601 diamonds and initially offered for sale for £50 million.

U.S. photographer Spencer Tunick photographs a record 18,000 nude volunteers in Mexico City's Zócalo.

Beijing Olympics showcase new projects by "starchitects" including Herzog & de Meuron, Rem Koolhaas, PTW, and Paul Andreu, and prompts summer art fairs throughout China, Southeast Asia. and Australia.

Eleven of the world's twenty topselling artists are Chinese. Zhang Xiaogang's works bring \$44 million at auction this year, and Zeng Fanzhi's *Mask Series* 1996 No. 6 sells for \$9.7 million at Christie's Hong Kong, making it the most expensive contemporary Chinese artwork ever.

Damien Hirst organizes an auction of his own work at Sotheby's, London, which takes in more than £110 million.

Jeff Koons's exhibition at Versailles pits contemporary Baroque kitsch against traditional Baroque splendor, to controversial effect.

Tens of thousands protest contested presidential election in Iran, the biggest threat to the Islamic regime in its thirty-year history.

Population of Africa reaches one billion, partly due to shortage of family planning and contraception.

Korean research team develops efficient method of manufacturing biodegradable plastics.

Water is discovered on the moon: NASA's Messenger probe maps 98 percent of planet Mercury.

The Burj Khalifa in Dubai becomes the tallest skyscraper ever built, rising to a height of 2,684 ft. (818 m) and comprising 160 floors.

James Cameron's science-fiction epic Avatar becomes highestgrossing film ever, surpassing his Titanic.

Haiti earthquake kills more than 230,000.

Monsoon rains in Pakistan kill two thousand and flood 20 percent of country.

Oil spill in Gulf of Mexico caused by BP kills eleven workers, becomes worst maritime environmental disaster in U.S. history.

Greek debt is downgraded to junkbond status, escalating European Union debt crisis.

WikiLeaks releases huge cache of classified documents from U.S. military. Its founder, Julian Assange, is charged with rape in Sweden but seeks refuge in the London embassy of Ecuador, which grants him political asylum in 2012.

Apple debuts iPad.

After rising 583 percent in five years, Artprice's index of contemporary Chinese art at auction crashes, reflecting the ongoing world financial crisis.

Qatar—with a population of less than two million—becomes world's largest contemporary art buyer.

French President Nicolas Sarkozy attends laying of foundation stone of the Louvre Abu Dhabi.

An armchair by Eileen Gray sells for more than \$28 million at a Paris auction, a record for modern decorative art.

Rocker Patti Smith's Just Kids, a coming-of-age story about herself and photographer Robert Mapplethorpe, wins National Book Award.

An average of one hundred museums, about half devoted to art, open in China each year over the past decade, peaking at about four hundred in 2010. There is an unfortunate shortage of art to fill them and experienced managers to run them.

The director of the National Portrait Gallery in Washington, D.C., removes David Wojnarowicz's film A Fire in My Belly (1986-87) from an exhibition of gay and lesbian portraiture, echoing the CULTURE WARS of the late 1980s.

Alberto Giacometti's sculpture Walking Man I (1960) sells for \$104 million at auction, a record that is exceeded later in the year by the sale of Picasso's painting Nude, Green Leaves, and Bust (1932) for \$106.5 million at auction.

The Arab Spring begins in Tunisia and spreads to Libya, Bahrain, Yemen, Egypt, and Syria. Outcomes include the ouster of Ben Ali in Tunisia, Qaddafi in Libya, and Mubarak in Egypt.

U.S. Navy SEAL team kills Osama bin Laden in Pakistan.

Huge earthquake hits Japan, triggering a 23 foot (7 m) tsunami that causes the Fukushima Daiichi nuclear power station to fail.

Occupy Wall Street catalyzes protests across U.S. against the enrichment of the top 1 percent at the expense of everyone else.

Rupert Murdoch's media empire in England is rocked by revelations of phone hacking and corporate malfeasance.

Kate Middleton marries Prince William in London.

Obama reelected U.S. president; Putin reelected Russian president; Chávez reelected Venezuela president (dies in 2013).

François Hollande elected president of France, returning Socialists to power for first time since 1995.

UN General Assembly upgrades status of Palestinian Authority to non-member state.

Myanmar opposition leader Aung San Suu Kyi elected to Parliament, after two decades of house arrest.

U.S. states of Colorado and Washington legalize the recreational use of marijuana.

Summer Olympics in London; U.S. swimmer Michael Phelps wins record nineteenth gold medal.

Mayan calendar cycle ends on December 21, world does not.

'11

12

Getty Research Institute sponsors *Pacific Standard Time: Art in L.A.* 1945–1980, consisting of dozens of exhibitions at venues throughout Southern California. This ambitious program challenges conventional wisdom about postwar art in the region.

The Qatari royal family buys a version of Cézanne's *Card Players* for \$259 million, making it the most expensive artwork ever sold.

Collector David Walsh opens Australia's largest privately funded museum, the Museum of Old and New Art in Hobart, Tasmania, to exhibit his eclectic holdings. Curator Michael Duncan coins the term ABJECT EXPRESSIONISM for the subtitle of his exhibiton L.A. Raw at the Pasadena Museum of California Art.

Moscow punk band and performance art troupe Pussy Riot targets the Communist Party, the Russian Orthodox Church, and official homophobia in made-for-video STREET ART and PERFOR-MANCES that enrage Putin regime. Three members of the group are jailed for an extended period.

Jeff Koons's sculpture Tulips sells for \$33.6 million at Christie's, New York, establishing the record for a work by a living artist.

Unveiling of Michael Heizer's Levitated Mass, a 340-ton boulder balanced above a walk-through trench, on the grounds of the Los Angeles County Museum of Art.

WHO Ding Fang, Fang Lijun, Geng Jianyi, Gu Wenda, Huang Yong Ping, Li Shan, Li Tianyuan, Li Yelin, Liu Xiaodong, Mao Xuhui, Ni Haifeng, Shu Qun, Song Yonghong, Song Yongping, Sun Liang, Wang Guangyi, Wang Jonson, Wei Guangqing, Wu Shanzhuan, Xiao Lu, Xu Bing, Xu Tan, Ye Yongqing, Yu Hong, Zeng Fanzhi, Zhang Peili, Zhang Xiaogang, Zhao Bandi, Zhou Chunya

▶WHEN 1985 to 1989

▶ WHERE China

▶ WHAT The term '85 New Wave was coined by critic Gao Minglu to describe a broad-based movement—really an explosion of avant-garde energy—in response to the lifting of the stultifying strictures of the Great Proletarian Cultural Revolution of the 1960s and '70s. Targets of the Cultural Revolution included "outmoded" individuals, groups, and institutions—such as intellectuals and well-to-do peasants, universities and temples, and classical architecture and art. Artists were imprisoned or placed under house arrest and sent to labor camps or farms for "reeducation" through agricultural labor and "self-criticism."

After the deaths of Zhou Enlai and Mao Zedong in 1976, leadership of the by-then discredited Cultural Revolution was assumed by Jiang Qing (Madame Mao) and the Gang of Four, who were subsequently arrested and executed. In 1978 the pragmatic Deng Xiaoping became leader of the Communist Party, replacing Maoist zealotry with utilitarian platitudes such as "Seek truth from facts." He enabled reforms ranging from the adoption of capitalist banking to the approval of (limited) debate at sanctioned sites such as the so-called Democracy Wall in Beijing, or the (brief and limited) tolerance for the STARS GROUP of artists.

The '85 New Wave movement was national in scope. It sprang up in a society without contemporary galleries, museums, or art publications. In its first two years, it involved more than two thousand artists in twenty-nine provinces, who organized themselves into seventy-nine avant-garde groups, sometimes manifesto-driven, that produced hundreds of exhibitions and conferences. The artistic languages and approaches they employed were highly eclectic: the term '85 New Wave is not a STYLISTIC designation so much as shorthand for the burgeoning creativity that was unleashed by Chinese artists' encounters with a half-century of avant-garde Western styles within a decade. The multitude of approaches they pursued can be loosely divided by geography—both North/South and East/West—as well as by distinctions between urban and rural sensibilities.

The Northern and Southern art produced in the 1980s and '90s continued to reflect the age-old distinctions between the academic painting associated with the North—centered on the imperial court in Beijing—

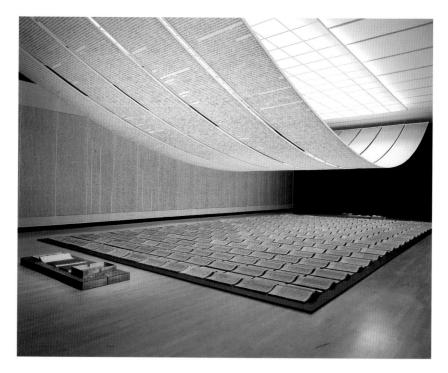

'85 NEW WAVE
Xu Bing (b. 1955)
Book from the Sky, 1987–91
Books and ceiling and wall scrolls printed
from wooden letterpress type using false
Chinese characters, dimensions variable
Installation view at Crossings,
National Gallery of Canada, Ottawa, 1998

and the highly valued amateur or *literati* painting associated with the South. Crudely put, this translated into an emphasis in the North on painting with a political bent, figurative imagery, and virtuoso realist technique, while in the South works of expressionistic abstraction in diverse materials and media were more typical. The art of the Beijing-oriented artists is often described as *Rational painting*, and many of its most accomplished practitioners are identified with the Northern Artists Group.

With its emphasis on poetry, personal expression, and openness to outside influences, work produced in the South is more difficult to characterize than that of the North. The Neo-Image Exhibitions of the Southwest Artists Group featured evocatively surrealistic explora-

tions of the natural world, while the Xiamen Dada group mounted the first exhibition of FOUND-OBJECT art in China. Its witty emblem was Huang Yong Ping's "A History of Chinese Painting" and "A Concise History of Modern Painting" Washed in a Washing Machine for Two Minutes, consisting of the mound of paper pulp resulting from the action of the title. A third tendency, represented by a straightforward art of soulful feeling and recognizable folk themes, emerged from the rural and autonomous regions of China, located mainly in the West and home to most of China's ethnic minorities.

The '85 New Wave movement can be bracketed by two exhibitions at the China Arts Gallery (now the National Art Museum of China) in Beijing. The first, The Young Art of Progressive China, opened in 1985 and coincided with the Open Door policy that enabled the country's rapid economic growth and liberalization in the late 1980s. The second, the China/Avant-Garde show of February 1989, organized by Gao Minglu, was shut down by the authorities almost immediately, after artist Xaio Lu fired a gun into her ironically titled installation-cum-performance piece, Dialogue. The near-simultaneous opening and closing of this exhibition seemed to presage the brutal crackdown on pro-democracy demonstrators in Tiananmen Square that followed four months later.

Abject Expressionism

- ▶ who John Altoon, Wallace Berman, William Brice, Hans Burkhardt, Robert Cremean, Connor Everts, Llyn Foulkes, David Hammons, John Paul Jones, Edward Kienholz, Rico Lebrun, Arnold Mesches, Jim Morphesis, John Outterbridge, Noah Purifoy, Ben Sakoguchi, Edmund Teske, Joyce Treiman, June Wayne, Charles White, Jack Zajac
- ▶WHEN 1945 to 1970
- **▶where** Los Angeles
- ▶ WHAT Coined by the critic and curator Michael Duncan for the subtitle of his exhibition *L.A. Raw* at the Pasadena Museum of California Art in 2012, *Abject Expressionism* is a term that points ahead to twenty-first-century approaches to art: it refers to general affinities of tone, theme, and style, without suggesting more precisely what an artwork might look like (as with OP ART) or its genre or medium (as with BODY ART). Synonyms that are occasionally heard include *Los Angeles Figurative Style* and the more general *figurative expressionism*.

Abject Expressionism refers to works of painting, assemblage, sculpture, and photography produced after World War II by artists in Los Angeles. These dark and humanistic meditations in the wake of Hiroshima and Buchenwald were rendered in figurative styles that ran counter to the ABSTRACT EXPRESSIONISM that dominated New York. Abject

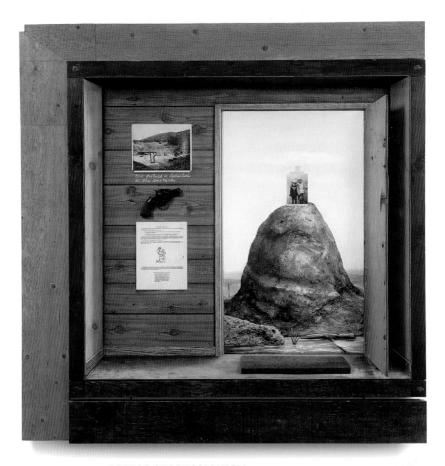

ABJECT EXPRESSIONISM Llyn Foulkes (b. 1934) Made in Hollywood, 1983 Mixed media, 53½ × 59 × 7 in. (135.9 × 149.9 × 17.8 cm) Museum of Contemporary Art San Diego

Expressionism also undermines the view of Los Angeles as a backwater whose art scene emerged only in the 1960s, with work as sunny as its climate, as embodied in the POP ART canvases of Ed Ruscha or the perceptual installations of LIGHT-AND-SPACE artist Robert Irwin. This notion, among many others, was debunked by exhibitions like L.A. Raw, one of dozens produced for the Getty Research Institute–sponsored Pacific Standard Time: Art in L.A. 1945–1980, on view at cultural institutions throughout Southern California from October 2011 to March 2012.

Although New York–style abstraction monopolized critical and media attention for two decades following World War II, expressionistic, figurative styles simultaneously flourished in other major U.S. art centers (and in Europe). In the 1950s the most notable of these were CHICAGO IMAGISM and the BAY AREA FIGURATIVE STYLE; Abject Expressionism was their more formally diverse counterpart. Few seemed to notice this correspondence. An exception was Peter Selz, who brought together an international roster of figurative artists for the New Images of Man exhibition at the Museum of Modern Art, New York, in 1959, which included Rico Lebrun from Los Angeles and Richard Diebenkorn and Nathan Oliveira from San Francisco. (Selz, the chief institutional advocate of avant-garde figurative art, moved to the West Coast to become the founding director of Berkeley Art Museum, where in 1967 he organized Funk, a groundbreaking show of figurative art from northern California.)

The existential themes that characterized Abject Expressionism were manifested in astonishingly numerous media, techniques, and styles. Examples range from John Paul Jones's melancholic, classically posed figure paintings and John Outterbridge's Southern-flavored ASSEMBLAGES, to allegorical prints by June Wayne, the founder of the pioneering Tamarind Press, and the politicized output of Llyn Foulkes, which mines POPULAR CULTURE, family history, and the American character and landscape. Some commentators, like Duncan, believe that Abject Expressionism also encompasses the work of later artists such as Chris Burden and Paul McCarthy. However, because their abjection seems less historically determined—that is, more psychological than social, more personal than philosophical—it is better considered as PATHETIC ART.

Aboriginal Art. See CONTEMPORARY INDIGENOUS AUSTRALIAN ART

Abstract/Abstraction

The adjective *abstract* usually describes artworks—known as *abstractions*—without recognizable subjects. Synonyms for *abstract* include *nonobjective* and *nonrepresentational*.

Abstract painting was pioneered between 1910 and 1913 by the Russianborn Wassily Kandinsky in Munich and, in Paris, by the Czech František Kupka and the Frenchman Robert Delaunay. Kandinsky, the most influential of the three, was the first to plunge into pure or total abstraction. The Russian Constructivist Vladimir Tatlin was the first artist to create three-dimensional abstractions, which assumed the form of reliefs produced between 1913 and 1916. Since then, abstract paintings and sculpture have been produced by thousands of artists, in styles ranging from Expressionism to Minimalism.

Many people, in fact, equate modern art with abstraction. But even though the MODERNIST mainstream has tended toward the abstract, numerous artists—Salvador Dalí, Georgia O'Keeffe, Willem de Kooning, and Pablo Picasso among them—have bucked its currents and pursued their own, nonabstract inclinations.

In addition to its meaning as an adjective, *abstract* is also a verb. To *abstract* is to generalize. For instance, imagine a dozen drawings of the same face that grow increasingly abstract as particulars are deleted. The first drawing shows the subject in detail—wrinkles, freckles, and all. The second is more sketchy and focuses on the subject's eyes. By the tenth drawing, even the subject's sex is indeterminate. Finally, the twelfth drawing is a perfect oval with no features, which we take to be a face. This is the *process* of abstraction. Abstraction and REPRESENTATION are at the opposite ends of a continuum. The first drawing described is representational, the twelfth is abstract, and the others fall somewhere in between. The tenth drawing is more abstract than the second. The adjective *abstract* and the noun *abstraction* often refer to works, like the twelfth drawing, that are entirely abstract. But the *entirely* is usually omitted.

An abstract image can be grounded in an actual object, like the twelve drawings of the face. Or it can give visual form to something inherently nonvisual, like emotions or sensations. Red, for example, can represent anger or passion. The idea that a musical, visual, or literary sensation has an equivalent in another medium of expression was a popular nineteenth-century idea called *synesthesia*, which helped fuel the drive toward abstraction.

Abstractions come in two basic variations. The first is geometric, or hard edge, which often suggests rationality and is associated with such modern movements as Constructivism and CONCRETE ART. The second is the looser and more personal style usually known as *organic*. Works in this style that evoke floral, phallic, vaginal, or other animate forms are termed *biomorphic*. Organic abstraction is associated with such modern movements as German Expressionism, ABJECT EXPRESSIONISM, and ABSTRACT EXPRESSIONISM.

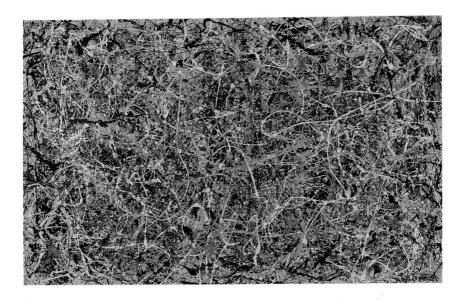

ABSTRACT EXPRESSIONISM
Jackson Pollock (1912–1956)
No. 1, 1949
Duco and aluminum on canvas,
63½ × 102½ in. (160.3 × 259.4 cm)
Museum of Contemporary Art, Los Angeles;
The Rita and Taft Schreiber Collection.
Given in loving memory of my husband,
Taft Schreiber, by Rita Schreiber

Abstract Expressionism

- **▶WHO** William Baziotes, **Willem de Kooning**, Adolph Gottlieb, Philip Guston, Franz Kline, Lee Krasner, Robert Motherwell, Barnett Newman, **Jackson Pollock, Mark Rothko**, Clyfford Still, Mark Tobey
- **▶WHERE** United States
- ▶ WHEN Mid-1940s through 1950s
- ▶ WHAT The term Abstract Expressionism originally gained currency during the 1920s as a description of Wassily Kandinsky's ABSTRACT paintings. It was first used to describe contemporary painting by the writer Robert Coates, in the March 30, 1946, issue of the New Yorker. Abstract Expressionism's most articulate advocates, the critics Harold Rosenberg and Clement Greenberg, originated the names Action painting and American-style painting, respectively. In the United States, Abstract Expressionism (or simply Ab Ex or even AE) was the name that stuck.

The European variant was dubbed ART INFORMEL by the French critic Michel Tapié in his 1952 book *Un Art autre* (Another Art).

Abstract Expressionism was the first art movement with joint European-American roots, reflecting the influence of European artists who had fled Hitler-dominated Europe (Max Ernst, Fernand Léger, Matta, and Piet Mondrian among them). Abstract Expressionists synthesized numerous sources from the history of modern painting, ranging from the EXPRES-SIONISM of Vincent van Gogh to the abstraction of Kandinsky, from the saturated color fields of Henri Matisse to the organic forms and fascination with the psychological unconscious of the SURREALIST Joan Miró. Only geometric and REALIST art played no part in this mixture of intensely introspective and even spiritual elements, often painted on mural-size canvases.

Abstract Expressionism was less a STYLE than an attitude. The calligraphic poured (or "drip") paintings by Jackson Pollock, for instance, share little visually with the intensely colored, landscapelike fields by Mark Rothko. Of paramount concern to all the Abstract Expressionists was a fierce attachment to psychic self-expression. This contrasted sharply with the REGIONALISM and SOCIAL REALISM of the 1930s but closely paralleled postwar existential philosophy's championing of individual action as the key to modern salvation. In Existentialist fashion Harold Rosenberg described the Action painter's canvas as "an arena to act in," in his influential essay "The American Action Painters," published in the December 1952 issue of Artnews.

The term Abstract Expressionist has been applied to some postwar photography, sculpture, and ceramics, but in such cases it rarely clarifies meaning. Neither photography nor the welded CONSTRUCTIVIST works that constitute the best sculpture of that era allow for the spontaneous interaction with art-making materials that characterizes Abstract Expressionism. The term is appropriately applied to the CERAMIC SCULPTURE of Peter Voulkos.

Academic Art

Academic art once meant simply the "art of the Academy"—that is, art based on academic principles. Having now acquired a negative connotation, it is often used to describe an artist or artwork that is long on received knowledge and technical finesse but short on imagination or emotion.

Art academies originated in late-sixteenth-century Italy, replacing the medieval guild apprentice system previously used to train artists and raising their social status in the process. Academies such as London's Royal Academy of Arts and Paris's Académie des Beaux-Arts institutionalized art training and established a strict hierarchy of subjects. History

painting (biblical or classical subjects) ranked first, then portraits and landscapes, and finally still lifes. Academic artists—who were almost invariably men—were initially taught to draw from white plaster casts of classical statues and then progressed to drawing from nude models, acquiring additional skills in a carefully programmed sequence.

The British Pre-Raphaelites and French Impressionists were among the first to reject academic standards and practices, taking aim not only at the academic aesthetic but also at the Academies' stranglehold on patronage in the cultural capitals of Western Europe. By the end of the nineteenth century public attention was starting to shift from artists associated with the Academy and toward those of the avant-garde. Not until the 1970s was there a revival of interest in the work of nineteenth-century academic artists such as Adolphe William Bouguereau.

The POSTMODERN attention to discredited historical forms has also extended to discredited academic STYLES. Artists such as the Russian expatriates Komar and Melamid and the Italian Carlo Mario Mariani employ such styles to comment, often ironically, on contemporary subjects and on the notion of style itself.

Academic painters have existed in China for as long as the imperial court. These artists, virtuoso professionals who produced the consummately crafted works of art (and craft) demanded by the emperor, have been overshadowed by their Southern counterparts, the *literati* or amateur painters, who were more concerned with originality and poetic self-expression.

Action Painting. See ABSTRACT EXPRESSIONISM

Action/Actionism

- **▶ who Joseph Beuys**, Günter Brus, **Yves Klein**, **Piero Manzoni**, Otto Mühl, **Hermann Nitsch**, Arnulf Rainer, Alfons Schilling, Rudolf Schwarzkogler
- ▶when Late 1950s to mid-1970s
- **▶where** Europe
- **PWHAT** The idea of the artist as actor and the related interest in artistic process were twin outgrowths of ABSTRACT EXPRESSIONISM and its variants, ART INFORMEL in Europe and GUTAI in Japan. The notion of the painting as a record of the artist's encounter with it inspired some artists to act out their artworks. HAPPENINGS, FLUXUS events, and Actions were three such live approaches—all precursors of PERFORMANCE ART. Happenings were precisely choreographed, formally arranged events that eluded explicit interpretation. Fluxus's diverse activities evolved from an open-ended poetic sensibility inflected with

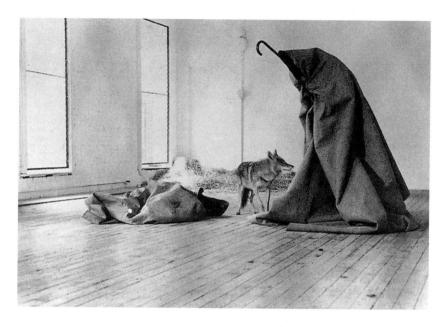

ACTION/ACTIONISM Joseph Beuys (1921–1986) I Like America and America Likes Me. 1974

Zen, DADA, and Beat elements. Actions was a catchall term for live works presented inside galleries or on city streets by artists like Yves Klein and Piero Manzoni.

Action artists grappled with concerns that ranged broadly from the spiritual and aesthetic to the social and political. About 1960 Klein started to make paintings with living "brushes"—nude women doused in paint and "blotted" onto canvas. Manzoni signed various individuals, transforming them into living sculpture. During the early 1970s Joseph Beuys created the Free University, a multidisciplinary international network, and called it a "social sculpture."

A preoccupation with the artist's role as shaman and the desire for direct political action outside the art world characterized Actions, linking them with what is known in German as Aktionismus, or "Actionism." It usually refers to a group of Viennese artists who created thematically related Actions starting about 1960. Artists such as Günter Brus, Otto Mühl, Hermann Nitsch, Alfons Schilling, and Rudolf Schwarzkogler explored Freudian themes of erotic violence in ritualistic performances utilizing bodily materials such as blood, semen, and meat. A typical Action—presented by Schilling to a small audience in Vienna on March 16,

1963—opened with the presentation of a skinned and bloody lamb. A white cloth on the floor was covered with the animal's entrails. Blood was repeatedly poured on the lamb, which was swung around by the legs, splashing the audience and the gallery. The artist threw raw eggs against the walls and chewed a rose. Such histrionic events were sometimes enacted especially for the camera.

In their exploration of the psyche's darkly destructive side, these events were a reaction against the canonization of creativity that typified Abstract Expressionism and Art Informel. Actions and Aktionismus are the bridge between those movements of the 1950s and the performance and BODY ART that would follow in the late 1960s and the 1970s.

AIDS Art

- ▶ WHO (art)ⁿ, Nayland Blake, Ross Bleckner, Kathe Burkhart, Nancy Burson, General Idea, Gilbert & George, Nan Goldin, Felix Gonzalez-Torres, Gran Fury, Group Material, Keith Haring, Bill Jacobson, Adrian Kellard, Cary Leibowitz/Candy Ass, Rudy Lemcke, Robert Mapplethorpe, Ann Meredith, Duane Michals, Pepe Miralles, Donald Moffett, Frank Moore, Piotr Nathan, Nicholas Nixon, Hunter Reynolds, Eric Rhein, Rod Rhodes, Dui Seid, Rosalind Solomon, Hugh Steers, Masami Teraoka, Kathy Vargas, Brian Weil, Albert Winn, David Wojnarowicz, Thomas Woodruff
- ▶ **WHEN** Since the mid-1980s
- ▶ WHERE Primarily the United States, but also Australia, United Kingdom, and Germany
- ▶ WHAT Echoing the intention of FEMINIST ART to truthfully represent the experiences of women, AIDS art arose from a similar concern about people with AIDS. After the initial onset of AIDS in the United States in 1981, only photojournalists produced images of it. Invariably modeled on earlier news photos depicting famines or other catastrophes, these often grisly pictures depressed the spirits of those with HIV and terrified those who did not have it. To counter these "negative" images, activists advocated "positive" portraits of people living with AIDS—that is, images of smiling subjects who looked no different than the average Joe or Jane. This, too, proved an unsatisfying approach that conveyed little information. The MODERNIST single image—the record of the "perfect moment"—was not up to the task of documenting AIDS or other complex subjects; AIDS was among the first signs of its imminent demise.

After the mid-1980s, photographers who were not journalists, such as Nicholas Nixon and Duane Michals, began to make pictures related to AIDS. The former's controversial series depicting people with AIDS showed them in progressively declining health, while the latter's poetic series portrayed death as a surreal shower of flowers. Photographers

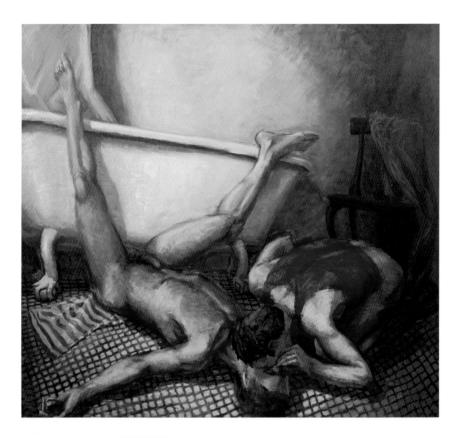

AIDS ART Hugh Steers (1962–1995) Blue Towel, Red Tank, 1988 Oil on canvas, 66 × 72 in (167.6 × 182.7 cm) Alexander Gray Associates, New York

and conceptual artists also turned to AIDS-related subjects without embodying them in people with AIDS: they targeted politicians, pharmaceutical companies, and the Catholic Church, the individuals and institutions responsible for transforming AIDS from "a manageable public health problem into a politicized crisis," in the words of Dr. Mathilde Krim, the founder of amFAR (the American Foundation for AIDS Research).

At the same time, a vital and effective outpouring of PUBLIC ART helped transform opinion and catalyze action during a decade characterized by U.S. President Ronald Reagan's failure even to mention AIDS. The NAMES Project—AIDS Memorial Quilt—conceived in San Francisco by

activist Cleve Jones—comprises thousands of unique 3 by 6 foot (0.9 by 1.8 m) quilt panels, each devoted to an individual who died of AIDS. It debuted on the National Mall in Washington, D.C., in 1987. Other public artworks about AIDS include Silence=Death, which was conceived by ACT UP (AIDS Coalition to Unleash Power) and couples the equated terms with a pink triangle referring to the treatment of homosexuals in Hitler's concentration camps. The Gran Fury collective, which functioned as ACT UP's informal propaganda bureau, generated controversy with their subway art and street graphics featuring horrifying AIDS statistics or witty provocations such as Men: Use Condoms or Beat It.

Visual AIDS, the New York-based organization committed to promoting AIDS awareness through art, conceived projects including the Red Ribbon and the annual Day With(out) Art. The former appropriated the Yellow Ribbon of the Gulf War, turning it into a sign of compassionate concern for people with AIDS; it debuted on the televised Tony Awards in 1991 and was ubiquitous on the lapels of public figures for many years. The ongoing Day With(out) Art, a "day of mourning and action in response to the AIDS crisis," was initiated on December 1, 1989, and provided a framework and impetus for thousands of organizations to produce events or exhibitions in its observance since then. En masse, the monumental body of public art about AIDS provided information about HIV and directed attention to the emotional and material needs of those with the illness and their caretakers, in contrast to the drumbeat of official inaction, scientific failure, and the ongoing censorship of artists with AIDS, such as Robert Mapplethorpe and David Wojnarowicz.

The first well-known artist to create work in conventional media about AIDS was the painter Ross Bleckner, who began to record the number of AIDS fatalities on canvas in the late 1980s and later depicted funerary urns or dimmed lights. Countless other artists responded with a range of painting, sculpture, photography, video, and mixed media whose breadth is matched only by feminist art—and that over a period of decades, rather than years. A subset of the multicultural and gay/lesbian art of the late 1980s and early 1990s, AIDS art had its heyday in those years, but its production of course continues, especially among artists with AIDS.

Prospects for the eradication of HIV seem to be worsening, despite the effective treatments developed in the mid-1990s. In 2013, the number of fatalities reached seventy million worldwide, and 620,000 in the United States, surpassing the number killed during the Civil War. It is now reasonable to compare the profound impact of AIDS on American arts and society with the effects of the Black Death or World War I on Europe.

Allegory

64

An allegory is an image or a story that refers to something else entirely—usually concepts such as good or evil. Although symbols and allegories are related—the term symbolize rather than allegorize is standard usage—a crucial distinction separates them. Many symbols have their origins in visual reality: the cross symbolizing Christianity, for instance, and the heart symbolizing love. Allegories, on the other hand, have no such basis: consider the correspondence between Venus and romantic love. The most straightforward allegories are known as personifications, figures that stand for ideas like good government or the seven deadly sins. The traditional use of such imagery deepened an artwork's meaning by referring to information outside the work, but it also demanded that the audience be educated enough to understand those references.

The use of allegory was a staple of Western art until the MODERNIST determination to purge art of literary content made it seem old-fashioned. Nonetheless, modern artists such as Max Beckmann, Georges Braque, Giorgio de Chirico, Max Ernst, Paul Gauguin, Fernand Léger, José Clemente Orozco, Pablo Picasso, and Odilon Redon used allegories in numerous paintings to comment on the human condition. Few allegorical references appeared in art from the 1950s to the mid-1970s, except in work by NEW REALIST painters such as Jack Beal. POST-MODERNISM changed that. The return of historical imagery and FIGURATIVE—as opposed to ABSTRACT—art made the return of allegory almost inevitable.

The premier allegorical artists of the late twentieth century were Italian and German—Francesco Clemente, Enzo Cucchi, Jörg Immendorff, Anselm Kiefer, and Helmut Middendorf among them. Obsessed with the effects of Nazism, German artists have attempted to reclaim their cultural past in a society committed to repudiating all that transpired before 1946. The paradigmatic figure in this regard is Kiefer, whose works use biblical history, historical sites, Teutonic myth, Johann Wolfgang von Goethe's Faust (1808/32), and other cultural emblems as allegories of contemporary German life. Because Kiefer's allegorical representations are unfamiliar to most of his viewers, even in Germany, they are often difficult to interpret. What the American painter Robert Colescott aptly termed his art historical "masterpieces in Black face" are more accessible allegories of racism.

Alternative Space

Alternative spaces first appeared in New York in 1969 and 1970 with the founding of 98 Greene Street, Apple, and 112 Greene Street, all of which were small-scale nonprofit institutions run by and for artists. These independent organizations were considered a necessity in an era of widespread artistic experimentation inimical to many museums, commercial galleries, and artist-run cooperatives. Alternative spaces also championed feminism and ethnic diversity by presenting work by women artists and artists of Asian, African, and Latin American descent. Throughout the 1970s alternative spaces proliferated in major American, Canadian, and (to a lesser extent) Western European cities. (In Canada they are known as parallel galleries.) The PLURALISM of that decade is virtually unimaginable without alternative spaces as a site for INSTALLATIONS, VIDEO, PERFORMANCE, and other CONCEPTUAL ART forms.

By the early 1980s the nature of such organizations had diversified. Recent art-school graduates could still find storefront venues for their video and performance endeavors, but some alternative spaces had evolved into highly structured institutions with large staffs and funding from foundations, municipalities, and the National Endowment for the Arts. Artists' organization or artist-run organization became the preferred nomenclature, and American alternative spaces established their own lobbying group, the National Association of Artists' Organizations (NAAO), in Washington, D.C. Ironically, the generation of the early 1980s began to regard such institutions as "the establishment," far removed from the art world's commercial center of gravity. This attitude led EAST VILLAGE artists in New York to open more or less conventional galleries as showplaces for their work.

By the end of the twentieth century, *alternative space* was increasingly being used—improperly—to describe nearly any small, independent curatorial, exhibition, or publishing project. In keeping with the term's historical origins, its use in connection with new organizations should be limited to those nonprofit endeavors that support artists in exhibiting innovative art.

Anti-Art

- ▶wно Group Kyushu, Hi Red Center, Neo Dadaism, Tokyo Fluxus
- **▶WHEN** 1960s
- **▶where** Japan
- ▶ WHAT The term anti-art stands for a number of different Japanese artists' groups or collectives, with a variety of intentions, founded (mainly) during the 1960s. These ranged from the Group Kyushu—a dues-paying association of untrained artists that specialized in such provocations as tar- or excrement-covered artworks—to a number of FLUXUS collectives, such as Hi Red Center. While the former's nihilism or negativity—its anti-art orientation—was intentional, the latter's reformist attempts at remaking art often elicited the charge of nihilism or antiart from unsympathetic viewers. Due to such misreadings, anti-art has

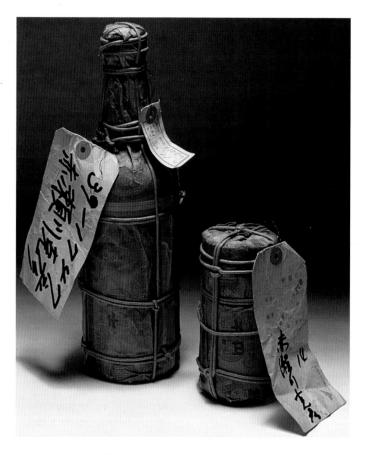

ANTI-ART
Akasegawa Genpei (b. 1937)
"1,000-Yen-Note Trial" Impounded
Objects: Bottle and Can, 1963
Sheets of model one-thousand-yen
notes, string, wire, paper tags, bottle,
and can, bottle: 97% × 37% × 23% in.
(25 × 10 × 6 cm), can: 5½ × 3½ × 3½ in.
(14 × 8 × 8 cm)
Collection of the artist (long-term
loan to Nagoya City Art Museum)

become the "default" label for every unconventional or avant-garde art approach to Japanese art of the 1950s and 1960s.

This imprecision also reflects the belated emergence of scholarship about postwar Japanese art, both in Japan, where it received little critical

support at the time of its production, and abroad. An ever-shrinking category, anti-art may eventually disappear with more nuanced analysis. For example, while some sources continue to include GUTAI among anti-art approaches, its connections to international currents of thought about the artist's process and relationship to materials suggests a different, and carefully considered, set of intentions.

Even acknowledging the ambiguity inherent in the term's broad use, anti-art is an illuminating lens for considering the evolving social role and reception of art in mid-1960s Japan. The Tokyo Olympics of 1964 symbolized Japan's confident return to the international arena as a peaceful and (economically) powerful player (just as the Beijing Olympics would for China in 2010). By contrast, the ongoing prosecution and persecution of artist Akasegawa Genpei that began in 1963 revealed an embarrassing intolerance for free expression, which undercut the official narrative of the day. To summarize, the so-called Model 1.000-Yen-Note Incident involved the artist's use of realistic-looking—but one-sided—copies of a thousand-yen note as an exhibition announcement, and his practice of turning everyday objects like bottles and scissors into sculptures by wrapping them in uncut sheets of the "model" banknotes. All of the model notes and works employing them were confiscated by officials. Despite the support of Japanese artists and intellectuals, Akasegawa was found guilty of deception four years later. In turn, he ratcheted up his provocative opposition by employing more elaborate, albeit more obviously fake, banknotes in his art.

Artistic practices like these can be associated with a broader international trend of countercultural actions that were intended to uncover official hypocrisy and propaganda, and which reflected a widespread disaffection with the "system." (The most important such action was the disclosure in 1971 of the so-called Pentagon Papers, which revealed the American military's misrepresentations of its success in the conduct of the Vietnam War.) The fundamental—if often unconscious—importance of anti-art was its attempt to transform art from a symbol of prestige and property, into an agent of consciousness and social change.

Antipodean Group

- ▶ who Charles Blackman, Arthur Boyd, David Boyd, John Brack, Robert Dickerson, John Perceval, Clifton Pugh
- **▶WHEN** 1960s
- **▶WHERE** Australia
- ▶ WHAT The Antipodean Group, composed of the above-named FIGU-RATIVE painters and the theorist Bernard Smith, sprang from a series of meetings in Melbourne, Australia, in 1959. In conjunction with its first show, held at the Victorian Artists' Society that August, the group

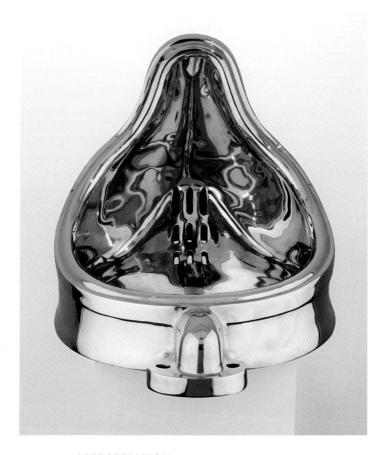

APPROPRIATION Sherrie Levine (b. 1947) Fountain (Madonna), 1991 Bronze and artist's wood base, 26 × 14½ × 14 in. (66 × 36.8 × 35.6 cm) Paula Cooper Gallery, New York

published a catalog with a controversial manifesto asserting: "The existence of painting as an independent art is in danger. Today tachists, action painters, geometric abstractionists, abstract expressionists and their innumerable band of camp-followers threaten to benumb the intellect... with their bland and pretentious mysteries." Their assault on the largely derivative ABSTRACTION produced by Australian artists of the 1950s was also a slap in the face to the Sydney-based critics who supported such work.

Their astute assessment of their contemporaries and their own allegiance to the world of appearances was all that united the Antipodean Group's art. Their individual outputs varied enormously, ranging from Robert Dickerson's melodramatic, Picasso-esque figures to Clifton Pugh's brushy images of decay, sometimes represented as Crucifixions, and from John Brack's acerbic depictions of city dwellers to Charles Blackman's quirky compositions based on *Alice in Wonderland*. The Antipodean Group—like the BAY AREA FIGURATIVE STYLE and the COBRA painters—can be seen as part of an international reaction against the domination of abstraction during the 1950s.

Appropriation

- ▶who Ken Aptekar, Mike Bidlo, David Diao, Komar and Melamid, Jeff Koons, Igor Kopystiansky, Louise Lawler, Sherrie Levine, Glenn Ligon, Carlo Maria Mariani, Yasumasa Morimura, Sigmar Polke, Richard Prince, Gerhard Richter, David Salle, Julian Schnabel, Peter Schuyff, Elaine Sturtevant
- **▶WHEN** 1980s
- **▶WHERE** United States and Europe
- ▶ **WHAT** To appropriate is to borrow. Appropriation is the practice of creating a new work by taking a pre-existing image from another context—art history, advertising, the media—and combining that appropriated image with new ones. Or, a well-known artwork by someone else may be represented as the appropriator's own. Such borrowings can be regarded as the two-dimensional equivalent of the FOUND OBJECT. But instead of, say, incorporating that "found" image into a new COLLAGE, the POSTMODERN appropriator redraws, repaints, or rephotographs it. This provocative act of taking possession flouts the MODERNIST reverence for originality. While modern artists often tipped their hats to their art historical forebears (Edouard Manet borrowed a well-known composition from Raphael, and Pablo Picasso paid homage to Peter Paul Rubens and Diego Velázquez), they rarely put such gleanings at the intellectual center of their work. A sea change occurred when Campbell's soup cans and Brillo boxes began to inspire artworks; POP ART was appropriation's precursor and Andy Warholits godfather.

Like COLLAGE, appropriation is simply a technique or a method of working. As such, it is the vehicle for a variety of viewpoints about contemporary society, both celebratory and critical. In perhaps the most extreme instances of appropriation, Sherrie Levine rephotographed photographs by Edward Weston and made precisely rendered facsimiles of Piet Mondrian's watercolors. Her work questions conventional notions of what constitutes a masterpiece, a master, and indeed, art history itself. By choosing to appropriate only the work of male artists, this

FEMINIST ARTIST asks viewers to consider the place of women within the art historical canon, and, in the case of Weston's nude photographs of his young son, to consider whether the gender of the photographer affects how pictures are viewed.

Jeff Koons, one of the few appropriators working in three dimensions, has his sculpture fabricated in stainless steel or porcelain to replicate giveaway liquor decanters and KITSCH figurines. Other artists such as David Salle and Julian Schnabel use appropriation to create a dense network of images from history, contemporary art, and POPULAR CULTURE. The multilayered, pictorial equivalent of free association, their art frequently defies logical analysis.

Art and Technology

- ▶ who Lowry Burgess, Helen and Newton Harrison, Robert Irwin, György Kepes, Piotr Kowalski, Julio Le Parc, Nam June Paik, Otto Piene, Robert Rauschenberg, Bryan Rogers, Nicolas Schöffer, James Seawright, Takis, James Turrell
- ▶ **WHEN** Mid-1960s to mid-1970s
- **▶WHERE** United States, primarily, and Western Europe
- ► WHAT Technology is a staple subject of MODERN art. Artistic responses to technology have ranged from celebration (by the Italian Futurists) to satire (by the DADA artists Marcel Duchamp and Francis Picabia). Visions of technological utopia were nurtured by the CONSTRUCTIVISTS, who imagined a future union of art with architecture, design, and science. In the late 1950s and the 1960s European artists picked up where the Constructivists had left off. Numerous groups—most notably ZERO, founded in Düsseldorf in 1957, and Groupe de Recherche d'Art Visuel (GRAV), founded in Paris in 1960—presented light sculpture, KINETIC SCULPTURE, and other machinelike artworks. Most of these groups disbanded by the late 1960s without having made the crucial connection with scientists that characterizes the art-and-technology phenomenon. ZERO's founder, Otto Piene, and many of the others then moved to the United States.

By the late 1960s the United States had produced the world's most advanced technology. At the same time POP ART was providing an optimistic vision of contemporary life, CONCEPTUAL ART was offering a model of problem solving and engagement with non-art systems of thought, and the modern faith in science and technology was at its peak.

Several particularly effective collaborations between artists and scientists were initiated. Experiments in Art and Technology (EAT) was founded in 1966 by the Swedish engineer Billy Klüver and the artist Robert Rauschenberg. New York-based EAT, which still exists, has

linked hundreds of artists and scientists and has presented numerous programs—the most famous being *Nine Evenings*, which was held at New York's 69th Regiment Armory in October 1966 and featured the participation of John Cage, Buckminster Fuller, György Kepes, and Yvonne Rainer, among others. The Art and Technology program at the Los Angeles County Museum of Art (1967–71) paired seventy-eight well-known artists with scientific-industrial facilities in California and then exhibited the results, some of them multimedia or environmental pieces involving sound, light, and kinetic elements. In 1967 Kepes opened the Center for Advanced Visual Studies at the Massachusetts Institute of Technology, which continues to promote dialogue among resident artists and Cambridge-area scientists.

The 1970s began with the enthusiasm generated by the moon landing, but soon technology came to be associated with environmental destruction, the use of napalm in Vietnam, and the near meltdown of a nuclear reactor at Three Mile Island. As a result, many artists—along with much of the American public—grew disenchanted with technology. Some of this antipathy was offset, beginning in the mid-1990s, by the telecommunications and software innovations that enabled ONLINE ART and by artists' ongoing involvement with space agencies (and recently an emerging commercial space industry), which continues to spur the slow but steady development of SPACE ART.

See COMPUTER ART, COPY ART, LIGHT-AND-SPACE ART, ONLINE ART, SPACE ART

Art Brut

The French artist Jean Dubuffet came up with the term Art Brut (pronounced broot) in 1945. It means "raw art" and refers to the art of children, naive artists, and the mentally ill (in this regard Dubuffet was strongly influenced by Hans Prinzhorn's 1922 book Bildnerei der Geisterkranken, or Artistry of the Mentally Ill). Dubuffet found the work of these nonprofessionals refreshingly direct and compelling. "[It is] art at its purest and crudest...springing solely from its maker's knack of invention and not, as always in cultural art, from his power of aping others or changing like a chameleon," he wrote in the essay "Art Brut Preferred to the Cultural Arts" (1949). In fact, we know now that schizophrenic and naive artists frequently pattern their art after extremely well-known paintings and sculptures.

Finding inspiration for his own art in the work of these nonprofessionals, Dubuffet began using quirky materials (including mud and a paste of asphalt and broken glass), odd methods (scraping and slashing into this paste), and a crude but expressive drawing style. Ironically, the term Art Brut has come to be applied to Dubuffet's anything-but-naive art. An

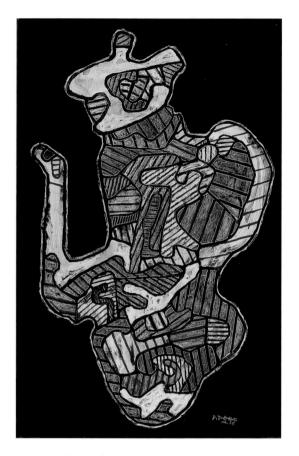

ART BRUT Jean Dubuffet (1901–1985) Coffee Pot II, 1965 Vinyl paint on canvas, 41½ × 26 in. (105.4 × 66 cm) Private collection

enthusiastic proselytizer of the authenticity and humanity he saw in Art Brut, he lectured widely on the subject; a 1951 address at the Chicago Arts Club radically altered the course of CHICAGO IMAGIST art. Dubuffet also collected thousands of examples of Art Brut, which are now in a museum devoted to them, opened by the city of Lausanne, Switzerland, in 1976.

See OUTSIDER ART

▶ WHO Giovanni Anselmo, Alighiero Boetti, Luciano Fabro, Jannis Kounellis, Mario Merz, Giulio Paolini, Giuseppe Penone, Michelangelo Pistoletto, Gilberto Zorio

▶when Mid-1960s through 1970s

▶where Italy

▶ WHAT Coined by the Italian critic Germano Celant in 1967, the term Arte Povera (pronounced ar-tay poh-vair-uh), which means "poor art," refers to usually three-dimensional art created from everyday materials. The associations evoked by humble cement, twigs, or newspapers contrast sharply with those summoned up by the traditional sculptural materials of stone and metal. It wasn't only materials that concerned the Arte Povera artist, though, and many artworks fashioned from "poor" or castoff materials are not Arte Povera.

Metaphorical imagery culled from nature, history, or contemporary life was frequently employed by Arte Povera artists. Coupling idealism about the redemptive power of history and art with a solid grounding in the material world, they typically made the clash—or reconciliation—of opposites a source of poignancy in their work. Michelangelo Pistoletto, for instance, evoked the issue of class stratification by presenting a plaster cast of the Venus de Milo contemplating a pile of brightly colored rags in his Venus of the Rags (1967). He gathered the rags near the gallery, siting his INSTALLATION in the geographical and sociological terrain of a specific neighborhood.

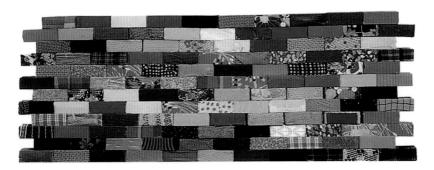

ARTE POVERA
Michelangelo Pistoletto (b. 1933)
Wall of Rags, 1968
Bricks and rags,
393% × 1023% × 85% in. (100 × 260 × 21.9 cm)
Gian Enzo Sperone, New York

The term *Arte Povera* is now applied almost exclusively to Italian art, although that was not Celant's original intent. It could aptly be used to describe the work of non-Italian PROCESS artists—including Joseph Beuys, Hans Haacke, Eva Hesse, and Robert Morris—who used unconventional materials and forms to make metaphorical statements about nature or culture.

Art Informel

- ▶ wно Alberto Burri, Jean Fautrier, Hans Hartung, Georges Mathieu, Pierre Soulages, Nicolas de Staël, Antoni Tàpies, Bram van Velde, Wols
- **▶WHEN** 1950s
- **▶**where Paris
- ► WHAT The term Art Informel was originated by the French critic Michel Tapié and popularized in his 1952 book Un Art autre (Another Art). A Parisian counterpart of ABSTRACT EXPRESSIONISM, Art Informel emphasized intuition and spontaneity over the Cubist tradition that had dominated SCHOOL OF PARIS painting. The resulting ABSTRACTIONS took a variety of forms. For instance, Pierre Soulages's black-on-black paintings composed of slashing strokes of velvety paint suggest the nocturnal mood of Europe immediately after the war.

Tachisme (from the French *tache*, or blot) is a subset of *Art Informel* that yielded works related to Jackson Pollock's Abstract Expressionist poured (or "drip") paintings. The Tachiste Georges Mathieu abandoned brushes entirely, preferring to squeeze paint directly from the tube onto the canvas.

Translating Art Informel as "informal art" or "informalism" is misleading. The point is not that artists renounced their concern for FORMAL values but that they rejected the discipline and structure of geometric abstraction in favor of a less cerebral approach.

Art in Public Places. See PUBLIC ART

Artists' Books

▶ WHO Art & Language, John Baldessari, George Brecht, Marcel Broodthaers, Nancy Buchanan, Victor Burgin, John Cage, Ulises Carrión, Hanne Darboven, Marcel Duchamp, Felipe Ehrenberg, Robert Filliou, Hamish Fulton, General Idea, Dick Higgins, Anselm Kiefer, Alison Knowles, Margia Kramer, Sol LeWitt, George Maciunas, Mario Merz, Richard Olson, Richard Prince, Martha Rosler, Dieter Roth, Ed Ruscha, Paul Zelevansky

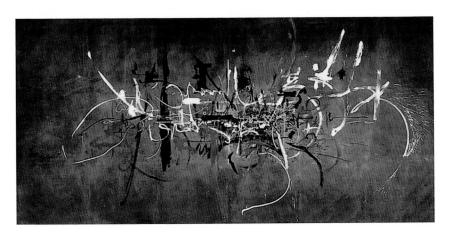

ART INFORMEL Georges Mathieu (1921–2012) The Capetians Everywhere, 1954 Oil on canvas, 9 ft. 7 in. × 19 ft. 7 in. (2.9 × 6 m) Musée National d'Art Moderne, Centre Georges Pompidou, Paris

▶ WHEN Late 1960s through 1970s

▶WHERE International

WHAT Artists' books refers not to literature about artists nor to sculptures constructed from books but to works by visual artists that assume book form. The term is credited to Dianne Vanderlip, who organized the exhibition Artists Books at Moore College of Art, Philadelphia, in 1973. The same year Clive Phillpot, the librarian at the Museum of Modern Art, put the synonymous term book art into print in the "Feedback" column of the July-August issue of Studio International. The first major show of artists' books had been mounted in 1972 at the Nigel Greenwood Gallery in London.

Precursors of artists' books date back at least as far as William Blake's illustrated epics from the early nineteenth century and—closer at hand—Marcel Duchamp's *Green Box* of the 1930s. Primary prototypes for contemporary artists' books include Ed Ruscha's POP-inspired foldout photo-books from the mid-1960s (one pictures every building on the Sunset Strip) and Dieter Roth's multivolume collection of meticulously filed debris from the street.

An artist's book may have images without words or narratives without images. It may assume sculptural form as a pop-up book or investigate

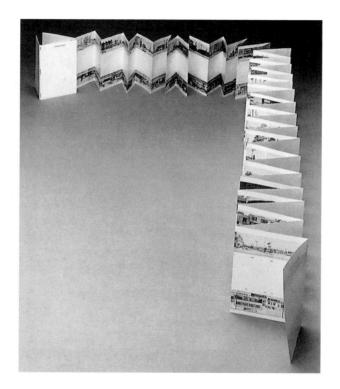

ARTISTS' BOOKS
Ed Ruscha (b. 1937)
Every Building on the Sunset Strip, 1966
Photo-book in continuous strip,
71/8 × 55/8 in. (18.1 × 14.3 cm) (closed)
Los Angeles County Museum of Art,
Library, Special Collections

the nature of the book format itself. It may take the DOCUMENTATION of ephemeral PERFORMANCES OF INSTALLATIONS as its point of departure. The thematic concerns of artists' books ranged as widely as those of the PLURALIST late 1960s and 1970s, with autobiography, NARRATIVE, and humor being favored.

Many artists working mainly in other media turned to books as a form suited to expressing ideas too complex for a single painting, photograph, or sculpture. FLUXUS and CONCEPTUAL artists who wanted to communicate ideas in accessible, inexpensive formats were also attracted to artists' books. Compared to the more precious products of the PRINT REVIVAL, artists' books seemed the essence of populism—even if the public-at-large did not always recognize them as art.

Artists' Furniture A

▶ WHO Harry Anderson, Scott Burton, Stephen De Staebler, R. M. Fischer, Frank Gehry, David Ireland, Yayoi Kusama, Kim MacConnel, Main and Main, Judy McKie, Howard Meister, Memphis, Isamu Noguchi, Peter Shire, Robert Wilhite, Robert Wilson

▶ WHEN Since the late 1970s

▶WHERE Primarily the United States

▶ WHAT Artists' furniture is furniture designed and often made by painters, sculptors, craftspersons, or architects, generally as one-of-a-kind pieces available only in galleries. Scott Burton created sculptural seating for indoor or outdoor sites as PUBLIC ART. R. M. Fischer's witty oversize lamps are constructed from FOUND OBJECTS and debris.

Examples of furniture by artists, including Pablo Picasso and Constantin Brancusi, date back at least as far as the early twentieth century. Although artists and architects of that era frequently designed furniture as part of populist programs initiated after the Revolution in the Soviet Union and at the Bauhaus school in Germany, the results were not generally regarded as art. The development of POSTMODERNISM in the 1970s and the blurring of the boundaries that had traditionally separated craft and art set the stage for the acceptance of artists' furniture as a hybrid art form.

See CRAFTS-AS-ART

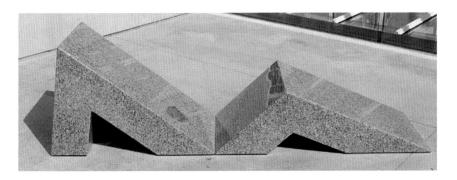

ARTISTS' FURNITURE Scott Burton (1939–1989) Two-Part Chaise (enlarged version), 1989 Rosso Granchio granite, 24% × 19¾ × 84¼ in. (61.9 × 50.2 × 214 cm) Private collection The term *art market* signifies the means by which contemporary art is ordinarily bought and sold—chiefly through auction houses or by art dealers (some of whom operate galleries and others of whom deal privately). Although auctions garner massive amounts of publicity based on the celebrity of the consignor and the consigned art, the five highest prices ever obtained for artworks were the result of private sales that took place in the past decade. (The most expensive was a version of Cézanne's *Card Players*, bought for \$259 million in 2011 by the Qatari royal family. For comparison, the highest price paid for an artwork at auction was \$82.5 million in 1990, or \$148 million when adjusted for inflation, for Van Gogh's *Portrait of Dr. Gachet*.) That some of the costliest private sales have actually been arranged by auction houses suggests the complexity of the market.

The nonauction art market is divided into *primary* and *secondary* markets. The former refers to the sale of an artwork for the first time; the latter refers to all subsequent sales. Living artists may share in the profits that accrue from subsequent sales of their work on the secondary market, but only in countries with artists' resale rights laws, which are typical in Europe, but not in the United States or the rest of the world.

A new development in art commerce has been the global growth of art fairs over the past few decades. These commercial trade shows are typically staged over a long weekend in exhibition halls in metropolitan capitals. Dealers lease booths for the brief run of the fair, which may not be devoted to contemporary art at all. (Some, for example, specialize in antiques or Old Master art.) Art fairs should not be confused with museum-style BIENNIAL exhibitions, although the two may be held concurrently in different venues in the same city, as was the case with the fairs and biennials that sprang up from Australia to China in the summer of 2008, timed to coincide with the Beijing Olympics.

The astonishing proliferation of art fairs is perhaps most evident in East Asia, where the first to be established was Art Taipei, in 1992. Twenty years later, six art fairs were staged in Hong Kong alone (which is now the world's third-largest auction market, after New York and London). Hong Kong's prestigious Art HK was recently purchased by the even more prestigious Art Basel, and the first edition of Art Basel in Hong Kong was mounted in 2013, joining Art Basel Miami as an extension of the preeminent art-fair brand. In certain countries, the art fair has become an emblem of the effectiveness of official art policy, and owners of major galleries throughout the world unequivocally assert that participation in art fairs is central to commercial success today.

The art world is a professional realm—or subculture in anthropological language—akin to those signified by the terms Hollywood or Wall Street. It can be regarded two ways: quantitatively, it is the sum of the individuals and institutions who belong to the global network dedicated to the production, distribution, and display of art and information about it; qualitatively, it is the set of customs and habits shared by those individuals and institutions.

However, even the "population" of the art world seems nearly impossible to determine. (Some studies attempt to count the number of artists or the income generated by "creative" industries. But even when targeted specifically toward visual art, the former fail to define the "professional" artist adequately, while the latter fail to include the output of museum workers, art educators, dealers, critics, and art-materials manufacturers.) Perhaps other art-related phenomena—the burgeoning role of art in urban redevelopment and cultural tourism, and its status as the third largest source of black market commerce after drug trafficking and pornography—allude to the actual size of this industry.

The qualitative nature of the art world can be equally opaque. Although its name may suggest a companionable society with "citizenship" open to all, the art world is in fact a professional universe with social codes and protocols likely to be invisible to the uninitiated. When the attorney general of New York forced art dealers to post their prices in the 1990s, for instance, defenses of a "gentlemanly" lack of discussion about money actually masked the illegal charging of different prices to different buyers.

Such ethically challenged practices are a reminder of the evolving nature of the art world. Just as contemporary art reflects the global, late-capitalist character of our era, so too does the art world. Its criteria of value have skewed ever closer to its economic fundamentals: An art ecosystem that once accorded approximately equal weight to the judgments of curators, collectors, dealers, and critics is now heavily weighted toward the views of those of financial means. Only wealthy collectors can afford contemporary art's stratospheric prices and the high costs of sitting on the boards of museums, whether private or tax-funded. Often motivated by a mutual desire to protect "investments" in works of art, relationships between collectors and museums are, of course, prone to conflicts of interest and tend to further the financial concerns of art dealers.

The proliferation of professional curatorial training programs has also had a homogenizing effect, which is reflected in the small group of "name" artists who dominate exhibition rosters worldwide. Meanwhile, art criticism seems to continue in a downward spiral, as seen in the diminution of support for it from educational institutions or the troubled world of print media. (The highly fragmented art blogosphere, whatever

its potential, remains in its infancy.) As a consequence of these trends, one of the few independent, economically disinterested voices in the artworld ecosystem—that of the critic—has been rendered nearly inaudible.

Assemblage

- ▶who Karel Appel, Arman, Tony Berlant, Wallace Berman, Joseph Beuys, Louise Bourgeois, John Chamberlain, Bruce Conner, Joseph Cornell, Edward and Nancy Reddin Kienholz, Donald Lipski, Marisol, Louise Nevelson, John Outterbridge, Robert Rauschenberg, Richard Stankiewicz, H. C. Westermann
- ▶ **WHEN** Despite its early-twentieth-century origins, assemblage moved above ground only during the 1950s
- ▶ WHERE International but especially in the United States
- ▶ WHAT The three-dimensional counterpart of COLLAGE, assemblage similarly traces its origin to Pablo Picasso. In collaboration with Georges Braque, he created the first assemblage in 1913 with his sheet-metal Guitar, two years before the DADA artist Marcel Duchamp attached a bicycle wheel to a stool and called it a readymade. Previously known simply as "objects," assemblages were named by Peter Selz and William Seitz, curators at the Museum of Modern Art, for the exhibition The Art of Assemblage in 1961.

Assemblage involves the transformation of non-art objects and materials into sculpture through combining or constructing techniques such as gluing or welding. This radically new way of making sculpture turned its back on the traditional practices of carving stone or modeling a cast that would then be translated into bronze.

The use of non-art elements or even junk from the real world often gives assemblages a disturbing rawness and sometimes a poetic quality. Assemblage shares with Beat poetry of the late 1950s a delight in everyday things and a subversive attitude toward "official" culture.

Assemblage can be mysterious and hermetic, like the shrouded figures of Bruce Conner, or aggressively extroverted, as in the biting tableaux of down-and-outers by Edward and Nancy Reddin Kienholz. Assemblages are not always Representational: John Chamberlain fashioned Abstract sculptures from crumpled auto fenders, and Louise Nevelson made enigmatic and sensuous painted-wood abstractions. Assemblage is a technique, not a STYLE.

Automatism. See SURREALISM

Avant-garde. See MODERNISM

ASSEMBLAGE Arman (1928–2005)
Infinity of Typewriters and Infinity of Monkeys and Infinity of Time = Hamlet, 1962
Typewriters in wooden box, $72 \times 68\% \times 11\%$ in. (183 × 175 × 30 cm)
Private collection

- **▶wно** James Albertson, **Joan Brown**, Robert Colescott, Cply, Charles Garabedian, **Neil Jenney**, Judith Linhares, Earl Staley
- **▶WHEN** 1970S
- **▶WHERE** United States
- ▶ WHAT "Bad" Painting—with ironic quotation marks—was the name of a 1978 exhibition curated by Marcia Tucker at the New Museum of Contemporary Art in New York. With its expressive, sometimes deliberately crude paint handling and intimations of narrative, "bad" painting was more an approach than a movement. Its subjects were predominantly FIGURATIVE, ranging from Joan Brown's scenes of holiday romances to Charles Garabedian's broadly brushed renderings of classical architecture and fragmented figures. The often autobiographical and eccentric imagery of "bad" painting contrasted sharply with the emotionally detached MINIMALISM and CONCEPTUALISM that a critical consensus deemed the "good" art of that day.

"Bad" painting had precedents in the highly personal, sometimes humorous postwar painting and sculpture by Philip Guston, Red Grooms, the CHICAGO IMAGISTS, and the BAY AREA FIGURATIVE and FUNK artists. In turn, it helped pave the way for the return of non-ABSTRACT painting in the 1980s.

Bay Area Figurative Style

- ▶wно Elmer Bischoff, Joan Brown, Richard Diebenkorn, Frank Lobdell, Manuel Neri, Nathan Oliveira, David Park, Paul Wonner
- ▶ WHEN Late 1940s to mid-1960s
- **▶where** San Francisco Bay Area
- ▶ WHAT The Bay Area figurative style embodies the attraction and repulsion many artists felt toward the ABSTRACT EXPRESSIONISM emanating from New York. The attraction was made evident through thick paint surfaces, expressive color, and GESTURAL brushwork, the repulsion through the rejection of total ABSTRACTION in favor of FIGURATIVE imagery. Bay Area figurative style artists tended to portray figures not as specific individuals but as elements in a still life, a generalizing approach that reflected the EXISTENTIALISM pervading the early 1950s ZEITGEIST.

Postwar San Francisco boasted the United States' most up-to-date art scene outside New York. As Abstract Expressionism was emerging in the late 1940s, local artists learned about it from the New York painters Ad Reinhardt, Mark Rothko, and Clyfford Still, all of whom taught at the California School of Fine Arts (now the San Francisco Art Institute)

BAD PAINTING
Neil Jenney (b. 1945)
Coat and Coated, 1970
Acrylic on canvas, 50 × 57³¼ in.
(127 × 146.7 cm)
Corcoran Gallery of Art, Washington, D.C.;
Museum purchase through funds of the
Friends of The Corcoran Gallery of Art
and the National Endowment for the Arts,
Washington, D.C., a federal agency

between 1946 and 1950. Their Californian colleagues at the school, David Park and Elmer Bischoff, emulated their abstract, gestural approach and transmitted it to star pupil Richard Diebenkorn.

By the mid-1950s all three Californians had made the radical move away from abstraction and back to paintings of the figure or landscape. Bischoff's account of this about-face to critic Thomas Albright (in the December 1975 issue of *Currant*) was typical: "The thing [Abstract Expressionism] was playing itself dry; I can only compare it to the end

BAY AREA FIGURATIVE STYLE Joan Brown (1938–1990) Lolita, 1962 Oil on canvas, 72 × 60 in. (182.9 × 152.4 cm) Private collection

of a love affair." For the generation of Bay Area painters who began their careers in the mid-1950s to early 1960s—including Joan Brown, Manuel Neri, and Nathan Oliveira—Abstract Expressionism was already history. Figurative painting and sculpture remained the dominant local tradition until CONCEPTUAL ART emerged at the end of the 1960s.

See FUNK ART

Biennial

The word biennial describes an event occurring every other year. It was first applied to an art exhibition in 1895, with the founding of the Venice Biennale (or Biennale di Venezia). The origins of the Whitney Museum of American Art's biennial go back to 1932, although it was actually an annual exhibition until 1973. The postwar era saw the founding of the São Paulo Bienal (1951), the Biennale de Paris (1959), and Documenta (1955), a quinquennial exhibition held every five years in Kassel, Germany. The proliferation of biennials—as well as triennials, quadrennials, and so on—has proceeded at a remarkable pace. More than forty major recurring exhibitions were initiated in the 1990s alone, and the Web site of the International Association of Art Critics (AICA) publishes links to over a hundred of them.

Like the world's fairs before them, such recurring exhibitions are intended to provide either a timely update on a particular art form—be it architecture, graphic art, or digital art—or a general survey of the art being produced in a specific region or across the globe. Often staged in locales formerly considered peripheral or outside the mainstream—for example, the Emirate of Sharjah—biennials have undoubtedly helped internationalize the ART WORLD. While some commentators assert that these exhibitions have contributed to wide-ranging debates about globalism and identity politics and provided international exposure for new or difficult media, others regard the favored artistic genre of the biennial—theinstallation—as a lingua franca lacking roots in Asia or Africa and promoting a new form of colonialism.

Biomorphism. See ABSTRACT/ABSTRACTION

Black Arts Movement

- ▶ who Benny Andrews, John Biggers, Elizabeth Catlett, Ed Clark, Murry De Pillars, Jeff Donaldson, Barkley Hendricks, Ben Jones, Lois Mailou Jones, Al Loving, Joe Overstreet, Noah Purifoy, Betye Saar, Jack Whitten, William T. Williams
- ▶WHEN 1965 to 1975
- **▶ WHERE** United States
- PWHAT The Black Arts Movement is the aesthetic branch of the Black Power Movement. It should be considered—like global FEMINISM or TROPICALISM in Brazil—a countercultural reaction to the racialized (and gendered) social and economic relations institutionalized in the United States (and the global society being remade in its image). Leaders of the Black Arts Movement, such as the playwright/poet LeRoi Jones (a.k.a. Amiri Baraka), built upon the political achievements of the Civil

BLACK ARTS MOVEMENT Betye Saar (b. 1926) Mti, 1973 Mixed-media floor assemblage, 42½ × 23½ × 17½ in. (108 × 59.7 × 44.5 cm) Collection of the artist

Rights movement of the 1950s while demanding a more radical transformation in the arts—and all other aspects of society. The origins of the Black Arts Movement are usually traced to two symbolic events of 1965: the assassination of Malcolm X and Amiri Baraka's move from Manhattan's Lower East Side to Harlem, the early-twentieth-century cultural capital of Black America.

The movement's effects on music, theater, poetry, literature, and art were profound: It revitalized the work of well-known older artists such

as Elizabeth Catlett and Lois Mailou Jones and helped validate figurative imagery that almost invariably announced the race (and gender) of its producers. This catalyzed discussion about the racialized criteria of "quality" in art and about the potential of ABSTRACT art to convey complexity in the hands of accomplished practitioners like Jack Whitten or William T. Williams. It also paved the way for artists such as Benny Andrews, Barkley Hendricks, and Betye Saar to follow more easily the dictates of their sensibilities.

While New York's contribution to the Black Arts Movement was central, both Chicago and Oakland, California (home of the Black Panthers), also played key roles. One of the most unusual artworks of the era was produced in Berkeley, by the cosmic musician Sun Ra, who began to teach at the University of California there in the late 1960s. His film *Space Is the Place* (1974) is a rare double embrace of both black nationalism and countercultural liberation, political comment, and musical avant-gardism. The film opens with his arrival on Earth in a handmade space ship, from which he descends, dressed as Tutankamun.

The Black Arts Movement was not only essential for later identity-oriented Hispanic and LGBT artists, but also a pillar of the multiculturalism that would be adopted by many institutions and individuals in the 1980s and 1990s.

Body Art

- ▶who Marina Abramović/Ulay, Vito Acconci, Janine Antoni, Stuart Brisley, Chris Burden, Bob Flanagan and Sheree Rose, Terry Fox, Gilbert & George, Rebecca Horn, Barry Le Va, Tom Marioni, Ana Mendieta, Linda Montano, Bruce Nauman, Dennis Oppenheim, Gina Pane, Mike Parr, Klaus Rinke, Jill Scott, Carolee Schneemann, Stelarc
- ▶ WHEN Late 1960s through the 1970s
- ▶ WHERE United States, Europe, and Australia
- ▶ WHAT A subset of CONCEPTUAL ART and a precursor of PERFOR-MANCE ART, body art is just what its name implies: an art form in which the artist's body is the medium rather than the more conventional wood, stone, or paint on canvas. Body art often took the form of public or private performance events and was then seen in DOCUMENTARY photographs or videotapes.

Frequently motivated by masochistic or spiritual intentions, body art varied enormously: Chris Burden had himself shot; Gina Pane cut herself in precise patterns with razor blades; Terry Fox attempted to levitate after constructing what he termed a "supernatural" gallery environment; and Ana Mendieta created earthen silhouettes of herself in poses reminiscent of ancient goddess figures from the Near East.

BODY ART Linda Montano (b. 1942) and Tom Marioni (b. 1937) Handcuff, 1973 3-day performance

Precedents for body art include some of Marcel Duchamp's early-twentieth-century DADA gestures (a star-shaped haircut, for example) and the ACTIONS of Yves Klein and Piero Manzoni during the early 1960s. Body art was at once a rejection of the cool MINIMALISM of the 1960s and an embrace of the body-oriented ferment of that moment. The experimentation with sex, drugs, and psychosexual frankness in society at large was mirrored by body artists.

The exhibition Marina Abramović: The Artist Is Present at the Museum of Modern Art, New York, in 2010 was unusual for its re-creations of body artworks and ACTIONS spanning the artist's career. The very entrance to the show featured a re-creation of the 1977 piece Imponderabilia, in which

Camp. See KITSCH

Capitalist Realism. See POP ART

Ceramic Sculpture

- ▶who Robert Arneson, Billy Al Bengston, Robert Brady, Stephen De Staebler, Viola Frey, John Mason, Jim Melchert, Ron Nagle, Ken Price, Richard Shaw, Peter Vandenberge, Peter Voulkos
- ▶when Since the mid-1950s
- **▶WHERE** Primarily California
- ▶ WHAT Ceramic sculpture refers to three-dimensional artworks made of clay and to the campaign that elevated clay from a crafts material (even in the hands of Pablo Picasso or Joan Miró) to the stuff of sculpture. The granddaddy of that campaign was Peter Voulkos, who arrived at the Otis Art Institute in Los Angeles in 1954 and moved on to the University of California at Berkeley in 1959. During the 1950s he and John Mason, Ken Price, and Billy Al Bengston worked on solving the technical problems involved in making clay forms of unprecedented size and shape.

Their work—and that of the ceramic sculptors who followed them—increasingly referred not to traditional craft forms but to high art: Voulkos's nonfunctional plates and vessels are linked to the GESTURALISM of ABSTRACT EXPRESSIONISM; Mason's floor pieces to MINIMALISM; Richard Shaw's trompe-l'oeil still lifes to NEW REALISM; and Robert Arneson's tableaux and objects to POP ART.

See CRAFTS-AS-ART

Chicago Imagism

- **▶wно** Roger Brown, **Leon Golub**, Ellen Lanyon, June Leaf, Gladys Nilsson, Jim Nutt, Ed Paschke, Seymour Rosofsky, **H. C. Westermann**
- ▶when Mid-1950s through 1970s
- ▶where Chicago
- ▶ WHAT Imagism is a blanket term for the FIGURATIVE art characterized by EXPRESSIONISM and SURREALISM that emerged in Chicago

(

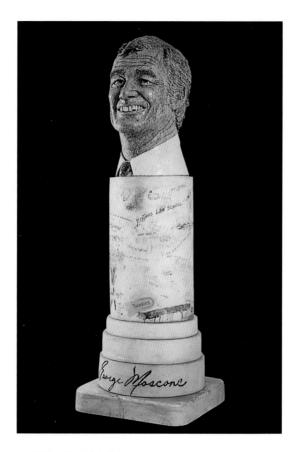

CERAMIC SCULPTURE
Robert Arneson (1930–1992)
Portrait of George (Moscone), 1981
Polychrome ceramic, 94 × 31½ × 31¼ in. (238.8 × 80 × 79.4 cm)
San Francisco Museum of Modern Art

following World War II. Images of sex and violence were often rendered in PRIMITIVE- or naive-looking STYLES. They range from Leon Golub's paintings of damaged figures derived from classical sculpture to Gladys Nilsson's and Jim Nutt's cartoon-style satires of contemporary life. Other artists, including the ASSEMBLAGE maker H. C. Westermann and the painter Ellen Lanyon, created more personal works that had little to do with history or POPULAR CULTURE but frequently incorporated everyday objects and images.

CHICAGO IMAGISM Roger Brown (1941–1997) Peach Light, 1983 Oil on canvas, 72 × 48 in. (182.9 × 121.9 in.) School of the Art Institute of Chicago

The elder statesman of Chicago Imagism was the local expressionist painter Seymour Rosofsky, and its catalysts were the Chilean Surrealist Matta, who taught at the School of the Art Institute; and Jean Dubuffet, the French ART BRUT painter who delivered an influential lecture called "Anticultural Positions" in 1951 at the Chicago Arts Club. The critic Franz Schulze dubbed the 1950s generation of painters—Golub, Lanyon, Rosofsky—the Monster Roster; the 1960s generation—Roger Brown, Nilsson, Nutt, Ed Paschke, Westermann—branded itself the Hairy Who.

Chicago Imagism's irreverent and frequently incendiary imagery put it in direct opposition to the generally ABSTRACT mainstream centered in New York. Along with ABJECT EXPRESSIONISM, FUNK, and the BAY AREA FIGURATIVE STYLE, Chicago Imagism offered an alternative to that mainstream.

CoBrA

- **▶wно Pierre Alechinsky**, **Karel Appel**, Corneille, Asger Jorn, Carl-Henning Pedersen
- ▶WHEN 1948 to 1951
- **▶WHERE** Northern Europe
- ▶ WHAT Founded in 1948 by the Belgian writer Christian Dotremont and an association of Dutch painters in Amsterdam known as the Experimental Group, CoBrA took its name from the three cities where many of the participants lived—Copenhagen, Brussels, and Amsterdam. Starting in 1948, CoBrA exhibitions were mounted in Amsterdam, Paris, and Liège, and a literary review was published in Denmark. In 1951 this highly influential group disbanded, although individual members continued to work in what had come to be known as the CoBrA STYLE, characterized by violent brushwork and saturated color. Their ABSTRACTED but still recognizably FIGURATIVE imagery was often derived from prehistoric, PRIMITIVE, or folk art. The high-pitched emotional range of their works runs the gamut from ecstasy to horror.

Along with ABSTRACT EXPRESSIONISM, ART BRUT, and ART INFORMEL, CoBrA was part of the international postwar revolt against cerebral art. Geometric abstraction, CONSTRUCTIVISM, and CONCRETE ART were rejected in favor of EXPRESSIONISM. This emotive response to the rationalized techno-horrors of World War II echoed the origins of DADA following World War I.

Collaborative Art

- ▶ WHO Ant Farm, Art & Language, Bernd and Hilla Becher, Center for Land Use Interpretation, Clegg & Guttmann, Equipo Crónica, Kate Ericson and Mel Ziegler, Fischli and Weiss, Martha Fleming and Lyne Lapointe, General Idea, Rimma Gerlovina and Valeriy Gerlovin, Gilbert & George, Gran Fury, Group Material, Guerrilla Girls, Helen Mayer Harrison and Newton Harrison, IRWIN, Kristin Jones and Andrew Ginzel, Komar and Melamid, Leone & Macdonald, McDermott & McGough, Pierre et Gilles, Anne and Patrick Poirier, Tim Rollins + K.O.S., Doug and Mike Starn, Jon Winet and Margaret Crane
- ▶ WHEN Since the mid-1960s

COBRA Karel Appel (1921–2006) Untitled, 1953 Oil on canvas, 42 × 42 in. (106.7 × 106.7 cm) Private collection

▶WHERE International

▶ WHAT Most art forms—theater, music, dance, architecture, film—are by nature collaborative, requiring the efforts of more than one creator. The visual arts and literature are unusual in that they are almost invariably the work of one individual. The notion of the artist as individual genius arose during the Renaissance and is epitomized by the current response to modern artists ranging from the once under-appreciated Vincent van Gogh to the internationally celebrated Pablo Picasso. But,

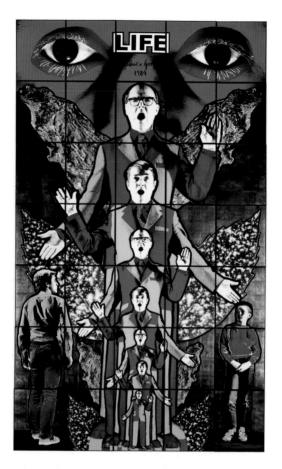

COLLABORATIVE ART
Gilbert & George (b. 1943 and 1942)
Life, from Death Hope Life Fear, 1984
Black-and-white photographs
colored and mounted on panels,
1661/8 × 983/8 in. (422 × 250 cm)
Tate, London

in fact, since the Renaissance, collaborations have emerged from the busy studios of artists such as Peter Paul Rubens and Rembrandt, in the shared development of Cubism by Picasso and Georges Braque, and from Andy Warhol's Factory (his studio), to name only a few examples. But in all these cases, a single creator signed—or took credit for—the resulting artworks.

An important shift toward collaborative art making has occurred since the 1960s. It is now common to see plural names affixed to works by hetero- or homosexual mates (such as Anne and Patrick Poirier or Leone & MacDonald); by friends (Komar and Melamid or Equipo Crónica); and by art collectives (such as Art & Language or Tim Rollins + K.O.S.), in which individual membership may change over time but a constant group identity remains.

This assault on the post-Renaissance tradition of the individual artist was a result of twin causes that originated in the 1960s: a widespread questioning of MODERNISM, with its emphasis on heroic, avant-garde originality, and the emergence of CONCEPTUAL art, which allowed artists to question the nature of the relationship between the artist and artwork. For example, with their ACTIONS, Gilbert and George (who consider themselves a single artist) attempted to become "living art" and to create works far outside the traditional forms of painting and sculpture. Collaborative artists Helen Mayer Harrison and Newton Harrison produce urban reclamation projects situated in the realms of both art and ecology. Bernd and Hilla Becher created documents of a disappearing industrial architecture that are valuable not only to art gallery- and museum-goers but also to historians and anthropologists. A recent trend in collaboration is the formation of collectives, such as the Center for Land Use Interpretation, devoted to subjects that necessitate research and intellectual perspectives derived from numerous non-art disciplines.

Collaborative art is not a STYLE or medium but a way of working. Collaboratively produced artworks can assume any form, from the POP ART-inflected paintings by Equipo Crónica and the wittily nostalgic photographs by McDermott & McGough documenting their nineteenth-century lifestyle, to the architecturally oriented PUBLIC ART projects by Kate Ericson and Mel Ziegler and the ONLINE examination of the American mental-health system and Americans' response to it in a Web site by Jon Winet and Margaret Crane.

Collage

The term *collage* comes from the French verb *coller* (to glue). In English it is both a verb and a noun: to "collage" is to affix papers or objects to a two-dimensional surface, thus creating a collage.

Picasso produced the first high-art collage, Still Life with Chair Caning, in 1912, when he glued onto his canvas a real piece of oilcloth printed with a caning pattern. By doing that instead of painting the caning pattern directly on his canvas, he forever blurred the distinction between reality and illusion in art. After World War I, DADA artists transformed debris from the street into their sometimes disturbing and politicized collages, while SURREALIST artists created collages that reflected

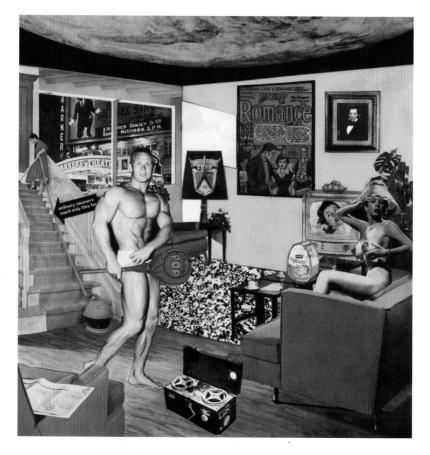

COLLAGE
Richard Hamilton (1922–2011)
Just What Is It That Makes Today's Homes
So Different, So Appealing? 1956
Collage on paper, 10¼ × 9¾ in. (26 × 24.8 cm)
Kunsthalle Tübingen, Tübingen, Germany;
Zundel Collection

their more psychologically attuned sensibilities. German Dada artists also invented a collage technique using snippets of photographs that is known as *photomontage*.

Postwar collage has been put to many different uses. Jasper Johns painted his images of flags and targets on backgrounds of collaged newsprint in order to produce richly textured, GESTURAL-looking surfaces. PATTERN-AND-DECORATION artists such as Miriam Schapiro, Robert Kushner, and Kim MacConnel have used collage to create brashly color-

ful and sensuous effects. Other postwar artists who have exploited the technique include Romare Bearden, Wallace Berman, Bruce Conner, Richard Hamilton, George Herms, David Hockney, Jess, Howardena Pindell, Robert Rauschenberg, Larry Rivers, Betye Saar, and Lucas Samaras. The sources of their collage materials range from magazine ads and maps to trash and old clothes.

Décollage, the opposite of collage, involves removing images superimposed on one another. This occurs spontaneously in cities when layers of posters are defaced or weathered, and it is this phenomenon that apparently inspired the pioneering use of décollage by the SURREALIST Leo Malet, beginning in 1934. (It has been said that Picasso's and Braque's inspiration for Cubist collage came from the layers of advertising posters that first blanketed Paris during the early twentieth century.) Décollage became a popular technique among Parisian NOUVEAU RÉALISTE artists of the 1950s, including Hervé Télémaque and Mimmo Rotella.

See ASSEMBLAGE

Color-Field Painting

- ▶who Jack Bush, Nassos Daphnis, Gene Davis, Friedel Dzubas, Helen Frankenthaler, Sam Gilliam, Paul Jenkins, Ellsworth Kelly, Morris Louis, Kenneth Noland, Jules Olitski, Larry Poons, Theodoros Stamos
- ▶when Mid-1950s to late 1960s
- **▶WHERE** United States
- **WHAT** As its name indicates, color-field painting has two components—"color" and "field." Rejecting illusions of depth and GESTURAL brushwork, color-field painters applied color in swaths that often span the entire canvas, suggesting that it is a detail of some larger field. Intent on eliminating any distinction between a subject and its background, color-field painters treated the canvas as a single plane. This emphasis on the flatness of the painting mirrored the FORMALIST imperative that painting respect its two-dimensional nature rather than create an illusion of three-dimensionality.

Various other names for color-field painting were coined during the 1950s and 1960s. The most notable was *Post-Painterly Abstraction*, the title of an influential 1964 exhibition at the Los Angeles County Museum, curated by the critic Clement Greenberg. It encompassed what is now called HARD-EDGE PAINTING. Another once-popular term was *Systemic Painting*, the title of a 1966 exhibition curated by Lawrence Alloway at the Guggenheim Museum in New York, which featured color-field and hard-edge painters who made systematic variations on a single geometric motif, such as a circle or chevron. Finally, there is *stain painting*, which should be regarded as a subset of color-field painting:

COLOR-FIELD PAINTING Helen Frankenthaler (1928–2011) Approach, 1962 Oil on canvas, 82 × 78 in. (208.3 × 198.1 cm) Private collection

artists such as Helen Frankenthaler and Morris Louis would stain their unprimed canvases by pouring paint rather than brushing it on, usually while working on the floor instead of on an easel or wall.

Just as Frankenthaler's technique was inspired by Jackson Pollock's poured paintings, so, too, was color-field painting an extension of ABSTRACT EXPRESSIONISM. Pollock, with his allover compositions, was the first field painter. The inspiration for the dramatic use of color in color-field painting came from the work of the Abstract Expressionists Mark Rothko and Barnett Newman.

Since color-field painting is invariably ABSTRACT, nature-based color has typically been abandoned in favor of more expressive hues. When examined at close range, the expansive canvases of the color-field painters frequently seem to envelop the viewer in a luxuriant environment of color. A French variant of color-field painting was known as Supports/Surfaces. The group comprised the artists André-Pierre Arnal, Vincent Bioulès, Louis Cane, Marc Devade, Daniel Dezeuze, Noël Dolla, Toni Grand, Bernard Pagès, Jean-Pierre Pincemin, Patrick Saytour, André Valensi, and Claude Viallat. Between 1966 and 1974 they frequently showed together, issued manifestos, and published a magazine.

Combine. See NEO-DADA

Comics Art

Comics couple words and drawings in sequential, boxed images—or strips—that tell a story or a joke. The comic artist's original renderings are reproduced for mass consumption either in newspapers or in individual comic books, which are sometimes known as "zines." Although the precise origins of the comic strip are disputed, perhaps the two key landmarks in the history of the form are the charming picture novels by Rodolphe Töpffer, a Swiss educator, which were published during the early nineteenth century, and the first publication in color of a comic strip—Richard Outcault's Yellow Kid, which appeared in an American newspaper in 1895.

The relationship between comics and modern art has a long and tangled history. (The related roles of caricature and cartooning in art—the former dating from the Renaissance and the latter epitomized by the brilliant satirical political cartoons by Honoré Daumier, who was also a painter—will not be considered here.) Some twentieth-century artists, such as Stuart Davis, Andy Warhol, and Roy Lichtenstein, utilized comic strips as the subject of their paintings. Others—including Öyvind Fahlström, Richard Hamilton, Jess, Jasper Johns, Joan Miró, and Kurt Schwitters—incorporated images or actual snippets of comic strips in their paintings and collages. One early-twentieth-century painter, Lyonel Feininger, even made a living drawing comic strips, and their style is sometimes evident in his paintings. But in all these cases, the distinction between the inexpensive, mass-produced comic strip and the one-of-a-kind artwork remained clear.

That distinction began to blur in the 1970s with the increasing interest in non-art drawings; fashion design, architectural renderings, magazine illustrations, and comics began to be exhibited and collected, often in galleries or museums devoted to a particular discipline (such as the Cartoon Art Museum in San Francisco). About the same time, art galleries also began to show the original, politically pointed drawings by

so-called underground comics artists such as Bill Griffith, S. Clay Wilson, and Robert Crumb.

This POPULAR CULTURE-driven trend has accelerated due both to the continued interest in comics as source material by contemporary artists who emerged in the late 1980s, such as Sue Williams, Raymond Pettibon, and Nicole Eisenman, and to the increasing popularity and sophistication of the works by comics artists themselves, especially graphic novels. The graphic novel, which can be defined as comics in book, rather than periodical, form became popular in the United States following the publication of Will Eisner's A Contract with God in 1978. Among the present generation of graphic novelists, whose genre of choice is actually the memoir rather than the novel, the breakthrough figure was Art Spiegelman. His Maus: A Survivor's Tale, an autobiographical meditation on the Holocaust, was not only a best seller in print but also appeared as a CD-ROM; the original drawings for it were shown at the Museum of Modern Art, New York, in 1991–92. Notable twenty-firstcentury graphic novelists include Alison Bechdel, known for her comic strip Dykes to Watch Out For and the graphic memoir Fun Home: A Family Tragicomic, published in 2006, and Chris Ware, creator of Jimmy Corrigan, the Smartest Kid on Earth (2000) and Building Stories (2012). Further blurring what would once have been considered high and low art, Ware curated UnInked, an exhibition of paintings, sculpture, and drawings by five cartoonists held in 2007 at the Phoenix Art Museum in Arizona.

Commodification

MODERN art had been bought and sold since its inception, but not in sufficient quantities or at high enough prices to command much public attention until the 1960s. Many artists reacted against the new boom in contemporary art with an anticapitalist fervor typical of the 1960s. They created works that were barely visible (such as CONCEPTUAL ART), physically unstable (PROCESS ART), geographically inaccessible (EARTH ART), or highly theoretical (MINIMAL ART). Yet their attempts to thwart the market were to no avail: as with the earlier "anti-art" of DADA, no contemporary art form has eluded the grasp of determined collectors. The most visible event to link contemporary art and big money was the auction of Robert and Ethel Scull's collection of POP ART at Sotheby's New York in October 1973. Works of the previous fifteen years brought astronomical prices that established contemporary art as a commodity that had become a valuable investment.

It was not until the 1980s that artists took the notion of art-as-commodity for the subject of their work. (A notable exception was the French artist Yves Klein, whose *Immaterial Pictorial Sensitivity* was a series of ACTIONS in 1961–62 that involved "zones" for the exchange of gold and checks, which were then tossed into the Seine.) Art invoking commodification

100

ranges from Jeff Koons's replication of throwaway KITSCH figurines in expensive materials to Mark Kostabi's Warhol-derived art "factory," in which employees produce artworks bearing his name.

See EAST VILLAGE, NEO-GEO

Computer Art

- ▶ who (art)ⁿ, Gretchen Bender, Nancy Burson, Jim Campbell, Harold Cohen, Peter D'Agostino, Char Davies, Paul Earls, Ed Emshwiller, Ken Feingold, Lynn Hershman Leeson, Perry Hoberman, Jenny Holzer, Milton Komisar, Bernd Kracke, George Legrady, Tatsuo Miyajima, Nam June Paik, Otto Piene, Sonya Rapoport, Alan Rath, Jill Scott, James Seawright, Softworlds, Eric Staller, Wen-Ying Tsai, Stan Vanderbeek, Ted Victoria
- ▶ WHEN Since the mid-1960s
- **▶ WHERE** United States and Europe
- ▶ **WHAT** Western artists have always responded quickly to new materials and technologies; consider the rapid replacement of egg tempera by oil paint in fifteenth-century Netherlands and, more recently, the emergence of VIDEO ART. It is not surprising that thousands of artists have seized on the computer as a tool since the mid-1960s. The first exhibitions of computer art were staged in 1965 at the Howard Wise Gallery in New York and the Technische Hochschule in Stuttgart, West Germany, but the computer graphics showcased in both shows had been produced by scientists rather than artists. The first museum show to focus exclusively on computer art was Cybernetic Serendipity: The Computer and the Arts, organized by Jasia Reichardt for the London Institute of Contemporary Arts in 1968. The two- and three-dimensional works featured there were also primarily by scientists, but some artists did participate. Such exhibitions demonstrated the need for the artist-scientist collaborations that were beginning to emerge at new institutions like MIT's Center for Advanced Visual Studies, as part of the contemporaneous ART AND TECHNOLOGY movement.

Artists' access to digital technology began to yield high-tech works that reflected the freedom that CONCEPTUAL ART had begun to provide. Examples of pioneering computer artworks, mostly from the 1970s, include Harold Cohen's computer-controlled drawing machines; James Seawright's performing garden-sculptures, whose kinetic elements can be manipulated by viewers; and Paul Earls and Otto Piene's outdoor "sky operas," which coupled inflatable vinyl forms and electronic music. Many art commentators criticized such works as "gimmicky" and museums have shown them only infrequently, creating until recently something of a computer-art ghetto.

C

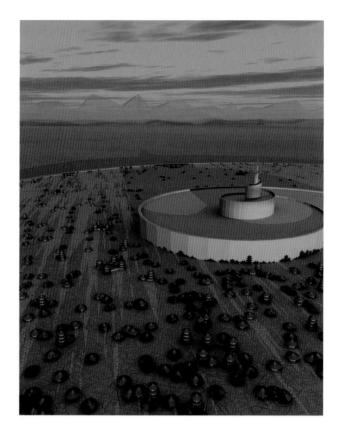

COMPUTER ART Softworlds (Janine Cirincione, Michael Ferraro, and Brian D'Amato) Screen capture from *The Imperial Message*, 1994 Virtual-reality computer game

This situation began to change with the debut, around 1980, of so-called paint systems—interactive, real-time painting programs that mimic the nonelectronic use of brushes and palettes. Computer software such as Images I, Paintbox, and Easel (as well as Photoshop, the photographic equivalent that arrived nearly a decade later) had been designed for illustrators and art directors. But the easy-to-use programs were picked up by many well-known artists, including Jennifer Bartlett, Keith Haring, David Hockney, Les Levine, and Kenneth Noland. Most used the software only as a tool to create the digital equivalents of their work in conventional media, but in conjunction with the ever-expanding roles of computers in our everyday lives, they helped pave the way for an increasing acceptance of computer art.

Most artists who employ digital technology think of themselves simply as artists, rather than computer, digital, or electronic practitioners. The use of digital tools in art—and other realms of contemporary life—is so widespread that it has undermined the ability of *computer* (or *digital*) to describe something distinctive about an artwork. However, these terms remain useful in connection with some historical computer art of the twentieth century and with contemporary artworks in which the digital means of production are foregrounded, as with virtual reality environments, satellite transmissions, and ONLINE ART. Ironically, the establishment of centers for digital art, including the ZKM (Zentrum für Kunst und Medientechnologie, or Center for Art and Media Technology) in Karlsruhe, Germany, and Eyebeam in New York (both opened in 1997), reflects the late-MODERNIST, twentieth-century practice of organizing institutions (and knowledge) along medium or disciplinary lines.

Conceptual Art

- ▶ WHO Giovanni Anselmo, Ant Farm, Art & Language, John Baldessari, Robert Barry, Iain Baxter, Joseph Beuys, Mel Bochner, Alighiero Boetti, Daniel Buren, Victor Burgin, James Lee Byars, John Cage, Luis Camnitzer, James Coleman, Hanne Darboven, Jan Dibbets, Howard Fried, Hamish Fulton, General Idea, Dan Graham, Josh Greene, Hans Haacke, Douglas Huebler, On Kawara, Paul Kos, Joseph Kosuth, Richard Kriesche, Suzanne Lacy, Barry Le Va, Les Levine, Richard Long, Tom Marioni, Jim Melchert, Antoni Miralda, Robert Morris, Vik Muniz, Antonio Muntadas, Bruce Nauman, Morgan O'Hara, Dennis Oppenheim, Mike Parr, Adrian Piper, Dieter Roth, Allen Ruppersberg, Michael Snow, Imants Tillers, Richard Tuttle, Bernar Venet, Lawrence Weiner, Tarsua Yamamoto
- ▶ WHEN Mid-1960s through 1970s
- **▶WHERE** International
- ▶ WHAT The term Conceptual art gained currency after "Paragraphs on Conceptual Art" by the MINIMALIST artist Sol LeWitt appeared in the summer 1967 issue of Artforum. (Similar ideas had been articulated earlier in writings by the artists Henry Flint and Edward Kienholz.) Conceptual art's chief synonym is Idea art.

In Conceptual art the idea, rather than the object, is paramount. Conceptual artists reacted against the increasingly commercialized art world of the 1960s and the FORMALISM of postwar art—especially the impersonality of then-contemporary Minimalism. To circumvent what they saw as the too-narrow limits of art, Conceptualists used aspects of SEMIOTICS, FEMINISM, and POPULAR CULTURE to create works that barely resembled traditional art objects. What the viewer of Conceptual art saw in the gallery was simply a DOCUMENT of the artist's thinking, especially in the case of linguistic works that assumed the form of words

on a wall. Conceptualism soon became an umbrella term used to describe other art forms that were neither painting nor sculpture, such as PERFORMANCE and VIDEO ART, and forms that most viewers saw only in drawings or photographs, such as EARTH ART.

The movement can trace its roots back to the early-twentieth-century readymades by the DADA artist Marcel Duchamp, which emphasized the artist's thinking over his manipulation of materials; to the later philosophically oriented ACTIONS of Yves Klein and Piero Manzoni; and to the painted conundrums of Jasper Johns—all of which asked "What is an artwork?" Due in part to the widespread dissemination of FLUXUS ideas through MAIL ART and other artist-controlled means of distribution, Conceptual art quickly became an international phenomenon. By the end of the 1960s, informal associations of Conceptual artists spanned the globe, from Yugoslavia (the OHO group) to Australia (the Inhibodress group). Conceptual art first reached a general audience through two major New York exhibitions in 1970: the Museum of Modern Art's Information (curated by Kynaston McShine) and the Jewish Museum's Software (curated by Jack Burnham).

The range of Conceptual art thinking is remarkably broad. It encompasses Morgan O'Hara's obsessive documentation of how she spends each waking moment, Robert Morris's construction of a box with the recorded sounds of its own making inside, and John Baldessari's documentation of the letters C-A-L-I-F-O-R-N-I-A, which he placed on the physical locations throughout the state that corresponded to the printed position of each letter on his map. Examples of more socially engaged Conceptualism include Les Levine's operation of a Canadian-kosher restaurant in New York as an artwork (unbeknownst to its patrons); Tom Marioni's organization of salon-style gatherings and exhibitions at the Museum of Conceptual Art in San Francisco, which he founded in 1970; and Hans Haacke's polling of visitors to the Museum of Modern Art in New York about museum trustee Nelson Rockefeller's support for the Vietnam War. Works like Haacke's, which examine the social and economic underpinnings of the ART WORLD, belong to a subset of Conceptual art known as institutional critique, which was popular during the 1980s.

Conceptual art's emphasis on the artist's thinking made any activity or thought a potential work of art, without the necessity of translating it into pictorial or sculptural form. This jettisoning of art objects aroused widespread controversy among artists, viewers, and critics. The artist and theorist Allan Kaprow championed Conceptualism as an interactive form of communication, especially in the wake of visual competition from spectacular, non-art events like the American landing of men on the moon. The critics Robert Hughes (who wrote for *Time*) and Hilton Kramer (who wrote for the *New York Times*) looked at Conceptual art and saw an emperor without clothes.

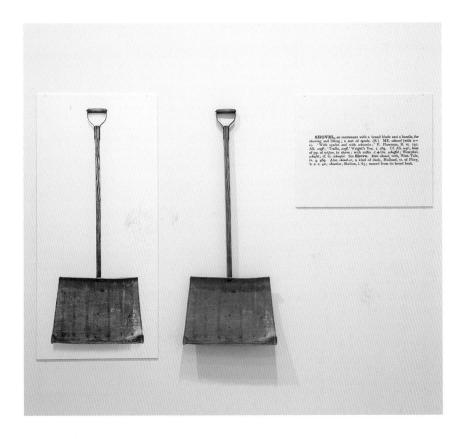

CONCEPTUAL ART
Joseph Kosuth (b. 1945)
One and Three Shovels [Ety.-Hist.], 1965
Shovel, photograph of the shovel, photographic enlargement of dictionary definition of "shovel" Photograph of shovel: 57½ × 26½ in. (146.1 × 67.3 cm), shovel: 50¼ × 20 × 4 in. (127.6 × 50.8 × 10.2 cm), definition: 24 × 30 in. (61 × 76.2 cm) Private collection

Although the revival of traditional-format painting and sculpture in the late 1970s seems visually far removed from Conceptual art, in fact it absorbed from the earlier movement an interest in storytelling, in politics, and in images from art history and popular culture. The term *Neo-Conceptualist* is most often employed in connection with INSTALLATIONS and other works in nontraditional formats.

- **▶wно Josef Albers**, Max Bill, Jean Dewasne, Lucio Fontana, Richard Paul Lohse, Alberto Magnelli, Hélio Oiticica
- ▶WHEN 1930s through 1950s
- ▶ WHERE Western Europe, primarily, and Brazil
- ▶ WHAT The Dutch artist Theo van Doesburg invented the term Concrete art in 1930 to refer to ABSTRACT art that was based not in nature but in geometry and the FORMAL properties of art itself—color and form, in the case of painting; volume and contour, in the case of sculpture. The term was popular before and after World War II, due to the proselytizing of the artist Josef Albers, who emigrated to the United States from Germany in 1933, and of his student Max Bill, who first applied the term to his own work in 1936.

In Concrete art, an appearance of "objectivity" is sought. The artist's personal touch is smoothed over, yielding art objects that sometimes appear to have been made by machine. Individual works vary from the mathematically precise compositions by Richard Paul Lohse, which anticipated OP ART, to Max Bill's undulating three-dimensional abstractions, which suggest the principles of physics and aerodynamics.

Concrete art has lost currency since the 1950s, but the underlying idea that an artwork has value as an independent object, even if it doesn't illuminate social concerns or express an artist's emotions, has been influential. Direct and indirect links tie Concrete art to COLOR-FIELD PAINTING, OP ART, and other CONSTRUCTIVISM-derived styles.

See NEO-CONCRETISM

Constructivism

- ▶ who Alexandra Exter, Naum Gabo, El Lissitzky, Antoine Pevsner, Pablo Picasso, Alexander Rodchenko, Olga Rozanova, Vladimir Tatlin
- **▶ WHEN** 1913 through 1920s
- **▶WHERE** Primarily the USSR
- ▶ WHAT This early-twentieth-century movement is relevant here because of its decisive influence on MODERN sculpture. Constructivism is now often used inaccurately to describe virtually any ABSTRACT sculpture constructed of geometric elements. The term is so frequently misused that the best way to avoid confusion is to examine its original meaning.

Constructivism refers to sculpture that is made from pieces of metal, glass, cardboard, wood, or plastic (often in combination) and that emphasizes space rather than mass. The traditional subtractive or additive ways of

C

Constructivism emerged from Georges Braque and Pablo Picasso's Cubist experiments. Translating the angular forms of his paintings and COLLAGES into three dimensions, Picasso created his first sheet-metal-and-wire construction of a guitar in 1912. After the Russian sculptor Vladimir Tatlin saw these works in Picasso's Paris studio a year later, he returned home and began to construct reliefs that were among the first total abstractions in the history of sculpture. He also formulated the influential Constructivist principle of "truth to materials," which asserted that certain intrinsic properties make cylinders the most appropriate shape for metal, flat planes the best for wood, and so on.

In terms of art made during the first quarter of the twentieth century, Constructivism is virtually synonymous with Russian Constructivism. Many constructions, such as Tatlin's model for the 1,300 foot (400 m) high structure Monument to the Third International (1919), are prototypes for architectural, stage, or industrial designs. Others are purely abstract but look as though they serve some purpose, such as Alexander Rodchenko's geometric hanging constructions that resemble molecular models. These homages to scientific rationality are among the most straightforward representations of the modernist impulse to adapt to the technology of the machine age.

After the Bolshevik Revolution of 1917 the Constructivist artists gained power. Dissension between those interested in a more personal art and those concerned with making utilitarian designs for the masses soon split the group. As the political climate changed in favor of the latter faction in the early 1920s, many of the Russian Constructivists moved to the West. Some went to Germany's technologically oriented Bauhaus school of art and design, ensuring the spread of Constructivist principles throughout Europe and later the United States.

The effect of Constructivism on postwar art has been profound. It influenced technique: combining different materials, often by welding, was the chief sculptural method from the 1940s through the early 1960s. Probably more important, it influenced ways of thinking about art in relation to science and technology. That rational approach infused not only KINETIC SCULPTURE, MINIMALISM, and ART-AND-TECHNOLOGY projects but even HARD-EDGE painting and geometric abstraction.

Contemporary

Generically, contemporary refers to current or recent art production. All art is contemporary to those who make it, whether they are the inhabitants of Renaissance Florence or twenty-first-century New York, and

regardless of whether they work in current or historical styles. In this general sense, contemporary is synonymous with modern.

Contemporary has also emerged as a blanket term for the art of the period following World War II, and is now widely yet inconsistently employed as such by museums, auction houses, and academic departments. Among the earliest uses of the term in connection with an art institution was the controversial renaming in 1948 of the Boston Museum of Modern Art, to the Institute of Contemporary Art, an apparent rejection of the ethos of MODERNISM itself. More typical is the Los Angeles Museum of Contemporary Art, which collects and exhibits a wide range of art from 1940 to the present, including examples of high modernism that predate World War II, in the belief that the story of postwar art is illuminated by its historical interconnections. Its mission thus overlaps with that of older museums with the word modern, rather than contemporary, in their names—such as the Museum of Modern Art in New York and the San Francisco Museum of Modern Art—which typically collect and exhibit art from the late nineteenth century to the present.

This chronological imprecision results from the arbitrariness of using World War II to delineate historical eras or "periods." Although this global conflict drastically altered political and economic relations, it did not reconfigure societies on a scale comparable to, for instance, the epochal (albeit gradual) transition from the agricultural, rural, and religious society of the medieval West to the urban, secular, and capitalist world of the Renaissance. (This shift was reflected in nearly every aspect of art as well, from systems of representation to patterns of patronage.) The gap separating the modern from the POSTMODERN era is similarly vast: the former is characterized by industrialization, faith in technology, and utopian systems; the latter, by digital means of production, global late capitalism, and skeptical views of both human nature and the role of humans vis-à-vis nature.

The rise of the term contemporary accompanied a sea change in the recognition and valuing (literal and figurative) of recent art. It was traditionally assumed that historical judgments about art could only be reached over time: works by living artists were generally regarded as too new to enter museums, to be the subject of academic attention, or to garner the stratospheric sales prices associated with Old Master art. This began to change after World War II, with the media attention accorded to ABSTRACT EXPRESSIONISM (and its living makers). But it was the 1973 auction of POP ART from Robert and Ethel Scull's collection that galvanized widespread attention—and resentment—for the high prices paid for art that had been bought cheaply just a few years earlier. This event symbolized the end of the romantic model of the impoverished and isolated artist, who was replaced by a more worldly, mediagenic successor, epitomized by Andy Warhol and his entourage or the trendy artist-hipsters depicted in such films as Michelangelo Antonioni's Blow-Up (1966).

Contemporary art was transformed—with mixed consequences—into an industry creating simultaneous demand for both individuality and conformity (often paradoxically coupled in the so-called "signature style"). This process of institutionalization ensured that contemporary art would be both quantitatively and qualitatively different from what preceded it. Quantitatively, the number of contemporary artists and galleries mushroomed, in part as a consequence of the GI Bill of 1944 and the subsequent growth in art school enrollment. Qualitatively, entirely new institutions (such as the contemporary art museum) and professions (the scholar and curator of contemporary art) were called into being. One paradigmatic material realization of the contemporary in its late-twentieth-century form is the Guggenheim Museum's outpost in Bilbao. Spain, opened in 1997. With its dazzling architecture by Frank Gehry, its economic value as a destination of cultural tourism, its hybrid modern-contemporary exhibition program, and its collection leased from the Guggenheim Foundation, the Guggenheim Museo Bilbao is one in a global network of franchised Guggenheims.

Contemporary Indigenous Australian Art

- ▶who Emily Kame Kngwarreye, David Malangi, Queenie McKenzie, Albert Namatjira, Dorothy Napangardi, Minnie Pwerle, Rover Thomas, Freddie Timms, Clifford Possum Tjapaltjarri, Johnny Warangkula, Judy Watson
- ▶when Since the 1930s
- **▶**where Australia
- **WHAT** Also known as *Aboriginal art*, Indigenous Australian art has been made by the Indigenous peoples of Australia since time immemorial. (Recent genetic studies suggest that the ancestors of Australian Aborigines were the first of the modern human populations to leave Africa, more than 64,000 years ago.) Aborigines painted, carved, wove, or engraved sacred images and symbols on rocks, bark, stones, or cave walls.

As with translations of other indigenous peoples' religious imagery onto more conventional (and commercially oriented "export") formats elsewhere the world, the contemporary Indigenous Australian art movement sprang from a variety of impulses and motives both respectful and exploitative, held by players and agents both native and European, and both knowledgeable and ignorant of Indigenous peoples and their art. The process began in 1934, when painter Rex Battarbee taught the Aboriginal artist Albert Namatjira the watercolor medium, with such success that he became the first Aboriginal Australian citizen. In the early 1970s artist Geoffrey Bardon urged Aboriginal people in remote Papunya to translate their "dreamings"—previously drawn on the sand in dots

that encoded the locations of secret ceremonies—onto canvas. Despite indiscreet revelations of some tribal secrets, this has become perhaps the most recognizable style associated with Aboriginal Australian culture.

A growing appreciation of Aboriginal culture was symbolized by the dedication in Canberra, the Australian capital, in 1988, of both the Aboriginal Memorial in the National Gallery and the mosaic pavement, designed by Michael Nelson Tjakamarra, that embellishes the forecourt of the new Parliament House. Dozens of Aboriginal artists are (justly) famous and commercially successful, although Aboriginal art is often collaboratively produced in cooperatives and art centers rather than by individuals. But even the statement that the market for Aboriginal art has burgeoned belies the difficulty of generalizing about diverse cultures dispersed across vast distances, whose art has traditionally depended on locally available materials and employed a variety of techniques.

Issues unusual in the contemporary art context—many of them ethical—spring to mind: Has current Aboriginal art production affected traditional spiritual practice? What are the nature and extent of Indigenous and Australian support for the preservation of Aboriginal cultural traditions? What models of political empowerment—such as the establishment of research institutions—suit the needs and character of Aboriginal peoples? Should contemporary Indigenous Australian art be exhibited alongside the historic religious objects from Oceania in such venues as the Musée du Quai Branly in Paris? That these questions may be more suited to the anthropologist than the art historian is a valuable reminder of the breadth of practices put to complex purposes that we unhesitatingly term art.

Content

Every work of art ever produced has *content*, or meaning. Analyzing the content of an artwork requires the consideration of subject, form, material, technique, sources, socio-historical context, and the artist's intention (though the artist's interpretation of the work may differ from the viewer's).

There are two widely held misconceptions about content. First, that it is the same as subject. In fact, the subject of a work is just one part of its content. An artist depicts a landscape or a figure, for example, and that is the work's subject. The subject can usually be identified by sight, whereas the content requires interpretation. Often that interpretation takes into account factors that are invisible in the work, such as the expectations of the patron who commissioned the work or art historical precedents. The content of a landscape might be divine benevolence or humanity's destructive impulses toward the planet. The content of a portrait might range from the glorification of the sitter's social standing to the artist's sexual objectification of the model.

The second common misconception about content is that it is the opposite of form—which includes size, shape, texture, etc. In effective artworks, form and content reinforce one another. For instance, the machine-made look of a HARD-EDGE painting devalues the importance of the artist's personal touch. Psychic depletion is suggested in Alberto Giacometti's pencil-thin figures by both the attenuation of the forms and their pitted metal surfaces.

Cooperative Gallery. See ALTERNATIVE SPACE

Copy Art

- ▶who Lucia Alvarez, Vittore Baroni, Evergon, Connie Fox, Wolfgang Hainke, Pati Hill, N'ima Leveton, Joan Lyons, Hirotaka Maruyama, Niall Monro, Bruno Munari, Esta Nesbitt, Ann Noël, Jurgen Olbrich, Marie-Hélène Robert, Danielle Sasson, Sonia Sheridan, Barbara Smith, Keith Smith, H. Arthur Taussig, Ruben Tortosa, Emmett Williams
- ▶WHEN 1960s through 1970s
- **▶WHERE** International
- ▶ WHAT The first practical copying machine was Thomas Alva Edison's Mimeograph, which became available in 1887. This was followed in 1910 by the French Photostat device and in 1938 by the invention of what would later become known as xerography (which is Greek for "dry writing.") Developed by the patent attorney Chester F. Carlson, xerography yielded direct-positive images that could be fixed by heat and transferred to ordinary paper. The process was refined by the Xerox Corporation and its competitors after World War II, and copying machines became commonplace in offices during the 1960s. The color copier debuted in 1968.

Artists began to use copy machines regularly during the early 1960s. Among the first to make copy art were N'ima Leveton, Esta Nesbitt, and Barbara Smith, but the history of the medium—also termed *electrographic art* or *xerography*—is sketchy. No medium requires a common approach or STYLE, other than those imposed by its limitations. For copy artists these limitations included the small size of the copier's "bed," on which objects or images were laid for copying, and the unnaturally brilliant and saturated palette of the first generations of color copiers.

Like other artworks utilizing new, technologically oriented print and photographic processes, copy art was often regarded by museum print curators as a medium handicapped by the distracting evidence of its technological means. Institutional support for copy art came largely from industry, in the form of 3M Company artist residencies and Kodak's sponsorship of copy-art exhibitions, such as the groundbreaking *Electrowork* at George Eastman House, in Rochester, New York, in 1979.

Crafts-as-Art

- **▶wно Rudy Autio**, Wendell Castle, **Dale Chihuly**, Dan Dailey, Marvin Lipofsky, Harvey K. Littleton, **Sam Maloof**, Nance O'Banion, Albert Paley, **Peter Voulkos**, Claire Zeisler
- ▶ WHEN First attracted national attention in the 1970s
- **▶WHERE** Primarily the United States
- ▶ WHAT The term *crafts-as-art* refers to the recent elevation of craft materials to art—clay to CERAMIC SCULPTURE, glass to glass sculpture, etc.—and the rise in status of some craftspersons to artists.

Until World War II crafts and art were easy to tell apart. Art was generally made of art materials (paint on canvas, bronze, etc.), had serious CONTENT, and served no function around the house. Crafts were made of craft materials (wool, wood, pottery) and were designed to be used.

During the 1950s the lines separating art and craft began to dissolve. Craftspersons began to create nonfunctioning objects, which became hard to distinguish from sculpture. This move away from the functional occurred first among ceramic sculptors in California and inspired artisans working in glass and metal during the 1960s and '70s. They, in turn, influenced artists of the 1970s such as Faith Ringgold, Miriam Schapiro, and Christopher Wilmarth to consider new materials. Likewise, many artists of that decade became interested in functional objects, producing ARTISTS' FURNITURE and other hybrid art/non-art forms. A chair being exhibited in a gallery today, for example, may be the work of an artist, an architect, a furniture designer, or a craftsperson.

Culture Wars

The term *culture wars* reflects the widespread confusion in the United States between the arts and culture. (The latter includes not only the arts but also food, fashion, humor, political orientation, and even styles of interpersonal relating and communication—as in Irish culture or corporate culture.) Although it is unclear who coined this term, columnist (and presidential candidate) Patrick Buchanan wrote a newspaper article called "Losing the War for America's Culture?" in May 1989. In 1992 Buchanan's repeated use of the term in an incendiary speech at the Republican National Convention in Houston was linked by commentators to Adolf Hitler's use of the term *kulturkampf* in his efforts to rid mid-twentieth-century Germany of so-called degenerate—or MODERNIST—art.

Most observers date the American culture wars to spring 1989, when controversies arose over the federal funding of exhibitions featuring the photographs of Serrano and Robert Mapplethorpe, whose works were deemed "blasphemous" and "obscene," respectively, by right-wing pressure groups and politicians. In fact, earlier in the decade the culture wars had fueled a new activist conservatism. Groups such as the Christian Coalition and the American Family Association made targets of popular entertainment such as movies, television, and rap music, as well as of painting and photography. (The NEA brouhahas followed hard on the heels of boycotts of Martin Scorcese's film *The Last Temptation of Christ* and of Pepsico, for its ads featuring Madonna's song "Like a Prayer.") The censors' stated objectives were to "protect children" and "respect religious and cultural beliefs and sensitivities." Unfortunately, both of these laudable intentions have functioned to disguise the less savory aim of silencing unwelcome viewpoints.

Taking a longer view, the censorship of visual art in the United States can be traced back to the mid-nineteenth century, when residents of Baltimore were outraged by sculptor Hiram Powers's buxom Neoclassical goddesses, which were quickly covered up. Since then, the puritanism of Anglo-Saxon culture has erupted in regular incidents of censorship in the U.S. Notable among them are the passage in the late nineteenth century of the so-called Comstock laws, which sought the elimination of "obscenity" in art and the criminalization of abortion and contraception, and the court battles over the supposed obscenity of modernist literary classics including James Joyce's Ulysses and D.H. Lawrence's Lady Chatterly's Lover, which raged for over half a century following World War I. Although the battle for free expression (literary at least) was won, when it came to publicly funded art, the U.S. Supreme Court decided that free expression could be left at the studio door. The contemporary culture wars have yielded two unfortunate effects: the destabilization of institutional funding for contemporary art and artists, and the creation of a climate in which legally protected imagery such as nudity in painting or sculpture is regarded by some as cause for virtually automatic censure.

Cynical Realism

- ▶who Fang Lijun, Guo Wei, Liu Wei (b. 1972), Liu Xiaodong, Song Yonghong, Wang Jinsong, Yang Shaobin, Yu Hong, Yue Minjun, Zhang Xiaogang, Zheng Fanzhi
- ▶WHEN 1989 to 2004
- ▶ WHERE China, primarily Beijing
- ▶ **WHAT** The term *Cynical Realism* was coined slightly after the fact, in 1992, by the critic Li Xianting in an article in the Hong Kong journal *The*

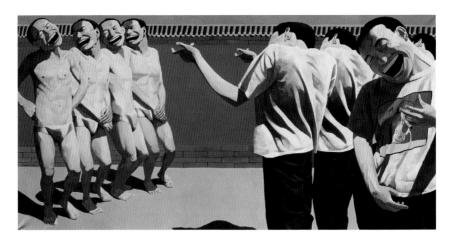

CYNICAL REALISM
Yue Minjun (b. 1962)
The Execution, 1996
Oil on canvas, 59 × 118½ in. (150 × 300 cm)
Private collection

Twenty-First Century. In the same article, he also named the sometimesoverlapping style POLITICAL POP, asserting that the pair of approaches effectively captured the ironic mood of China after 1989. The shared characteristics of the two styles can make representative examples of them difficult to distinguish.

In a statement introducing a 1992 exhibition of paintings by Fang Lijun and Liu Wei (b. 1972), Li again evoked a "trend": "I call the neo-realistic trend that emerged after 1988 or 1989...concentrated mainly in Beijing Cynical Realism," Li wrote. "'Cynical' is an English word, and we take up its connotations of ridicule, sarcasm, and cold views on reality and life." Like American POP ART, this hyperrealistic style was put to untraditional ends. Cynical Realist works assault the idealization and groupthink of SOCIALIST REALISM through disturbing group portraits of nearly identical figures, such as the men in Yue Minjun's works, with their identical idiotic smiles, or the families in Zhang Xiaogang's Bloodline series, which underline the genetic similarity of the Chinese citizenry.

For artists growing up during the Cultural Revolution and coming of age soon after it, the 1980s offered mixed messages. The tentative liberalization of the second half of the decade—epitomized by the '85 NEW WAVE movement and the discussions that followed—ended with the shuttering of the *China/Avant-Garde* exhibition in 1989. Government policy

paradoxically favored both liberal economics and reactionary politics. Despite the ideologically critical meaning of some artworks, officials tolerated the unfettered development of a global market for contemporary Chinese art, hesitant to curtail a growth industry that generated hard currency and cultural prestige. This trade-off, coupled with the increasing commercialization of Chinese art and society at large, resulted in the ambivalence of the Cynical Realists toward modern universalizing systems, whether utopian political programs or utopian artistic programs (or "isms").

C

By 1993, the term *Cynical Realism* had gained currency throughout the international art world. Works in this style became the instantly recognizable face of contemporary Chinese art and would soon garner stratospheric auction prices. The term was also too often used to imply a movement in the traditional sense of a self-conscious avant-garde with shared artistic aims expressed through a manifesto and group exhibitions. It nonetheless seems a useful descriptor for a number of artists whose works embodied a common attitude, including some—Wang Jinsong, Yue Minjun, and Zhang Xiaogang—who lived and worked together in the Yuanmingyuan Artist Village near Beijing. Although the face of Chinese contemporary art abroad, Cynical Realism remained an almost underground movement inside China until the breakthrough show *China's New Art*, *Post-1989*, held at the Hong Kong Arts Centre in 1993.

- **▶wно** Jean (Hans) Arp, **Marcel Duchamp**, **Max Ernst**, Hannah Höch, **Francis Picabia**, Man Ray, Morton Schamberg, Kurt Schwitters
- **▶WHEN** 1915 to 1923
- **▶WHERE** New York and Western Europe
- **WHAT** Dada, an *early*-twentieth-century movement, is included here because postwar art cannot be understood without referring to Dada art forms, ideas, and attitudes.

Dada means a variety of things in a variety of languages, including hobby horse in French and yes, yes in Slavic tongues. One version of the name's origin has it that in 1916 the poet Tristan Tzara stuck a penknife in a dictionary at random and it landed on the nonsensical-sounding term.

Dada sprang up during and immediately after World War I; first in the neutral cities of Zürich, New York, and Barcelona, later in Berlin, Cologne, and Paris. It was largely a response to the tragic toll—more than ten million dead—exacted by the "Great War." That the new machineage technology could wreak such havoc made many wonder whether the price for modernity's material benefits was too high. The Dada artists blamed society's supposedly rational forces of scientific and technological development for bringing European civilization to the brink of self-destruction. They responded with art that was the opposite of rational: simultaneously absurd and playful, confrontational and nihilistic, intuitive and emotive.

Dada, then, is not a STYLE, or even a number of styles, but a world view. Nor were its attitudes embodied only in artworks. Active as citizen-provocateurs rather than studio-bound producers of objects, Dada artists organized incendiary public events. The results varied from the rabble-rousing mixed-media programs at Zürich's Cabaret Voltaire, which anticipated PERFORMANCE ART, to the quasi-philosophical inquiries posed by Marcel Duchamp's many inventions, such as the readymade.

Jean Arp's chance-derived compositions and Man Ray's threatening objects—an iron with nails on its face titled *Gift* (1921), for example—similarly assaulted traditional notions of what art should be. (Such objects also paved the way for SURREALISM.) Francis Picabia and Duchamp produced paintings, sculptures, and constructions that were more conventional in format, including images of people as machines, which at the time went largely unappreciated.

The aggressive absurdity of much Dada art enraged many viewers. Although its critical stance toward bourgeois society is characteristic of MODERN art, the Dada artists were the most virulent of modernists in their rejection of middle-class morality. (CONCEPTUAL ART and late

1980s artworks examining the role of art as COMMODITY are rooted in Dada ideas and gestures.) Later aptly dubbed *anti-art*, Dada objects ironically have become valued as priceless masterpieces in today's art world, and Duchamp is now revered, along with Pablo Picasso, as the most influential artist of the twentieth century.

See NEO-DADA

Dau al Set

- ▶wно Modest Cuixart, Josep Guinovart, Jaume Muxart, Joan Ponç, Antoni Tàpies, Joan-Josep Tharrats
- ▶WHEN 1948 to 1956
- **▶WHERE** Barcelona
- ▶ WHAT Dau al Set means "dice [or its singular, die] at seven," and the suggestion of chance embodied in its name telegraphs one of its missions—the popularizing of SURREALISM in Spain. An association of artists and writers, Dau al Set comprised not only the above-named artists but also the poet Joan Brossa, the EXISTENTIALIST writer Arnau Puig, and the critics Juan Eduardo Cirlot and Alexandre Cirici Pellicer. The group published a "little" magazine called Dau al Set with the avowed intention of awakening Barcelona to the MODERNIST ferment that had bypassed Spain, especially following the establishment of the Franco dictatorship after the Spanish Civil War of the 1930s.

Dau al Set's members favored diverse aesthetic sensibilities. As a group, they not only became the first and chief exponents of Surrealism in Spain but also championed the first stirrings of expressive abstraction and ART INFORMEL. Strongly nationalistic, the group also championed such Catalan artists as the Surrealist Joan Miró and the late-nineteenth-century architect Antoni Gaudí. Their importance rests less on their promotion of a particular style than in their helping to reestablish an avant-garde milieu in Barcelona.

See EL PASO

Décollage. See COLLAGE

Deconstruction. See SEMIOTICS

Digital Art. See COMPUTER ART

D

Documentation has two meanings. Its everyday meaning refers to photographs, videotapes, or written materials related to an artwork's creation, exhibition, or history.

A more complex notion of documentation applies to CONCEPTUAL ART, especially works of EARTH ART and PERFORMANCE ART. Some ephemeral performances or out-of-the-way earthworks—including the private rituals enacted by Vito Acconci or Donna Henes, the geographically inaccessible *Lightning Field* by Walter De Maria, and the short-lived environmental spectaculars by Christo and Jeanne-Claude—are known mainly through documentation. When made by the artist him- or herself, this sort of documentation can be art as well as historical record. As such, it is exhibited and sold as art, unlike the work it documents.

Düsseldorf School of Photography

- **▶wно Andreas Gursky**, Candida Höfer, Axel Hütte, **Thomas Ruff**, **Thomas Struth**
- **▶ WHEN** 1980 to early 1990s
- **▶WHERE** Düsseldorf, (West) Germany
- ▶ WHAT The Düsseldorf School of Photography refers to a group of artists who were students of the prominent photographic CONCEPTUALISTS Bernd and Hilla Becher at the Düsseldorf Academy during the 1970s and established their careers in the following decade. The "photography" label is somewhat misleading, given the Conceptualist character of the Düsseldorf School's outlook and output.

Their mentors, the Bechers, are renowned for sober-looking grids of similarly composed, black-and-white, frontal views of particular types of structures, such as grain elevators or barns. Careful looking at these inventories—or "typologies," as they called them—of industrial-era structures reveals differences as well as similarities between each picture. The Bechers gained international exposure with the New Topographics show at the International Museum of Photography in Rochester, New York, in 1975. It placed them within a context of well-crafted photographs by such (American) photographers as Robert Adams and Stephen Shore who employed everyday imagery akin to theirs. But the Bechers' interest in the catalog and the category, and in the nature of similarity and difference, would ultimately place their work in the blurry terrain where photographic truth and Conceptualist inquiry meet.

Their students were deeply impacted by these images. As a group, they adopted a shared preference for documentary neutrality expressed through the frontal view, the unpeopled scene, and the panoramic

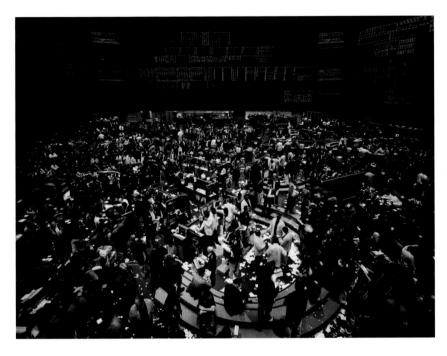

DÜSSELDORF SCHOOL OF PHOTOGRAPHY Andreas Gursky (b. 1955) New York Mercantile Exchange, 1999 80¾ × 94½ in. (205 × 240 cm) Private collection

landscape or highly legible architectural interior or facade. Advances in digital photography in the early 1990s began to undermine this sobriety, especially in the dazzling work of Andreas Gursky. His mural-size, almost hallucinogenic photographs of crowds in airports or at the stock exchange possess a remarkable clarity that enables the viewer to distinguish literally hundreds of finely detailed figures from one another. In such images, we no longer notice the mechanically derived conventions of photographic focus and composition; in fact, the experience is far closer to that of viewing certain late medieval or early Renaissance paintings.

- ▶ who Alice Aycock, Christo and Jeanne-Claude, Walter De Maria, Jan Dibbets, Hamish Fulton, Michael Heizer, Nancy Holt, Richard Long, Ana Mendieta, Mary Miss, Robert Morris, Dennis Oppenheim, Michael Singer, Robert Smithson, Alan Sonfist, James Turrell
- ▶ WHEN Mid-1960s through 1970s
- ▶ **WHERE** Primarily northern Europe and the United States
- ▶ WHAT Earth art, or environmental art, was a broad-based movement of artists who generally shared two key concerns of the 1960s: the rejection of the commercialization of art, and the support of the emerging ecological movement, with its "back-to-the-land" antiurbanism and sometimes spiritual attitude toward the planet. Funding for the earth artists' frequently large and costly projects was provided by individual patrons and private foundations.

The wide-ranging methods and goals of these artists are best described through examples. Alan Sonfist landscaped urban sites in an attempt to return them to their prehistoric, or natural, states. Nancy Holt constructed astronomically oriented architectural structures suggestive of Stonehenge. Michael Heizer and Robert Smithson moved tons of earth and rock in the deserts of the American West to create massive earth sculptures sometimes reminiscent of ancient burial mounds. Richard Long recorded his excursions through the landscape and the ephemeral arrangements of rocks and flowers he made there in elegantly composed photographs.

Exhibiting photographic DOCUMENTATION of remote works is standard operating procedure for earth artists, as it is for CONCEPTUAL artists. Earth art should also be considered alongside contemporaneous ARTE POVERA and PROCESS ART. While process artists incorporated the rhythms and systems of nature within their work, earth artists actually moved into nature itself. Although aggressive assaults on the landscape like Smithson's spectacular *Spiral Jetty*—a 1,500 foot (450 m) long rock-and-salt-crystal jetty in Utah's Great Salt Lake—are the best known of the earthworks, more ecologically sensitive works were produced by artists such as Long, Dennis Oppenheim, Michael Singer, and Sonfist.

The Dia Art Foundation, a longtime supporter of earth art, funds (and maintains) works in remote places, like Walter De Maria's *Lightning Field* (1977) in Catron County, New Mexico. This installation, consisting of a grid of stainless-steel poles occupying one square kilometer of the desert, has become a stop on an informal "pilgrimage route" of earth art in New Mexico, Utah, and Nevada.

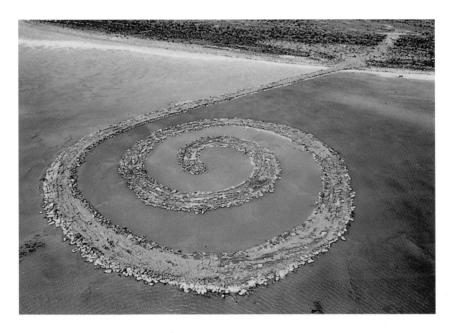

EARTH ART Robert Smithson (1938–1973) Spiral Jetty, 1970 Black rocks, salt crystal, earth, red water, algae, length: 1,500 ft. (457.3 m), width: 15 ft. (4.6 m) Estate of Robert Smithson

East Village

▶ who Jean-Michel Basquiat, Mike Bidlo, Arch Connelly, Jimmy DeSana, Rodney Alan Greenblat, Richard Hambleton, Keith Haring, Marilyn Minter, Nicolas Moufarrege, Peter Nagy, Walter Robinson, Kenny Scharf, Peter Schuyff, Huck Snyder, Meyer Vaisman, David Wojnarowicz, Martin Wong, Zephyr, Rhonda Zwillinger

▶WHEN 1981 to 1987

▶WHERE New York

▶ WHAT East Village means East Greenwich Village, until recently a working-class neighborhood in downtown Manhattan. During the early and mid-1980s East Village came to stand for an explosion of art, PERFORMANCE ART, and musical activity in the clubs and galleries that helped define the rapidly gentrifying neighborhood.

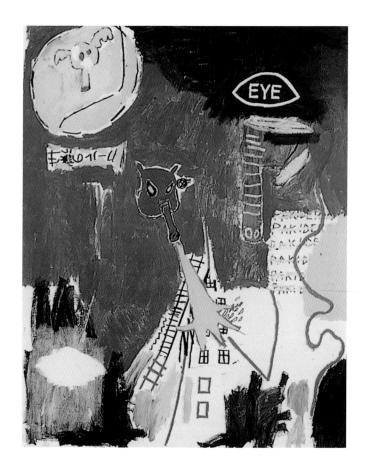

EAST VILLAGE
Jean-Michel Basquiat (1960–1988)
Pakiderm, 1984
Oil and acrylic on canvas,
86 × 68 in. (218.4 × 172.7 cm)
Broad Collection, Los Angeles

In terms of visual art, the East Village was characterized by a bustling entrepreneurial scene, with many East Village artists doing double duty as art dealers. This Warholian embrace of commerce was a rejection of the publicly funded activities of the ALTERNATIVE SPACES of the previous decade and a reflection of New York's Wall Street–driven boom economy of the mid-1980s. Collectors of new art garnered considerable publicity, and more than 150 eccentrically named galleries (including Fun, Civilian Warfare, Gracie Mansion, and Nature Morte) sprang up to serve them. The

East Village art scene quickly became too trendy for the hipster pundits, for whom the opening of non-artist Pat Hearn's posh new gallery on Avenue B in late 1983 signaled the beginning of the end of the neighborhood.

GRAFFITI ART and NEO-EXPRESSIONISM are often associated with the East Village, but other STYLES were made and shown there too. During the mid-1980s neo-CONCEPTUAL and NEO-GEO art began to emerge in the then-fertile environment. The decline of the East Village art scene began in 1985, when the four-year-old Fun Gallery, the first in the neighborhood, closed its doors. But the problems were more than commercial: the neighborhood was among the hardest hit in the United States by the related problems of intravenous drug use and AIDS, which decimated it during the late 1980s. By the 1988–89 season, the vast majority of the galleries had either moved to Soho, where rents were now cheaper and patrons more plentiful than in the East Village, or shut down.

Electrographic Art. See COPY ART

El Paso

- **▶wно Rafael Canogar**, Martin Chirino, **Luis Feito**, **Manolo Millares**, Manuel Rivera, **Antonio Saura**, Manuel Viola
- ▶WHEN 1957 to 1960
- **▶WHERE** Madrid
- ▶ WHAT El Paso (meaning "the passage" and implying a gateway to the new) was an association of artists formed in Madrid in 1957. Its founders were the painters Rafael Canogar, Luis Feito, Manolo Millares, and Antonio Saura, along with the writers José Ayllón and Manuel Condé. El Paso was founded as both an extension of, and a response to, the DAU AL SET group, which had been established in 1948 in Barcelona—Madrid's rival as the center of Spanish art. Whereas Dau al Set championed new art primarily in the form of SURREALISM, El Paso looked to ART INFORMEL and ABSTRACT EXPRESSIONISM for inspiration.

The El Paso painters (and sculptor Martin Chirino) staged a number of group exhibitions, featuring work that ranged from the evocatively paint-encrusted and distressed-looking surfaces of canvases by Canogar, Feito, and Millares to Saura's more calligraphic paintings. Their exhibitions sometimes triggered public demonstrations, reflecting the hostility of the right-wing Franco regime toward MODERNISM in general. El Paso was instrumental in making expressive abstraction the dominant mode of painting in Spain during the 1960s.

Existentialism

The emphasis on individuality and on the absurd inexplicability of human existence helped create an almost romantic aura around existentialism, especially in the wake of the disillusionment that followed World War II. The mindset (it was never an organized movement) was a response to—and a rejection of—the authoritarian systems of communism and fascism, ubiquitous nationalism, and the new technocratic horrors symbolized by Auschwitz and Hiroshima. Its influence and popularity were also enhanced by the work of writers such as Albert Camus, André Gide, and Simone de Beauvoir in France and the Beat poets in the United States; the latter were not philosophers, but their works are permeated by existentialism. Sartre's turn to Marxism at the end of the 1950s was a sign of existentialism's waning importance to contemporary philosophy.

Existentialism permeated the visual art of the 1940s and '50s. Like other thinkers, artists felt the need to assert personal autonomy in the face of chaos—a frequently invoked term that typically meant existential chaos. Robert Motherwell sought "ordered chaos" in his paintings, while his fellow ABSTRACT EXPRESSIONIST Barnett Newman proposed leaping into the chaotic unknown to discover the "meaning of life and death" and further noted that "the aesthetic act always precedes the social one." Such thinking transcended national borders; Italian Spatialist Lucio Fontana noted that "change is the essential condition of existence," and GUTAI founder Jiro Yoshihara placed the quest for meaningful action high among art's purposes.

The art that emerged from this ZEITGEIST took many forms, with existentialism rippling like an undercurrent through the work of abstractionists such as the Abstract Expressionist and ART INFORMEL painters. Because expressionistic gestures were regarded as an emblem of individual autonomy and the assertion of self, they became the mark of existentially oriented artists of varied stylistic leanings. The philosophy's influence could be seen even more directly in the work of independent figurative artists such as the sculptor Alberto Giacometti and the painters Leon Golub and Jean Dubuffet, as well as among those artists involved in such figure-oriented movements as ABJECT EXPRESSIONISM, the BAY AREA FIGURATIVE STYLE, COBRA, SCHOOL OF LONDON, and SPATIALISM.

124

Expressionism

Expressionism refers to art that puts a premium on expressing emotions. Painters and sculptors communicate emotion by distorting color or shape or surface or space in a highly personal fashion.

The "opposite" of expressionism is Impressionism, with its quasiscientific emphasis on capturing fleeting perceptions, such as the appearance of light on a cathedral façade at a specific time of day. Like ABSTRACTION and REPRESENTATION, expressionism and Impressionism are not diametric opposites so much as two ends of a spectrum along which most artworks are positioned.

The adjective *expressionist* is used to describe artworks of any historical era that are predominantly emotive in character. The noun *expressionism* is usually associated with MODERN art but not with any one movement or group of artists. There have been several expressionist movements; their names are always modified with an adjective, such as German Expressionism or ABSTRACT EXPRESSIONISM, or given another name entirely, such as the "Fauves" (literally the "wild beasts").

Modern expressionism is usually traced back to the works of Vincent van Gogh and the Fauves (Henri Matisse, André Derain, Raoul Dufy, Maurice de Vlaminck), whose idiosyncratic choice of colors was intended to evoke feeling rather than to describe nature. The PRIMITIVIZING art of two early-twentieth-century groups—Die Brücke (The Bridge; Erich Heckel, Ernst Kirchner, Karl Schmidt-Rottluff) and Der Blaue Reiter (The Blue Rider; Alexei von Jawlensky, Wassily Kandinsky, Paul Klee, August Macke, Franz Marc, Gabriele Münter)—is known as German Expressionism. The tag ABSTRACT EXPRESSIONIST was applied to American painters of the 1940s and '50s to distinguish them from abstract painters with a more geometric or cerebral—that is, less emotive or intuitive—bent.

In Western society the public regards modern art chiefly as a therapeutic vehicle for releasing emotion. Despite that widely held view, the current of modern art's mainstream has tended to shift between art emphasizing rational thought and art emphasizing feeling. Following the many CONCEPTUAL ART-derived models of the 1970s, the expressionist impulse resurfaced with NEO-EXPRESSIONISM, the first of the POSTMODERN movements characterized by an orgasmic explosion of feeling.

Fashion Aesthetic

- ▶ who Richard Avedon, Lillian Bassman, Guy Bourdin, Frank Majore, Robert Mapplethorpe, Helmut Newton, Irving Penn, Herb Ritts, Deborah Turbeville, Chris von Wangenheim, Bruce Weber
- ▶ **WHEN** Since the late 1960s
- ▶ WHERE Primarily the United States and Western Europe
- ▶ WHAT The fashion aesthetic (or fashion sensibility) usually refers not to fashion photography—commercial work commissioned for advertisements—but to the use of fashion photography's glamorizing style in "art" photographs intended for gallery walls. The fashion photograph—and now the fashion-aesthetic portrait or figure study—relies on bold and simple design flavored with a dash of class and sexiness. Many of its most suggestive qualities have been pirated from avant-garde art and photography, usually long after the fact. Cubism, which had emerged before World War I, was "borrowed" by Irving Penn and Horst during the 1940s for fashion photo-layouts. Richard Avedon's fascination with physical movement in fashion pictures was rooted in art photography made thirty years earlier by Henri Cartier-Bresson and André Kertész.

Most photographers producing fashion-aesthetic pictures are also fashion photographers. Art photographers have supported themselves with their fashion shots since fashion photography's inception in the work of early-twentieth-century figures such as Baron Adolph de Meyer, Edward Steichen, Louise Dahl-Wolfe, and Cecil Beaton. Despite this crossover, the distinction between a photographer's art photography and his or her fashion photography was strictly delineated. Then, in 1978, the prestigious Metropolitan Museum of Art in New York eroded this distinction by mounting a major exhibition integrating Avedon's fashion, art, and journalistic pictures.

The situation has grown increasingly confused ever since. Throughout the 1970s Irving Penn straightforwardly applied the fashion aesthetic to garbage and cigarette butts, endowing such gritty subjects with elegance. During the 1980s photographers like Robert Mapplethorpe and Bruce Weber synthesized a homoerotic sensibility that virtually merged fashion and art—only the context of who commissioned the pictures and where they were intended to be seen distinguishes the two types of their photographs. With historic work, even this line has grown blurred. Lillian Bassman, for instance, was an innovative magazine art editor and fashion photographer following World War II who reemerged in the 1990s as an acclaimed art photographer. Inspired by the discovery of her long-lost commercial negatives, she printed her *Reinterpretations*—as

126

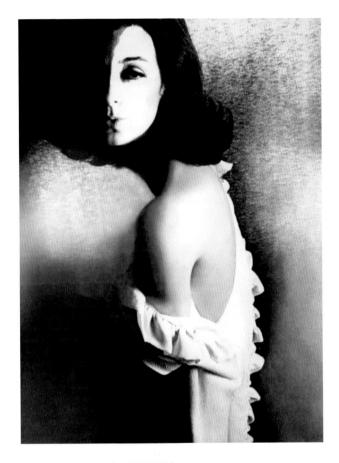

FASHION AESTHETIC Lillian Bassman (1917–2012) Carmen, early 1950s Estate of Lillian Bassman

she aptly called the new works derived from the old—employing the bleaching and toning techniques she had pioneered four decades earlier.

Feminist Art

▶ who Eleanor Antin, Judith Barry, Lynda Benglis, Helen Chadwick, Judy Chicago, Judy Dater, Dyke Action Machine, Mary Beth Edelson, Rose English, Feminist Art Workers, Karen Finley, Harmony Hammond, Lynn Hershman Leeson, Rebecca Horn, Joan Jonas, Mary Kelly, Silvia Kolbowski, Barbara Kruger, Leslie Labowitz, Suzanne Lacy, Sherrie

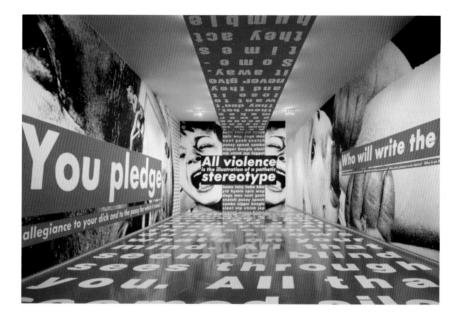

FEMINIST ART Barbara Kruger (b. 1945) Untitled installation at the Mary Boone Gallery, 417 West Broadway, New York, January 1991

Levine, Hung Liu, Ana Mendieta, Meredith Monk, Linda Montano, Anne Noggle, Donna-Lee Phillips, Pussy Riot, Yvonne Rainer, Martha Rosler, Faith Ringgold, Ulrike Rosenbach, **Miriam Schapiro**, Carolee Schneemann, Cindy Sherman, Barbara Smith, Nancy Spero, **May Stevens**, Rosemarie Trockel, Hannah Wilke, Sue Williams, Sylvia Ziranek

- **▶ WHEN** Since the late 1960s
- **▶ WHERE** Primarily Great Britain and the United States
- ▶ WHAT Women artists such as Helen Frankenthaler, Grace Hartigan, and Bridget Riley gained considerable reputations during the 1950s and 1960s. Although they were female, the CONTENT of their work was not, by design, feminist: that is, it neither addressed the historical condition of women nor could it be identified as woman-made on the basis of appearance alone. Until the end of the 1960s most women artists sought to "de-gender" art in order to compete in the male-dominated, mainstream art world.

The counterculture of the 1960s inspired new and progressive social analyses. The mainstream was no longer regarded as ideologically neutral. Feminist analysis suggested that the art "system"—and even art history itself—had institutionalized sexism, just as the patriarchal society-at-large had done. Feminists employed the classic strategy of the disenfranchised, as did racial minorities, lesbians, and gays: they restudied and reinterpreted history. Of special concern to feminist theorists was the historical bias against crafts vis-à-vis high art. This new interest in art forms that had traditionally been relegated to the bottom of the status hierarchy (quilts, Persian rugs, Navajo blankets) eventually led to the emergence of PATTERN AND DECORATION in the mid-1970s.

By 1969 overtly feminist artworks were being made and feminist issues raised. That year saw the creation of both WAR (Women Artists in Revolution), an offshoot of the New York-based Art Workers' Coalition. and the Feminist Art Program, led by Judy Chicago at California State University in Fresno. (It soon recruited Miriam Schapiro as codirector and moved to the California Institute of Arts in Valencia.) Fledgling feminist institutions quickly arose in New York, Los Angeles, San Francisco, and London, including galleries (A.I.R., SoHo 20, the Women's Building, Womanspace); publications (Women and Art, Feminist Art Journal, Heresies); and exhibitions (Womanhouse, Womanpower). Throughout the 1970s the meaning of feminist art and the roles that politics and spirituality play within it (the latter sometimes in the form of the "Great Goddess") were articulated by thoughtful critics such as Lucy Lippard and Moira Roth. By the end of the decade the position of the essentialists-that there was a biologically determined female identity that should be expressed in women's creations—was challenged by feminist artists and writers who regard that identity as culturally determined or "socially constructed."

Feminist artworks have varied greatly. Predominating in the 1970s were autobiographical works in many media and cathartic, ritualized PERFORMANCES—including Mary Beth Edelson's Memorials to the 9,000,000 Women Burned as Witches in the Christian Era and Suzanne Lacy and Leslie Labowitz's In Mourning and in Rage, a series of events featuring black-hooded figures that was designed to attract the attention of the news and disseminate information about violence against women at the time of the Hillside Strangler rape-murders in Los Angeles.

The return in the 1980s to traditional media encouraged feminist artists to create works with a CONCEPTUAL—and critical—bent. The notion of the patriarchal "male gaze" directed at the objectified female OTHER has been explored by artists including Yvonne Rainer, Silvia Kolbowski, and the British artist Victor Burgin. Two examples of feminist art that received widespread attention in the 1980s are Cindy Sherman's photographic investigations of the self in a culture of role-playing and

Barbara Kruger's evocations of cultural domination through the graphic vocabulary of advertising. If such works seem less overtly feminist than their predecessors, it is largely because feminist principles have been so widely accepted—despite the brouhaha frequently surrounding the term itself. In opposition to the purity and exclusivity of MODERNISM, feminism called for an expansive approach to art. The feminist use of NARRATIVE, autobiography, decoration, ritual, CRAFTS-AS-ART, and POPULAR CULTURE helped catalyze the development of POSTMOD-ERNISM, while its pioneering explorations of gender led to what has come to be known as queer theory.

Despite its name—a vernacular put-down of homosexuals—queer theory is only incidentally about gay and lesbian subjects. It instead refers to whatever is "queer"—that is, at odds with the prevailing social norms. Named by the cultural theorist Teresa de Lauretis in 1990, queer theory grows out of the challenges to the belief in the essential—that is, stable and unchanging—nature of gender that were posed by feminist and gay/lesbian studies and brilliantly developed by the philosopher Michel Foucault. Its key proponents—including the scholars Judith Butler and Eve Kosofsky Sedgwick, and the poet Adrienne Rich—regard gender and sexuality as a series of performed actions, rather than a concrete, socially determined identity used to enforce a narrow range of patriarchal, "heteronormative" behaviors.

The performative view of gender has been influential among many artists and critics since the 1990s. Works by performance artists and collectives such as Annie Sprinkle, Dyke Action Machine, and Queer Nation broadcast this outlook. So, too, did the first exhibition of queer art at a major U.S. museum, In a Different Light, organized by Lawrence Rinder and Nayland Blake at the Berkeley Art Museum in 1995. Rather than works by gay and lesbian artists, the show featured work exploring the "resonance of gay and lesbian experience" by artists of different, sometimes unknown sexual orientations.

Figurative

Figurative is a word that is used in two sometimes contradictory ways. Traditionally it has been applied to artworks that are REPRESENTATIONAL rather than completely ABSTRACT. Grounded in nature, such images encompass everything from nudes and portraits to still lifes and landscapes.

According to Webster's dictionary, figurative also means "having to do with figure drawing, painting, etc." This sense of the term is gaining popularity. To many speakers, figurative painting means paintings of the human figure. You are likely to hear it used both ways.

Finish Fetish

- ▶who Peter Alexander, Larry Bell, Billy Al Bengston, Judy Chicago, Joe Goode, Robert Irwin, Craig Kauffman, John McCracken, Kenneth Price, DeWain Valentine
- ▶when Mid-to late 1960s
- **▶WHERE** Los Angeles and environs
- ▶ WHAT Finish Fetish—along with its synonyms Los Angeles "look" and L.A. Slick—refers to two- and three-dimensional abstractions, usually crafted from fiberglass or resins. Glossy and impersonal, with slick finishes suggestive of the machine-made, they have often been compared to automobiles and surfboards, two iconic staples of life in Southern California.

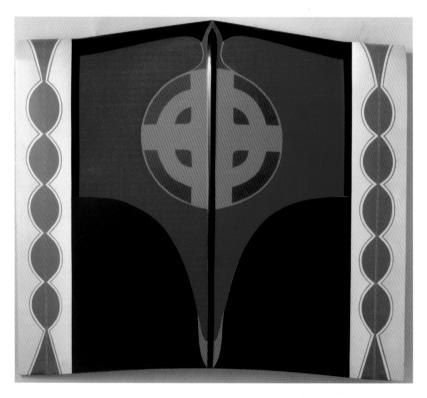

FINISH FETISH
Judy Chicago (b. 1939)
Car Hood, 1964
Sprayed acrylic lacquer on Corvair car hood,
42% × 49¼ × 4¾ in. (109 × 125 × 11 cm)
Moderna Museet, Stockholm

In their simplicity and abstraction, such works are certainly an offshoot of then-contemporary MINIMALISM. But unlike rigorously theoretical Minimalist art, these works are upbeat and accessible. Their often bright colors and manufactured appearance recall POP ART's evocation of commercial products.

The work itself ranges from the simple standing or leaning slabs by John McCracken and Peter Alexander to objects that incorporate light, such as Larry Bell's glass boxes and Robert Irwin's white disks. (Such works paved the way for the LIGHT-AND-SPACE ART of the 1970s.) For some, the Finish Fetish constitutes Southern California's most substantive contribution to the history of postwar art. In the mid-1980s artists such as McCracken were rediscovered by NEO-GEO artists in New York interested in abstraction and the look of everyday domestic objects.

Fluxus

▶ who Joseph Beuys, George Brecht, Robert Filliou, Ken Friedman, Geoff Hendricks, Dick Higgins, Davi Det Hompson, Ray Johnson, Alison Knowles, George Maciunas, Jackson MacLow, Charlotte Moorman, Yoko Ono, Nam June Paik, Daniel Spoerri, Ben Vautier, Wolf Vostell, Robert Watts, La Monte Young

▶WHEN 1960s

- **WHERE** International, having begun in Germany and quickly spread to New York and the northern European capitals. Similar activities were taking place independently in Japan, California, and Latin America.
- **WHAT** The term Fluxus was first used by George Maciunas on an invitation to a 1961 lecture series at the Gallery A/G in New York. Implying flow or change in several languages, Fluxus is more a state of mind than a STYLE.

With Fluxus artists, social goals often assumed primacy over aesthetic ones. The main aim was to upset the bourgeois routines of art and life. Early Fluxus events—guerrilla theater, street spectacles, concerts of electronic music—were aggressive demonstrations of the libidinal energy and anarchy generally associated with the 1960s. Rather than an alliance with POPULAR CULTURE, Fluxus artists sought a new culture, to be fashioned by avant-garde artists, musicians, and poets. Mixed media was the typical Fluxus format. Numerous art forms were simultaneously and cacophonously deployed at events that sometimes resembled contemporaneous ACTIONS OF HAPPENINGS, though they tended to be more humorous and open-ended.

Such events ranged from group readings of Haiku-length poems that prescribed simple activities like taking a stroll or burning a Christmas tree to attention-getting events such as the Charlotte Moorman–Nam

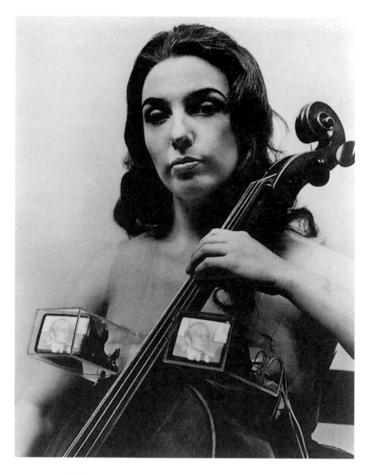

FLUXUS
Nam June Paik (1932–2006)
TV Bra for Living Sculpture, 1969
Television sets and cello
(worn by cellist Charlotte Moorman, 1933–1991)

June Paik collaboration featuring Moorman playing her cello while wearing little more than a brassiere fashioned from miniature television sets.

Fluxus activity was not limited to live events. MAIL ART, for instance, was pioneered by Fluxus artists, especially Ray Johnson. Fluxus artworks can sound eccentric and inconsequential, but their underlying iconoclastic attitudes made them influential precursors of CONCEPTUAL and PERFORMANCE art.

Formalism derives from form. A work's "formal" qualities are those visual elements that give it form—its shape, size, structure, scale, composition, color, etc. Formalism is generally believed to imply an artistic or interpretive emphasis on form, rather than CONTENT, but form and content are, in fact, complementary aspects in any work.

Although philosophical debates about form were initiated in ancient Greece, the concept of formalism is generally associated with MODERN art and especially with the thinking of three influential theorists: the critics Clive Bell, Roger Fry, and Clement Greenberg. At the beginning of the twentieth century the British writers Bell and Fry sought to create a quasi-scientific system based on visual analysis of an artwork's formal qualities rather than its creator's intentions or its social function. Developed in response to the early modern interest in artworks foreign to the Western tradition—especially Japanese prints and African sculpture—their method was intended to permit the cross-cultural evaluation of art from any place or time.

The formalist approach dominated art criticism and modernist thought after World War II. Its best-known exemplar is the American Clement Greenberg, whose influence rose along with that of American art—chiefly ABSTRACT EXPRESSIONISM and later manifestations of NEW YORK SCHOOL painting and sculpture.

A new generation of articulate formalist critics such as Michael Fried and Rosalind Krauss emerged in the 1960s, but so did the limits of the formalist approach. POP ART, in particular, defied meaningful formal analysis. How could Roy Lichtenstein's images taken from comic books be understood without investigating their social and cultural meanings? Pop art proved to be a precursor of POSTMODERNISM, and since the mid-1970s formalist interpretation has been yielding to more expansive critical approaches based in FEMINISM, SEMIOTICS, and DECONSTRUCTION.

Found Object

A found object is an existing object—often a mundane manufactured product—given a new identity as an artwork or part of an artwork. The artist credited with the concept of the found object is Marcel Duchamp. (Georges Braque and Pablo Picasso had already begun to inject bits of non-art material into their pioneering COLLAGES and ASSEMBLAGES of 1912–15, but they significantly altered those materials.) In 1913 Duchamp began to experiment with what he dubbed the *readymade*. After adding a title to an unaltered, mass-produced object—a urinal or a shovel, for example—he would exhibit it, thereby transforming it into

134

a readymade sculpture. His intention was to emphasize art's intellectual basis and, in the process, to shift attention away from the physical act or craft involved in its creation. Other DADA and SURREALIST artists mined the nostalgic potential of found objects in works less cerebral than Duchamp's.

Post–World War II artists put found objects to a variety of different purposes. They range from Edward Kienholz's chilling tableaux assembled from mannequins and discarded furniture to Haim Steinbach's more theoretical ensembles of domestic objects intended to question whether artworks made of mass-produced components can be simultaneously functional, decorative, and expressive. Joseph Beuys's dog-sled sculpture invokes his personal history, and even painters such as Jasper Johns have utilized found objects (in Johns's case, a broom, a chair, ball bearings) by affixing them to their paintings. Whether old or new, a found object infuses an artwork with meanings associated with its past use or intended function.

See NEO-DADA

Funk Art

- **▶WHO** Robert Arneson, Clayton Bailey, Bruce Conner, **Roy De Forest**, Mel Henderson, **Robert Hudson**, Richard Shaw, **William T. Wiley**
- **▶ WHEN** Mid-1960s to mid-1970s
- **▶ WHERE** San Francisco Bay Area
- ▶ WHAT Funk derives from funky, a musical term that was applied to numerous visual artists in Northern California starting in the early 1960s. Peter Selz, then director of the Berkeley Art Museum, officially christened the movement with the 1967 exhibition Funk.

Funk art is offbeat, sensuous, and direct. Humor, vulgarity, and autobiographical narrative are typical elements, although funk art imagery ranges far and wide, from Roy De Forest's paintings of anthropomorphic animals to Robert Hudson's brightly painted sculptural abstractions. Funk artists frequently delighted in the manipulation of unusual materials and FOUND OBJECTS. Their unconventional use of materials not only obscured the division between painting and sculpture but also helped transform clay from a crafts material to a sculptural one.

Funk art was heavily influenced by earlier anti-art movements, especially the playful absurdity of DADA and NEO-DADA. (William T. Wiley's punning work has been aptly dubbed "Dude Ranch Dada.") Reacting against the seriousness of New York— and Los Angeles—centered ABSTRACTION, funk artists have looked to POPULAR CULTURE—especially music—rather than the history of art for inspiration.

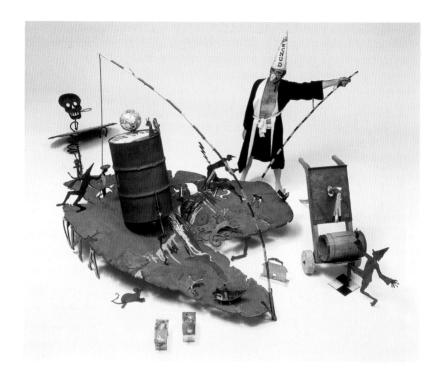

FUNK ART
William T. Wiley (b. 1937)
Nomad Is an Island, 1981
Mixed-media installation,
9 × 18 × 20 ft. (2.7 × 5.5 × 6.1 m)
John and Maxine Belger Family
Foundation, Kansas City, Missouri

In 1969 the Chicago artists Jim Nutt and Gladys Nilsson were guest teachers at the University of California at Davis, an hour's drive north of San Francisco. While working in this bastion of funk art they helped cement the strong bonds between CHICAGO IMAGIST and Bay Area artists.

Gaudy Art. See POLITICAL POP

Gesture/Gesturalism

Gesturalism refers to paintings or drawings that emphasize the artist's expressive brushwork. By calling attention to his or her "handwriting," an artist evokes the subjectivity of painting itself.

The expression of artistic personality through gestural brushwork dates back at least as far as the seventeenth-century paintings of Frans Hals and Diego Velázquez and in modern art to the canvases of Edouard Manet. Gesturalism became a vehicle for Expressionism starting with the work of Vincent van Gogh, and the two have been linked ever since, including in the gestural output of NEO-Expressionist artists.

Graffiti Art

- ▶ who Jean-Michel Basquiat, Crash, Daze, Dondi, Fab 5 Freddy (a.k.a. Freddy Brathwaite), Futura 2000, Keith Haring, Lady Pink, Lee Quinones, Rammellzee, Samo (a.k.a. Basquiat and Al Diaz), Taki 183, Alex Vallauri, Zephyr (a.k.a. Andrew Witten), Zhang Dali (a.k.a. AK-47 and 18k)
- ▶ **WHEN** Mid-1970s to mid-1980s
- **▶WHERE** Primarily New York
- ► WHAT Graffito means "scratch" in Italian, and graffiti (the plural form) are drawings or images scratched into the surfaces of walls. Illicit graffiti (of the "Kilroy was here" variety) dates back to ancient Egypt. Graffiti slipped into the studio as a subject after World War II. Artists such as Cy Twombly and Jackson Pollock were interested in the way it looked, the Frenchman Jean Dubuffet was interested in what it meant as a kind of OUTSIDER ART, and the Catalan Antoni Tàpies was interested in the ways it could be incorporated into his imagery of urban walls.

During the early 1970s—soon after aerosol spray paint in cans became readily available—New York subway trains were subjected to an onslaught of exuberantly colored graffiti. The words and "tags" (graffiti writers' names) were soon augmented with elaborate cartoon-inspired images. Most graffitists were neither professional artists nor art students but streetwise teenagers from the Bronx and Brooklyn.

Several milestones marked graffiti's move from the street to the gallery: the United Graffiti Artists' 1975 exhibition at New York's Artists Space; Fab 5 Freddy's widely discussed spray-painted homage to Andy Warhol's Campbell's soup cans in 1980; the Times Square Show, also in 1980, which galvanized the attention of the New York art world; the ongoing support in the form of exhibition opportunities and career counseling provided by Fashion Moda, an Alternative space in the Bronx; and, ultimately, the development of a graffiti style by professionally trained artists such as Keith Haring.

The popularization of graffiti raised questions of unusual aesthetic and sociological import. Was graffiti vandalism? Or urban folk art? The writer Norman Mailer romanticized it as the anarchic manifestation

GRAFFITI ART
Zhang Dali (b. 1963)
Demolition: Forbidden City, 1998
Color coupler print, 37¾ × 58¾ in.
(95.9 × 149.2 cm)
Eli Klein Fine Art, New York
(The artist's tag, AK47, is partially visible at left.)

of social freedom, while such critics as Suzi Gablik charged that ghetto youths were being exploited by a novelty-crazed art market.

The year 1983 saw the zenith of graffiti art, with its first major museum exhibition at the Museum Boijmans Van Beuningen in Rotterdam and the *Post-Graffiti* show at Sidney Janis's blue-chip gallery in New York. By mid-decade it already seemed outmoded. Underground "tags" and images designed to be rapidly spray-painted or seen only in motion did not often survive the transition to the more conventional two- and three-dimensional formats exhibited in galleries.

The most notable exceptions were the works of Jean-Michel Basquiat and Keith Haring. Their considerable talents brought them critical and commercial success equal to that of any young artist of the day, led to collaborations with Andy Warhol, and (inadvertently) drew a clear distinction between their imaginatively realized visions and the narrower skill of tagging a subway car.

One of Haring's greatest successes as an ambassador for the expressive possibilities of graffiti was posthumous. The young Chinese artist Zhang Dali, who spent several years in Italy beginning in 1989, came to idolize Haring and his work. In 1993 Zhang returned to Beijing and became the sole graffitist in that city, where public order was more rigorously policed than in New York. (By tagging only the walls of homes marked for demolition—or already demolished—he garnered the sympathy of police.) In addition to his tags, 18k and AK47, he created huge, cartoonish silhouettes of his head in pairs: one a "negative" image cut out of the wall and providing a view of the rubble of the traditional courtyard home beyond; and the second a "positive" image spray-painted on the wall and focusing attention on it as a container of domestic life sealed off from public intrusion. His photographs of his activities as a graffitist are poignant: they both document modern ruins and evoke the traditional home and lifestyle that flourished within them. Zhang, who began to spray-paint his silhouettes while still in Italy, is perhaps the only figure outside the original circle of New York graffiti artists who ought to be considered at least an honorary part of it.

Rather than romanticizing the New York origins of graffiti art, it is useful to consider other defining events that made it so short-lived a movement, including the death of African-American graffitist Michael Stewart in 1983. Caught tagging by New York police in a downtown subway station, he was savagely beaten and then transported to a nearby hospital in a coma, dying soon after. Both Basquiat and Haring were dead by 1990—the former, in his mid-twenties, from a heroin overdose and the latter, in his early thirties, from HIV-related causes.

See EAST VILLAGE

Gutai

- who Norio Imai, Akira Kanayama, Takesada Matsutani, Sadamasa Motonaga, Shuji Mukai, Saburo Murakami, Shozo Shimamoto, Kazuo Shiraga, Yasuo Sumi, Atsuko Tanaka, Tsuruko Yamazaki, Minoru Yoshida, Jiro Yoshihara, Michio Yoshihara
- **▶WHEN** 1954 to 1972
- **▶where** Japan
- ▶ WHAT Gutai means "concreteness" and was the name chosen by the painter Jiro Yoshihara for the group of artists he founded in Ashiya (near Osaka) in western Japan. Comprising twenty artists at the time of its founding in July 1954, the Gutai Art Association spanned two generations and numbered fifty-nine artists over its eighteen-year existence. Yoshihara exhorted young artists to reject tradition and seek new and direct—that is, concrete—encounters with the materials of art, regarded

as metaphors of forceful encounters with life itself. In the wake of postwar devastation, Yoshihara's call to action was an antidote to EXISTENTIAL despair. He concluded the *Gutai Art Manifesto* (1956) by stating that "our work is the result of investigating the possibilities of calling the material to life" and "we hope...that the discovery of new life will call forth a tremendous scream in the material itself."

This was not merely hyperbole. The Gutai exhibitions that had already taken place outdoors in festival-like public programs between 1954 and 1956 included performances unlike any ever presented: Saburo Murakami hurled himself through layers of paper, and Kazuo Shiraga wallowed in mud. Other artists used bare feet or thrown bottles to produce paintings, which—like those of Jackson Pollock, who was a key influence—were records of encounters between the artist and his materials rather than depicted images. Gutai artists continued to work in two-dimensional formats with unusual materials including vinyl, plastic, and resin, but they also experimented with three-dimensional works, such as Atsuko Tanaka's eye-popping wearable art fabricated from illuminated lightbulbs.

The Gutai group received little support from Japanese critics, who dismissed them as clowns, ignoring their work and its influence on later artists such as the Mono-ha group. The Gutai artists documented their activities and cultivated connections with Western avant-gardists through an active publication program of ten magazine-like annuals published between 1955 and 1965; these were valued by artists like Allan Kaprow, whose slightly later happenings reflect creative impulses similar to those of Gutai actions. But these interactions, too, have been downplayed by historians and are only beginning to emerge through recent research and major exhibitions organized in New York, San Francisco, and Tokyo since 2010.

A new view that is gaining support depicts the Gutai group's important role in an international network of artists and associations that variously contributed to the emergence of Happenings, FLUXUS, ARTE POVERA, and other CONCEPTUALIST forms. But whether the Gutai group produced the first happening, before Allan Kaprow presented his own very different Happenings, is less important than understanding the model of creation that drove art-making after World War II. Did it depend on an international network—akin to that which existed during the early twentieth century? Or a single center from which all ideas emanated? The latter model—the cold war-inspired narrative that positions New York as the triumphant successor to Paris at the center of art, as a corollary to American dominance in other realms—seems increasingly problematic.

The Gutai group is often divided into two, not strictly chronological phases. The second is marked by the construction in 1962 of the

Gutai Pinacotheca, an art center, which enabled experimentation in art and technology at a time when similar research was taking place in Düsseldorf, Amsterdam, and the United States. Many historians regard the new technologically oriented art that resulted as less compelling and accessible than Gutai work of the 1950s. The group disbanded following the death of Jiro Yoshihara in 1972.

Hairy Who. See CHICAGO IMAGISM

Happening

- ▶who Jim Dine, Red Grooms, Al Hansen, **Allan Kaprow**, Claes Oldenburg, Carolee Schneemann, Robert Whitman
- **▶WHERE** Primarily New York
- ▶ when Early to mid-1960s
- **WHAT** The name *Happening* comes from Allan Kaprow's first show at New York's Reuben Gallery in 1959, called 18 *Happenings in 6 Parts*. Within three rooms a carefully rehearsed multimedia event unfolded. Performers coolly read fragmented texts (a sample: "I was about to speak yesterday on a subject most dear to you all—art...but I was unable to begin"); assumed mimelike poses; painted on canvas; played the violin, flute, and ukulele. Meanwhile, the audience moved from room to room on cue, "becom[ing] part of the happenings" as the invitation had promised. It also became the audience's task to decipher the disconnected events. Kaprow offered little help, having cautioned those attending that "the action will mean nothing clearly formulable so far as the artist is concerned."

Kaprow defined a Happening as an "assemblage of events performed or perceived in more than one time and place"—that is, as an environmental artwork activated by performers and viewers. The artists who made Happenings never issued a group manifesto defining their art form, and that may help account for its variety. Red Grooms's Burning Building (1962) was a vaudeville-style evocation of a fire that had performers tumbling out of the set's windows. Claes Oldenburg's eerie Autobodys (1963), staged at a Los Angeles drive-in movie theater, was populated primarily by figures on roller skates and black-and-white cars inspired by the limousines prominent in the television coverage of President Kennedy's then-recent funeral.

Some have cited the Happening-like spectacles created by the Japanese GUTAI group as precedents for Happenings, but neither the Gutai artists nor their work was known in New York until the early 1960s. Precursors closer to home were the various DADA events, with their chance-derived arrangements or compositions. The composer John Cage spread the

word about them, first at Black Mountain College in North Carolina and later at the New School for Social Research in New York, where most of the Happening artists attended his classes during the mid-1950s. The mixing of media and the concern for everyday life in Happenings relates them to INTERMEDIA and POP ART.

See ACTION/ACTIONISM, FLUXUS, PERFORMANCE ART

Hard-Edge Painting

- ▶who Karl Benjamin, Lorser Feitelson, Frederick Hammersley, Al Held, Ellsworth Kelly, John McLaughlin, Kenneth Noland, Jack Youngerman
- ▶ WHEN Late 1950s through 1960s

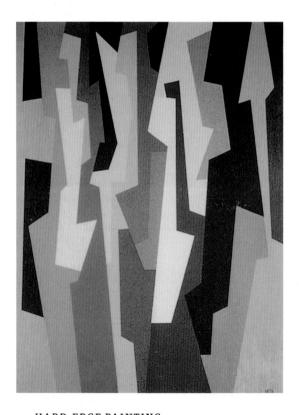

HARD-EDGE PAINTING Karl Benjamin (1925–2012) I. F. Green, Ochre, Umber, 1958 Oil on canvas, 40 × 30 in. (101.6 × 76.2 cm) Modernism Gallery, San Francisco

▶WHERE United States

▶ WHAT The term hard-edge painting was first used in 1958 by the Los Angeles critic Jules Langsner to describe the ABSTRACT canvases of West Coast painters uninterested in the brushy GESTURALISM OF ABSTRACT EXPRESSIONISM. The following year the critic Lawrence Alloway applied the term to American paintings with surfaces treated as a single flat unit. The distinction between figure and background was eliminated in favor of the allover approach pioneered by Jackson Pollock a decade earlier. Unlike Pollock's free-form compositions, hard-edge paintings are typically geometric and limited in palette. Other precursors from the 1950s include Ad Reinhardt, Leon Polk Smith, and Alexander Liberman.

Hard-edge paintings vary from Kenneth Noland's chevron-patterned compositions to Ellsworth Kelly's oddly shaped monochrome paintings on canvas or metal. The machine-made look of such works pointed ahead to the three-dimensional "primary structures" of MINIMALISM. Although the precision and impersonality of hard-edge painting distinguish it from the spontaneous-looking compositions of COLOR-FIELD PAINTING, the two styles overlapped, and artists such as Noland worked in both modes.

T

Heftige Malerei. See MÜLHEIMER FREIHEIT

High Art. See POPULAR CULTURE

Hyper-Realism. See PHOTO-REALISM

Idea Art. See CONCEPTUAL ART

Identity Politics. See MULTICULTURALISM

Inhibodress Group. See CONCEPTUAL ART

Installation

▶ WHO Matthew Barney, Lothar Baumgarten, Joseph Beuys, Nayland Blake, Barbara Bloom, Christian Boltanski, Jonathan Borofsky, Marcel Broodthaers, Tony Brown, Chris Burden, Daniel Buren, Sophie Calle, Walter De Maria, Olaffur Eliasson, Elmgreen & Dragset, Terry Fox, Howard Fried, General Idea, Frank Gillette, Dan Graham, Brent Green, Group Material, Ingo Günther, Hans Haacke, David Hammons, Helen Mayer Harrison and Newton Harrison, Mona Hatoum, Patrick Ireland, IRWIN, Robert Irwin, Ilya Kabakov, Tadashi Kawamata,

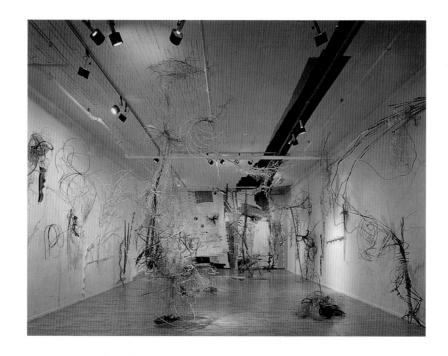

INSTALLATION Judy Pfaff (b. 1946) Deep Water, 1980 Mixed-media installation Holly Solomon Gallery, New York

Joseph Kosuth, Yayoi Kusama, Wolfgang Laib, Sol LeWitt, Glenn Ligon, Donald Lipski, Rafael Lozano-Hemmer, James Luna, Tom Marioni, Paul McCarthy, Barry McGee, Mario Merz, Annette Messager, Antonio Muntadas, **Bruce Nauman**, Miquel Navarro, Cady Noland, Maria Nordman, Lorraine O'Grady, Hélio Oiticica, Pepón Osorio, Nam June Paik, **Judy Pfaff**, Adrian Piper, **Michelangelo Pistoletto**, Navin Rawanchaikul, Julia Scher, Yinka Shonibare, Lorna Simpson, Sandy Skoglund, Alexis Smith, Kiki Smith, Nancy Spero, Sarah Sze, Danny Tisdale, Francesc Torres, James Turrell, Bill Viola, Carrie Mae Weems, Fred Wilson

▶ WHEN Since the 1970s

- ▶ WHERE United States, primarily, and Europe
- ▶ WHAT The everyday meaning of *installation* refers to the hanging of pictures or the arrangement of objects in an exhibition. The less generic, more recent meaning of *installation* is a site-specific artwork. In this sense, the installation is created especially for a particular gallery space

or outdoor site, and it comprises not just a group of discrete art objects to be viewed as individual works but an entire ensemble or environment. Installations provide viewers with the experience of being surrounded by art, as in a mural-decorated public space or an art-enriched cathedral.

Recent precedents for installations date mainly from the POP ART era of the late 1950s and 1960s. The most notable are Allan Kaprow's "sets" for HAPPENINGS, Edward Kienholz's tableaux, Red Grooms's theatrical environments such as *Ruckus Manhattan*, Claes Oldenburg's *Store* filled with his plaster renditions of consumer objects, and Andy Warhol's enormous prints in the form of wallpaper.

Unlike many of the works mentioned above, most installations are unsalable. Some examples: Judy Pfaff creates dramatic environments comprising thousands of throwaway elements that evoke undersea gardens or dreamlike fantasy worlds. Daniel Buren installs patterns of stripes that comment by their placement on the physical or social character of the site. Donald Lipski brings together hundreds of manufactured objects to create witty, three-dimensional variants of allover painting.

Installations generally are exhibited for a relatively brief period and then dismantled, leaving only DOCUMENTATION. Their unsalability and their labor-intensiveness proved an unsatisfying combination in the increasingly market-attuned art world of the early 1980s. The "crash" of the art market at the end of the 1980s and a reawakening of interest in CONCEPTUALISM, led, in the early 1990s, to a proliferation of installations. The burgeoning number of art fairs and BIENNIAL exhibitions in that decade also helped establish the installation as the lingua franca of contemporary art. As this trend lacks roots in Asia or Africa, it is unclear whether it represents—in addition to globalism—a new form of colonialism.

See LIGHT-AND-SPACE ART, PATTERN AND DECORATION, PUBLIC ART

Intermedia

The FLUXUS artist and publisher Dick Higgins coined the term *intermedia* in an article of the same name published in 1966. By it, he referred to those hybrid genres *between* conventional art forms such as visual art and music, or visual art and theater. He accurately predicted that they would prove fruitful sites for innovation and would eventually acquire their own names—SOUND ART and PERFORMANCE ART, in these instances. His manifesto-like declaration was a full-throated attack on modernist FORMALISM, with its emphasis on *purity* and the necessity of ensuring the separate identity of individual art forms. (Among the best-known applications of this idea was the art historian Michael Fried's controversial attack on MINIMALISM for its "theatricality" in 1967.)

One of Higgins's inspirations was the early-twentieth-century artist Marcel Duchamp, who was rediscovered in the United States during the 1960s. Higgins believed that Duchamp's greatness derived from the expansiveness of his vision and his constructive demolition of outmoded categories. Although New York was indisputably the center of world art at this time, many of its most inventive artists, such as Vito Acconci, Richard Foreman, Carolee Schneemann, Robert Wilson, and the Wooster Group, did not fit into the mainstream of MODERNIST style but, rather, embodied Higgins's idea of intermedia.

The descriptive value of the term *intermedia* was immediately recognized by Higgins's Fluxus associates (underlining the importance of identifying and naming a phenomenon). Hans Breder founded the first—and still best-known—intermedia M.F.A. program in the United States at the University of Iowa, which was followed by Fluxus scholar Owen Smith's graduate program at the University of Maine, and eventually by a half dozen others in the U.S., Canada, and the United Kingdom. Robust disciplines, including expanded cinema, concrete poetry, and visual poetry—all of which are beyond the scope of this book—have been nourished in intermedia environments. Ironically, as intermedia has become the term of choice for the multidisciplinary, the call for a vaguely defined, more synthetic approach known as *transmedia* can be heard across academia today.

Junk Sculpture

- **▶wно** Arman, Lee Bontecou, **César**, **John Chamberlain**, Eduardo Paolozzi, Robert Rauschenberg, Richard Stankiewicz, Jean Tinguely
- ▶ **WHEN** Primarily the 1950s
- **▶WHERE** Europe and the United States
- ▶ WHAT Junk sculptures are ASSEMBLAGES fashioned from industrial debris. Their roots can be traced to the Cubist COLLAGES and constructions by Pablo Picasso and Georges Braque. The real originator of junk sculpture, however, is the German DADA artist Kurt Schwitters, who began to create assemblages and collages from trash gathered in the streets after World War I.

By World War II the Western nations—especially the United States—had inadvertently pioneered the production of industrial refuse on a grand scale. Dumps and automobile graveyards became a favorite haunt of artists who gathered auto parts and other manufactured cast-offs. They welded them into art or sometimes presented them as FOUND OBJECTS relocated from the trash heap to the gallery.

The range of effects created with these materials is striking. César had entire cars compressed into squat and strangely beautiful columns that

clearly reveal their origins as vehicular junk. Lee Bontecou combines steel machine parts with fabric to produce ABSTRACT reliefs that typically suggest a face-vagina with horrific zipper-teeth. The use of discarded materials in such works eloquently comments on the "throwaway" mentality of postwar consumerism. It also implies that welded iron and steel are more appropriate sculptural materials for the machine age than carved marble or cast bronze.

Kinetic Sculpture

- ▶who Yaacov Agam, Pol Bury, David Medalla, George Rickey, Nicolas Schöffer, Jesús Rafael Soto, Jean Tinguely
- ▶ WHEN Late 1950s through 1960s
- ▶ WHERE International, but primarily of interest to Europeans
- ▶ WHAT Kinetic sculpture is sculpture that contains moving parts, powered by hand or air or motor. It began when the DADA artist Marcel Duchamp mounted a spinnable bicycle wheel on a stool in 1913. In the 1920s the Eastern European artists Naum Gabo and László Moholy-Nagy started to experiment with kinetic sculpture that resembled machines. Shortly thereafter the American Alexander Calder invented the mobile, a delicately balanced wire armature from which sculptural elements are suspended.

К

Kinetic sculptures are not limited to any one STYLE, but they do share a germinal source of inspiration: the twentieth-century infatuation with technology. The term encompasses a wide variety of approaches. The metal rods of George Rickey's constructions sway in the wind, responsive to the natural elements. Jean Tinguely's kinetic JUNK SCULPTURE Homage to New York (1960) destroyed itself in the Museum of Modern Art's garden and demonstrated a darkly satirical view of the industrial era.

The use of modern machinery in kinetic sculpture made it a precursor of—and inspiration for—artists' experiments with more advanced hardware such as lasers and computers. Although these high-tech works are technically kinetic sculptures, they are more often considered in conjunction with the movement known as ART AND TECHNOLOGY.

Artists creating kinetic sculpture today include Mark Pauline, founder of the Survival Research Laboratory. This San Francisco-based group orchestrates cacophonous spectacles in which horrific, essentially low-tech machines do battle with one another, evoking the militarization of technology and the gritty realities of life in the urban jungle.

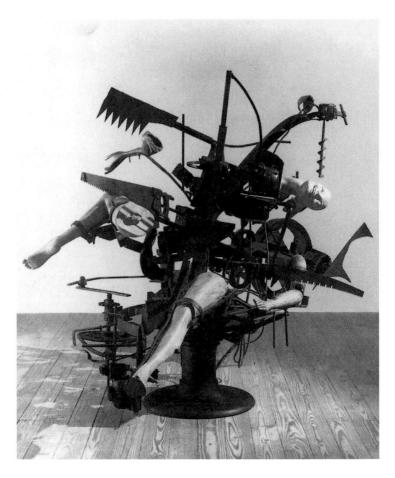

KINETIC SCULPTURE
Jean Tinguely (1925–1991)
Dissecting Machine, 1965
Motorized assemblage; painted cast iron and welded-steel machine parts with mannequin parts, 72% × 74 × 83% in.
(185 × 188 × 212.9 cm)
Menil Collection, Houston

Kitsch

Kitsch refers to the low-art artifacts of everyday life. It encompasses lamps in the shape of the Eiffel Tower, paintings of Elvis Presley on velvet, and lurid illustrations on the covers of romance novels. The term comes from the German verb *verkitschen* (to make cheap). Kitsch is a byproduct of the industrial age's astonishing capacity for mass production and its creation of disposable income.

The critic Clement Greenberg characterized kitsch as "rear-guard" art—in opposition to avant-garde art. Kitsch, he observed (in "Avant-Garde and Kitsch," published in Partisan Review in fall 1939), "operates by formulas...it is vicarious experience and faked sensation. It changes according to style, but remains always the same. Kitsch is the epitome of all that is spurious in the life of our time." He defined kitsch broadly to include jazz, advertising, Hollywood movies, commercial illustration—all of which are generally regarded now as POPULAR CULTURE rather than kitsch. Although Greenberg's definition of kitsch is overly expansive, his analysis of how it operates remains apt. Today kitsch is most often used to denigrate objects considered to be in bad taste.

Attitudes toward kitsch became more complicated with the advent of POP ART in the early 1960s. What had been dismissed as vulgar was now championed by individuals who were fully aware of the reviled status of the "low-art" objects of their affections. This ironic attitude toward kitsch came to be known as "camp," following the publication of the essay "Notes on 'Camp'" by the cultural commentator Susan Sontag in *Partisan Review* in fall 1964.

K

Obscuring the distinctions between low and high art was key to the repudiation of MODERNISM and the emergence of POSTMODERNISM. Beginning in the late 1970s kitsch became a favorite subject for such artists as Kenny Scharf, who has depicted characters from Saturdaymorning cartoons, and Julie Wachtel, who has APPROPRIATED figures from goofy greeting cards.

See SIMULATION

Light-and-Space Art

- ▶ who Michael Asher, Robert Irwin, Bruce Nauman, Maria Nordman, Eric Orr, Hap Tivey, James Turrell, DeWain Valentine, Susan Kaiser Vogel, Doug Wheeler
- ▶ WHEN Late 1960s through 1970s
- **▶WHERE** Southern California
- ▶ WHAT The use of radically new art-making materials and the dematerialization of the art object characterize light-and-space art. It can be considered a descendant of the earlier FINISH FETISH, whose practitioners experimented with unusual materials such as cast resin and fiberglass.

As immaterial as CONCEPTUAL ART, light-and-space art focuses less on ideas than on sensory perceptions. Robert Irwin has created numerous

LIGHT-AND-SPACE ART Robert Irwin (b. 1928) Room with Twin Skylights, Facing Wall Removed, 1980 Malinda Wyatt Gallery, Venice, CA

M

INSTALLATIONS in which constantly changing natural light—often filtered through transparent scrims—is used to redefine a space. For viewers, his mysterious light-shot environments intensify sensory awareness and heighten the experience of nature itself in the form of light.

Works of light-and-space art have frequently—and aptly—inspired either scientific or metaphysical interpretations. Irwin and James Turrell, for instance, investigated the phenomenon of sensory deprivation (which influenced the development of their similarly spare light-works) as part of the ART-AND-TECHNOLOGY program initiated by the Los Angeles County Museum of Art in 1967. For his series of works on the theme of alchemy. Eric Orr used natural light as well as blood and fire.

Los Angeles "Look." See FINISH FETISH

Low Art. See POPULAR CULTURE

Lyrical Abstraction. See COLOR-FIELD PAINTING

Mail Art

- ▶ WHO Eleanor Antin, Anna Banana, Ulises Carrión, Guglielmo Achille Cavellini, Lowell Darling, Jerry Dreva, Robert Filliou, Hervé Fischer, General Idea, Brion Gysin, **Dick Higgins**, Davi Det Hompson, **Ray Johnson**, On Kawara, George Maciunas, Tom Marioni, Raul Marroquin, Yoko Ono, Liliana Porter, Angelika Schmidt, Vincent Trasov, Wolf Vostell
- ▶WHEN 1960s through 1970s
- **▶WHERE** International
- ▶ WHAT Mail art—along with the synonymous terms postal art and correspondence art—refers to small-scale works that utilize the mail as a distribution system. These terms have also come to refer to related formats, including artist-designed "postage stamps," postcards, and even impressions from rubber stamps. (Rubber-stamp impressions have been utilized in art since World War I, initially by the DADA artist Kurt Schwitters, but only as one of many decorative, COLLAGE-like elements.) The first self-conscious network of mail artists was begun in 1962 by Ray Johnson, who dubbed the endeavor the New York Correspondance School. Its collective output was featured in a show at the Whitney Museum of American Art in 1970.

Although mail art is one of the most populist art forms in history, it has seldom been given a place in museums. Instead of creating objects and finding a place to exhibit them, mail artists need only postage and some means, often COPY ART-based, to make their letters or postcards.

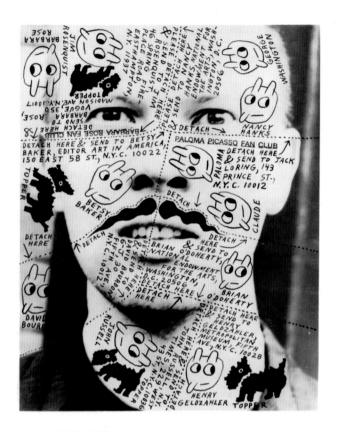

MAIL ART
Ray Johnson (1927–1995)
Untitled, n.d.
Mixed-media collage, 8½ × 11 in.
(21.6 × 27.9 cm)
Richard L. Feigen & Co., New York

Mail-art exhibitions (often unjuried) featured eclectic themes, ranging from opposition to the Vietnam War to homages to comic-strip heroes. The egalitarian aims of mail art, in fact, dovetailed closely with those of fluxus, which provided a cadre of artist-correspondents. Unusual mail-art works have been produced by conceptual or Fluxus artists such as On Kawara, who for years sent rubber-stamped postcards proclaiming the location and time he got up each morning, and Tom Marioni, who sent engraved announcements of his (fictitious) appointment as director of the San Francisco Museum of Art in 1973.

Manipulated Photography

- ▶ WHO Ellen Carey, Walter Dahn, Joan Fontcuberta, Benno Friedman, Jack Fulton, Paolo Gioli, Judith Golden, Susan Hiller, Astrid Klein, Jerry McMillan, Arnulf Rainer, Lucas Samaras, Deborah Turbeville, Lynton Wells, Joel-Peter Witkin
- ▶WHEN Mid-1970s through 1990s
- **▶WHERE** Europe and the United States
- ▶ WHAT A manipulated photograph has been altered, embellished, or assaulted. A variety of GESTURAL "manipulating" techniques have been utilized by artists and photographers starting in the 1970s. Arnulf Rainer drew on his prints, producing EXPRESSIONISTIC self-portraits. Lucas Samaras treated the still-wet emulsions of his Polaroid prints like finger paints, creating a tumult of pattern. Joel-Peter Witkin scribbled on his negatives, yielding disturbingly surreal compositions.

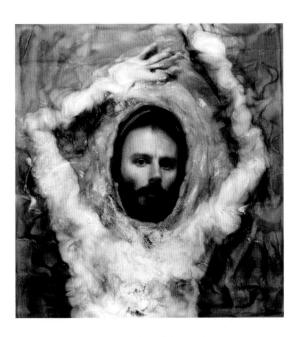

MANIPULATED PHOTOGRAPHY Lucas Samaras (b. 1936) Photo-Transformation, 1976 Polaroid SX-70 photograph, 3 × 3 in. (7.6 × 7.6 cm) Pace/MacGill Gallery, New York

At the end of the nineteenth century, some photographers marked or hand-colored their photographs in order to emulate more prestigious print media such as etching. The techniques employed by late-twentieth-century manipulators were inspired not by history but by the urge to make expressive pictures that resembled paintings only incidentally, or to undermine STRAIGHT PHOTOGRAPHY's concern for the medium's documentary capabilities. The desire to make such work, however, seems nearly to have disappeared with the widespread availability of software expressly created for the manipulation of photographs, such as Photoshop. The ubiquity of digitally manipulated images has made the adjective Photoshopped a slangy put-down in art school critiques.

Media Art

- ▶ WHO Ant Farm, Joseph Beuys, Border Art Workshop, Chris Burden, Lowell Darling, Gran Fury, Group Material, Guerrilla Girls, Jenny Holzer, Christian Jankowski, Komar and Melamid, Leslie Labowitz and Suzanne Lacy, Les Levine, Mike Mandel and Larry Sultan, Antonio Muntadas, Raqs Media Collective, Marshall Reese, Martha Rosler, Krzysztof Wodiczko, Yes Men
- **▶WHEN** Since the 1970s
- **▶WHERE** Primarily the United States
- ▶ WHAT Les Levine coined the term media art in 1970. Media, in this case, refers not to the physical constituents of art, such as acrylic paint or bronze, but to the mass media. Art of this type assumes the form of such far-flung means of communication as newspapers, television, advertising posters, and billboards. Former advertising illustrator Andy Warhol made mass media his subject, using tabloid photographs as the sources for his silkscreened images of movie stars and disasters. Unlike Warhol, most media artists have been highly critical of the mass media and their methods of manipulating public opinion.

Some have attempted to reveal the ideological biases of the mass media. Chris Burden, in the widely broadcast satirical videotape *Chris Burden Promo* (1976), targeted the media's cult of personality by putting his name at the end of a list of revered artists that begins with Michelangelo. Others, such as the Guerrilla Girls and Gran Fury, have functioned as muckraking journalists by providing the public with little-known information about sexism and the AIDS crisis in the form of posters that they paste on New York walls. In a similar vein, the Yes Men, an anonymous collective of "culture jamming" media artists, have created counterfeit Web sites and impersonated corporate titans in order to disseminate little-known information about these companies' activities or to make hoax announcements, proclaiming, for example, that Dow Chemical would compensate the victims of the 1984 Bhopal Disaster.

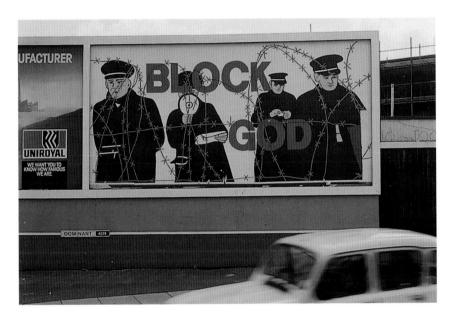

MEDIA ART Les Levine (b. 1935) Block God, 1985 Printed outdoor billboard, 10 × 22 ft. (3.1 × 6.7 m) Mott Art U.S.A., Inc.

(In the digital realm, such interventions have come to be known as *tactical media*.) During the early 1980s Les Levine purchased billboard space in Great Britain to reactivate dialogue about Northern Ireland's civil war through such oblique messages as "Block God." Such unconventional approaches were a challenge to the notion that only the rich and powerful have access to the media or—as A.J. Liebling, the *New Yorker* magazine writer, put it—"Freedom of the press is guaranteed only to those who own one."

Mediation. See VIDEO ART

Minimalism

▶ who Carl Andre, Rasheed Araeen, Ronald Bladen, Dan Flavin, Mathias Goeritz, Donald Judd, Sol LeWitt, Robert Mangold, Brice Marden, Agnes Martin, John McCracken, Robert Morris, Dorothea Rockburne, Robert Ryman, Nobuo Sekine, Richard Serra, Tony Smith, Frank Stella, Kishio Suga, Katsuo Yoshida

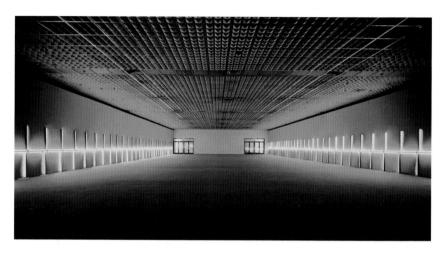

MINIMALISM
Dan Flavin (1933–1996)
Untitled (to Saskia, Sixtina, and Thordis), 1973
Pink, yellow, green, and blue fluorescent
light, 8 ft. (244 cm) high, width variable
CL no. 334

▶WHEN 1960s to mid-1970s

▶WHERE Primarily the United States

▶ WHAT The term Minimalism emerged in the writings of the critic Barbara Rose during the mid-1960s. "ABC Art," the title of an influential article she wrote for the October 1965 issue of Art in America, did not catch on as a name for the movement, but in that article she referred to art pared down to the "minimum," and by the late 1960s Minimalism was commonly being used. It aptly implies the movement's MODERNIST goal of reducing painting and sculpture to essentials, in this case the bare-bones essentials of geometric abstraction. Primarily descended from early-twentieth-century CONSTRUCTIVISM, Minimalism was heavily influenced by the clarity and severity of works by the postwar artists Barnett Newman, Ad Reinhardt, and David Smith. Minimalism is the first art movement of international significance pioneered exclusively by American-born artists.

Minimalist painting eliminated REPRESENTATIONAL imagery and illusionistic pictorial space in favor of a single unified image, often composed of smaller parts arranged according to a grid. Despite this tendency toward mathematically regular compositions, Minimalist painting varies widely—from the evocation of the sublime in the nearly

M

monochrome canvases by Agnes Martin or Robert Ryman to the spare and rigorous essays in geometry by Robert Mangold or Brice Marden.

Minimalism was more frequently associated with sculpture than painting. Minimalist sculpture also eliminated representational imagery, pedestals (human scale predominated), and sometimes even the artist's touch. Typically produced by industrial fabricators, such elemental geometric forms came to be known as *primary structures*, after an influential show of the same name organized by Kynaston McShine at New York's Jewish Museum in 1966.

Committed to the ideal of creating new forms rather than recycling old ones, Minimalist sculptors hoped to transcend the production of mere art objects by producing three-dimensional works that straddled the boundary between art and the everyday world. Robert Morris's boxlike cubes and Donald Judd's shelflike slabs resembled the similarly geometric forms of then-contemporary International Style architecture and late-modern interior design. Despite the artists' interest in infiltrating the urban environment, the public generally found their works inaccessible. Ironically, Minimalism became the sculptural STYLE of choice for corporate collections during the 1970s, at the same time that the sleek glass boxes of International Style architecture came to symbolize corporate power.

Minimalism dominated the art of the late 1960s just as ABSTRACT EXPRESSIONISM had dominated the art of the 1950s—and as no single style would do in the 1970s. International variants arose in Mexico and in Japan, where an important school of Minimalist sculpture, called MONO-HA, was centered in Tokyo between 1968 and 1972.

The term Post-Minimalism was coined by the critic Robert Pincus-Witten and appeared first in "Eva Hesse: Post-Minimalism into Sublime," in the November 1971 issue of Artforum. Pincus-Witten used it to distinguish the more embellished and pictorial approach of Richard Serra's cast-lead works and Eva Hesse's pliable hangings from the stripped-down, prefabricated look of pre-1969 Minimalist works by Judd and Morris. The late 1980s saw the return of the sleek, machined look of Minimalism in the work of young sculptors who rejected the high-pitched emotionalism of NEO-EXPRESSIONISM.

See NEO-GEO

- ▶ **WHEN** A decade starting in the mid-1990s
- **▶WHERE** San Francisco
- ▶ WHAT The term Mission School was coined by art critic Glen Helfand and first appeared in print in the San Francisco Bay Guardian in 2002. It refers to the Mission District, a historic neighborhood named after the Mission Dolores, constructed in 1776 in what was then Spanish territory (prior to its subsequent ownership by Mexico and the United States) and memorably seen in Alfred Hitchcock's film Vertigo (1958). A recently gentrified but traditionally working-class area, the Mission retains some of the flavor of its once-sizable Hispanic population and the hipster influx that began at the end of 1970s. The former is visible in nearly a halfcentury of Latino mural production (officially sanctioned) and the latter in remnants of (illegal) STREET ART. The term street art refers here to both unsanctioned or "outlaw" PUBLIC ART—much of it reflecting a local tradition of cartoons, zines, and posters dating back to the psychedelia of the 1960s—and GRAFFITI, the spray-painted tags or names staking out gang (or individual) turf that were largely eradicated as property values rose. Influenced by both these traditions, the work of the Mission School artists would range from spray-painted tags to discreetly stenciled images with captions. The astonishing success of graffiti art in New York a decade earlier would also provide inspiration.

The members of the Mission School were mostly graduates of the San Francisco Art Institute, a longtime incubator of countercultural approaches and attitudes. These artists did not, however, make up a formal group; they neither issued a manifesto nor pursued collective goals, with one exception: Around 1990 several of them collaborated on indoor installations in municipal venues including the Yerba Center for the Arts and the South of Market Cultural Center. These were their most engaging productions, taking the form of vivid three-dimensional "murals" composed of FOUND OBJECTS and overlapping drawings applied directly to the wall, blurring the boundaries between the contributions of different artists.

So many of the Mission School artists were also graffitists—including Barry McGee (whose tag was "Twist"), Margaret Kilgallen ("Meta"), Dan Plasma, and Ruby Neri ("Reminisce")—that it makes little sense to distinguish between their identities as taggers and as artists. Whether in San Francisco or (increasingly) across the globe, it is simpler to consider the tangled amalgam of "outlaw" public art that followed the New York graffiti artists of the early 1980s as street art, rather than to try to disentangle its threads. One generalization, however, will likely always

158

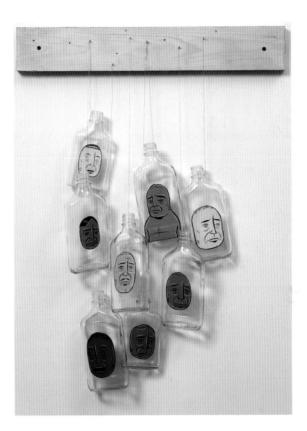

MISSION SCHOOL Barry McGee (b. 1966) Untitled (8 Bottles), 2003 Painted bottles, wire, and wood, c. 30 × 23 × 4 in. (76 × 58 × 10 cm) Roberts & Tilton, Culver City, CA

apply: tagging is a young person's pursuit, as its dangers will deplete the ranks of any circle of graffitists over time.

Ironically, by the time it was named, the Mission "school" barely existed: individual careers had been consolidated apart from the group, such as those of Barry McGee, who received international acclaim for his work in the Venice Biennale of 2001, and his wife Margaret Kilgallen, who was (posthumously) featured in the Whitney Biennial of 2002. The departure of Ruby Neri for Los Angeles also seems emblematic: the arresting images of horses she once painted on concrete freeway stanchions, she now renders in more conventional formats.

Modernism

Generically, *modern* refers to the contemporaneous. All art is modern to those who make it, whether they are the inhabitants of Renaissance Florence or twentieth-century New York. Even paintings being made today in a fifteenth-century STYLE are still modern in this sense.

As an art historical term, *modern* refers to a period dating from roughly the 1860s through the 1970s and is used to describe the style and the ideology of art produced during that era. It is this more specific use of *modern* that is intended when people speak of modern art or modernism—that is, the philosophy of modern art.

What characterizes modern art and modernism? Chiefly, a radically new attitude toward both the past and the present. Mid-nineteenth-century Parisian painters, notably Gustave Courbet and Edouard Manet, rejected the depiction of historical events in favor of portraying contemporary life. Their allegiance to the new was embodied in the concept of the *avant-garde*, a military term meaning "advance guard." Avant-garde artists began to be regarded as ahead of their time. Although popularly accepted, this idea of someone's being able to act "outside history," apart from the constraints of a particular era, is rejected by art historians.

Crucial to the development of modernism was the breakdown of traditional sources of financial support from the church, the state, and the aristocratic elite. The old style of patronage had mandated artworks that glorified the institutions or individuals who had commissioned them. Newly independent artists were now free to determine the appearance and CONTENT of their art but also free to starve in the emerging capitalist art market. The scant likelihood of sales encouraged artists to experiment. The term "art for art's sake"—which had been coined in the early nineteenth century—was now widely used to describe experimental art that needed no social or religious justification for its existence.

Modern art arose as part of Western society's attempt to come to terms with the urban, industrial, and secular society that began to emerge in the mid-nineteenth century. Modern artists have challenged middle-class values by depicting new subjects in dislocating new styles that seemed to change at a dizzying pace. Certain types of content—the celebration of technology, the investigation of spirituality, and the expression of PRIMITIVISM—have recurred in works of different styles. The celebration of technology and science took the form of the glorification of speed and movement seen in Futurism, and the use of scientific models of thinking by artists linked with CONSTRUCTIVISM, CONCRETE ART, and the ART-AND-TECHNOLOGY movement. The investigation of spirituality embodied in early ABSTRACTION, LIGHT-AND-SPACE

160

ART, and the shamanistic rituals by ACTION and FEMINIST artists was a reaction against the secularism and materialism of the modern era. Expressions of primitivism in Post-Impressionism, Cubism, and German EXPRESSIONISM simultaneously reflected new contacts with Asian, African, and Oceanic cultures "discovered" through imperialism and a romantic longing to discard the trappings of civilization in favor of a mythical Golden Age.

Modern art, especially abstract art, was thought by FORMALIST critics to progress toward purity; in the case of painting, this meant a refinement of the medium's essential qualities of color and flatness. (The flattened treatment of pictorial space and concern for the "integrity" of the PICTURE PLANE culminated in the monochrome paintings of the 1950s and 1960s.) This progressive reading of modern art posited a direct line of influence running from Impressionism to Post-Impressionism and on to Cubism, Constructivism, expressionism, DADA, SURREALISM, ABSTRACT EXPRESSIONISM, POP ART, and MINIMALISM, virtually ignoring the contribution of artists working outside Paris or New York.

This idea of progress was especially popular during the late modern era, the twenty-five years or so after World War II. In retrospect that linear view seems to mirror the frenetic output of products, and their instant obsolescence, in the modern industrial age. A booming market for contemporary art emerged in the 1960s with a flurry of stylistic paroxysms that seemed exhilarating to some observers but struck others as a parody of fashion's constantly moving hemlines. Many artists reacted by attempting to create unsalable works.

Modernism's apotheosis of avant-garde novelty—what the American critic Harold Rosenberg called the "tradition of the new" in his 1959 book of that name—encouraged artists to innovate. One aspect of that innovation was the use of odd new art-making materials (including FOUND OBJECTS, debris, natural light, high-tech equipment, and the earth itself); new processes and media (COLLAGE, ASSEMBLAGE, VIDEO, and COMPUTER ART); and new forms (abstraction, APPROPRIATION, CRAFTS-AS-ART, INSTALLATIONS, and PERFORMANCE ART).

See POSTMODERNISM

Mono-ha

- **▶wно** Koji Enokura, Susumu Koshimizu, Katsuhiko Narita, **Nobuo Sekine**, Kishio Suga, Noboru Takayama, **Lee Ufan**
- **▶WHEN** 1968 to 1972
- **▶where** Japan
- ▶ **WHAT** The origin of the name *Mono-ha* is unknown. It is invariably (and misleadingly) translated as *School of Things*, but its chief interest is less

MONO-HA
Nobuo Sekine (b. 1942)
Phase–Mother Earth, 1968/2012
Earth and cement, cylinder and hole:
106¼ × 86½ (diameter) in.
(270 × 220 cm), each
Blum & Poe, Los Angeles

in things or three-dimensional art objects than in the spatial relationships between things, or between viewer and thing, experienced in the form of a constantly changing physical and psychic encounter. If the term Mono-ha is imprecise, its debut was not. It is precisely dated to the creation of Nobuo Sekine's *Phase–Mother Earth* in October 1968, in the *First Open Air Contemporary Sculpture Exhibition* in Suma Rikyu Park in Kobe. This work took the form of a large cylindrical hole almost nine feet (2.7 m) deep, with the excavated dirt compacted to the identical dimensions of the hole, implying its possible reinsertion. Its power was startling, especially at a time when sculpture was invariably cast or fabricated. Both Japanese (and Zen) in its origins, Sekine's work also fit squarely within an international movement involving the rejection of conventional art objects, as with EARTH ART, or even the rejection of the object itself, as with earlier GUTAI art in Japan, and CONCEPTUAL and PROCESS art.

Sekine soon met the Korean-born artist Lee Ufan, who became the theorist of the group, having studied both Zen and Western philosophy. He similarly juxtaposed elemental materials such as iron and rubber, or, evocatively, set a stone block on a sheet of glass, which it cracked. Both Sekine's and Lee's works are remarkable for the clarity of their intertwined concerns for artistic process, materiality, and time. Not all of the Mono-ha artists so fully shared these predilections, but all of them were interested in arranging or joining relatively unaltered materials.

Mono-ha was a loosely defined movement without a manifesto that might pin down the shared goals of its members in the short yet clearly defined moment of their association. Their considerable individual accomplishments aside, the historical position of the Mono-ha artists as a group remains ambiguous. Some regard their work as Japanese-inflected variants of an international impulse leading to Conceptualism, while, increasingly, many consider it the first instance of a wholly Japanese practice, one that younger artists would have to grapple with in the 1970s, even if most of them rejected the Mono-ha approach.

Monster Roster. See CHICAGO IMAGISM

Mülheimer Freiheit

- ▶**who** Hans Peter Adamski, Peter Bömmels, Walter Dahn, Jiří Georg Dokoupil, Gerhard Kever, Gerhard Naschberger
- **▶WHEN** 1979 to 1983
- **▶where** Cologne, Germany
- ▶ WHAT Mülheimer Freiheit is the name taken by the six artists listed above after they jointly inaugurated a studio located at Mülheimer Freiheit 110, in Cologne, in 1979. (Freiheit happens to mean "freedom" or "liberation," a coincidence the group appreciated.) Hans Peter Adamski, Peter Bömmels, Jiří Georg Dokoupil, and Gerhard Naschberger had met in New York during the mid-1970s, when Dokoupil was a student there. By the end of the decade all six of the artists in the group were living in Cologne.

Their artistic backgrounds were quite different and they never issued a manifesto, but they did share a belief in freedom of conceptual approach and style. This translated into collaboratively made works that were alternately EXPRESSIONISTIC, SURREALISTIC, and PRIMITIVE looking; that encompassed pirated elements from contemporary German painting; and that were arranged in informal INSTALLATIONS composed of paintings, objects, and wall drawings in random-looking configurations. Their first group show was held in the gallery of a local artists' organization in 1980; it was quickly followed by an exhibition at

164

the prestigious Paul Maenz Galerie, also in Cologne. They continued to exhibit together—holding their last group show in London in 1983—but increasingly Bömmels, Dahn, and Dokoupil also accepted offers for solo exhibitions.

Mülheimer Freiheit represents an influential middle ground between the CONCEPTUAL ART that dominated Germany during the 1970s and the NEO-EXPRESSIONISM (or Neue Wilde)—epitomized by the Berlinbased group Heftige Malerei ("violent painting"), including the painters Elvira Bach, Rainer Fetting, Karl Hödicke, Helmut Middendorf, and Salomé—which dominated the first half of the 1980s. By the late 1980s, northern European artists seemed generally to have rejected expressionism in favor of cool, conceptually oriented art forms.

Multiculturalism

Multiculturalism is the opposite of ethnocentricity. In terms of the visual arts, it describes the increasingly widespread opposition among curators, critics, and artists to the elevation of the European cultural tradition over those of Asia, Africa, and the indigenous or nonwhite populations of the Americas. The concept gained currency in the United States and Europe during the late 1980s partly because of the dramatic influx of nonwhite immigrants and the often racist responses triggered by such migrations. The instant transmission of information and ideas across national borders made possible by contemporary technology has also encouraged multiculturalism.

Multiculturalism rejects the vestiges of colonialism embodied in tendencies to regard art from other cultures either as "primitive" or as the exotic products of cultural OTHERS. It demands that works of art from non-European cultures be considered on their own terms. The Centre Georges Pompidou in Paris mounted the controversial exhibition *Les Magiciens de la terre* in 1989. Its coupling of works by well-known Western artists and works by third-world artists unknown to the art world frequently revealed radically different ideas about the nature of art itself. Shows such as the third International Istanbul Biennial exhibition in 1992 were organized in response to *Magiciens*.

Likewise, at the end of the 1980s, numerous American museums began to mount exhibitions organized on the basis of artists' ethnic, racial, and gender identities. (This approach has since come to be known as *identity politics*.) The most comprehensive of these shows was *The Decade Show: Framework of Identity in the 1980s*, which was simultaneously presented in New York in 1990 by the Museum of Contemporary Hispanic Art, the New Museum of Contemporary Art, and the Studio Museum of Harlem. The critical emphasis of much of the work presented in such exhibitions

tended to offend right-wing commentators, who derided such efforts as misguided attempts to undermine what they regarded as absolute standards of quality. Such attitudes found their non-art corollaries in controversies about broadening the literary canon and the historical purview of university curricula, and helped fuel the CULTURE WARS.

See PRIMITIVISM

Multiple

- ▶ WHO Yaacov Agam, Jonathan Borofsky, Alexander Calder, John Chamberlain, Mark di Suvero, Marcel Duchamp, Jane Hammond, Ellsworth Kelly, Edward Kienholz, Isamu Noguchi, Claes Oldenburg, Robert Rauschenberg, Man Ray, Daniel Spoerri, Joe Tilson, Jean Tinguely, Victor Vasarely
- ▶ WHEN Since about 1960
- **▶WHERE** Europe and the United States
- **WHAT** A multiple is a three-dimensional artwork produced in a limited quantity known as an *edition*. They are part of a long European tradition in which prints (etchings and lithographs) and statuary (in bronze and china) were fabricated by workshops or factories. Multiples have rarely been made in large numbers, despite a considerable amount of rhetoric about making art affordable through mass production.

M

In 1955 the artists Yaacov Agam and Jean Tinguely suggested the idea of doing multiples to the Parisian art dealer Denise René. Four years later the artist Daniel Spoerri founded Editions M.A.T. (Multiplication Arts Transformable) in Paris, which produced reasonably priced multiples in editions of one hundred by Alexander Calder, Marcel Duchamp, Man Ray, Tinguely, Victor Vasarely, and others. Developments in the early 1960s such as the PRINT REVIVAL and POP ART's interest in the mass-produced object made the idea seem especially promising. That promise was realized in the late 1960s with the emergence of collectors attracted to the investment potential of those relatively low-priced works of contemporary art.

MULTIPLE
Jane Hammond (b. 1950)
Clown Suit, 1995
Lithograph with silkscreen and collage,
55 × 46.5 in. (139.7 × 118.1 cm)
Published by Universal Limited Art Editions,
Bay Shore, NY; edition of 45

Naive Art. See OUTSIDER ART

Narrative Art

▶ WHO JO Harvey Allen, Terry Allen, Eleanor Antin, Ida Applebroog, John Baldessari, Jonathan Borofsky, Joan Brown, Colin Campbell, Bruce Charlesworth, Sue Coe, Robert Colescott, Robert Cumming, Öyvind Fahlström, Eric Fischl, Vernon Fisher, Walton Ford, Leon Golub, Jörg

N

Immendorff, Jean Le Gac, Alfred Leslie, Agnes Meyer-Brandis, Duane Michals, Grégoire Müller, Odd Nerdrum, Dennis Oppenheim, Faith Ringgold, Allen Ruppersberg, Dana Schutz, Alexis Smith, Earl Staley, Mark Tansey, Hervé Télémaque, William Wegman, Xing Danwen, Bruce and Norman Yonemoto

- ▶ WHEN Since the mid-1960s
- **▶WHERE** Europe and the United States
- **WHAT** Narrative—or story—art represents events taking place over time. These events may, however, be compressed into a single image that implies something that has already happened or is about to take place.

Painting, of course, has told stories since at least the time of the ancient Egyptians. Starting in the Renaissance, "history painting"—paintings of events from biblical or classical history—acquired the highest status. Nineteenth-century painting and sculpture depicted not only great moments in history but also domestic dramas of a decidedly sentimental nature. Such subjects were rejected by MODERN painters during the late nineteenth century in favor of scenes from contemporary life. Later modern artists sought to purge painting and sculpture of narrative. Storytelling was thought best pursued by writers rather than visual artists, and literary became an insult in the argot of modern art.

By the 1960s the modernist insistence on ABSTRACTION and the taboo against narrative had made telling tales irresistible to many artists. POP ART, NEW REALIST painting and sculpture, and NOUVEAU RÉALISME all provided FIGURATIVE imagery into which narratives could be read—whether or not they were intended by the artist.

The most popular forms of visual narrative now are painting and VIDEO ART, with PERFORMANCE and INSTALLATION art the runners-up. Narrative artwork ranges from Bruce Charlesworth's amusing "whodunit" installations suggestive of pulp novels to Faith Ringgold's affecting autobiographical stories written and painted on quilts. (Words are a frequent element in narrative art.) The narrative approach seems especially suited to psychological self-examination and the investigation of the role-playing that is so conspicuous an element of late-twentieth-century social interaction.

See ALLEGORY

Naturalism. See REALISM

Neo-, See POST-

NARRATIVE ART
Sue Coe (b. 1951)
Woman Walks into Bar—Is Raped by 4 Men
on the Pool Table—While 20 Men Watch, 1983
Mixed media on paper mounted on canvas,
91 × 113 in. (231.1 × 287 cm)
Museum of Modern Art, New York

Neo-Conceptualism. See CONCEPTUAL ART

Neo-Concretism

- ▶who Hercules Barsotti, Sergio Camargo, Aluísio Carvão, Amilcar de Castro, Lygia Clark, Ferreira Gullar, Reynaldo Jardim, Cildo Meireles, Hélio Oiticica, Lygia Pape, Theon Spanudis, Franz Weissmann
- **▶WHEN** 1959 to 1972
- **▶**where Brazil
- ▶ **WHAT** The Manifesto Neoconcreto—published in the newspaper Jornal do Brasil on March 23, 1959—gave the Grupo Neoconcreto its name. It rep-

resents the culmination of postwar debate within the CONCRETE ART movement in Brazil, and the divisions into which it had split.

Following World War II the Swiss artist Max Bill helped introduce to Brazil the ideas of European Concretism—an amalgam of Bauhaus, De Stijl, and CONSTRUCTIVIST ideas of rationality, as expressed in an impersonal style of geometric ABSTRACTION. This led to the founding of the avant-garde associations of the early 1950s—the Frente Group (Grupo Frente) in Rio de Janeiro and the Rupture Group (Grupo Ruptura) in São Paulo—which included many of the key artists of the day. The abstract painting and sculpture of the Brazilian Concretists was among the most accomplished produced anywhere in that decade, and like all Concrete art, it betrayed no sign of the national origin (or gender) of its

creator.

However, a survey of Concrete art, the Exposição Nacional de Arte Concreta, seen in São Paulo in 1956 and Rio de Janeiro in 1957, revealed a distinct difference of sensibility among Brazilian artists: those from São Paulo, the Europeanized industrial powerhouse, favored geometric abstraction and rationality, while those from Rio de Janeiro, the cosmopolitan port and (at that time) federal capital, were coming to embrace a diametrically opposed position. It was the latter group who would issue the Manifesto Neoconcreto, in which they accused the Concretists of "dangerously indulg[ing] in excessive rationalism" at the expense of creativity, uncensored personal expression, and attention to the needs of audiences. Faced with such criticisms—which were the same ones that would undermine the authority of high MODERNISM elsewhere in the world—even the ultimate expression of Brazilian modernism, the purpose-built federal capital of Brasilia in the country's remote interior, came to symbolize far more than its designers intended: not just the industrial development and utopian modernity explicit in its design, but the undemocratic tendencies implicit in the vast distance separating the seat of government from the Brazilian populace.

If Concretism remained bound to a modernism of waning importance, Neo-Concretism symbolized the yearning for both a more humane future and a return to the impassioned quest for relevance that had first ignited modernism a century earlier. With its concern for artistic individuality and diversity, Neo-Concretism should be considered part of TROPICALISM, a broad expression of the revolutionary ideals fundamental to Brazilian society and all art forms of the day.

NEO-CONCRETISM Cildo Meireles (b. 1948) Southern Cross, 1969–70 Cube of oak and pine, ¾ in. (0.9 cm) per side Courtesy the artist

Neo-Dada

- **▶ WHO** Wallace Berman, Bruce Conner, **Jasper Johns**, Edward Kienholz, **Robert Rauschenberg**
- ▶when Mid-1950s to mid-1960s
- **▶WHERE** United States
- **WHAT** The term *Neo-Dada* derives, of course, from DADA, the early-twentieth-century movement. It was first applied to the work of Jasper Johns, Allan Kaprow, Robert Rauschenberg, and Cy Twombly in an unattributed comment in the January 1958 issue of *Artnews* magazine. It has come to be associated primarily with the work of Johns and Rauschenberg rather than that of Kaprow and Twombly, but it is also appropriate to apply it to the slightly later ASSEMBLAGES by Wallace Berman, Bruce Conner, and Edward Kienholz.

The Artnews evocation of DADA referred to two aspects of the earlier movement. First, there was a Dada-like sense of paradox and ambiguity embodied in Johns's paintings of targets, numbers, and maps that filled the entire surface of the canvas. Second, there was a connection to Marcel Duchamp, Kurt Schwitters, and other Dada artists in Rauschenberg's use of junk and FOUND OBJECTS to create "combines"—hybrid painting-sculptures. (For one of them, the artist used his own mattress and quilt as his "canvas.")

N

Neo-Dada provided a bridge between ABSTRACT EXPRESSIONISM and POP ART. Johns and Rauschenberg shared the former's predilection for GESTURAL brushwork and grand scale but rejected the sublimity of Abstract Expressionism in favor of everyday imagery. In this regard they influenced the development of Pop art. Neo-Dada's counterpart in Europe was NOUVEAU RÉALISME.

Neo-Expressionism

▶ WHO Elvira Bach, Miguel Barceló, Georg Baselitz, Jean-Michel Basquiat, Jonathan Borofsky, Sandro Chia, Francesco Clemente, Chema Cobo, Sue Coe, Luis Cruz Azaceta, Enzo Cucchi, Rainer Fetting, Eric Fischl, Gérard Garouste, Nancy Graves, Karl Hödicke, Jörg Immendorff, Oliver Jackson, Roberto Juarez, Anselm Kiefer, Per Kirkeby, Christopher Le Brun, Robert Longo, Markus Lüpertz, Helmut Middendorf, Robert Morris, Mimmo Paladino, Ed Paschke, A. R. Penck, David Salle, Salomé, Julian Schnabel, José Maria Sicilia, Earl Staley, Donald Sultan, Juan Uslé

▶when Late 1970s to mid-1980s

▶WHERE International

WHAT The first use of the term *Neo-Expressionism* is undocumented, but by 1982 it was being widely used to describe new German and Italian art. An extremely broad label, it is disliked—as are so many media-derived tags—by many of the artists to whose work it has been applied.

Neo-Expressionism (often shortened to Neo-Ex) was a reaction against both CONCEPTUAL ART and the MODERNIST rejection of imagery culled from art history. Turning their backs on the Conceptual art modes in which they had been trained, the Neo-Expressionists adopted the traditional formats of easel painting and cast and carved sculpture. Turning to modern and premodern art for inspiration, they abandoned MINIMALIST restraint and Conceptual coolness. Instead their work offered violent feeling expressed through previously taboo means—including GESTURAL paint handling and ALLEGORY. Because it was so widespread and so profound a change, Neo-Expressionism represented both a generational changing of the guard and an epochal transition from modernism to POSTMODERNISM.

It is difficult to generalize about the appearance or CONTENT of Neo-Expressionist art. Its imagery came from a variety of sources, ranging from newspaper headlines and SURREALIST dreams to classical mythology and the covers of trashy novels. The German artists invoked early-twentieth-century EXPRESSIONISM to deal with the repression of German cultural history following World War II. Some American painters, such as Julian Schnabel, used eclectic historical images to create

NEO-EXPRESSIONISM Julian Schnabel (b. 1951) Self-Portrait in Andy's Shadow, 1987 Oil, plates, and Bondo on two wood panels, 103 × 72 × 10 in. (261.6 × 182.9 × 25.4 cm) Broad Collection, Los Angeles

highly personal and allusive works. Others, such as Sue Coe, referred to contemporary events to create pointed social commentary.

Neo-Expressionism's return to brash and emotive artworks in traditional and accessible formats helped fuel the booming art market of the 1980s and marked the end of American dominance of international art.

See EAST VILLAGE, MÜLHEIMER FREIHEIT, TRANSAVANTGARDE

- **▶wно** Ashley Bickerton, Peter Halley, Jeff Koons, Meyer Vaisman
- ▶when Mid-1980s
- **▶WHERE** New York
- ▶ WHAT Neo-Geo is short for "neo-geometric CONCEPTUALISM." It is used, confusingly, to refer to the art of the four very different artists noted above. It probably limits the confusion to apply Neo-Geo only to the work of those four artists, although the evocative use of domestic objects as sculptural material by Haim Steinbach and the Swiss artist John Armleder does seem closely related.

Jeff Koons's stainless-steel replicas of KITSCH consumer objects, including whiskey decanters in the form of celebrity portraits, are far from geometric and certainly better understood as APPROPRIATION art. They have little in common with Peter Halley's paintings of linked rectangles (or "cells") inspired by Jean Baudrillard's SIMULATION theory. Both Ashley Bickerton and Meyer Vaisman made "wall sculptures"—thick paintings that extend from the wall and can be viewed from three sides. Vaisman coupled photographic blowups of canvas weave with fragmented images of faces or figures; Bickerton produced paint-encrusted ABSTRACTIONS that evoke household objects or even surfboards. What this disparate work does share is an interest in the cool ironies of POP ART and the use of Conceptual art to address issues related to the nature of the art market during New York's economic boom of the 1980s.

N

Many regard the term *Neo-Geo* as nothing more than a marketing device, important as an emblem of art-world careerism (Vaisman was also an EAST VILLAGE dealer who showed the work of Koons and Halley) and of the art market's insatiable appetite for the new, rather than as an aesthetic signpost. It has come to be associated with an October 1986 show at the prestigious Sonnabend Gallery in New York that certified the meteoric rise of the four young artists. A poorly received 1987 exhibition of work from the Saatchi Collection in London called *New York Art Now* dampened international enthusiasm for the "movement." By 1989 the term itself was rarely heard, although the artists associated with it continued to receive widespread attention.

Neue Wilde. See MÜLHEIMER FREIHEIT

NEO-GEO Peter Halley (b. 1953) Untitled, 2005 Acrylic on canvas, 17 × 42 ft. (5.2 × 12.8 m) Dallas/Fort Worth International Airport

New Image

- ▶who Nicholas Africano, Jennifer Bartlett, Jonathan Borofsky, Neil Jenney, Robert Moskowitz, Susan Rothenberg, Joel Shapiro, Pat Steir, Donald Sultan, Joe Zucker
- ▶when Mid-1970s to early 1980s
- **▶WHERE** United States
- ► WHAT The name New Image derives from the Whitney Museum of American Art's 1978 show New Image Painting, curated by Richard Marshall. Although the exhibition was derided as a grab bag of disparate styles—it showcased paintings by many of the artists listed above—it did point to two crucially important phenomena: the return of recognizable FIGURATIVE imagery after a decade of MINIMALISM; and the return of the familiar paint-on-canvas format after a decade of the non-objects of CONCEPTUAL ART.

The progenitor of New Image painting is former ABSTRACT EXPRES-SIONIST Philip Guston. By 1970 he had abandoned the shimmering abstractions for which he was known in favor of idiosyncratic cartoonlike scenes of the tragic human comedy. None of the New Image painters mimicked Guston's highly personal style; it was his gutsy eccentricity that proved catalytic.

Each of the New Image painters charted a highly individual course, but many of their works do create the effect of a figure tentatively emerging from an ABSTRACT background. Consider, for example, Susan Rothenberg's sketchy horses, Nicholas Africano's tiny characters, and Robert Moskowitz's silhouetted objects—all seen against essentially abstract and PAINTERLY backgrounds. Other artists identified as New Image painters applied more Conceptual approaches. Neil Jenney coupled painted images with punning, explanatory titles limned on frames; Jennifer Bartlett produced paintings on steel plates that systematically explored painting's language of abstraction and REPRESENTATION through dozens of differently handled versions of the same subject; and Jonathan Borofsky created large INSTALLATIONS composed of paintings, mechanical sculptures, FOUND OBJECTS, and texts, all intended to evoke a dreamy faux-naïf consciousness.

Although it is difficult to generalize about so varied a group of artists, New Image painting anticipated the POSTMODERN interest in figura-

NEW IMAGE Susan Rothenberg (b. 1945) Hector Protector, 1976 Acrylic and tempera on canvas, 67 × 1115% in. (170.2 × 283.5 cm) Gagosian Gallery, New York

tive imagery and even, in the case of Pat Steir, the APPROPRIATION of historical painting as a source of subjects. During the late 1970s New Image was sometimes regarded in tandem with PATTERN AND DECORATION—two nearly diametrically opposed routes back to traditional-format painting after an era in which it had been abandoned.

New Leipzig School

- **▶wно** Tim Eitel, Martin Kobe, **Neo Rauch**, Christoph Ruckhäberle, David Schnell, Matthias Weischer
- ▶ **WHEN** Since the mid-1990s
- ▶ WHERE Leipzig, Germany
- ▶ WHAT New Leipzig School (Neue Leipziger Schule) is an imprecise name rejected by art historians and even by the artists to whom it is said to apply. It was promoted, instead, by Leipzig art dealer Gerd Harry Lybke and later by the American collectors Don and Mera Rubell. If New Leipzig School evokes other marketing tags such as Charles Saatchi's YOUNG BRITISH ARTISTS in its lack of precision, it does at least refer to an earlier group of "old" Leipzig School artists and an actual school—the Leipzig Academy of Art—that the artists attended.

Otherwise, their correspondences are largely limited to gender, medium, and a starkly deindustrialized environment of ruined factories in the southern part of Leipzig that has provided many of them with spacious studios and some with imagery. Unfortunately, the style of the group's best-known figure, Neo Rauch—a delirious or melancholic SURREALISM expressed in shifts of scale, dreamy imagery, and narrative fragments—has too often been attributed to the entire group, which consists of at least two generations of artists representing numerous approaches to painting. (Some, like Weischer, Eitel, and Schnell, studied at the Leipzig Academy in the mid-1990s or after, and experienced a divided Germany only as children or adolescents.)

The work of the New Leipzig School belongs to a broader revival of German painting that began in the late 1970s and was driven both by a generational response to the avant-garde, politicized Conceptualism of Joseph Beuys in the West and by a reappraisal of state-sanctioned painters from the East at high-profile venues, including Documenta. This encouraged more subtle responses to the work of official artists, some of whom were complex figures, such as the Leipzig painter Bernhard Heisig. Initially lauded by the communist regime for his SOCIALIST-REALIST canvases, he became the subject of harsh criticism as his work grew increasingly more subjective, embracing its Expressionist roots in images of the tragic suffering of Germany in the 1920s by the painters Max Beckmann and Otto Dix. These more nuanced responses to

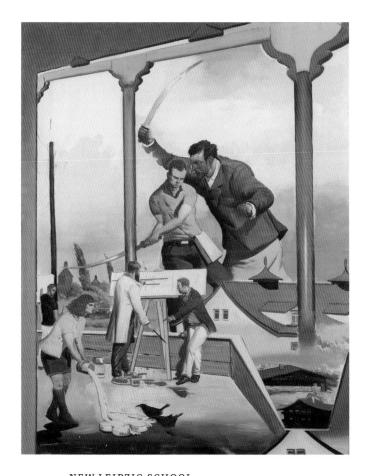

NEW LEIPZIG SCHOOL Neo Rauch (b. 1960) Abstraktion, 2005 Oil on canvas, 106½ × 82½ in. (270 × 210 cm) Galerie EIGEN + ART, Leipzig

artists like Heisig and other "old" Leipzig School painters—and Heisig's presence at the Leipzig Academy—influenced the generation of painters that included Arno Rink, whose work fit within the international NEO-EXPRESSIONIST idiom of the 1980s. Rink's generation, in turn, taught the New Leipzig School painters like Rauch, whose tenure as an academy student coincided with the joyous prospect of free expression represented by German reunification in 1990. A willing bearer of tradition, Rauch now teaches at the academy.

New Media

New media is a blanket term that once referred exclusively to the genre of art produced by mechanical reproduction in media more recently invented than photography—that is, beginning with video. (New media was initially defined in opposition to the long-established media of photography, painting, and sculpture; in art schools, it was sometimes paired with performance under the rubric of time-based art.) The use of new media in this sense was primarily limited to schools and museums, where it continues to be employed in this way.

New media has acquired a second, more widespread, non-art meaning, referring to all forms of digital mass media, in contrast to "old media" such as print newspapers or magazines. Confusingly, it is also occasionally used in reference to private means of electronic communication, such as e-mail.

New Realism

- ▶wно William Bailey, Jack Beal, William Beckman, Martha Erlebacher, Janet Fish, Lucian Freud, Gregory Gillespie, Neil Jenney, Alex Katz, Alfred Leslie, Sylvia Mangold, Alice Neel, Philip Pearlstein, Fairfield Porter, Joseph Raffael, Neil Welliver
- ▶ **WHEN** 1960s through 1970s
- **▶ WHERE** Primarily the United States
- ▶ WHAT By 1962 the term New Realism was being used in the United States and France (where it was called NOUVEAU RÉALISME) as a name for POP ART. That use never caught on in the United States, and the term began to signify instead a new breed of REALISM. The traditional variety had linked humanistic CONTENT with the illusionistic REPRESENTATION of observed reality and the rejection of flattened pictorial space derived from ABSTRACTION.

By contrast, New Realism—although a radical departure from the ABSTRACT EXPRESSIONISM that dominated the 1950s—incorporated the flattened space, large scale, and simplified color of MODERNIST painting. Some New Realist artists like Alfred Leslie had, in fact, switched from abstract to representational painting.

New Realism is too broad a term to have much meaning except as a shorthand for a FIGURATIVE alternative to the abstraction of Abstract Expressionism or MINIMALISM. It has taken many forms, from Fairfield Porter's serene landscapes to Alice Neel's slyly psychological portraits, and from the abstracted nudes by Philip Pearlstein to the cerebral self-portraits by William Beckman. The term also tends to imply a nongestural or nonexpressionistic handling of paint that suggests

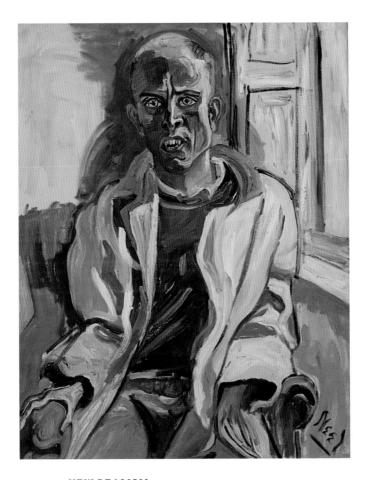

NEW REALISM Alice Neel (1900–1984) Randall in Extremis, 1960 Oil on canvas, 361/8 × 281/8 in. (91.8 × 71.4 cm) Estate of the artist

fidelity to appearances. The belief that New Realist artists are primarily motivated by an interest in the way things look is belied by the psychic probing of Lucian Freud's work or the radically simplified stylizations of Alex Katz.

New Wave

New Wave was a journalistic tag initially—and pejoratively—applied to new French filmmakers of the late 1950s, including François Truffaut and Jean-Luc Godard. During the mid-to late 1970s it began to be applied to a new generation of pop musicians in the United States, some of whom were art-school graduates. The increasingly theatrical and eclectic nature of Performance Art had encouraged many art students to form bands such as Romeo Void and the spectacularly successful Talking Heads. California art-school graduates from institutions like the San Francisco Art Institute opened storefront Alternative spaces that showcased punk music and performance as well as exhibitions. An Expressionistic type of advertising poster developed that would influence NEO-Expressionist painting.

Soon new wave began to be applied, imprecisely, to the visual arts. Two large-scale exhibitions in New York thrust the new-wave aesthetic into the media. The first was the Times Square Show of 1980, organized by Collaborative Projects, Inc., and the alternative space Fashion Moda. A decaying former massage parlor was transformed into an illegal, multistory exhibition space. For the first time, GRAFFITI artists were brought together with a new generation of painters and sculptors (including John Ahearn and Tom Otterness) who were reacting against the anti-object orientation of CONCEPTUAL ART. Offering an alternative to the austerity of all-white galleries, the circuslike show created an appealing amalgam of the gallery, the club, and the streets. By the time the second exhibition extravaganza, New York New Wave (curated by René Ricard). opened at P.S. 1 in September 1981, the term new wave simply referred to the mix of graffiti, Neo-Expressionist, and EAST VILLAGE art that would dominate the first half of the 1980s. Now—as with film—it is merely a synonym for the new and the abrasive.

New York School. See SCHOOL OF PARIS

Nonobjective. See ABSTRACT/ABSTRACTION

Nonrepresentational. See ABSTRACT/ABSTRACTION

Northern Artists Group. See '85 NEW WAVE

- ▶who Arman, César, Christo, Yves Klein, Mimmo Rotella, Niki de Saint Phalle, Daniel Spoerri, Jean Tinguely
- ▶ WHEN Late 1950s to mid-1960s
- **▶where** France
- ▶ WHAT The term Nouveau Réalisme was coined by the French critic Pierre Restany and appeared on a manifesto signed by many of the artists noted above on October 27, 1960. It translates as "NEW REALISM," but in English that name has come to stand for a more conventional sort

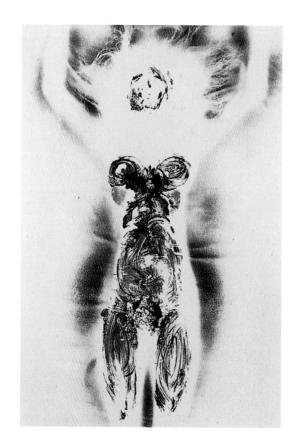

NOUVEAU RÉALISME Yves Klein (1928–1962) Shroud Anthropometry 20—Vampire, 1960 Pigment on canvas, 43 × 30 in. (109.2 × 76.2 cm) Private collection

Ν

of realist painting. To complicate matters further, POP ART, too, was once called *New Realism*, and it is Pop art to which Nouveau Réalisme is closely related.

The Nouveaux Réalistes favored the grittiness of everyday life over the elegantly imaginative and introspective products of 1950s-style ABSTRACTION. Their individual approaches to making art, though varied, all constituted a reaction against the international dominance of ABSTRACT EXPRESSIONISM, ART INFORMEL, and Tachisme. They shared this attitude with that of their American contemporaries the NEO-DADAISTS Jasper Johns and Robert Rauschenberg and the HAP-PENING artist Allan Kaprow.

The manifesto that the Nouveaux Réalistes signed in Yves Klein's apartment in 1960 called only for "new approaches to the perception of the real." Its vagueness well suited the diversity of their art. As a group they are best known for their use of junk and FOUND OBJECTS: Arman created ASSEMBLAGES of musical instruments or domestic appliances, and Daniel Spoerri affixed the remains of meals to wooden panels.

OHO Group. See CONCEPTUAL ART

Online Art

- ▶ WHO Laurie Anderson, David Blair, Heath Bunting, Shu Lea Cheang, Margaret Crane and Jon Winet, Peter D'Agostino, Douglas Davis, Jeff Gates, Eduardo Kac, Cati Laporte, Antonio Muntadas, Joseph Nechvatal, Perry Hoberman, Cary Peppermint, Julia Scher, John Simon, Nina Sobell and Emily Hartzell, Stelarc, Mark Tribe, Eva Wöhlgemuth and Kathy Rae Huffman, Adrianne Wortzel, Yes Men
- ▶when Since the early 1990s
- **▶WHERE** International
- **WHAT** Online art refers to art designed for the Internet; as such it can be considered a medium like painting or photography, offering myriad possibilities of use. Although numerous artists have presented their works in traditional media online for the purpose of documentation or marketing, a photograph or a painting displayed in a virtual gallery remains a photograph or a painting, rather than an online artwork. The advent of YouTube in 2005, however, solved the problem of how VIDEO ART might be distributed to large audiences.

The predecessors of online art include MEDIA ART and CONCEPTUAL ART. Like television or daily newspapers, the Internet is a site (or format) for mass media. With its built-in links and interactivity, it also offers the potential for audience participation, a longtime interest of Conceptual artists.

182

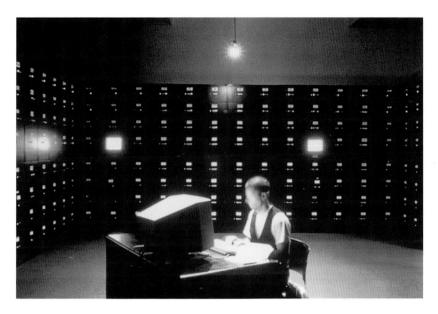

ONLINE ART Antonio Muntadas (b. 1942)/Randolph Street Gallery The File Room, 1994 Web site, www.thefileroom.org Randolph Street Gallery, Chicago

Many media artists—such as Peter D'Agostino, Douglas Davis, and Antonio Muntadas—produced pioneering online works that extended their interests in communications theory and mass media. Muntadas's File Room, for instance, takes advantage of the database capabilities of digital technology to create a virtual archive that allows visitors not only to learn about the history of censorship but also to contribute accounts of their own experiences. Mark Napier's witty Digital Landfill simultaneously provides a virtual trash dump for unwanted data—be it spam, outdated links, or that digital artwork which never lived up to expectations—and creates elegant views of this detritus that are metaphorical testimony to failure. Seemingly bringing science fiction to life, the BODY ARTIST Stelarc used the Internet to operate his own body, feeding signals from remote computers into an electric muscle-stimulation system that he wore.

Online reality has also created nearly unlimited opportunities for cultural commentary by artists. The auction site eBay, for instance, has proved irresistible to artists. Cary Peppermint auctioned off his services as a video artist, promising to make a five- to fifteen-minute work

184

in accordance with the highest bidder's instructions, while Jeff Gates (unsuccessfully) attempted to sell his demographics—that is, a detailed profile of his habits as a consumer. When a group of students from the California Institute for the Arts tried to auction their scheduled fiveday show at the school's gallery, the winning bid from a dissident North Korean political group could not be accepted because the U.S. Export Administration Act forbids trading with North Korea. This commingling of art and the law underlines the often hybrid character of so much online art.

Rarely have museums responded so quickly to a new medium as they did to online art. During the mid- and late 1990s early adopters such as the Guggenheim Foundation devoted significant funds to cyber-projects. The Guggenheim's first online commission was Shu Lea Cheang's Brandon, a year-long project about Teena Brandon—a young woman in Nebraska who dressed as a man, dated young women, and was murdered for these "transgressions." While Brandon was complemented by several compelling live events, Cheang's literary approach to her material seemed ill-suited to an online presentation. This contrasts sharply with the other works cited in this entry, which seem impossible to imagine in any other form than online art.

Such experiences led museums to scale back their commitment to online art, leaving the field to institutions specializing in COMPUTER ART, such as ZKM and Eyebeam, which both opened in 1997. However, most large museums have since incorporated online art within their video or NEW MEDIA departments. And the assimilation of online media into daily life has been reflected in art as well: it is increasingly regarded as simply another of the formats, approaches, or tools that today's artist—freed from allegiance to any one medium—may use as seems appropriate for a particular work.

Op Art

- **▶wно** Yaacov Agam, Getulio Alviani, Richard Anuszkiewicz, Larry Poons, **Bridget Riley**, Jesús Rafael Soto, Julian Stanczak, **Victor Vasarely**
- ▶when Mid-1960s
- **▶WHERE** Europe and the United States
- ▶ WHAT Op art is short for optical art; other names for this STYLE are retinal art and perceptual abstraction. The sculptor George Rickey coined the term in 1964, in conversation with Peter Selz and William Seitz, two curators at the Museum of Modern Art. Op art is always ABSTRACT, and the optical refers to "optical illusion": Op paintings create the illusion of movement. Parallel wavy black lines set against a white background, for instance, convincingly suggest movement and depth in Bridget Riley's vibrant works.

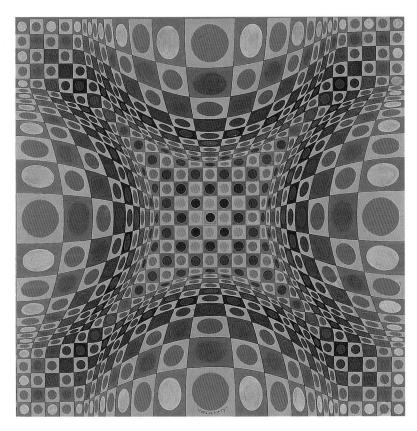

OP ART Victor Vasarely (1906–1997) Ond S.J., 1968 Tempera on panel, 16½ × 16½ in. (41.3 × 41.3 cm) Private collection

Op's antecedents date back at least as far as Josef Albers's courses on color theory and optical experimentation at the Bauhaus school of art in Germany during the late 1920s. Op art's moment of greatest celebrity came in 1965 with the Museum of Modern Art's exhibition *The Responsive Eye*. But soon after that Op art was recycled as a motif in fabric and interior design, and having come to symbolize stylistic change for its own sake, it quickly faded from the scene. Because it epitomized trendy stylistic turnover, it was picked up in the late 1980s by Appropriation artists such as Philip Taaffe and Ross Bleckner, who were investigating MODERN art's succession of styles.

The Other

The concept of "the Other" refers to women, people of color, inhabitants of the so-called third world, lesbians, and gays—that is, all groups that have traditionally been denied economic and political power. Its origins have sometimes been traced to the French theorist Simone de Beauvoir's Second Sex, a pioneering work of EXISTENTIALISM-suffused feminism written in 1949.

To regard people as Others is to see them as objects rather than as subjects driven by psychological needs and desires similar to the viewer's. (Adherents of the influential French psychoanalytic theorist Jacques Lacan tend to view the first Other as the mother.) This is, of course, the foundation of prejudice and a psychic defense against understanding people different from oneself.

The Other entered the discourse of artists and critics in the late 1970s and began to be frequently heard in the mid-1980s. The cultural historian Edward Said ably utilized this concept in his investigations of "Orientalism," nineteenth- and twentieth-century depictions of Asians and Africans by Western artists that failed to accord them the psychological complexity and humanity with which Europeans were depicted. During the 1970s the Brazilian artist Hélio Oiticica asserted that Western "cultural cannibalism" might be reversed by stealing back what had been taken from the tropics. The 1984 traveling exhibition Difference: On Representation and Sexuality, organized by the critic Kate Linker for the New Museum of Contemporary Art in New York, examined the social construction of gender and sexuality in both film and the visual arts. The late 1980s saw a growing number of visual artists in the United States and Great Britain addressing issues of "Otherness."

See MULTICULTURALISM

Outsider Art

Roger Cardinal coined the term *outsider* art for his book of the same name, published in 1972. Originally intended to describe the art of those outside of society, such as prisoners and psychotics, it has come to be used more broadly to describe art by *self-taught* or *naive* artists.

Although outsider artists lack formal training, they are often obsessively committed to their art making. Their works may appear to be innocent, childlike, and spontaneous, but this is usually deceptive. Outsider artists frequently borrow conventional compositions and techniques from the history of art, and many maintain a remarkably consistent level of quality.

186

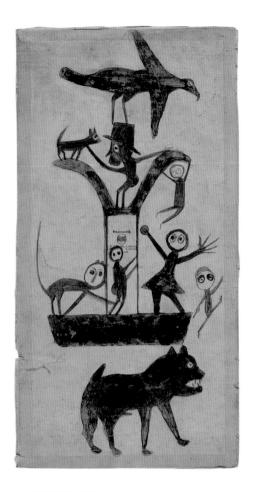

OUTSIDER ART
Bill Traylor (c. 1854–1949)
Untitled (Figures and Construction with
Blue Border), c. 1941
Poster paint and pencil on cardboard,
15½ × 8 in. (39.4 × 20.3 cm)
American Folk Art Museum; gift of
Charles and Eugenia Shannon, 1991.34.1

There is a general outsider STYLE. In painting this tends toward bright colors, abundant detail, and flat space. In sculpture (or architectural constructions), it often involves assembling junk or cast-off materials in exuberant constructions such as Simon Rodia's Watts Towers in Los Angeles or in extravagantly decorated environments that have grown

188

out of the artist's living space, such as Grandma Prisbrey's Bottle Village, also in Southern California.

The modern interest in outsider art stems from MODERNISM's fascination with "primitive" cultures and unconscious states of mind. The development of ABSTRACTION has made the distortions of outsider art seem part of the mainstream. The first evidence of this phenomenon may be the popularity of Henri Rousseau, a former Sunday painter whose charmingly abstracted fantasies seemed appealingly avant-garde to Pablo Picasso and his circle in early-twentieth-century Paris.

Outsider art should not be confused with folk art. Folk art features traditional decoration and functional forms specific to a culture. (Folk art has been generally corrupted by the demands of tourism.) Outsider art is a product of individual psyches rather than communal history, and it tends to be decorative and nonfunctional.

In recent decades many art dealers and collectors have begun to specialize in outsider art. The annual Outsider Art Fair has been held in New York since 1993, and is now expanding to Paris. Outsider artists who have gained an international reputation include the Americans Henry Darger, Martín Ramírez, and Judith Scott, and the Indian Nek Chand.

See ART BRUT, PRIMITIVISM

Painterly

The Swiss art historian Heinrich Wölfflin coined this term in 1915 in order to distinguish the optical qualities of Baroque painting from Neoclassical painting. As he saw it, the loose and GESTURAL paint handling, or "painterly" quality, of the former focuses the viewer's attention on dazzling visual effects, whereas the sculptural linearity of the latter invites touch. The opposite of painterly is not sculptural but linear. The term linearity is only rarely heard anymore, but painterly is often used to describe paint handling that is loose, rapid, irregular, gestural, dense, uneven, bravura, or Expressionist, or that calls attention to itself in any other way.

FORMALIST critics after World War II adopted Wölfflin's dualism as a strategy for championing ABSTRACT painting. Although the idea of "painterly painting" may seem redundant, it corresponds with MODERN notions of an art form's progressing toward its "essence"—in painting's case, an emphasis on flatness, color, and tactile paint surfaces.

The critic Clement Greenberg suggested calling ABSTRACT EXPRESSIONISM painterly abstraction, and in 1964 he curated an influential show of COLOR-FIELD and HARD-EDGE painting at the Los Angeles County Museum called Post-Painterly Abstraction.

Parallel Gallery. See ALTERNATIVE SPACE

Pathetic Art

- ▶ who Robert Blanchon, Jessica Diamond, Vincent Fecteau, Karen Finley, Robert Gober, Georg Herrold, Scott Hewicker, Mike Kelley, Cary S. Liebowitz/Candy Ass, Paul McCarthy, John Miller, Cady Noland, Raymond Pettibon, Kiki Smith, Luc Tuymans, Jeffrey Vallance
- ▶WHEN Mid-1980s through 1990s
- **▶WHERE** Primarily United States
- **WHAT** Pathetic art is shabby, unappealing, flawed, even embarrassing or off-putting. The expression of a distinct sensibility, it bears no resemblance to the expression of unintentional bad taste of KITSCH. In fact, pathetic art is a self-conscious response to the empty visual perfection and uplift of so many slick pop-cultural products, such as music videos and advertising. It is unclear who originated the term, but by 1990, when the critic Ralph Rugoff curated the traveling exhibition *Just Pathetic*, it was already common parlance. In an age of consumer-culture absurdities, public confession and redemption, therapy and self-help, pathetic art offers an effective vehicle for social commentary.

Pathetic art is not a STYLE but the embodiment of an attitude that rejects the model of the MODERNIST artist's quest for the heroic sublime. Self-deprecating and emotionally ambivalent, pathetic artworks reject the familiar notion of art as a quest or journey in favor of settling in the psychic terrain of failure and ineptitude. In three-dimensional works this attitude is often expressed through the use of cheap materials or shoddy craftsmanship; in two-dimensional works it tends to be embodied in a preference for cartoonlike drawings over the more status-laden format of paint on canvas. Examples include Cary S. Leibowitz's "loser" line of mugs and T-shirts; Cady Noland's *Chicken in a Basket* (1989), a shopping basket filled with a flag, a rubber chicken, and beer cans; and Raymond Pettibon's oblique, sometimes nonsensical amalgams of drawn images and snippets of text.

Some pathetic art functions at a deeper psychological level, however, and can be termed *abject* (an adjective synonymous with *wretched* or *miserable*). This term was occasionally heard in the early 1990s, often in conjunction with works touching on taboo themes related to gender and sexuality by such artists as Kiki Smith, Karen Finley, and Robert Gober. Los Angeles artists including Paul McCarthy and Mike Kelley emerged from a Southern California milieu marked by the earlier, psychologically dark explorations of ABJECT EXPRESSIONISM. McCarthy's sometimes

P

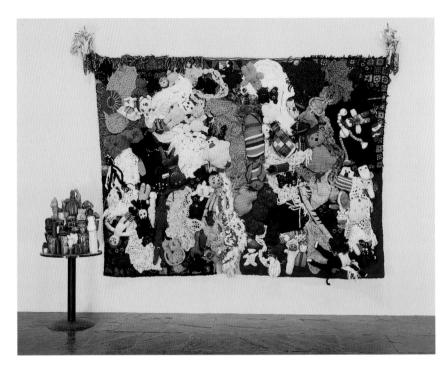

PATHETIC ART
Mike Kelley (1954–2012)
More Love Hours Than Can Ever Be Repaid
and The Wages of Sin, 1987
Stuffed fabric toys and afghans on canvas
with dried corn, 7 ft. 6 in. × 9 ft. 10¾ in. × 5 in.
(2.29 × 3.03 × 0.13 m), plus wax candles on
wood and metal base
Whitney Museum of American Art, New York

horrific representations of the nightmarish and repressed—whether performed, or photographed or filmed—are indebted to the work of the Viennese ACTIONISTS. He is drawn to the dark underbelly of the manufactured sunniness of postwar Southern California culture, a fascination shared by Kelley. The latter used his signature material, soiled stuffed animals, to create genuinely unnerving works about the reality of children's lives and childhood sexuality.

Pattern and Decoration

- ▶who Brad Davis, Tina Girouard, Valerie Jaudon, Joyce Kozloff, Robert Kushner, Kim MacConnel, Rodney Ripps, Miriam Schapiro, Ned Smyth, Robert Zakanitch
- ▶when Mid-1970s to early 1980s
- **▶WHERE** United States
- ▶ WHAT By the mid-twentieth century the adjective decorative was firmly established as an insult in contemporary art parlance. The prevailing critical view of decoration as trivial has rarely been shared by non-Western cultures, as is evident from the complex and sophisticated patterning of Islamic, Byzantine, and Celtic art. Inspired by such sources—as well as by carpets, quilts, fabrics, mosaics, and other crafts, both Eastern and Western—a group of artists in the mid-1970s began to create works that challenged the taboo against decorative art.

Unlike so many other "isms," Pattern and Decoration (or P and D) actually was a movement. Feeling alienated from the concerns of the mainstream art world, the Pattern-and-Decoration artists—many of them from Southern California—gathered in a series of meetings in Robert Zakanitch's New York studio during the fall of 1974. They met to

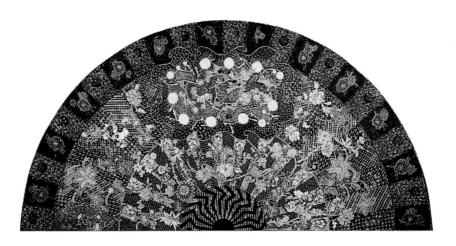

PATTERN AND DECORATION Miriam Schapiro (b. 1923) Black Bolero, 1980 Fabric, glitter, and paint on canvas, 6 × 12 ft. (1.8 × 3.7 m) Art Gallery of New South Wales, Sydney, Australia; Purchased 1982

discuss the nature of decoration and their attraction to it. Some had been influenced by the feminist concern for womanmade crafts such as quilts and Navajo blankets. Others, including the astute critic Amy Goldin, were fascinated with non-Western art forms. Their desire to raise the status of decoration in contemporary art resulted in a number of panel discussions and public presentations during 1975. Many of the Patternand-Decoration artists would soon begin to show with the then-fledgling New York art dealer Holly Solomon.

Although they were reacting against MINIMALISM, Pattern-and-Decoration artists often started with the same flattening grid frequently employed by Minimalist painters. The effects they achieved, however, are precisely the opposite of the rigorously theoretical Minimalist canvases. They produced large, boldly colored paintings or sewn works on unstretched fabric that suggest flower-patterned wallpaper (in the case of Robert Zakanitch), Japanese fans (by Miriam Schapiro), and Celtic-inspired interlaces (by Valerie Jaudon). Proceeding from an understanding of decoration's role not just in art but in domestic and public places, Pattern-and-Decoration artists also create functional objects and INSTALLATIONS—Ned Smyth and Joyce Kozloff in tile, Tina Girouard in linoleum, Kim MacConnel by painting on 1950s furniture.

Performance Art

- ▶ wно Vito Acconci, Laurie Anderson, Eleanor Antin, Anna Banana, Bob and Bob, Eric Bogosian, Stuart Brisley, Nancy Buchanan, Chris Burden, Scott Burton, Theresa Hak Kyung Cha, Ping Chong, Colette, Papo Colo, Paul Cotton, Ethyl Eichelberger, Jan Fabre, Karen Finley, Terry Fox, General Idea, Gilbert & George, Guillermo Gómez-Peña, Rebecca Horn, Joan Jonas, Tim Miller, Meredith Monk, Linda Montano, Nice Style—the World's First Pose Band, Luigi Ontani, Gina Pane, Mike Parr, Ulrike Rosenbach, Rachel Rosenthal, Jill Scott, Stelarc, Mark Tribe, the Waitresses. Robert Wilson
- ▶ **WHEN** Since the late 1960s
- **▶WHERE** International
- **PWHAT** The term *performance* art is extraordinarily open-ended. Since the late 1970s it has emerged as the most popular name for art activities that are presented before a live audience and that encompass elements of music, dance, poetry, theater, and video. The term is also retroactively applied to earlier live-art forms—such as BODY ART, HAPPENINGS, ACTIONS, and some FLUXUS and FEMINIST art activities. This diffusion in meaning has made the term far less precise and useful.

Starting in the late 1960s many artists wanted to communicate more directly with viewers than painting or sculpture allowed, and their ways of doing so were inspired by a variety of visual art sources. These ranged

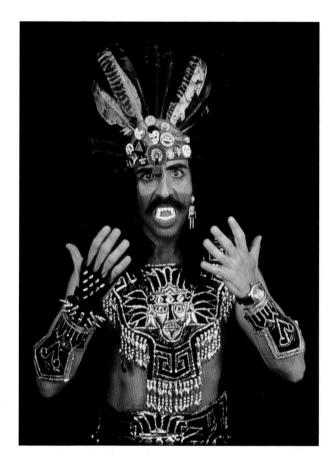

PERFORMANCE ART Guillermo Gómez-Peña (b. 1955) El Aztec Vampire, 1990

from early-twentieth-century DADA events (composer John Cage helped spread the word about them in postwar New York) to Jackson Pollock's painting for a film camera in 1950. Until the late 1970s artists specifically rejected the term *performance* for its theatrical implications.

The type of performance art that began in the late 1960s was primarily a CONCEPTUAL activity, and such events bore little resemblance to theater or dance. Instead, they took place in galleries or at outdoor sites, lasted anywhere from a few minutes to a few days, and were rarely intended to be repeated. A few examples suggest the variety of approaches to performance during this era. Starting in 1969 the British duo Gilbert & George dubbed themselves "living sculpture" and appeared as robotic art objects

194

in their exhibitions or on the streets of London. For Seedbed, part of his January 1972 show at New York's Sonnabend Gallery, Vito Acconci masturbated under a ramp on which audience members walked while listening to his microphone-amplified responses to their presence. Duet on Ice (1975) found Laurie Anderson on a Bologna street corner teetering on ice skates and playing classical and original compositions on the violin until the blocks of ice encasing the skate's blades melted. And in 1977 Leslie Labowitz created Record Companies Drag Their Feet, a performance designed to focus attention on the use of exploitative images of women on album covers and in society at large. Many artists of this generation (Scott Burton, Gilbert & George, and Vito Acconci among them) eventually moved from making performances to making art objects.

A second generation of performance artists emerged in the late 1970s. Rejecting the austerity of Conceptual art and its traditionally critical approach to POPULAR CULTURE, the first generation of artists raised on TV moved performance out of the galleries. Performance can now be seen in theaters, in clubs (as music or stand-up comedy), and on videotape or online. Performance, usually with striking visual elements, often seems synonymous with avant-garde dance, drama, or music. The 1980s has produced numerous "cross-over" talents whose roots can be traced to performance and the visual arts. They include the musicians Laurie Anderson and David Byrne, the actors Ann Magnuson and Spalding Gray, the comics Whoopi Goldberg and Eric Bogosian, the new vaudevillian Bill Irwin, and the opera designer Robert Wilson.

Photomontage. See COLLAGE

Photo-Realism

- **▶ wно Robert Bechtle**, John Clem Clarke, **Chuck Close**, Robert Cottingham, Rackstraw Downes, Don Eddy, **Richard Estes**, Audrey Flack, Ralph Goings, Richard McLean, **Malcolm Morley**
- **▶WHEN** Mid-1960s to mid-1970s
- **▶WHERE** Primarily the United States
- ▶ WHAT The New York art dealer Louis Meisel is generally credited with originating the term Photo-Realism. (It prevailed over Realism, Sharp-Focus Realism, and, in Europe, Hyper-Realism.) Photo-Realism is just what the name implies: a type of REALIST painting whose subject is the photograph, or the photographic vision of reality. In his painting of a family posed in front of its late 1950s car, Robert Bechtle, for instance, was more concerned with the flattening effect of the camera on the image than with the nostalgic depiction of suburban family life. Put another way, it is the photographic effect that interests many Photo-Realist painters as much as their subjects.

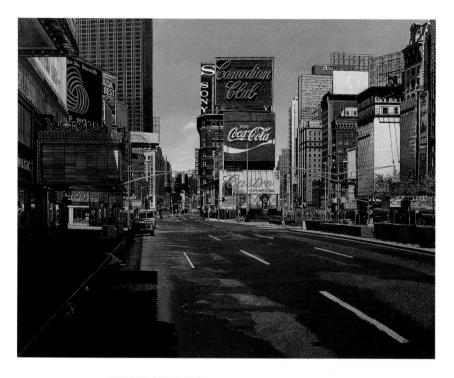

PHOTO-REALISM Richard Estes (b. 1932) Canadian Club, 1974 Oil on masonite, 48 × 60 in. (122 × 152 cm) Private collection

Most Photo-Realists specialize in a certain type of subject: Richard Estes in photographs of highly reflective windows; Audrey Flack in photographs of symbolic still lifes seen from above; and Malcolm Morley in photographs of travelers on glamorous cruise ships. The polyvinyl sculptures of Duane Hanson and John De Andrea—who work from casts of clothed or unclothed models—can be considered the three-dimensional equivalent of Photo-Realism.

When Photo-Realist paintings appeared in large numbers at Documenta 5—the 1972 version of the important German mega-exhibition—most critics derided it as intolerably backward looking. In fact, the banality of the images, the technique of painting from slides projected onto the canvas, the shallow pictorial space, and the use of thinly applied acrylic paint link many Photo-Realist paintings with POP ART.

Picture Plane

The concept of a picture plane originated during the Renaissance and spurred the development of the principles of perspective. It is not the physical surface of a painting but an imaginary one, which theorists and critics have traditionally equated with a window separating viewers from the image. The picture plane can be "punctured" in a variety of ways: by the depiction of an out-of-scale object in the foreground that appears to occupy the space between the forward limits of the pictorial space and the viewer, or—in the case of an ABSTRACTION—by the inclusion of an illusionistic rendering of, say, an X painted with its shadow so it appears to leap off the surface of an otherwise flat composition. FORMALIST critics of the 1950s and '60s inveighed against violations of the "integrity of the picture place" (a common phrase) in pursuit of absolute flatness.

Pictures Generation

▶who Troy Brauntuch, Gregory Crewdson, Jack Goldstein, Louise Lawler, Sherrie Levine, Robert Longo, Richard Prince, Cindy Sherman, Laurie Simmons

▶WHEN Late 1970s to 1980s

▶WHERE United States

▶ WHAT The Pictures Generation takes its name from a 2009 exhibition at the Metropolitan Museum of Art (*The Pictures Generation*, 1974–84), which in turn tips its hat to the 1977 show *Pictures*, curated by the art historian Douglas Crimp at the Artists Space gallery in New York. The Metropolitan Museum show included artists who were not represented in the initial exhibition—such as Cindy Sherman and Laurie Simmons—but all of them had been casually referred to as "pictures artists" since the 1990s, probably for want of a better name.

The artists of the Pictures Generation were mostly graduates of the California Institute of the Arts at Valencia (CalArts) and the Department of Visual Studies of the University at Buffalo (also known as SUNY Buffalo), both known for their adventurous curricula. When Artists Space director Helene Winer founded the Metro Pictures Gallery with Janelle Reiring in 1980, many of these artists would find a congenial home there.

The members of the Pictures Generation were linked by their attraction to photography's mechanically reproduced image, which they put to distinctly "unphotographic" purposes. Like the CONCEPTUALISTS before them, these artists rejected the goal of creating a "truthful" photographic image; instead, they pursued a larger project of deconstructing the media-age culture in which photographs play so large a role. The photographic image inflected and infected every aspect of contemporary

196

PICTURES GENERATION
Louise Lawler (b. 1947)
Persimmon and Bottle, 1993/2010
Cibachrome face-mounted to plexiglass on museum box, 37¾ × 29 in. (95.9 × 73.7 cm)
Metro Pictures, New York

life, enabling these artists to engage with every imaginable element of contemporary culture.

Their varied approaches included the APPROPRIATION art of Sherrie Levine and Richard Prince—her indistinguishable copies of Walker Evans's photo-portraits of his son, and his photographic replicas of advertising images like the Marlboro Man—which raise issues of authorship, originality, and gender. The elaborate STAGED PHOTOGRAPHS by Gregory Crewdson, resembling scenes from a Hollywood production,

198

would, like Sherman's and Simmons's pictures, assault traditional notions of photographic reality by creating imagery solely in order to photograph it.

Film might be considered a more advanced version of "mechanical reproduction," which introduced the wondrous and fearsome spectacle of flickering lifelike images. In this medium, too, the Pictures Generation pursued varied courses, with results ranging from Jack Goldstein's *Metro-Goldwyn-Mayer* (1975), his repetitious yet oddly dramatic presentation of the leonine corporate logo roaring for two minutes straight, to Sherman's *Untitled Film Stills* (1977–80), self-portraits in varied costumes that suggest unknown films by iconic directors. Robert Longo and Sherman would also make narrative movies in the 1990s, the former an expensive science-fiction film for Hollywood and the latter an independent, and quirky, genre thriller.

Pluralism

Pluralism is the opposite of a clearly defined mainstream. It refers to the coexistence of multiple STYLES in which no single approach commands the lion's share of support or attention. Although all kinds of art—from REALIST to ABSTRACT and Impressionist to EXPRESSIONIST—were produced simultaneously throughout the MODERN period, in the 1920s modern art began to be regarded as a tidy succession of styles originating in the late nineteenth century. During the 1950s ABSTRACT EXPRESSIONISM was seen as the culmination of that development, and critical interest was focused on it to the exclusion of other approaches.

By the mid-1960s a more variegated tapestry of contemporary art was being woven: POP ART, COLOR-FIELD PAINTING, and MINIMALISM were all receiving critical and commercial attention. The 1970s were pluralist with a vengeance. New styles and new media included ARTE POVERA, CONCEPTUAL ART, CRAFTS-AS-ART, EARTH ART, FEMINIST ART, MEDIA ART, PATTERN AND DECORATION, PERFORMANCE, and VIDEO, among many others. The pluralism of the 1970s clearly sprang from the political and cultural upheavals of the late 1960s. Women, for instance, achieved quantitatively larger representation in the art world than at any time before or since.

The complexity of the pluralist art scene of the 1970s—the decade most associated with pluralism—alienated some observers. Critics hostile to pluralism decried the emphasis on forms other than painting and sculpture, which demanded radically new criteria of evaluation. Others viewed the situation as open rather than chaotic and maintained that it more accurately reflected the diversity of contemporary society. The subsequent decline of NEO-EXPRESSIONISM in the mid-1980s has been followed by a pluralist situation in which virtually all forms of work are exhibited and written about.

Political Art

Every artwork is political in the sense that it offers a perspective—direct or indirect—on social relations. Andy Warhol's images of Campbell's soup cans, for instance, celebrate consumer culture rather than criticize it. Jackson Pollock's ABSTRACTIONS proclaim the role of the artist as a free agent unencumbered by the demands of creating recognizable images. The politics are almost invariably easier to spot in pre-MODERN works, such as portraits of kings or popes that frankly announce themselves as emblems of social power.

Milestones of twentieth-century political art include Soviet avant-garde art from about 1920, Mexican mural paintings and the United States' WPA projects of the 1930s, Pablo Picasso's Guernica (1937), and the American sculptor David Smith's antifascist Medals for Dishonor (1936–40). Many of these works take leftist positions supporting the distribution of art to mass audiences or criticizing official policies. Right-wing views were expressed in the art and architecture of the Nazi

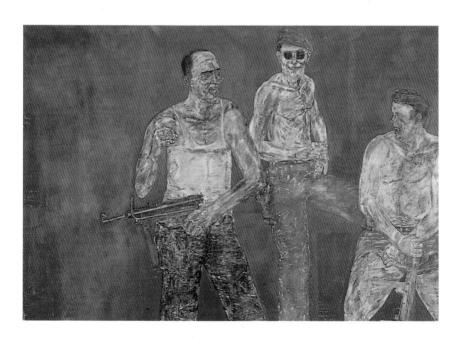

POLITICAL ART Leon Golub (1922–2004) Mercenaries II, 1979 Acrylic on loose canvas, 10 × 12 ft. (3.05 × 3.66 m) Montreal Museum of Fine Arts; Purchase, Horsley and Annie Townsend Bequest

In current usage *political art* refers to works with overtly political subjects made to express criticism of the status quo. Political artists include Rudolf Baranik, Joseph Beuys, Victor Burgin, Sue Coe, Robbie Conal, Harun Farocki, Leon Ferrari, Ganzeer (Mohamad Fahmy), Leon Golub, Guillermo Gómez-Peña, Hans Haacke, Mona Hatoum, Jerry Kearns, Suzanne Lacy, Shirin Neshat, Hélio Oiticica, Martha Rosler, May Stevens, and collective groups such as the Border Art Workshop, Critical Art Ensemble, Feminist Art Workers, Gran Fury, Group Material, the Guerrilla Girls, and the Otolith Group. The efficacy of political art becomes a thornier matter when questions of distribution, context, and audience are considered. Can a painting sold for \$100,000 to a bank or a multinational corporation function critically?

Some politically inclined artists have turned to CONCEPTUAL ART or to making posters for the street in order to control not only the production of their art but also its distribution and context. Others, known as SOCIAL PRACTICE artists, have concentrated on projects that rely on the participation of others, usually non-artists, to transmit messages encouraging good citizenship or personal growth. Such works—which are likely to strike some viewers as far from art's traditional concerns—are better thought of as socially engaged than political.

Political Pop

- ▶wно Feng Mengbo, Li Shan, Liu Fenghua, Luo Brothers, Qi Zhilong, Ren Sihong, Sheng Qi, Wang Guangyi, Wang Xingwei, Wang Ziwei, Yu Youhan, Zhang Hongtu
- **▶WHEN** 1989 to 2004
- **▶where** China
- ▶ WHAT The critic Li Xianting coined the term Political Pop shortly after the fact, in a 1992 article in the Hong Kong journal The Twenty-First Century. In the same piece, he also named another style, CYNICAL REALISM; together, he claimed, these approaches captured the ironic mood

200

of China after 1989. Indeed, examples of the two can sometimes be hard to tell apart, due to their shared characteristics.

American POP ART was first seen in China in Robert Rauschenberg's 1985 show at the China Art Gallery in Beijing (now the National Art Museum of China), which was sponsored by the artist's own Rauschenberg Overseas Cultural Interchange (ROCI). In addition to works made in the West, Rauschenberg exhibited a series of prints collaged from photographs he took during a 1982 trip to China. This influential show reached huge audiences—as did such contemporary popular-media phenomena as China's first televised lottery, which drew 200 million viewers, and its first broadcast of a U.S. Super Bowl, which drew 300 million.

Although Political Pop began to be made in the late 1980s, it remained an almost underground movement inside China until the 1993 exhibition *China's New Art, Post-1989* at the Hong Kong Arts Centre. Political Pop is derived from Western Pop art's visually arresting depictions of everyday subjects in styles borrowed from comics and advertising. Its political dimension lies in its exposure—through playful artistic means involving pastiche, parody, irreverence, and cynicism—of the similarities between the ideological power of advertising and that of state-sponsored propaganda. The subjects of Political Pop are typically appropriated from both Chinese propaganda and Western culture, in the form of either consumer goods or pop icons such as Marilyn Monroe and Michael Jackson. (In the mid-1990s Li would also coin the term *Gaudy Art* to describe a closely related approach that garishly combines the imagery of consumer culture, folk art, and KITSCH, as in the work of the Luo Brothers or the American Jeff Koons.)

The most popular subject of all was Mao Zedong, usually portrayed in caricature. The official tolerance of such treatment was surprising. In his *Untitled (Mao/Marilyn)* (2005), Yu Youhan merged two Warhol-derived images of his subjects, resulting in a brightly colored androgynous blend. This manipulation of Mao's gender and sexuality is common in works by Political Pop artists, most notably those of Li Shan, such as his iconic *Blue Mao* (2005).

The mediums and techniques of Political Pop ran the gamut from painting, photography, and video to bronze, stone, and FOUND OBJECTS. Perhaps most noteworthy among the non-painters is Feng Mengbo, who employs non-art formats such as video games in his electronic art. His Taking Mount Doom by Strategy (1997) is an interactive gaming platform that blends the idealized Cultural Revolution—era opera Taking Tiger Mountain by Strategy and the violent Western video game Doom. This combination of state-sponsored culture and corporate-produced diversion inspires reflection about the conjoined relationship of political power and economic violence.

POLITICAL POP Feng Mengbo (b. 1966) Long March: Restart, 2008 Interactive installation: video game Edition of 8

Political Correctness. See CULTURE WARS

Pop Art

▶ WHO Robert Arneson, Klaus Brehmer, Jim Dine, Equipo Crónica, Öyvind Fahlström, Richard Hamilton, David Hockney, Karl Hödicke, Robert Indiana, R. B. Kitaj, Roy Lichtenstein, Konrad Lueg, Claes Oldenburg, Eduardo Paolozzi, Sigmar Polke, Mel Ramos, Gerhard Richter, James Rosenquist, Ed Ruscha, Wayne Thiebaud, Wolf Vostell, Andy Warhol, Tom Wesselmann

▶ WHEN Late 1950s through 1960s

- ▶ WHERE Primarily Great Britain and the United States, but also Germany; global in influence
- ▶ WHAT Pop art stands for popular art. The term Pop art first appeared in print in an article by the British critic Lawrence Alloway, "The Arts and the Mass Media," which was published in the February 1958 issue of Architectural Design. Although Pop art is usually associated with the early 1960s (Time, Life, and Newsweek magazines all ran cover stories on it in 1962), its roots are buried in the 1950s. The first Pop work is thought to be Richard Hamilton's witty COLLAGE of a house inhabited by fugitives from the ad pages called Just What Is It That Makes Today's Homes So Different, So Appealing? (1956). That work was first seen at This Is Tomorrow, an exhibition devoted to POPULAR CULTURE, by the Independent Group of the Institute of Contemporary Arts in London. The show that thrust Pop art into America's consciousness was The New Realists, held at New York's Sidney Janis Gallery in November 1962. A German variant of Pop art known as Capitalist Realism (the term is attributed to Gerhard Richter) debuted in a show of the same name at the René Block Gallery in Berlin in 1964.

Precedents for Pop art include DADA, with its interest in consumer objects and urban debris, and the paintings and collages of Stuart Davis, an American MODERNIST who used Lucky Strike cigarette packaging as a subject in the 1920s. Chronologically closer at hand, Jasper Johns's NEO-DADA paintings of everyday symbols like the flag were crucially important to American Pop artists. Some observers regard NOUVEAU RÉALISME as the precursor of Pop. In fact, the rapprochement with popular culture that was epitomized by Pop art seems to have been part of the ZEITGEIST of the 1950s in England, France, and the United States.

Popular culture—including advertising and the media—provided subjects for Pop artists. Andy Warhol mined the media for his iconic paintings and silkscreened prints of celebrities such as Marilyn Monroe, and Roy Lichtenstein borrowed the imagery and look of comic strips for his drawings and paintings. Claes Oldenburg transformed commonplace objects like clothespins and ice bags into subjects for his witty large-scale monuments.

Pop art was simultaneously a celebration of postwar consumerism and a reaction against ABSTRACT EXPRESSIONISM. Rejecting the Abstract Expressionist artist's heroic personal stance and the spiritual or psychological content of his work, Pop artists took a more playful and ironic approach to art and life. Pop painting did not, however, eschew the spatial flatness that had come to characterize twentieth-century avantgarde painting.

POSTMODERNISM, NEO-GEO, and APPROPRIATION art—grounded in popular culture, the mass media, and SEMIOTIC interpretation—could never have happened without the precedent of Pop art.

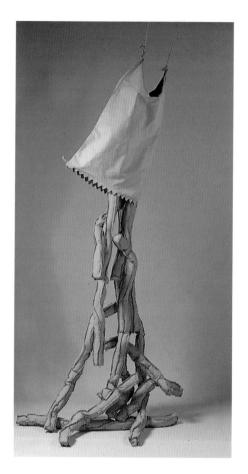

POP ART Claes Oldenburg (b. 1929) Falling Shoestring Potatoes, 1965 Painted canvas and kapok, 108 × 46 × 42 in. (274.3 × 116.8 × 106.7 cm) Walker Art Center, Minneapolis; Gift of the T. B. Walker Foundation, 1966

Popular Culture

Popular culture used to be called *mass culture*, which is now an outmoded term. Made up of a multitude of forms of cultural communication—illustrated newspapers, movies, jazz, pop music, radio, cabaret, advertising, comics, detective novels, television—it is a distinctly MODERN phenomenon that was born in urban Western Europe during the nineteenth

century. A nascent working class with a bit of leisure time on its hands created a demand for new art forms that were more accessible than opera, classical music, ACADEMIC painting, traditional theater, and literature. Those elite art forms, developed for aristocratic audiences, required education to be understood. They are known as high art; popular (or pop) culture is often referred to as low art. The competition between high and low culture peaked in the 1950s and '60s with debates over whether intellectuals (and children) should watch television, whether POP ART was art, and other cultural controversies.

For the first half of the twentieth century, the gulf separating high art and popular culture was cavernous. Modern art regarded itself as revolutionary and critical of bourgeois, or middle-class, culture. Uncompromisingly idealistic and frequently hard to sell, it stood apart from commerce. Popular culture, on the other hand, was defined by its commercial success or failure. Although many modern artists were fascinated with jazz or the movies of Charlie Chaplin, their fascination surfaced only indirectly in their art. The popular entertainments offered at music halls and cabarets, for instance, were frequently portrayed by early modern painters. But for the most part they made paintings of these nightspots, rather than inexpensive prints or advertising posters. The high-art status of their works was never in doubt.

With the advent of Pop art about 1960, this changed. Art was no longer insulated from the consumer-oriented imagery that had become so distinctive a feature of mid-twentieth-century life. The seeds of the symbiotic relationship between art and popular culture that were planted in the Pop art of the 1960s blossomed in the CONCEPTUAL ART of the 1970s. PERFORMANCE, MEDIA, and VIDEO artists of the second half of that decade frequently took as their subjects pop-cultural forms, including soap operas, pulp novels, and advertisements. Ironically, this reconciliation between popular culture and high art signaled the success of the modernist demand for the portrayal of contemporary experience. Artists could no longer see themselves as beleaguered outsiders confronting a backward-looking bourgeois establishment. (Many began to appear in liquor advertisements beginning in the mid-1980s.) In POSTMODERN art, hostility toward popular culture has been replaced by direct engagement with it. NEO-EXPRESSIONIST painters, for example, were just as likely to take their motifs from Saturday-morning cartoons as from arthistorical depictions of Marie Antoinette frolicking in milkmaid's attire.

See KITSCH

Post-

The prefix post- signifies after. Post-MINIMALISM means "after MINIMALISM," POSTMODERNISM means "after MODERNISM," and so on. The use of the term is a modern development. It was first applied to

the Post-Impressionists—Paul Cézanne, Paul Gauguin, Georges Seurat, Vincent van Gogh, and others—the major French painters who followed the Impressionists.

That these painters shared little besides their excellence and their historical moment points to the problematic nature of post—save in such objective terms as postwar. Its use is likely to mislead or mask the real meaning of movements or artworks by implying that they are primarily reactions to what preceded them rather than independent phenomena. (The term neo—meaning "new," as in NEO-EXPRESSIONISM—is similarly problematic.) Ultimately, this rush to judgment—we usually think of new work in terms of what we already know—results in a linear but not necessarily accurate vision of history. Such terms frequently obscure, rather than enhance, the understanding of art.

Postal Art. See MAIL ART

Post-Minimalism. See MINIMALISM

Postmodernism

The term postmodernism probably first appeared in print in Joseph Hudnot's Architecture and the Spirit of Man (1949). Charles Jencks helped popularize it two decades later, when it was also widely invoked in connection with Judson-style dance, which was named after the Judson Memorial Church in Greenwich Village and championed everyday or "vernacular" movement. It was not until the late 1970s that the term began to be routinely used by art critics. Its definition was so vague then that it meant little more than "after MODERNISM" and typically implied "against modernism."

Many theorists believe that the transition from modernism to postmodernism signified an epochal shift in consciousness corresponding to momentous changes in the contemporary social and economic order. The intertwined nature of that economic (and financial) system was revealed in the near-global meltdown that was triggered in the U.S. in 2007 and quickly affected a majority of nations around the globe. Digital communication has spurred changes as widespread as those associated with Gutenberg's invention of the printing press. It has enabled the almost-instant transmission of ideas and information nearly everywhere, serving as a potent tool not only in the workplace but also on the streets, in times of social unrest and revolution. Postmodern or postindustrial capitalism has successfully promoted a consumerist vision that is causing a rapid redrawing of the East-West boundaries established after World War II. The ecological revolt that dawned during the 1960s—as did most of the changes that distinguish postmodernism from

206

P ___

modernism—signaled a loss of modern faith in technological progress, which was replaced by postmodern ambivalence about the effects of that "progress" on the environment. Just as modern culture was driven by the need to come to terms with the industrial age, so postmodernism has been fueled by the desire for accommodation with the electronic age.

Following World War II, modern art making and art theory grew more reductive, more prescriptive, more oriented toward a single, generally abstract mainstream. (Many other kinds of art were being produced, but that kind of art and theory received the bulk of support from the art establishment.) With MINIMALISM, artists of the 1960s reached ground zero—creating forms stripped down almost to invisibility—and the historical pendulum was set back in motion. Modernism's unyielding optimism and idealism gave way to the broader, albeit darker, emotional range of postmodernism.

Building directly on the POP, CONCEPTUAL, and FEMINIST ART innovations of the 1960s and '70s, postmodernists have revived various genres, subjects, and effects that had been scorned by modernists. The architect Robert Venturi succinctly expressed this reactive aspect of postmodernism by noting, in his influential treatise *Complexity and Contradiction in Architecture* (1966), a preference for "elements which are hybrid rather than 'pure,' compromising rather than 'clean,' ambiguous rather than 'articulated,' perverse as well as 'interesting.'"

It is important to distinguish what is new about postmodernism from what is a reaction against modernism. In the latter category is the widespread return to traditional genres such as landscape and history painting, which had been rejected by many modernists in favor of ABSTRACTION, and a turning away from experimental formats such as PERFORMANCE ART and INSTALLATIONS. APPROPRIATION artists challenge the cherished modern notion of avant-garde originality by borrowing images from the media or the history of art and re-presenting them in new juxtapositions or arrangements that paradoxically function in the art world as celebrated examples of innovation or a new avant-garde. Such practices are one source of the difficulty in defining this openended term—many commentators speak of postmodernisms, plural.

One distinctly new aspect of postmodernism is the dissolution of traditional categories. The divisions between art, POPULAR CULTURE, and even the media have been eroded by many artists. Hybrid art forms such as furniture-sculpture are now common. In terms of theorizing about art, earlier distinctions between art criticism, sociology, anthropology, and journalism have become nonexistent in the work of such renowned postmodern theorists as Michel Foucault, Jean Baudrillard, and Fredric Jameson.

Perhaps the clearest distinction between modern and postmodern art involves the sociology of the art world. The booming art market of the

208

1980s fatally undermined the modern, romantic image of the artist as an impoverished and alienated outsider. What many term the Vincent van Gogh model of the tormented artist has been replaced by the premodern ideal of the artist as a (wo)man of the world, à la Peter Paul Rubens, the wealthy Flemish artist and diplomat who traveled widely throughout European society during the seventeenth century. The postmodern phenomenon of retrospective exhibitions for acclaimed artists in their thirties puts heavy pressure on artists to succeed at an early age and frequently results in compromises between career concerns and artistic goals, a problem unknown to the generations of modern artists who preceded them.

Post-Painterly Abstraction. See COLOR-FIELD PAINTING

Primary Market. See ART MARKET

Primary Structure. See MINIMALISM

Primitivism

There are several kinds of primitivism. There is art by prehistoric or non-Western peoples. (In this case the terms *primitive* and *primitivism* frequently appear in quotes to suggest the inaccuracy and ethnocentricity of such characterizations.) There are subjects or forms borrowed from non-Western sources, including Paul Gauguin's renderings of Tahitian motifs and Pablo Picasso's use of forms derived from African sculpture. There is also work by artists who are self-taught, but *primitivism* is rarely used that way anymore.

The idea of primitivism stems in large part from the sentimental notion of the "Noble Savage" as a superior being untainted by civilization, which was popularized by the eighteenth-century French philosopher Jean-Jacques Rousseau. Imperial conquests in Asia, Africa, and Oceania brought exotic foreign cultures to the attention of Europeans. Showcased in the spectacular expositions and fairs of the nineteenth century, the arts and crafts of non-Western peoples offered artists expressive, non-naturalistic alternatives to the illusionistic tradition that had prevailed in Western art since the Renaissance.

The desire to express a truth that transcended mere fidelity to appearance was a fundamental tenet of MODERNISM. Although non-Western art provided many European artists with a model for emotive and sometimes antirational art, they frequently misinterpreted it. Fierce-looking West African masks, for instance, were seen as representations of the mask maker's own inflamed feelings, when they were actually produced as talismans to insure a tribe's good fortune in battle.

The compelling desire to invest art with emotional or spiritual authenticity distinguishes modern from Victorian art, which tried to instruct or divert viewers. To communicate genuine feeling, modern artists turned to a multitude of primitivizing forms and approaches. The motif of the shaman in Feminist, Action, and Performance art alludes to the prehistoric connection between art, religion, and magic. Earth art may evoke prehistoric places of worship. The abundance of childlike imagery in modern art, epitomized in paintings by Paul Klee, embodies the related yearning to escape adulthood and "civilized" social responsibilities. The Graffiti or art brut artist's role as a social outsider implies the rejection of an over-civilized world. In Western culture, romantic myths of primitivism are among the most enduring ideas of the last two hundred years.

See the other

Print Revival

- ▶ WHO The foremost printer-publishers are Cirrus Editions Limited (Los Angeles); Crown Point Press (San Francisco); Experimental Workshop (San Francisco); Gemini G.E.L. (Graphics Editions Limited) (Los Angeles); Landfall Press (Chicago); Parasol Press Ltd. (New York); Tamarind Lithography Workshop (Albuquerque); Tyler Graphics, Ltd. (Mount Kisco, New York); Universal Limited Art Editions (ULAE) (West Islip, New York)
- ▶ **WHEN** Since the late 1950s
- **▶WHERE** United States
- ▶ WHAT Print revival is actually a misnomer, because the European tradition of collaboration between printmakers and artists had never been institutionalized in the United States in the first place. A few pre-World War II American MODERNISTS, such as John Marin and Edward Hopper, did make prints, but their output was irregular and tended to be synonymous with "scratchy" etchings.

The distance separating American artists and printmakers began to shrink in the late 1930s as European artists fleeing Hitler arrived in New York. Along with them came Stanley William Hayter, the renowned English printer who moved his printmaking studio, Atelier 17, from Paris to New York in 1941. He collaborated with such artists as Mark Rothko and Willem de Kooning, instructing them in numerous lithographic and etching techniques. In 1950 he returned to Paris, although New York's Atelier 17 remained open until 1955.

The print revival began in earnest when Tatyana Grosman opened Universal Limited Art Editions in West Islip on Long Island in 1957, followed by the artist June Wayne's establishment of Tamarind Lithography Workshop in 1960 in Los Angeles. Grosman and Wayne are widely

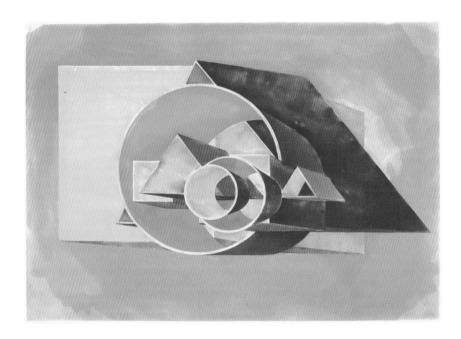

PRINT REVIVAL
Al Held (1928–2005)
Fly Away, 1992
Color spit bit aquatint, image:
20¾ × 30 in. (52.7 × 76.2 cm), sheet:
31¾ × 39½ in. (80.6 × 100.3 cm)
Published by Crown Point Press,
San Francisco; edition of 50

credited with initiating unprecedented interest in American lithography; Kathan Brown would soon do the same for etching at Crown Point Press in the San Francisco Bay Area. All three enabled the most critically acclaimed contemporary artists to experiment with printmaking in collaboration with master printers.

A milestone in the history of American printmaking was the production of Robert Rauschenberg's six foot (1.8 m) tall Booster (1967) at Gemini G.E.L. At that time the largest lithograph ever created, it mixed lithographic and screenprinting techniques to achieve the effects that Rauschenberg desired. Conceptual artists' emphasis on finding the appropriate means to realize an idea stimulated printers and artists to experiment. This spirit of innovation and eclecticism has been America's major contribution to printmaking. Similar approaches are now common in Europe, having been pioneered at the Kelpra Studio in

P

London, where founder Chris Prater began working with artists in 1961. Today there are few contemporary artists of note throughout Europe, Latin America, and the United States who do not include printmaking in their repertoire.

See MULTIPLE

Process Art

- ▶who Lynda Benglis, Joseph Beuys, Agnes Denes, Sam Gilliam, Hans Haacke, Eva Hesse, Jannis Kounellis, Robert Morris, Richard Serra, Keith Sonnier
- ▶ WHEN Mid-1960s to early 1970s
- **▶ WHERE** United States and Western Europe
- ▶ WHAT In process art the means count for more than the ends. The artist sets a process in motion and awaits the results. Eva Hesse used malleable materials like fiberglass and latex to create ABSTRACT forms that seem to spring from the interactions of her unstable materials and that are slowly decomposing over time. In Hans Haacke's plexiglass cubes, or "weather boxes," water condenses and evaporates in response to the changing levels of light and temperature in the gallery.

Process art was "certified" by two important museum exhibitions in 1969: When Attitudes Become Form, curated by Harold Szeeman for the Bern Kunsthalle, and Procedures/Materials, curated by James Monte and Marcia Tucker for the Whitney Museum of American Art in New York. Antecedents of process art include Jackson Pollock's ABSTRACT EXPRESSIONIST poured paintings and the slightly later stain paintings by COLOR-FIELD artists such as Helen Frankenthaler. For Pollock and Frankenthaler, the appearance of their work depended partly on chancy processes and the viscosity of specific paints.

MINIMALISM was a crucial catalyst, for process artists reacted against its impersonality and FORMALISM. They sought to imbue their work with the impermanence of life by using materials such as ice, water, grass, wax, and felt. Instead of platonic, abstract forms that would be at home anywhere in the Western world, they made their works "site specific," sometimes by scattering components across a studio floor or outdoor setting.

Process artists' commitment to the creative process over the immutable art object reflects the 1960s interest in experience for its own sake. Also, they hoped to create nonprecious works with little allure for the newly booming art market. Process art should be considered alongside other anti-Minimalist trends of that day such as ARTE POVERA, CONCEPTUAL ART, EARTH ART, and PERFORMANCE ART.

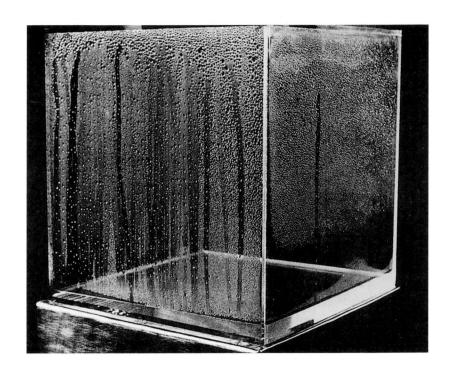

PROCESS ART Hans Haacke (b. 1936) Condensation Cube, 1963–65 Acrylic, plaster, water, and the climate in the area of the display, $11^{3}/4 \times 11^{3}/4 \times 11^{3}/4$ in. $(29.9 \times 29.9 \times$

Public Art

- ▶who Dennis Adams, John Ahearn, Siah Armajani, Alice Aycock, Judy Baca, Chris Burden, Scott Burton, Houston Conwill, Mark di Suvero, Peter Eisenman, Jackie Ferrara, R. M. Fischer, Richard Fleischner, Richard Haas, Lloyd Hamrol, Michael Heizer, Doug Hollis, Nancy Holt, Robert Irwin, Valerie Jaudon, Luis Jiménez, Joyce Kozloff, Roy Lichtenstein, Maya Lin, Mary Miss, Max Neuhaus, Isamu Noguchi, Claes Oldenburg, Tom Otterness, Albert Paley, Judy Pfaff, Martin Puryear, Wolfgang Robbe, Niki de Saint Phalle, Richard Serra, Tony Smith, Ned Smyth, Alan Sonfist. Rachel Whiteread
- **▶WHEN** Since the late 1960s
- **▶WHERE** United States

Р

▶ WHAT In the most general sense, public art is simply art produced for—and owned by—the community. This notion of art is as old as art itself, dating back to prehistoric cave-painting and idol-carving. The history of art encompasses far more examples of public than private art, ranging from the frescoes and sculpture of temples and cathedrals to the commemorative statuary created for public squares.

Radical changes came with MODERN art. The avant-garde search for the new was incompatible with the aim of reaching a wide public. So, too, was the modernist emphasis on the purity of individual art forms, which mandated that the traditional relationship of sculpture and architecture, for instance, be dissolved. By the late 1950s this had led to the construction of myriad unembellished buildings with ABSTRACT sculptures—what today's architects and public artists jokingly call "plop art"—placed on their sterile plazas.

The growth of public art in the U.S. is related to two government initiatives of the late 1960s: the percent-for-art programs and the National Endowment for the Arts' Art in Public Places program. The percent-for-art programs now operating in about half of the states and many cities and counties set aside for art a certain percentage (usually one percent) of the construction budget for a public project. The Art in Public Places program funded the creation or acquisition of more than seven hundred artworks between 1967 and 1995.

Changes in thinking about the nature of art itself in the late 1960s dovetailed with such official encouragement. Many artists were leaving their studios to create EARTH ART and other environmental forms that demanded an architectural rather than a studio scale. The challenges of realizing such complex projects provided artists with not merely the necessary skills but also the willingness to collaborate and give up the complete control that comes from working alone in a studio.

Public artworks range from Joyce Kozloff's tiled murals in subway stations to Max Neuhaus's SOUND SCULPTURES for similar sites; from Isamu Noguchi's multi-acre parks and plazas to Richard Haas's trompel'oeil murals that transform drab walls into architectural fantasies, and from Dennis Adams's politically probing bus-shelter images to Judy Baca's murals of the history of Los Angeles and its Hispanic communities painted on the concrete walls of the Los Angeles River. Artists are even designing what were once anonymous architectural elements, such as seating, lighting, and ornamental pavements.

Hostility to a small number of public artworks that some observers found inappropriate led to heated controversies in the 1980s. Maya Lin's abstract Vietnam Veterans Memorial in Washington, D.C., was augmented with Frederick Hart's more conventional FIGURATIVE sculpture, and Richard Serra's site-specific sculpture Tilted Arc was removed

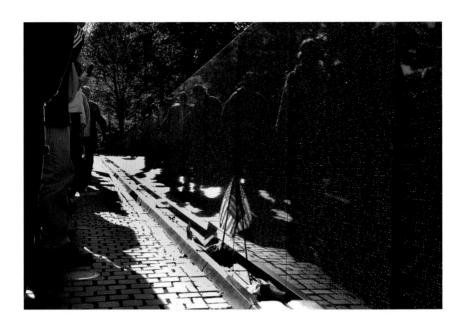

PUBLIC ART
Maya Lin (b. 1959)
Vietnam Veterans Memorial, 1982
Black granite, height: 10 ft. (3.05 m),
length of each wall: 250 ft. (76.22 m)
Constitution Gardens, Washington, D.C.

from its lower Manhattan site in 1989 after years of legal and administrative wrangling. One outcome of such disputes has been the widespread adoption of procedures that encourage greater community input and bring artists into the design process at an earlier stage, but are also prone to result in bland works calculated to avoid controversy. This is unfortunate given that public art—and especially the memorial—has become the primary social arena for dealing with seemingly intractable matters of identity and history. Although the memorial has been the province of stellar artists from Michelangelo to Rodin, today most proposals for them are solicited from designers and architects rather than from sculptors.

Public Practice. See SOCIAL PRACTICE

Queer Theory. See FEMINIST ART

Readymade. See FOUND OBJECT

Realism

Realist art—like realist literature—originated in mid-nineteenth-century France. It was pioneered by the painter Gustave Courbet, who announced that never having seen an angel, he could certainly never paint one. His resolve to be truthful to his own experience made him a forebear of MODERNISM.

In its original, nineteenth-century sense, *realism* implied not just the accurate depiction of nature, but an interest in down-to-earth everyday subjects. *Naturalism* referred only to an artist's fidelity to appearances. Carried to its illusionistic extreme, naturalism results in *trompe-l'oeil*—literally "fool-the-eye"—painting. By the mid-twentieth century the distinction between the two had largely disappeared, and today *realism* and *naturalism* are used interchangeably.

Apart from the SURREALISTS, who invented a naturalistic style of portraying their often unnatural dreams, and the German artists of the Neue Sachlichkeit (or New Objectivity) movement, who laced their realist portraits with biting psychological insights, avant-garde artists rejected realism in favor of ABSTRACTION. (Neue Sachlichkeit and Surrealist artists were roundly criticized for their use of recognizable figurative imagery.) During the 1950s realism seemed to disappear, save for the relatively unsung Kitchen Sink School in Great Britain. Their art was compared to the writings of the "Angry Young Men" playwrights because they shared an abrasive approach to downbeat domestic subjects. As the 1960s dawned, realism reemerged in the forms of POP ART and NEW REALISM. The scope of today's realism is capacious, most of it falling into the loose category of New Realism. Effective realist art, such as Eric Fischl's psychologically charged renderings of domestic drama, recalls the nineteenth-century sense of the term as a powerful means of commenting on—and illuminating—contemporary experience.

Regionalism

Regionalism has two meanings—one that predates World War II and one that follows it. The earlier use, which gained currency in the mid-1930s, applies to American artists of that day who rejected MODERNISM in favor of developing independent styles. The Regionalists—also known as the American Scene painters—included Thomas Hart Benton, Grant Wood, and John Steuart Curry. Although they were usually regarded as conservative defenders of family and flag, this view is oversimplified. Benton, for instance, held unorthodox views that were evident in his satirical paintings of midwestern life.

A second meaning of *regionalism* has emerged since World War II and New York's apotheosis as international art capital. As New York claimed center stage, artists in other centers of art-making activity, such as Los

Angeles, San Francisco, and Chicago, were relegated to marginal status. (Artists who worked in New York School-derived modes were considered mainstream no matter where they lived.)

Regionalism tends to be used pejoratively, with the connotation of provincialism. Unlike the prewar Regionalist "school," latter-day regionalism is largely a function of geography rather than philosophy. New York remains the center of the American art world, but its predominance is no longer exclusive. Decentralization has been fueled by real-estate costs that make New York a prohibitively expensive place for artists and critics to live, by the development of digital communications that allow the dissemination of alternative viewpoints, and by the emergence of art schools such as the California Institute of the Arts, which educated many of the most eminent American artists of the 1980s.

See bay area figurative style, chicago imagism, finish fetish

Relational Aesthetics. See SOCIAL PRACTICE

Representation

A representation is a depiction of a person, place, or thing. Representational refers to artworks with a recognizable subject, as opposed to works that are termed ABSTRACT.

The interpretation of representations is nearly synonymous with the study of images and symbols known as *iconography*. The study of representations may, however, range further afield than those of iconography, to address the mass-media aspects of POPULAR CULTURE such as advertising, which had previously been outside the art historian's scope. Such analyses are often interdisciplinary. The study of representations of the elderly, for example, might encompass images and texts found in the news media, film, advertising, and art of various cultures.

Rubber-Stamp Art. See MAIL ART

Saint Ives Painters

- ▶who Wilhelmina Barns-Graham, Jonathan Clark, Terry Frost, **Barbara**Hepworth, Patrick Heron, Roger Hilton, Peter Lanyon, Alexander
 MacKenzie, **Ben Nicholson**, John Wells, Bryan Wynter
- ▶ **WHEN** Mid-1940s through late 1950s
- **▶WHERE** Great Britain

216

S

▶ WHAT During the late nineteenth century, the term Saint Ives School referred to a now largely forgotten group of Victorian painters under the sway of John Ruskin's advocacy of naturalism in art. During World War II, the term began to be applied to a group of painters who gathered in Saint Ives, Cornwall, in part because of the presence of Barbara Hepworth and Ben Nicholson. Internationally renowned sculptors (Nicholson was also a painter), both husband and wife were pioneers of ABSTRACTION in Great Britain. In Saint Ives they encountered Peter Lanyon, a local painter, and an informal group developed around them that lasted long after the end of the war.

Stylistically, these painters were a diverse group, who ostensibly shared little with Hepworth and Nicholson. Despite that, the abstract orientation of the famous couple seems to have rubbed off on them. The younger painters—in part because of their wartime isolation in a remote part of the British countryside—tended to paint landscapes in brushy, GESTURAL styles that often resulted in highly abstract, if still recognizable, compositions. In historical terms, their role in encouraging EXPRESSIONISTIC and abstract approaches to British painting during the 1950s and early 1960s was crucial.

Salon. See ACADEMIC ART

Scatter Art

▶who Polly Apfelbaum, Nicole Eisenman, Tony Feher, Paula Hayes, Karen Kilimnik, Jack Pierson, **Jessica Stockholder**

▶WHEN 1990S

- **▶ WHERE** United States
- ▶ WHAT Scatter art—as the term implies—is the positioning of objects around the gallery in sometimes random-looking configurations. A subset of INSTALLATION art, it employs disparate items, often FOUND OBJECTS, to create a whole far greater than the sum of its parts. The term was occasionally heard during the 1970s, then began to appear regularly in reviews as a visually acute, if not otherwise very precise, descriptor of works by a new generation of neo-CONCEPTUAL artists in the early 1990s. The roots of scatter art lie in the PROCESS ART pioneered by Eva Hesse, Robert Morris, and Richard Serra from the mid-1960s through the early 1970s. Serra, for instance, flung, dribbled, and scattered molten lead around his studio in manifesto-like demonstrations of the mutability of art. Later, during the 1980s, Jonathan Borofsky created installations comprising hundreds of drawings and sculptures in arrangements that seemed to have resulted from the rampage of a hurricane through his studio.

Today's scatter artists have no single agenda. Their work is united by a stylistic approach relying on evocative juxtapositions of—and a casual attitude toward—materials, which often suggests the beauty available in the banal detritus of contemporary urban life. Jessica Stockholder tends to use brightly colored building materials to produce her ABSTRACT, three-dimensional compositions. Tony Feher often works with mundane objects such as packing foam or empty bottles to create installations evoking a range of themes, from AIDS to the place of the pastoral in our frenetic urban lives.

School of London

- **▶wно** Michael Andrews, Frank Auerbach, **Francis Bacon**, **Lucian Freud**, **R. B. Kitaj**, Leon Kossoff
- **▶WHERE** London
- ▶WHEN 1960s through 1980s
- ▶ WHAT The expatriate American artist R. B. Kitaj coined the term School of London for himself and a few other London-based figurative painters in 1976, but conceded its vagueness at the outset. It was not until 1987 that their first group exhibition was held, which was titled A School of London: Six Figurative Painters and traveled throughout Europe. The group term seems to have caught on as the fame of the individuals associated with it increased, especially during the 1980s. The end of the group is marked by the deaths of Francis Bacon and Michael Andrews in the early 1990s.

During the 1960s these painters had socialized together at the Colony Room, a private club in London's Soho district whose doyenne was Muriel Belcher—a frequent subject of Bacon's portraits until her death in 1979. Despite their on-again, off-again social interaction, the group never really constituted a movement, and the term *School of London* reveals little about their art—or anything else. (Only one of the six, Leon Kossoff, was even born in London; four were born outside England.) The only crucial link among them is their use of figurative styles honed mostly during the 1950s, when late-modern ABSTRACTION was at its zenith. But the distances among them are surely far greater. Compare Kitaj's pop-cultural or literary imagery with Michael Andrews's late, poetic scenes of the Thames, or the painterly EXPRESSIONISM of Frank Auerbach with the spare, draftsmanlike paint application of Bacon. English art writers sometimes include within this group John Minton and John Craxton, who are not well known outside Great Britain.

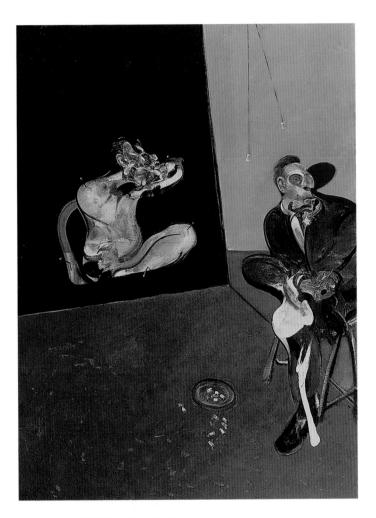

SCHOOL OF LONDON Francis Bacon (1909–1992) Two Studies for a Portrait of George Dyer, 1968 Oil on canvas, 78 × 58 in. (198.1 × 147.3 cm) Sara Hildén Art Museum, Tampere, Finland; Collection Sara Hildén

School of Paris is a rather vague term for numerous movements in MOD-ERN art that emanated from Paris during the first half of the twentieth century. Chief among them were Fauvism, Cubism, and SURREALISM.

The term also refers to Paris's pre-eminent position as the center of modern art from its inception until World War II. Following the war the United States came to dominate art making among the Western allies, just as it dominated the group's political and economic life. The New York School—beginning with ABSTRACT EXPRESSIONISM and including, according to some observers, COLOR-FIELD PAINTING and MINIMALISM—is invariably invoked in triumphant opposition to the School of Paris it "dethroned."

Secondary Market. See ART MARKET

Semiotics

All communication requires the use of signs, language itself being the most universal system of signs. Semiotics is the science of those signs. Although the term is several hundred years old, semiotics is largely a twentieth-century phenomenon. Semiotic analysis has been trained on numerous subjects, ranging from snapshots and comic strips to body language and the barking of dogs. Artists and critics became interested in it during the 1960s following the emergence of POP ART, which rejected the language of art in favor of that of advertising. CONCEPTUAL artists used the languagelike codes of the mass media, structural anthropology, and other disciplines previously outside the scope of art and impervious to FORMALIST criticism.

Semiotics is rooted in separate investigations by the Austrian philosopher Ludwig Wittgenstein and the Swiss linguist Ferdinand de Saussure early in the twentieth century. Instead of analyzing classical philosophical propositions or concepts involving ethics or aesthetics, they analyzed the language in which they were couched in search of their underlying nature and biases. Their work foretold the increasingly important role of communications and the packaging and promotion of ideas in MODERN culture. They noted that language provides the chief metaphor for organizing meaning, used to describe phenomena as dissimilar as the "genetic code" and the "fashion vocabulary."

Semiotics has provided an analytical tool for writers: Roland Barthes used it to analyze photography, and Umberto Eco applied it to architecture. Some artists—including the Conceptual and FEMINIST artists Judith Barry, Victor Burgin, Hans Haacke, and Mary Kelly—have deconstructed social stereotypes, myths, and clichés about gender and power that are communicated and reinforced by mass-media sign systems.

One and Three Chairs (1965), by the Conceptual artist Joseph Kosuth, exemplifies a semiotic approach to the nature of meaning. It comprises a wooden folding chair, a full-scale photograph of that chair, and the dictionary definition of *chair*. In the vocabulary of semiotics the wooden chair is a "signifier," the definition of *chair* is the "signified," and together they equal the "sign." Kosuth augmented this simple equation by providing the photograph of the chair as a substitute for the viewer's perception of the real chair, thereby suggesting that art—unlike semiotics—may not be reducible to scientific principles.

Set-Up Photography. See FABRICATED PHOTOGRAPHY

Shaped Canvas

- ▶who Lucio Fontana, Ellsworth Kelly, Kenneth Noland, Leon Polk Smith, Richard Smith, Frank Stella
- **▶WHEN** 1960s
- ▶ WHERE United States and Europe
- **WHAT** Paintings are usually rectangular, but circular pictures, or tondos, were popular in Europe during the Renaissance and there are examples of oval- and diamond-shaped canvases in early-twentieth-century art. The term *shaped canvas* gained currency as more than a neutral descriptor with the exhibition of Frank Stella's "notched" paintings at the Leo Castelli Gallery in New York in September 1960. These were MINIMALIST paintings in which symmetrically arranged pinstripes echoed the unconventional shape of the stretched canvas. The imagery and the underlying canvas were integrated; the painting became less an illusionistic rendering than an independent object, the two-dimensional counterpart of Minimalism's three-dimensional primary structures.

Although such works sometimes seemed to synthesize painting and sculpture, the intention was precisely the opposite. A single, extremely flat surface was maintained, in contrast to later multilevel three-dimensional ASSEMBLAGES and reliefs, most notably by Stella himself, that did obliterate the distinction between painting and sculpture. Contemporary painters have put the nonrectangular format to a variety of different purposes, ranging from the fragmented imagery spread across Elizabeth Murray's brash multicanvas works to the spirituality of Ron Janowich's ABSTRACTIONS.

S

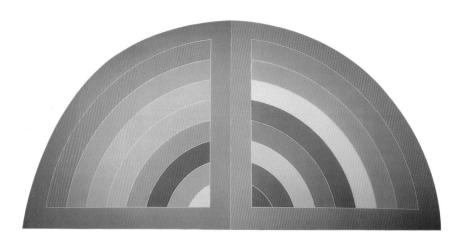

SHAPED CANVAS Frank Stella (b. 1936) Kufa Gate II, 1968 Synthetic polymer on canvas, 120 × 240 in. (3.05 × 6.1 m) Private collection

Simulacrum. See SIMULATION

Simulation

A simulation is a replica, something false or counterfeit. The terms simulation and simulacrum (the plural is simulacra) are virtually synonyms in the parlance of art. Although simulation can accurately be used to describe a forgery or the reenactment of a newsworthy event, in the art world it usually refers to the POSTMODERN outlook of Jean Baudrillard and other French thinkers whose beliefs became influential in the late 1970s.

Baudrillard asserted that we can no longer distinguish reality from our image of it, that images have replaced what they once described. Or, in the SEMIOTIC language of "The Precession of Simulcra," published first in the September 1983 issue of Art & Text, "It is no longer a question of imitation, nor of reduplication... [but] of substituting signs of the real for the real itself." Responding to new technology that facilitated the endless reproduction or cloning of information and images—television, fax machines, even genetic engineering—Baudrillard suggested that the notion of authenticity is essentially meaningless. His work poses the questions: What is an original? And where do public events leave off and the flow of images representing and interpreting them begin?

S

Baudrillard's line of reasoning dovetailed with some artists' concerns about the meaning of originality at the end of the MODERN era, an epoch that had placed so high a premium on avant-garde originality. Artists such as Sarah Charlesworth, Clegg & Guttmann, Peter Halley, Barbara Kruger, Sherrie Levine, Allan McCollum, and Richard Prince—and critics writing about them—often referred to Baudrillard's notion of the simulacrum. Many of these artists are associated with APPROPRIATION, the self-conscious use of images culled from art history or POPULAR CULTURE. During the mid-1980s the term simulationism was briefly popular.

Site Specific. See INSTALLATION

Situationism

- **▶wно** André Bertrand, Constant, **Guy Debord**, Pinot Gallizio, **Asger Jorn**, Spur Group
- **▶WHEN** 1957 to 1972
- **▶WHERE** Western Europe
- ▶ WHAT The Situationist International was founded in 1957 when two earlier avant-garde groups—the Lettrist International and the Movement for an Imaginist Bauhaus—formally merged. Highly theoretical, Situationism emerged from an analysis of Western society that indicted capitalism for its transformation of citizens into passive consumers of the depoliticized media spectacle that had replaced active participation in public life. (This viewpoint is best articulated in Guy Debord's influential 1967 book Society of the Spectacle.)

Situationism's roots can be traced back to the SURREALIST mission of radically disrupting conventional, bourgeois life. It can, in fact, be considered a postwar form of Surrealism, in which the emphasis on the psychological unconscious was replaced by an interest in the concepts of détournement (diversion or displacement), dérive (drift), and urbanisme unitaire (integrated city life). Urbanisme unitaire necessitated the creation of artworks that crossed the boundaries separating art forms—paintings larger than buildings, for instance—and of urban environments as locales for Situations, or meaningful social interactions.

These theoretical concerns were translated into a variety of artistic approaches with a shared intellectual foundation but no common STYLE. Asger Jorn exhibited "détourned" works painted over partially obliterated cheap reproductions of art, calling into question the value of originality and authorship. Pinot Gallizio created 475 foot (145 m) long, city-scaled "industrial" paintings satirizing automation, which he sold

by the meter. Magazines, posters, and films were also produced, primarily by the Spur Group and Debord.

By the mid-1960s Situationist art making had largely given way to theoretical writing and political organizing. The French general strike of May 1968 owed much to Situationist ideas and was immortalized in the Situationist posters and cartoons that embodied the goals of the student Left. The Situationist International was dissolved in 1972. A major Situationist exhibition, On the Passage of a Few People Through a Rather Brief Moment of Time, was mounted by the Centre Georges Pompidou in 1989 and proved controversial in its attempt to present this highly politicized movement through art objects and historical artifacts.

Situationism vitally influenced the development of British punk art, inspired some European CONCEPTUAL and ARTE POVERA artists, and presaged the strategies of POSTMODERNISTS like Barbara Kruger and Richard Prince, who subvert the visual idioms of advertising.

Snapshot Aesthetic

- **▶ who** Larry Clark, Bruce Davidson, **Robert Frank**, **Lee Friedlander**, Joel Meyerowitz, **Garry Winogrand**
- ▶ WHEN Late 1950s through 1970s
- **▶WHERE** Primarily the United States
- ▶ WHAT The vast majority of twentieth-century photographs have been either photojournalistic images or snapshots taken by amateurs. The least self-conscious or sophisticated of photographic approaches, amateur snapshots follow certain conventions determined by the camera itself and by popular ideas about what a photograph should look like.

Snapshots are almost invariably views of people or the landscape, made at eye level, with the subject in middle distance and in natural light. The central placement of the subject often allows random bits of reality to sneak into the edges of the picture. It is this unplanned "marginalia" that endows some snapshots with a complexity and humanity otherwise achieved only by the most skilled professional photographers.

During the 1960s and 1970s this naive but powerful approach exerted a tremendous influence on art photography. The originator of this aesthetic was Robert Frank, who in 1958 published a book of black-and-white photographs called *The Americans*. This Beat-era, on-the-road vision of America as an amalgam of parking lots, gas stations, backyards, and small-town politicians and their constituents was simultaneously a compelling and a damning look at the frequently romanticized small-town American scene. Frank's project was revolutionary not merely for his sometimes mundane subjects but also for the relatively straightforward STYLE of his pictures. Although it rejected the ennobling, even

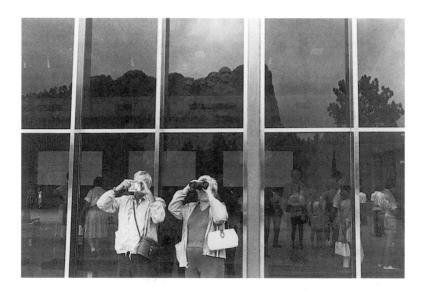

SNAPSHOT AESTHETIC
Lee Friedlander (b. 1934)
Mount Rushmore, South Dakota, 1969
Gelatin-silver print, 7½ × 11½ in.
(18.9 × 28.3 cm)
Philadelphia Museum of Art; Purchased with a grant from the National Endowment for the Arts and matching funds contributed by Lynne and Harold Honickman, the J. J. Medveckis Foundation, Harvey S. Shipley Miller and J. Randall Plummer, and D. Robert Yarnall, Jr.

mystical aims of Ansel Adams, Alfred Stieglitz, Edward Weston, and other pioneers of STRAIGHT PHOTOGRAPHY, the camera-derived, unembellished snapshot aesthetic is a tributary of the straight photographic mainstream.

The irony and detachment inherent in the snapshot aesthetic aligned it with POP ART, which was developing at the same time. Both took as their point of departure the world as it is, rather than as it ought to be. Garry Winogrand and Lee Friedlander, for example, produced pictures about American rites, foibles, and obsessions previously unexplored by photographers. Their often random-looking compositions attempted to embody the flux and flow of rapidly changing contemporary lifestyles, usually with tongue-in-cheek humor. The apparent artlessness of such work masked its own conventions, including the production of relatively small prints and virtually exclusive use of black-and-white—rather than color—film.

Sometimes confused with SOCIAL REALISM, the term socialist realism applies exclusively to the propagandistic art of communist societies, notably the USSR (now Russia) after 1932 and later the Soviet-dominated countries of Eastern Europe, the People's Republic of China, North Korea, and Cuba. Today socialist realist has become a pejorative term for banal, realist images of the working class meant to be accessible to every viewer, of any age or IQ. It is no longer the only officially approved art-making approach anywhere.

With its goals of educating the masses in the virtues of patriotism, the state, and communist dogma, socialist realism was the doctrine against which artists reacted in both the crumbling Soviet Empire and the liberalizing China of the 1980s. Until then, artistic experimentation had been condemned as a sign of decadent Western influence and individualism by official systems that controlled every aspect of art education, association, and patronage. Whether in the forms of literature, film, theater, or the visual arts, socialist realism's irony-free images of heroic workers and soldiers seem even less sophisticated and convincing than advertising. Socialist realism became fodder for parody by SOTS artists in the former USSR of the 1980s and for POLITICAL POP artists in the China of the 1990s.

Social Practice

- ▶ who Francis Alÿs, Vanessa Beecroft, Henry Bond, Tania Bruguera, Mel Chin, Theaster Gates, Douglas Gordon, Liam Gillick, Felix Gonzalez-Torres, Carsten Höller, Pierre Huyghe, Suzanne Lacy, John Malpede/LAPD (Los Angeles Poverty Department), Jorge Pardo, Philippe Parreno, Gregory Sale, Slanguage, Superflex, Rirkrit Tiravanija
- ▶ WHEN Since the late 1980s
- **▶ WHERE** Global
- **PWHAT** The origin of the term social practice is a mystery. Synonyms for it are public practice, participatory art, dialogical aesthetics, and relational aesthetics, the last phrase from the influential 1998 book of the same name by the French art historian and theorist Nicolas Bourriaud. Although the definition of social practice is vague, the use of the term by art schools and universities has led to its rapid institutionalization. In 2005, the California College of the Arts in San Francisco established the first of many MFA programs in social practice, prior to the founding of SPARC (Social Practice Arts Research Center) at the nearby University of California, Santa Cruz. Support also comes from foundations such as the Pulitzer Foundation for the Arts, nonprofit arts organizations such as Creative Time, and some museums, most notably the Queens Museum of Art, New York, which commissions projects by social practice artists who work with immigrants.

SOCIALIST REALISM
Geli Korzhev (1925–2012)
Raising the Banner, from the triptych
Communists, 1957–60
Oil on canvas, 60% × 113½ in.
(154.6 × 287.3 cm)
State Russian Museum, St. Petersburg, Russia

Although the influence of the Internet or the sobering events of 9/11 have been evoked in connection with the origins of social practice, the yearning for participation inherent in this form has been a constant in art of the past half-century. Participatory art programs have existed since Judy Chicago and Miriam Schapiro established the Feminist Art Program at the California Institute of the Arts in the early 1970s for creative collaborations with their students (including Suzanne Lacy), and other examples have included the vast projects executed in collaboration with volunteers by Chicago, Christo and Jeanne-Claude, and the Border Arts Workshop, as well as interactive, CONCEPTUAL artworks like Bonnie Sherk's Farm. While such works sometimes addressed matters of format, authorship, or taxonomy, they rarely interrogated all of them simultaneously, as social practice art can sometimes do.

Social practice ranges across a vast spectrum: At one end are the mostly European artists influenced by Conceptualism, whose work consists of one-time events and is usually termed *relational art*—for instance, Carsten Höller's construction of a hotel room for two in the Guggenheim Museum, New York, which visitors could occupy for a night (for a fee) in 2008, or Rirkrit Tiravanija's signature Thai dinners intended to spur social interaction among guests. At the other end of the spectrum are the

creators of ambitious, long-term projects, usually Americans and often little-known groups, whose aim is social transformation and the transmission of communitarian values that predate modern art's emphasis on pleasure. Suzanne Lacy's performance *Crystal Quilt* (1987) was the culmination of a three-year project intended to give voice to the experiences of older women and diversify their representations in the media. A group of 430 women performed before an audience of three thousand in an elaborate production that was also broadcast live on television.

Such works demand of artists skills associated with numerous non-art disciplines—including those of the social worker, activist, art therapist, teacher, geographer, conference or symposium organizer, producer, investigative journalist, community organizer, or psychotherapist. Although for some viewers this open-endedness raises the troubling, century-old question *Is it art?* others are challenged to probe and assess the character of the social experiences at the heart of such works.

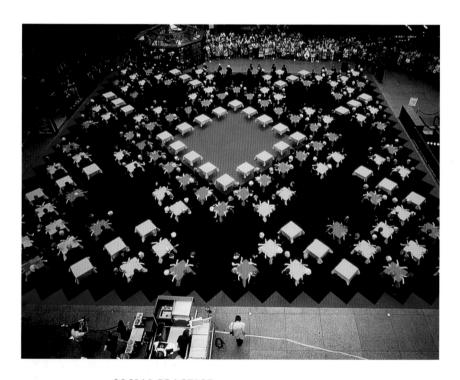

SOCIAL PRACTICE Suzanne Lacy (b. 1945) The Crystal Quilt, 1987 Performance in Minneapolis, Mother's Day (May 10), 1987

The term Social Realism refers to leftist political art produced during the 1920s and 1930s, primarily in the United States, Mexico, and Germany. Its antecedents include European realist painting of the mid-nineteenth century and the work of the early-twentieth-century American artists of the Ashcan School, including George Bellows and Robert Henri. Social Realism was not originally used to mean any particular STYLE, and examples of it range widely, encompassing paintings on topical themes of class struggle by the American Ben Shahn; the ambitious Mexican mural cycles by Diego Rivera and José Clemente Orozco; the Depression-era murals commissioned for public buildings by the Works Progress Administration in the United States; and the photographs of America's rural poor by Dorothea Lange and Walker Evans, commissioned at that same time by the U.S. Farm Security Administration. The bias of Social Realism against ABSTRACTION and toward didactic representations of working-class men and women gave it a pronounced anti-MODERNIST flavor.

Sots Art

- ▶who Eric Bulatov, Valeriy Gerlovin and Rimma Gerlovina, Ilya Kabakov, Kazimir Passion Group, Komar and Melamid, Alexander Kosolapov, Leonid Lamm, Leonid Sokov, Alexander Yulikov
- **▶ WHEN** Early 1970s to 1990
- ▶ **WHERE** Europe, United States, and the USSR
- ▶ WHAT The term Sots art was coined by Komar and Melamid in 1972 in Moscow, where the now American-based collaborators were then living. A friend had likened the mass-cultural imagery they were using to Western POP ART, which inspired their ironic abbreviation of the phrase Socialist art.

Socialist stood for the SOCIALIST REALIST view of art that had dominated Soviet culture since the time of Stalin. A Soviet doctrine promulgated in 1934 demanded artworks "national in form and Socialist in content." By the end of the 1960s official artistic production had degenerated into hackneyed ACADEMIC images of Revolutionary heroes and heroines, assembly lines, and workers on tractors.

Artists began to APPROPRIATE and subvert these clichéd images of nationalism, gender, and power. To do this, they utilized parody, ironic juxtapositions, and dislocating backdrops against which they set their subjects. Komar and Melamid, for instance, painted a 1972 double self-portrait of themselves in the manner of countless state portraits of Lenin and Stalin; Leonid Sokov created viciously satirical sculptures of Soviet leaders.

S

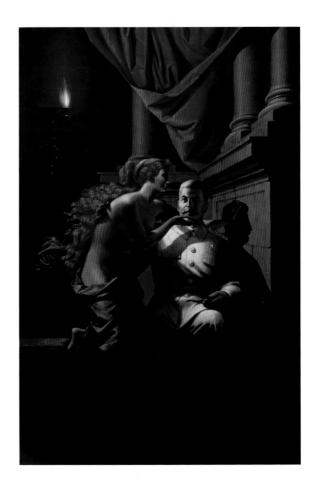

SOTS ART Komar and Melamid (Vitaly Komar, b. 1943, and Alexander Melamid, b. 1945) The Origin of Socialist Realism, 1982–83 Oil on canvas, 72 × 48 in. (182.9 × 121.9 cm) Jane Voorhees Zimmerli Museum, Rutgers University, New Brunswick, NJ

These "unofficial"—as opposed to government-supported—artists found it impossible to exhibit their work in the USSR. The Sots art group issued a manifesto and tried to participate in an open-air exhibition of 1974, which was dubbed the "Bulldozer" show after officials mowed it down. In the wake of the ensuing international criticism a follow-up show was mounted two weeks later, but the Sots artists were never permitted to hold a group exhibition exclusively devoted to their work.

During the 1970s many of the Sots artists were allowed to emigrate, primarily to New York. (Not until the inception of Gorbachev's *glasnost* in the late 1980s would the line separating "official" and "unofficial" art begin to dissolve.) The first major New York exhibition offering Sots art was Komar and Melamid's 1976 show (smuggled out of Moscow) at Ronald Feldman Fine Arts; the most important was the traveling group show *Sots Art*, mounted by the New Museum of Contemporary Art in 1986.

Sots art was the first avant-garde art movement within the USSR since the 1930s. The Pop art-like irreverence of Sots art, its interest in mass communication and cultural signs (or SEMIOTICS), and its appropriation-based method all linked it with the international rise of POSTMODERNISM in the late 1970s.

Sound Art

▶ WHO Laurie Anderson, John Anderton, Jacki Apple, Rosland Bandt, Connie Beckley, Allan Bridge, Charles and Mary Buchner, Paul Earls, Brian Eno, Terry Fox, Doug Hollis, Paul Kos, Joe Lewis, Alvin Lucier, Tom Marioni, Haroon Mirza, Bruce Nauman, Max Neuhaus, Pauline Oliveros, Dennis Oppenheim, Nam June Paik, Susan Phillipsz, Jim Pomeroy, Jill Scott, Keith Sonnier, Wen-Ying Tsai, Stephen Vitiello, Yoshi Wada

▶WHEN 1970S

▶WHERE International

WHAT Sound art is an INTERMEDIA format. The art half of the term announces that such works, composed primarily of sound, are made by visual artists (or by crossover PERFORMANCE artists). Sound art is usually presented in visual-art venues—galleries, museums, and PUBLIC ART and performance sites—or in digital formats.

Luigi Russolo first assailed the division between art and music with his 1913 Futurist manifesto *The Art of Noise* and with his orchestras of strange instruments (gurglers, shatterers, buzzers, and the like) used to suggest the auditory ambience of the street. What would become the CONCEPTUAL ART aspect of this art-music fusion was initiated when a screw was allegedly dropped into DADA artist Marcel Duchamp's readymade A Bruit secret (With Hidden Noise) (1916). After World War II, Duchamp's disciple John Cage continued in this spirit with his silent compositions designed to focus attention on ambient sound. They were predicated on Cage's assertion that "Music never stops, only listening." HAPPENINGS and FLUXUS events frequently included sound or music.

Sound sculpture took off as a Conceptual art form beginning in the late 1960s and, like so many other Conceptual art forms, peaked in the 1970s. Many Conceptual artists, including Bruce Nauman and Jill

Scott, created sound works while simultaneously working in other media such as INSTALLATIONS and VIDEO. Two 1970 shows—at New York's Museum of Contemporary Crafts and San Francisco's Museum of Conceptual Art—suggested how widespread the use of sound by artists was becoming.

Since then, artists have used sound to chart a variety of courses. Some, including Laurie Anderson, have incorporated pop music within their theatrical performances. Others, such as Brian Eno, Doug Hollis, and Max Neuhaus, have created subtly textured sound environments. Hollis's outdoor works, for instance, are sometimes triggered by natural phenomena such as the wind. It is environments such as these, which focus almost entirely on the aural, that are most often considered "sound art." Allan Bridge put sound to highly conceptual purposes in the Apology Line, an interactive phone service in New York in which callers could apologize and hear confessions by others.

Southwest Artists Group. See '85 NEW WAVE

Space Art

- ▶ who Lowry Burgess, Center for Land Use Interpretation, Richard Clar, Agnes Meyer-Brandis, Forrest Myers, Trevor Paglen, Carrie Paterson, Marko Peljhan, Frank Pietronigro, Bradley Pitts, Tim Otto Roth, Janet Saad-Cook, Connie Samaras, Trieste Constructivist Cabinet, Christian Waldvogel, Arthur Woods
- ▶ WHEN Since the 1980s
- **▶WHEN** Europe and the United States
- **WHERE** Space art refers not to sculptural or three-dimensional forms or illustrations of spacecraft, but to the theme of "outer space," including not just its exploration but its cultural meanings. Its earliest antecedents include the late-nineteenth-century astronomical research enabled by advances in telescopic technology and the concurrent publication of the imaginative novels of the French writer Jules Verne, a forerunner of the science fiction genre, whose tales of extraterrestrial, subterranean, and undersea adventure remain among the most widely translated books ever.

The cold war "space race" between the United States and the USSR, initiated by the Soviet launch of the first satellite, Sputnik, in 1957, focused international attention on space travel. Pondering the riveting spectacle of the American manned lunar mission of 1970, HAPPENING pioneer Allan Kaprow advised artists to trade their outmoded practices and studios for more public modes and processes. In the same year Frank J. Malina published "On the Visual Fine Arts in the Space Age" in Leonardo, the journal devoted to art-science interaction that he helped found.

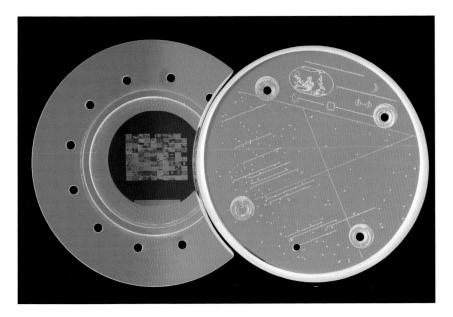

SPACE ART Trevor Paglen (b. 1974) The Last Pictures Artifact, 2012 Ultra-archival image disc inside gold-plated aluminum shell Orbiting Earth on the EchoStar XVI satellite

Arguably the first space art work was Forrest Myers's *Moon Museum* (1969), a ceramic tile less than a square inch in size, inscribed with six black-and-white drawings by leading artists of the day, including Andy Warhol and Claes Oldenburg, along with Myers himself. Covertly attached to Apollo 12's *Intrepid* landing vehicle, the tile presumably remains on the moon, wrapped—along with other smuggled objects—within the insulation shielding the legs of the landing vehicle.

Space art is best considered an outgrowth and subset of the ART AND TECHNOLOGY movement that flowered in the late 1960s and 1970s. In addition to involving many of the same artists, space art projects have often been developed in the same long-established, university-based centers, such as MIT's Center for Advanced Visual Studies or Carnegie Mellon's STUDIO for Creative Inquiry. New transatlantic support systems have also emerged for realizing space art projects: the Association Leonardo/OLATS has done much to organize conferences and facilitate communication, and Arts Catalyst has played a vital role in developing and commissioning projects, and in arranging collaborations with the

government agencies that control access to facilities like the Russian Mir space station. (In addition to the visual artists listed above, dance and theater creators have also been involved in such projects.) In 1993 Arthur Wood's Cosmic Dancer, the first sculpture designed for weightlessness, arrived at the Mir space station. Two Russian cosmonauts evaluated the impact of sharing their environment with the floating and spinning sculpture and produced documentary photos and video that completed the project.

Space art ranges across a broad spectrum of forms and concerns, many of them having little to do with contemporary technology per se. The German artist Agnes Meyer-Brandis combines interests in metaphor, research, and outreach to nonspecialists. Her investigations of the earth's core shifted to weightlessness and flight, most recently resulting in the extensive Moon Goose Colony project. The complex narrative structure of this work is based on Francis Godwin's early-seventeenth-century story The Man in the Moone, which features a mythical flight to the moon in a chariot towed by moon geese. In order to begin to realize her work, Meyer-Brandis raised eleven geese from birth at a farm in Italy, imprinting on them as their mother, giving them astronauts' names, and training them to fly.

By contrast, Trevor Paglen's Last Pictures (2012) is more straightforward: a collection of one hundred images placed on "permanent" media and launched into space on the communications satellite EchoStar XVI, thereby offering a response to the question, "How might future civilizations (or aliens) understand us?" Connie Samaras's photographs of bleak-looking NASA facilities in the American southwest present a more critical perspective by deflating the romanticism surrounding space exploration.

Unfortunately, the cost and difficulty of accessing the necessary technology or research facilities often force space artists to rely on the cooperation of official agencies and institutions. The ongoing inability—or unwillingness—of many governments to recognize the value of art is exemplified by NASA's failure to appoint a successor to their first and only artist in residence, Laurie Anderson, and by the underuse of the Cultural Center of European Space Technologies, or KSEVT, in Slovenia. But this may change as commercial space travel moves closer to the launching pad. The recent emergence of a commercial space industry in Southern California—capitalizing on the presence of research facilities like the Jet Propulsion Laboratory and a military infrastructure for air- and spacecraft testing—may provide a bonanza for artists, recalling the Los Angeles County Museum of Art's Art and Technology Program, which catalyzed fruitful and ambitious collaborations between artists and corporations for four years, beginning in 1967.

Spatialism

- **▶who** Edmondo Bacci, Giuseppe Capogrossi, Roberto Crippa, Enrico Donati, Gianni Dova, **Lucio Fontana**, Emilio Scanavino
- **▶where** Italy
- **▶ WHEN** 1947 through 1950s
- **WHAT** Spatialism is the English translation of Spazialismo or Movimento Spaziale. Its aims were defined by Lucio Fontana, the movement's founder, and first articulated in his Manifesto blanco (White Manifesto), which was published in Buenos Aires in 1946—the year before he founded the Spatialist movement in Milan. In the Manifesto blanco, Fontana called for collaboration with scientists in creating new and up-to-date ideas and the materials for their realization—including, he would soon urge, neon and television. Many of the manifesto's other

SPATIALISM Lucio Fontana (1899–1968) Spatial Concept, 1961 Water paint on linen, 393% × 487% in. (100 × 124 cm) Sperone Westwater, New York tenets are familiar from earlier MODERN movements, including SUR-REALISM, with which it shared the belief that "all artistic concepts come from the subconscious," and Futurism, which espoused propositions similar to Fontana's claim that "in painting we see a progressive elimination of the elements that do not permit the impression of dynamism." Fontana issued other Spatialist manifestos annually between 1947 and 1952, including a "technical" manifesto in 1951.

The Milanese artists who associated themselves with Spatialism were overshadowed by the more radical Fontana, and by the early 1950s most of them had reverted to GESTURAL painting styles that ought to be termed ART INFORMEL or Tachisme. But Fontana continued to create innovative work exemplifying his belief that Spatialist art must "transcend the area of the canvas or the volume of the statue" by moving into real rather than illusionistic space. In 1949 he produced a ground-breaking all-black room (or "Spatial Environment"), to which he would later add neon; soon after, he created his signature technique of evoking spatial ambiguity by puncturing or slashing his canvases. Ultimately, Spatialism became virtually synonymous with Fontana, whose ideas about technology influenced the ZERO group.

See ART AND TECHNOLOGY

Staged Photography

who Harry Bowers, Ellen Brooks, James Casebere, Bruce Charlesworth, Gregory Crewdson, Robert Cumming, Judy Dater, John Divola, Bernard Faucon, Fischli and Weiss (Peter Fischli and David Weiss), Adam Füss, Lyle Ashton Harris, Pieter Hugo, Barbara Kasten, Lynn Hershman Leeson, David Levinthal, Mike Mandel and Larry Sultan, Yasumasa Morimura, Olivier Richon, Don Rodan, Cindy Sherman, Laurie Simmons, Sandy Skoglund, Boyd Webb, William Wegman

▶ **WHEN** Since the mid-1970s

▶WHERE United States and Western Europe

Although the term *staged* photography suggests falsification or fakery, it actually means pictures conceived and constructed by the photographer for the purpose of being photographed. It is synonymous with the less frequently used *set-up* photography and encompasses the subset of *fabricated* photography.

The difference between fabricated and staged photography is one of subject matter. Fabricated photographs depict exclusively inanimate objects, ranging from Ellen Brooks's feminist-inflected tableaux of Barbie-style dolls enacting suburban social rituals to John Divola's documents of his spray-paint assault on an already vandalized lifeguard station, creating a contemporary ruin. Staged photography, on the other

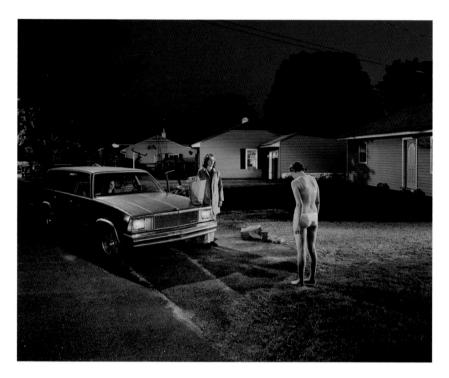

STAGED PHOTOGRAPHY Gregory Crewdson (b. 1962) Untitled (Penitent Girl), 2002, from the Twilight series Digital color coupler print, 481/8 × 601/4 in. (122.2 × 153 cm) Gagosian Gallery, New York

hand, includes images not only of inanimate objects but also of human or animal actors, such as Cindy Sherman's pictures of herself in artful disguise, William Wegman's photographs of his dressed-up dogs, and Gregory Crewdson's enigmatic and elaborately staged images, which look like production stills from a multimillion-dollar Hollywood production in the making.

All these approaches reject traditional, observable subjects—Yosemite Falls, a bell pepper, the photographer's lover—in favor of highly theatrical, frankly fictitious ones. However, the lengths to which photographers like Crewdson must go to impart a sense of ambiguity and mystery to their staged scenes suggest that in the age of Photoshop and digital effects, the border between reality and fiction is no longer the charged photographic no-man's-land it once was.

Stars Group

- ▶who Ai Weiwei, Bo Yun, Huang Rui, Li Shuang, Ma Desheng, Mao Lizi, Qu Leilei, Shao Fei, Wang Keping, Yan Li, Yang Yiping, Yin Guangzhong, Zhong Acheng (a.k.a. Ah Cheng)
- **▶WHEN** 1979 to 1983
- ▶ WHERE China, primarily Beijing
- ▶ WHAT The name of the Stars Group sprang from discussions of the concept of ziwo, which can be defined as "self-image" or "ego," instigated by the Beijing artists Ma Desheng and Huang Rui. These conversations affirmed Western notions of the individual's primary role in creative expression to benefit society at large. As Ma declared, "Every artist is a little star. Even the greatest artists are still little stars from a cosmic point of view."

The Stars Group's members were "nonprofessionals" who came of age at the end of the Cultural Revolution, most of them having acquired their art educations at the Beijing Worker's Cultural Center. As nonelites, they rejected the sometimes-corrupt official art institutions and associations and cultivated their artistic pursuits independently. This concern for individuality, rather than any common aesthetic outlook, was what united them. They organized in 1979 to mount an unofficial exhibition to counter—and coincide with—the official Fifth National Art Exhibition at the China Arts Gallery (now the National Art Museum of China) in Beijing.

The Stars Art exhibition opened on September 27, 1979, in a small park adjacent to the China Arts Gallery, beneath a sign that read, "Käthe Kollwitz is our banner-bearer, Pablo Picasso is our pioneer." Works by twenty-three artists were hung on the railings of the park's iron fence. The outdoor exhibition was declared illegal on September 28. The Stars organized a protest march on October 1, the thirtieth anniversary of the founding of the People's Republic of China, which resulted in an invitation to mount their exhibition again the following month. (It opened on November 23 in the Huafang Studio in nearby Beihai Park and ran undisturbed until December 2.)

Works by the Stars Group members varied greatly. While the first officially sponsored exhibition of Western art in postwar China, shown in 1978, was of nineteenth-century French landscape painting, the Stars Group favored less pastoral approaches. They instead borrowed latenineteenth- and early-twentieth-century avant-garde styles, including German Expressionism, Fauvism, DADA, Cubism, and Surrealism, which together announced an irreparable break with the status quo

STARS GROUP
Wang Keping (b. 1949)
Idol, 1979
Stained birch, 263/8 × 153/4 × 57/8 in.
(67 × 40 × 15 cm)
Collection of the artist

of SOCIALIST REALISM. Some of their works were overtly political—such as Wang Keping's *Idol* (1979), a caricature of Mao that suggested both his self-regard and the esteem in which the citizenry were encouraged to hold him—while others, such as Huang Rui's Cubist *Self-Portrait* (1980), were stylistically radical.

In 1980 the Stars Group registered with the Beijing Artists Association and was granted a permit for an exhibition at the China Arts Gallery. This was the first time a group of independent artists was allowed to show its work at a prestigious state institution (and it would be another decade before experimental artworks were shown there again, in the

240

controversial *China/Avant-Garde* exhibition of 1989). If the group's permit was granted in the belief that audiences were incapable of grasping the meaning of the exhibited works—which may have been true of the ABSTRACTIONS, but could hardly have been true of the nudes—the show's spirit of freedom and resistance was unmistakable.

The show opened on August 24, 1980, and attracted more than 80,000 visitors—some estimates put the number at 200,000. The critic Feng Yidai, writing in the journal *New Observer*, championed the group's heroism and rapturously applauded the show's art: "They grew up in a nightmarish and hideous decade; yet they still retained their beautiful souls.... They took up their paintbrushes and engraving tools to deal ugliness a deathblow, and opened up a new road to a bright future."

In 1983 the collective's final group show was held at the Zixin Road Primary School in Beijing—a venue with a much lower profile than the China Arts Gallery. Officials closed the show soon after it opened, citing the recently instituted "spiritual cleansing" campaign of the early 1980s. Along with the painters of Rustic Realism and Scar Art, and the members of the April Photographic Society, the Stars Group embodied the first stirrings of contemporary art in post–Cultural Revolution China.

Following the group's dissolution, many of the twelve original artist-members moved abroad, most to successful careers. In 1987 the majority of them participated in the founding of the Chinese United Overseas Artists Association, headquartered in New York, which announced an organized diaspora of Chinese artists. The Stars Group's pioneering role in contemporary Chinese art history was recognized with a tenthanniversary re-creation of the group's first exhibition, at the Taipei and Hong Kong locations of the Hanart Gallery; with *Demand for Artistic Freedom*, a twentieth-anniversary exhibition at the Tokyo Gallery in Japan; and with *Origin Point*, a comprehensive exhibition at the Today Art Museum in Beijing in 2007, featuring many of the works shown in the 1979 and 1980 shows.

Story Art. See NARRATIVE ART

Straight Photography

- **▶**wно Berenice Abbott, **Ansel Adams**, Diane Arbus, **Eugène Atget**, Bill Brandt, **Henri Cartier-Bresson**, Imogen Cunningham, **Walker Evans**, **Robert Frank**, Lee Friedlander, Lewis Hine, Dorothea Lange, Albert Renger-Patzsch, Alfred Stieglitz, Paul Strand, **Edward Weston**, Garry Winogrand
- ▶ **WHEN** 1900 through 1970s
- ▶ WHERE Europe and the United States

▶ WHAT The term straight photography probably originated in a 1904 exhibition review in Camera Work by the critic Sadakichi Hartmann, in which he called on photographers "to work straight." He urged them to produce pictures that looked like photographs rather than paintings—a late-nineteenth-century approach known as Pictorialism. To do so meant rejecting the tricky darkroom procedures that were favored at the time, including gum printing, the glycerine process, and scratching and drawing on negatives and prints. The alternative demanded concentrating on the basic properties of the camera and the printing process.

The great MODERNIST tradition of straight photography resulted from the thinking of Hartmann and many others. It featured vivid black-and-white photographs ranging from Eugène Atget's luminous images of a rapidly disappearing Parisian cityscape to Imogen Cunningham's striking nudes of her husband on Mount Rainier. It was often considered equivalent, especially during the first half of the century, to documentary photography—loosely, the pictorial equivalent of investigative reporting. Documentary photography was epitomized by Lewis Hine's early-twentieth-century images of slum dwellers and the government-sponsored portraits of the Depression-era poor by Walker Evans and Dorothea Lange.

Straight photography is so familiar that it is easy to forget that it is an aesthetic, no less artificial than any other. The fact that black-and-white pictures may look more "truthful" than color prints, for instance, points to just one of straight photography's highly influential conventions. After World War II the orthodoxies of straight photography began to be challenged. Unconventional approaches emerged, including an interest in eccentric lighting, blurred images of motion, and tilting of the frame for expressive effect. So, too, was there widespread interest in the SNAP-SHOT AESTHETIC and, finally, even the use of color.

The debate over whether photography is an art raged for nearly a century. The early-twentieth-century photographer, publisher, critic, and gallery owner Alfred Stieglitz linked straight photography's destiny to modernism by simultaneously championing it along with modern painting and sculpture. While straight photographs have been exhibited in museums and galleries since 1909, a market for them did not really develop until the 1970s, when painting and sculpture in traditional formats were in unusually short supply.

Straight photography has lost much of its prestige as POSTMODERN photographers have rejected its once-dominant tenets. They now produce works that counter the purist emphasis on straight photographic process (MANIPULATED PHOTOGRAPHY), on documentary veracity (STAGED and manipulated photography), and on maintaining the distinction between art and POPULAR CULTURE (FASHION AESTHETIC).

STRAIGHT PHOTOGRAPHY
Garry Winogrand (1928–1984)
Park Avenue, New York, 1959
Gelatin silver print, 1338 × 834 in.
(34.1 × 22.2 cm)
Museum of Modern Art, New York;
Gift of the photographer

- who Jef Aérosol, Ai Weiwei, Banksy, Robbie Conal, CutUp Collective, Ron English, Shepard Fairey, John Fekner, Ganzeer (Mohamad Fahmy), Gran Fury, Jenny Holzer, Alfredo Jaar, Chris Johanson, Margaret Kilgallen, Barry McGee, Blek le Rat, Rigo 23, Tsang Tsou Choi, David Wojnarowicz
- ▶ WHEN Since the late 1980s
- ▶where Global
- **WHAT** As its name implies, the term *street* art refers to artworks presented in places visible to the public, usually without permission (distinguishing it from some PUBLIC ART). It varies widely in materials (favoring the cheap and expendable), media (viewing location and circumstances may dictate the relative benefits of word, image, or both), and message (as with all art, a range from the personal to the political, and from the subtly poetic to the stridently propagandistic). The antithesis of the proverbial "masterpiece," street art is rooted in the soil of POPULAR CULTURE and reflects artists' long-standing interests in the accessibility and subversive potential of posters, cartoons, bill-boards, advertising, and graffiti. With POSTMODERNISM, the boundary separating high art and popular culture has been virtually eradicated, sometimes making the street the exhibition venue of choice for talented, professional artists.

Street art's relationship to GRAFFITI ART also needs clarification. Graffiti art is best understood as a short-lived phenomenon that emerged in New York around 1980. Those responsible were working-class "taggers," art school–educated artists, and (later) downtown Manhattan art dealers such as Tony Shafrazi, who promoted its transformation from illegal activity into collectible commody. Few of the nonprofessional New York graffitists viewed themselves as artists or managed the transition from subway to Soho gallery. Other artist-professionals since then have incorporated graffiti within their repertoire of techniques or experimented with it as one of many phases of a career, making street art a more apt descriptor of their work.

The widespread emergence of street art came about in the late 1980s. This tumultuous era, marked by the end of the (MODERN) cold war and the onset of the (postmodern) digital age, provided both do-it-yourself opportunities for freer expression and plenty to express. Jenny Holzer's aphoristic Truisms, for example, found their complement in Robbie Conal's wittily captioned posters featuring unflattering portraits of American public figures. An informal and international "fraternity" of street artists, including Banksy, Blek le Rat, and John Fekner, employed "traditional" graffiti materials and methods to "bomb" urban streets around the world with culturally diverse spray-painted tags and images.

S

The explosion of street art was also stimulated by economic conditions: The severe transatlantic recession that crippled the art market also freed artists to experiment apart from commercial demands and encouraged those seeking support for publicly sited work to make use of the sudden abundance of unsold advertising space on subway cars, billboards, and buses. These became unconventional exhibition "venues" for artists, both authorized and unauthorized. Some private foundations and local governments developed commissioning practices that encouraged an unprecedented diversity and forthrightness, yielding street art every bit as gutsy and iconoclastic as artists' self-produced efforts.

The AIDS-activist collective Gran Fury, for instance, created an image, inspired by a notorious United Colors of Benetton advertising campaign, that featured three kissing couples—one opposite- and two same-sex pairs—beneath the caption "Kissing Doesn't Kill: Greed and Indifference Do" (1989). Although the project was privately funded, the appearance of this image on the sides of city buses in Chicago caused an uproar. A year later, as the official American representatives to the Venice Biennale, Gran Fury received an even more clamorous response for their installation condemning Pope John Paul II's anti-condom views, only narrowly avoiding arrest.

Gran Fury's Media Art-derived approach both recalls conceptualist works such as Les Levine's provocative billboard and subway pronouncements and looks forward to the work of Ganzeer, the pseudonymous Egyptian artist who garnered international attention during the 2011 Egyptian revolution. His overtly political—and critical—"Martyr Murals" painted on highly visible walls in Cairo drew the ire of Egypt's military rulers, who had him arrested. A similar fate befell the dissident Chinese artist Ai Weiwei for posting to his now-shuttered blog a list of the names of schoolchildren who died in the Sichuan earthquake of 2008.

The situation in the West could hardly be more different. Following the economic success of graffiti art in the early 1980s, street art's commercialization seemed inevitable. Banksy led a mild revolt against the production of portable art objects derived from wall-sized compositions, at least raising essential questions in the process. Street art's most vigorous promoter has been the former New York art dealer Jeffrey Deitch, who became the director of the Museum of Contemporary Art, Los Angeles, in 2010. His first show there, Art in the Streets (2011), of which he was a curator, was indelibly marred by his peremptory order to remove a controversial outdoor mural commissioned for the exhibition. Deitch's diktat seemed to fly in the face of the raison d'être of street art itself: the freedom (arguably) inherent in producing and exhibiting art outside the restrictive practices of institutions, politics, and markets.

There is no such thing as a work of art without a style. The idea of style as defined by art history is rooted in the belief that artworks from a particular era (the Tang Dynasty, the Italian Renaissance, the 1960s) share certain distinctive visual characteristics. These include not only size, material, color, and other FORMAL elements, but also subject and CONTENT.

Artists cannot transcend the limits of their era. (Forgeries of Jan Vermeer's seventeenth-century works that were painted by the notorious forger Hans van Meegeren in the 1930s and '40s seemed authentic then but now loudly announce themselves as works of their day.) Without the twentieth-century tradition of spatially flattened ABSTRACTION behind them, it's difficult to imagine that the PATTERN-AND-DECORATION artists of the 1970s would have turned to Middle Eastern rugs and tiles for inspiration. If consumer society had not mushroomed after World War II, POP ART could not have come into being.

Other factors such as locale, training, and perhaps even gender—this has been the subject of heated debate among feminists and nonfeminists—affect the styles of individual artists. A multitude of personal styles contribute to the stylistic currents of a given era. No artist's style is likely to completely embody any one particular style; it is, after all, individuality and personality that contemporary Westerners value in art.

Supports/Surfaces. See COLOR-FIELD PAINTING

Surrealism

- ▶who Jean (Hans) Arp, Joseph Cornell, Salvador Dalí, Max Ernst, Frida Kahlo, René Magritte, André Masson, Matta, Joan Miró, Meret Oppenheim, Pablo Picasso, Man Ray, Yves Tanguy, Remedios Varo
- ▶WHEN 1924 to 1945
- ▶ WHERE Primarily Europe, but also Latin America and the United States
- **WHAT** Surrealism, the movement that dominated the arts and literature during the second quarter of the twentieth century, is included here because it is central to MODERN and CONTEMPORARY art. Its enduring importance derives from both its innovative subjects and its influence on postwar ABSTRACT painting.

The term *Surrealism* is now used too indiscriminately. It was coined by the French poet Guillaume Apollinaire in 1917 to refer to his freshly minted drama *Les Mamelles de Tirésias* and to Pablo Picasso's set designs for the ballet *Parade*. Its meaning was articulated by the French poet André Breton in the first "Manifesto of Surrealism" (1924), which is Surrealism's birth certificate. Breton defined it as "pure psychic

S

automatism by which it is intended to express...the true function of thought. Thought dictated in the absence of all control exerted by reason, and outside all aesthetic or moral preoccupations."

Surrealism is a direct outgrowth of DADA; the two are often considered in tandem, and the Dada artists Max Ernst and Jean Arp were bridges to Surrealism. Dada contributed such essentials as experimentation with chance and accident, interest in FOUND OBJECTS, biomorphism, and automatism (pictorial free association). The Surrealists gave these Dada concerns a psychological twist, helping to popularize the Freudian fascination with sex, dreams, and the unconscious.

During the 1920s two styles of Surrealist painting developed. The first is exemplified by the bizarre, hallucinatory dream images of Salvador Dalí and others, which are rendered in a precise, REALIST style. To many observers, that return to illusionistic FIGURATION marked a regressive step in the course of increasingly abstract modern art. This sort of dream imagery entered the popular imagination not only through art but also via film, fashion, and advertising.

The second, actually earlier, Surrealist approach was the automatism favored by Joan Miró and André Masson. Lyrical and highly abstract, their compositions present loosely drawn figures or forms in shallow space that evoke Native American pictographs and other forms of non-European art.

The Paris-based Surrealists remained an organized cadre of writers and artists throughout the 1930s. Hitler's rise to power and the prospect of war sent many of them to New York. There they provided the role models for Arshile Gorky, the last of the official Surrealist painters, and the artist who helped point the way from the automatic variety of Surrealism to ABSTRACT EXPRESSIONISM.

Synesthesia. See ABSTRACT/ABSTRACTION

Systemic Painting. See COLOR-FIELD PAINTING

Tachisme. See ART INFORMEL

Transavantgarde

▶**who** Sandro Chia, Francesco Clemente, Enzo Cucchi, Nicola De Maria, Mimmo Paladino, Remo Salvadori

▶**WHEN** Late 1970s to mid-1980s

▶where Italy

▶ WHAT The term *Transavantgarde* is the invention of the Italian critic Achille Bonito Oliva. He defined Transavantgarde art as traditional in format (that is, mostly painting or sculpture); apolitical; and, above all else, eclectic. The Transavantgarde artists APPROPRIATED images from history, POPULAR CULTURE, and non-Western art.

Oliva's characterization of the Transavantgarde is essentially a definition of NEO-EXPRESSIONISM, coined before that term caught on. Although he intended his description to apply to the international Neo-Expressionist mainstream that emerged in the early 1980s, it has become identified only with Italian artists of that sensibility.

TRANSAVANTGARDE
Francesco Clemente (b. 1952)
Francesco Clemente Pinxit
(detail, one of 24 miniatures), 1981
Natural pigment on paper,
each miniature: 8¾ × 6 in. (22.2 × 15.2 cm)
Virginia Museum of Fine Arts, Richmond;
Gift of Sydney and Frances Lewis

Τ

Tropicalism

- wно Lygia Clark, Hélio Eichbauer, Flávio Império, Hélio Oiticica,
 Lygia Pape
- **▶WHEN** 1967 to 1972
- **▶where** Brazil
- ▶ WHAT Tropicalism, an awkward-sounding translation of the Portuguese Tropicália, refers to a revolutionary movement (and moment) in Brazilian culture that dramatically affected all art forms—film, poetry, theater, and (especially) music, in addition to visual art. The name derives from artist Hélio Oiticica's Tropicália, an environmental INSTALLATION presented at Rio de Janeiro's Museum of Modern Art in 1967. (Some art historians prefer the term NEO-CONCRETISM for the visual art associated with this movement. However, Neo-Concretism, which arose from the specialized debates of the 1950s concerning Concretism, Objectivism, and "rationalism" in art, is better understood as an early subset of Tropicalism.)

Tropicalist works in all forms shared a monumental goal: to jettison the universalizing, colonialist view of Brazilian culture as a primitive work-in-progress completed by European "civilization" and replace it with a variegated tapestry mirroring the complexity of class, race, ethnicity, and natural environment that accounts for Brazilian culture's singularity. Its theoretical basis is the *Manifesto Antropófago* (Cannibalist Manifesto) composed by the poet Oswald de Andrade in 1928. Part anthropology, part poetry, part hallucinatory cultural commentary, even in translation this work is an ecstatic and impassioned assault on the still-widespread Eurocentric version of Brazilian history.

All of Oiticica's work—whether in the very different looking forms of *Penetráveis* (penetrable environments) or *Parangolés* (wearable artworks)—celebrated the Afro-Brazilian heritage and underlined the vast distance separating the races and classes in Brazil. His multipart installation *Tropicália* transported the notorious *favela* (or slum) where he was living into the galleries of a prestigious museum. Tropical plants, birds, and a pair of shacks were set alongside a menacingly dark labyrinth that led only to a television set (and a multiplicity of interpretations). Oiticica's name for these environments, *penetrables*, emphasized the viewer's active experience moving in and out of the work, rather than the artist's role in its creation. He shared these artistic interests in interactivity, function, and the role of the body—both the artist's and the viewer's—with two longtime associates and innovators, the artists Lygia Clark and Lygia Pape. Each of them experimented with mobile, wearable art or functional sculpture. Oiticica's *Parangolés*, capelike garments

TROPICALISM Hélio Oiticica (1937–1980) Tropicália, Penetrables PN 2 "Purity is a myth" and PN 3 "Imagetical," 1966–67 Mixed-media installation, dimensions variable Tate, London

through which the wearer "performed" the art, became an emblem of more than a decade of his unconventional investigations.

One virtue of Tropicália's creative disordering was its openness to developments outside Brazil. Such receptivity and optimism are especially impressive in light of the cold-war political context. Three years after a U.S.-supported military coup in 1964, the dictatorship deported the celebrated musicians Gilberto Gil and Caetano Veloso, who were beginning to create what they would later call their Tropicalist fusion of rock-androll, African, and indigenous sounds. (A half-century later, it remains synonymous with Brazilian popular music throughout the world.) Oiticica left Latin America in 1970 because of the homophobia encouraged by the military regime. By then the crackdown had spread from "opponents" of the regime in the streets to dissenters of any kind, and from censorship and arrest to torture and "disappearance." Although many see the officially sanctioned return of Gil and Veloso in 1972 as signaling the end of the era's worst repression, the year was also marked by the suicide of their friend, the Tropicalist poet, journalist, and songwriter Torquato Neto.

Video Art

▶ who Vito Acconci, Chantal Akerman, Max Almy, Laurie Anderson, Ant Farm, Robert Ashley, Matthew Barney, Stephen Beck, Guy Ben-Ner, Ursula Biemann, Dara Birnbaum, Peter Campus, Peter D'Agostino, Douglas Davis, Stan Douglas, Juan Downey, Ed Emshwiller, Feng Mengbo, Terry Fox, Richard Fung, Frank Gillette, **Douglas Gordon**, Dan Graham, John Greyson, Doug Hall, Gary Hill, Rebecca Horn, Joan Jonas, Michael Klier, Paul Kos, Richard Kriesche, Shigeko Kubota, Marie-Jo Lafontaine, Les Levine, Joan Logue, Chip Lord, Mary Lucier, Stuart Marshall, Antonio Muntadas, Bruce Nauman, Shirin Neshat, Tony Oursler, Nam June Paik, Howardena Pindell, Walid Raad, Araya Rasdjarmrearnsook, Klaus Rinke, Ulrike Rosenbach, Martha Rosler, Jill Scott, Richard Serra, Yinka Shonibare, Michael Snow, John Sturgeon, Skip Sweeney and Joanne Kelly, Janice Tanaka, Diana Thater, Ryan Trecartin, T. R. Uthco, Stan Vanderbeek, Woody and Steina Vasulka, Bill Viola, Wang Jianwei, Gillian Wearing, William Wegman, Paul Wong, The Xijing Men, Bruce and Norman Yonemoto, Zhang Peili

▶WHEN Since the mid-1960s

- **▶WHERE** International
- ▶ WHAT Video art is video made by visual artists. It originated in 1965, when the Korean-born FLUXUS artist Nam June Paik made his first tapes on the new portable Sony camera and showed them a few hours later at Café au Go Go in New York's Greenwich Village.

Video is a medium, not a STYLE. Artists use video technology in remarkably varied ways. Some (including Paul Kos, Mary Lucier, Jill Scott, and Bill Viola) make videotapes to be used in PERFORMANCE ART or in INSTALLATIONS. Others (such as Les Levine, Martha Rosler, and the Vasulkas) create videotapes to be screened on video monitors in art museums or galleries. Still others (including Skip Sweeney and Joanne Kelly, and the Yonemotos) have preferred to broadcast or cablecast their videotapes on television, a modus operandi that required conforming to the costly technical standards and corporate values of the networks or accepting the limited audience reach of public-access cable channels. The issue of the relationship of video art and television that has dogged artists since the genre's inception has been resolved by Youtube (launched in 2005), which has dramatically leveled the playing field for anyone willing to post video online.

The best way to suggest the astonishing variety of video art is to cite a few important early examples. Frank Gillette's six-monitor video installation *Aransas* (1978) created a portrait of the swampy landscape of Aransas, on the Gulf Coast of Texas, that literally surrounded viewers. The German artist Michael Klier's *Der Riese* (*The Giant*, 1983) is a collage of "found" video footage from surveillance cameras. Joan Jonas's *Organic*

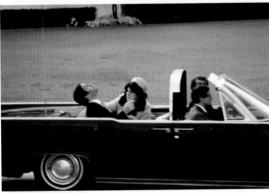

VIDEO ART T. R. Uthco and Ant Farm The Eternal Frame, 1975 Video with sound, 21 min., 22 sec. Photographs by Diane Andrews Hall Honey's Vertical Roll (1973) used the rolling images of poorly adjusted video monitors as an expressive distortion. Ant Farm and T. R. Uthco's Eternal Frame (1976), a re-creation of John F. Kennedy's assassination in Dallas, raises disturbing questions about our increasingly mediated—or media-derived experience—of reality. For Leaving the Twentieth Century (1982), Max Almy utilized the latest digital technology to create special effects that seemed to anticipate the high-tech imagery that would soon take hold in the music videos shown on MTV.

Infinitely reproducible in today's digital formats, video art would seem the least collectible of art media. In fact, there are dedicated collectors who have acquired both screen works and unique sculptural installations incorporating video. Most notable among them are Pamela and Richard Kramlich of San Francisco, who began collecting in the 1980s and founded the New Art Trust in 1997 to support research about video, and the Düsseldorf collector Julia Stoschek, who began acquiring multimedia art in 2004 and now owns more than four hundred works.

Xerography. See COPY ART

Xiamen Dada. See '85 NEW WAVE

Young British Artists

- ▶ wно Angela Bulloch, Jake and Dinos Chapman, Mat Collishaw, Tracey Emin, Angus Fairhurst, Marcus Harvey, Damien Hirst, Gary Hume, Abigail Lane, Sarah Lucas, Ron Mueck, Chris Ofili, Marc Quinn, Fiona Rae, Jenny Saville, Mark Wallinger, Gillian Wearing, Rachel Whiteread
- ▶WHEN 1987 to 2000
- **▶WHERE** Great Britain

252

▶WHAT The Young British Artists—often abbreviated as the YBAs—is the term for an informal and eclectic group that emerged at the end of the 1980s. It derives from a multiyear series of exhibitions of the same name at the Saatchi Gallery, London, which began in 1992. It has also come to signal—retroactively—the arrival of the UK as a player on the contemporary art stage.

Many of the YBAs attended Goldsmiths, an art college in London notable for its blurring of disciplinary boundaries, its thoughtful approach to art's social character, and its faculty of artist-mentors. Otherwise the YBAs shared little: they issued no manifestos and pursued distinctly personal artistic visions.

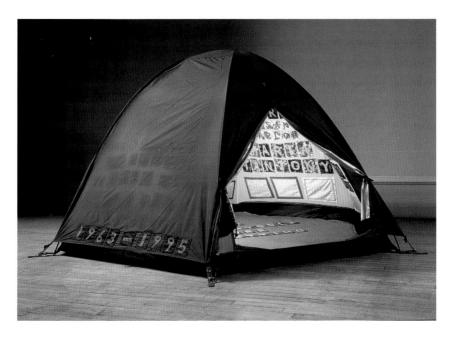

YOUNG BRITISH ARTISTS
Tracey Emin (b. 1963)
Everyone I Have Ever Slept With 1963–1995,
1995
Appliquéd tent, mattress, and light,
48 × 96½ × 84¼ in. (122 × 245 × 214 cm)
Formerly Charles Saatchi collection
(destroyed in fire, 2004)

The group's origins can be traced to the initiation, in 1988, of a series of self-organized exhibitions in recession-emptied warehouses on loan from developers. The second in the series, *Freeze*, is the best known. Organized (mainly) by Damien Hirst, it is remembered less for the work of the sixteen YBA stalwarts that was shown than for its shameless promotion, its professionally produced catalog, and the appearance of celebrity dealers and opinion-makers at its opening. The most prominent guest was Charles Saatchi, a partner in the family advertising agency credited with the successful "marketing" of Prime Minister Margaret Thatcher. His attraction to the raw and visceral in art aligned his sensibility with that of the YBAs.

Although it is difficult to generalize about so large a group, an emphasis on accessibility and emotional expression is a constant in the YBAs' work. (It is also a generational response to the emotionally removed CONCEPTUALISM of British art of the 1970s.) Theirs is a universe that

has replaced nature with culture, the pastoral vision at the heart of so much British art with gritty, tabloid-style representations of contemporary life. If the social breakdown inherent in a media-constructed universe is a common motif or theme in the work of many YBAs, the variety of their approaches to it is noteworthy. Gary Hume employed the tabloid page as a literal compositional device; Sarah Lucas deconstructed its ideology and modus operandi for her investigations of gender; the brothers Jake and Dinos Chapman evoked its science fiction–style paranoia in their genetically disordered sculptural ensembles; and Marcus Harvey appropriated an iconic mugshot of Myra Hindley, a notorious child molester and murderer of the 1960s, as the source for his gigantic portrait Myra (1995), which was realized not with a brush but with a plaster cast of a child's handprint.

Numerous works by these artists were owned by Saatchi, who seemed to have spent much of the 1990s on a YBA shopping spree. By the time he staged the first in the series of Young British Artists shows at the Saatchi Gallery, he had commissioned from Damien Hirst The Physical Impossibility of Death in the Mind of Someone Living (1991), a fourteen foot (4 m) long tiger shark suspended in a thirty foot (9 m) long vitrine filled with formaldehyde that became the iconic artwork of the YBAs.

In 1997, the exhibition Sensation! Young British Artists from the Saatchi Collection opened in London, before traveling to Berlin and New York. The show was a magnet for controversy, and its manipulative title alone seemed to taunt the restive media. Much of the controversy was philistine, as with the complaints against Chris Ofili's Holy Virgin Mary (1996), a painting adorned with tiny wrapped parcels of elephant dung linked to the artist's Nigerian background; Marcus Harvey's Myra; and Tracey Emin's Everyone I Have Ever Slept With 1963–1995, a diary in the form of a tent with names appliquéd on it.

The show's New York venue, the tax-supported Brooklyn Museum of Art, was also criticized for another reason—the size of the loan fee paid to Saatchi, which was widely regarded as inappropriately large, neglecting the value to the collector of exhibiting the work in New York. That Saatchi continues to buy and sell the works of the YBAs—his sale of *The Physical Impossibility of Death in the Mind of Someone Living* for \$8 million in 2004 being the most spectacular example—validates this concern.

Just as the YBAs have aged, so too has the term itself. Princess Anne named Tracey Emin, now a professor of drawing at London's Royal Academy of Arts, a CBE (Commander of the British Empire) at a ceremony in Buckingham Palace in March 2013. Two months later, Charles Saatchi announced the winners of the sixth annual New Sensations prize honoring recent art school graduates (and maintaining his Sensations "brand"). Today the original YBAs are primarily regarded as individuals, rather than a group. This not only suits the diversity of the art that

initially brought them to attention in the late 1980s but also reflects the varied creative paths they have traveled since then.

Zeitgeist

This German word (pronounced tsīt-gīst) has entered the English language untranslated. It literally means "spirit of the time" and suggests the mood and thinking of a given era or, colloquially, "what's in the air." In art terms zeitgeist refers to certain characteristics of a period or moment: the melancholic introspection of the fin de siècle (1890s); the optimism and experimentation of the 1960s; POSTMODERNISM's ironic embrace of tradition and history.

Index

Page numbers in **boldface** refer to main entries. Those in *italics* refer to illustrations.

Α '85 New Wave, **51-53**, 52, 114 Abbott, Berenice (U.S., 1898–1991), 240 ABC Art, 155 Abject Expressionism (a.k.a. Los Angeles Figurative Style or figurative expressionism), 49, 53-55, 54, 56, 92, 124, 189 Aboriginal art, 37; contemporary Indigenous Australian art, 40, 43, 109-10 Aboriginal Memorial, Canberra, Australia, 37, 110 Abramović, Marina (Serbia/U.S., b. 1946), 87, 88-89 abstract/abstraction (nonobjective or nonrepresentational), 55-56, 74, 167, 196, 207, 215, 218, 240, 245; biomorphic, 56; existentialism and, 124; geometric, 56, 74, 92, 97, 106, 107, 169 (see also Minimalism); modernism and, 160, 161, 167; organic, 56; outsider art and, 188; painterly painting and, 188; reactions against, 69, 82, 92, 135, 229; representation vs., 216. See also specific artists, groups, and styles Abstract Expressionism, 16, 19, 56, 57, **57-58**, 89, 92, 108, 123, 125, 134, 161, 198, 220, 246; Actions and, 59, 61; color-field painting and, 98; existentialism and, 124; Neo-Dada and, 171; painterly abstraction as name for, 188; process art and, 211; reactions against, 53, 61, 83-84, 143, 178, 182, 203. See also Art Informel academic art, 58-59, 205; in China, 51-52, 59; in Russia, 229 Académie des Beaux-Arts, Paris, 58-59 Acconci, Vito (U.S., b. 1940), 87, 118, 146, 192, 194, 250 Actionism, 60-61

Action painting, 19, 57. See also

Actions, **59–61**, 60, 88, 95, 100, 104,

Abstract Expressionism

161, 190, 192, 209

ACT UP (AIDS Coalition to Unleash Power), 63 Adams, Ansel (U.S., 1902–1984), 225, 240 Adams, Dennis (U.S., b. 1948), 212, 213 Adams, Robert (U.S., b. 1937), 118 Adamski, Hans Peter (Germany, b. 1947), 163 Aérosol, Jef (France, b. 1957), 243 Africano, Nicholas (U.S., b. 1948), 174, Agam, Yaacov (Israel, b. 1928), 147, 165, 184 Ahearn, John (U.S., b. 1951), 180, 212 AIDS, 34, 40, 123, 154 AIDS art, 37, 38, **61-63**, 62 Ai Weiwei (China, b. 1957), 40, 238, 243, Akasegawa Genpei (Japan, b. 1937), 25, 67; "1,000-Yen-Note Trial" Impounded Objects: Bottle and Can, 66 Akerman, Chantal (Belgium, b. 1950), Albers, Josef (U.S., 1888–1976), 106, 185 Albertson, James (U.S., b. 1943), 82 Albright, Thomas, 83 Alechinsky, Pierre (Belgium, b. 1927), Alexander, Jane, 40 Alexander, Peter (U.S., b. 1939), 131, 132 allegory, **64**, 171 Allen, Jo Harvey (U.S., b. 1942), 166 Allen, Terry (U.S., b. 1943), 166 Alloway, Lawrence, 22, 97, 143, 203 Almy, Max (U.S., b. 1948), 250, 252 Alors la Chine? (Well then, China?) (Paris, 2003), 45 alternative spaces, 28, **64-65**, 122, 180 Altoon, John (U.S., 1925–1969), 53 Alvarez, Lucia (Spain), 111 Alviani, Getulio (Italy, b. 1929), 184 Alÿs, Francis (Belgium, b. 1959), 226 American Family Association, 113 American Scene, 215 American-style painting, 57. See also Abstract Expressionism Anderson, Harry (U.S.), 77 Anderson, Laurie (U.S., b. 1947), 182, 192, 194, 231, 232, 234, 250 Anderton, John (Great Britain), 231 Andrade, Oswald de, 248 Andre, Carl (U.S., b. 1935), 155

	Andreu, Paul, 47	art and technology, 23, 29, 36, 70-71 ,
	Andrews, Benny (U.S., 1930–2006), 85,	107, 147, 160, 233. See also computer
	87	art; copy art; light-and-space art;
	Andrews, Michael (Great Britain,	online art; space art
	1928–1995), 218	Art Basel, 78
	Anne, Princess, 254	Art Brut, 16, 19, 71-72 , 72, 92, 209
	Anselmo, Giovanni (Italy, b. 1934), 73,	art collectives. See collaborative art
	103	art criticism, 79
	Ant Farm (U.S.), 92, 103, 154, 250; The	art dealers, 37, 78, 79
	Eternal Frame, 251, 252	Arte Povera, 27, 28, 73, 73-74 , 120, 140,
	anti-art, 65–67 , 66, 117, 135	211, 224
	Anti-Illusion: Procedures/Materials (New	art fairs, 39, 47, 78
	York, 1969), 28, 211	Art HK, 78
	Antin, Eleanor (U.S., b. 1935), 127, 151,	Art Informel, 19, 58, 74 , 75, 92, 117,
	166, 192	123, 182, 236; Actions and, 59, 61;
	Antipodean Group, 67-69	existentialism and, 124
	Antoni, Janine (U.S., b. 1964), 87	Art in Public Places, 27, 213
	Anuszkiewicz, Richard (U.S., b. 1930),	Art in the Streets (Los Angeles, 2011),
	184	244
	Apek (U.S.), 158	artist-run organizations, 65. See also
	Apfelbaum, Polly (U.S., b. 1955), 217	alternative spaces
	Apollinaire, Guillaume, 245	artists' books, 29, 30, 74-76 , 76
	Appel, Karel (Netherlands, 1921–2006),	Artists Books (Philadelphia, 1973), 30, 75
	80, 92; Untitled, 93	Artists Call Against U.S. Intervention in
	Apple, Jacki (U.S., b. 1941), 231	Central America, 35
	Applebroog, Ida (U.S., b. 1929), 166	artists' furniture, 48, 77 , 77, 112, 207
	appropriation, 39, 68, 69–70 , 161, 173,	artists' organizations, 65. See also
	176, 203, 207; kitsch and, 149; Op art	alternative spaces
	and, 185; simulation and, 223; Sots	artists' resale rights laws, 78
	art and, 229, 231; Transavantgarde	Artists Space, New York, 31, 32, 137, 196
	and, 247	art market, 37, 78 , 79, 160, 207–8;
	April Photographic Society, 240	commodification and, 100–101 , 103,
	Aptekar, Ken (U.S., b. 1950), 69	108–9, 117; Young British Artists and,
	Arbus, Diane (U.S., 1923–1971), 29, 240	254
	Area, New York, 36	(art) ⁿ , 61, 101
		Art of Assemblage, The (New York, 1961),
	Arman (France (U.S., b. 1939), 212	-
	Arman (France/U.S., 1928–2005), 80,	24, 80
	146, 181, 182; Infinity of Typewriters	Arts Catalyst, 233–34
	and Infinity of Monkeys and Infinity of	Art Maylean' Gaalitien 28, 122
	Time = Hamlet, 81	Art Workers' Coalition, 28, 129
	Armleder, John (Switzerland, b. 1948),	art world, 79–80 ; art as commodity
	173	and, 100–101, 117. See also auctions
	Arnal, André-Pierre (France, b. 1939), 99	Ashcan School, 229
	Arneson, Robert (U.S., 1930–1992), 89,	Asher, Michael (U.S., b. 1943), 150
	135, 202; Portrait of George (Moscone),	Ashley, Robert (U.S., b. 1930), 250
	34,90	Asian Art Museum, San Francisco, 26
	Arp, Jean (Hans) (France, 1886–1966),	Asia Society, New York, 42
	116, 245, 246	assemblage, 24, 80 , 81, 134, 161, 182,
	Ars Electronica Museum, Linz, Austria,	221. See also junk sculpture
	41	Association Leonardo/OLATS, 233
	Art against AIDS, 37	Atelier 17, New York, 209
	Art & Language (Great Britain), 74, 92,	Atget, Eugène (France, 1857–1927), 240,
258	95, 103	241

auctions, 30, 33, 37, 38, 46, 47, 48, 49, 78, 100, 108; online, 183–84 Auerbach, Frank (Great Britain, b. 1931), 218 Australia: Antipodean Group in, 67–69; contemporary Indigenous Australian art in, 40, 43, 109–10 Autio, Rudy (U.S., b. 1926), 112 automatism, 245–46 avant-garde, 18, 22, 59, 66, 126, 132, 160, 194, 207, 213, 215, 223, 231 Avedon, Richard (U.S., 1923–2004), 126 Aycock, Alice (U.S., b. 1946), 120, 212 Ayllón, José, 123	Bassman, Lillian (U.S., 1917–2012), 126–27; Carmen, 127 Battarbee, Rex, 109 Baudrillard, Jean, 173, 207, 222–23 Bauhaus, 77, 107, 169, 185 Baumgarten, Lothar (Germany, b. 1944), 143 Baxter, Iain (Canada, b. 1936), 103 Bay Area figurative style, 55, 69, 82–84 , 84, 92, 124. See also funk art Baziotes, William (U.S., 1912–1963), 57 Beal, Jack (U.S., b. 1931), 64, 178 Bearden, Romare (U.S., 1911–1988), 97 Beat, 60, 80, 124, 224	
Ay11011, Juse, 123	Beaton, Cecil, 126	
В	Beauvoir, Simone de, 18, 124, 186	
Baca, Judy (U.S., b. 1946), 212, 213	Bechdel, Alison (U.S., b. 1960), 100 Becher, Bernd (Germany, 1931–2007)	
Bacci, Edmondo (Italy, b. 1913), 235 Bach, Elvira (Germany, b. 1951), 164, 171	and Hilla (Germany, b. 1934), 92, 95,	
Bacon, Francis (Great Britain, 1909–	118 Parktle Pohort (ILS, b. 1000) 104	
1992), 218; Two Studies for a Portrait of George Dyer, 219	Bechtle, Robert (U.S., b. 1932), 194 Beck, Stephen (U.S.), 250	
"bad" painting, 82 , 83	Beckley, Connie (U.S., b. 1951), 231	-
"Bad" Painting (New York, 1978), 32, 82	Beckman, William (U.S., b. 1942), 178	
Bailey, Clayton (U.S., b. 1939), 135 Bailey, William (U.S., b. 1930), 178	Beckmann, Max (Germany, 1884–1950), 64, 176	
Baldessari, John (U.S., b. 1931), 74, 103,	Beecroft, Vannesa (Italy, b. 1969), 226	
104, 166	Beijing Worker's Cultural Center, 238	
Banana, Anna (Canada, b. 1940), 151,	Belcher, Muriel, 218 Bell, Clive, 134	-
192 Bandt, Rosland (Australia), 231	Bell, Daniel, 23	
Banksy (Great Britain), 243, 244	Bell, Larry (U.S., b. 1939), 131, 132	
Baraka, Amiri (a.k.a. LeRoi Jones), 26,	Bellows, George (U.S., 1882–1925), 229	
85, 86 Baranik, Rudolf (U.S., b. after 1920),	Bender, Gretchen (U.S., b. 1951), 101 Benglis, Lynda (U.S., b. 1941), 127, 211	
200	Bengston, Billy Al (U.S., b. 1934), 89, 131	
Barceló, Miguel (Spain, b. 1957), 171	Benjamin, Karl (U.S., 1924–2012), 142;	
Bardon, Geoffrey, 109–10 Barney, Matthew (U.S., b. 1967), 143, 250	I. F. Green, Ochre, Umber, 142 Benton, Thomas Hart (1889–1975), 215	
Barns-Graham, Wilhelmina (Great	Berkeley Art Museum, Calif., 27, 130	
Britain, 1912–2004), 216	Berlant, Tony (U.S., b. 1941), 80	
Baroni, Vittore (Italy, b. 1956), 111	Berman, Wallace (U.S., 1926–1976), 53,	
Barrie, Dennis, 38 Barry, Judith (U.S., b. 1949), 127, 220	80, 97, 170 Bern Kunsthalle, 28, 211	
Barry, Robert (U.S., b. 1931), 103	Bertrand, André (France), 223	
Barsotti, Hercules (Brazil, b. 1914), 168	Beuys, Joseph (Germany, 1921–1986),	
Barthes, Roland, 220 Bartlett, Jennifer (U.S., b. 1941), 102,	59, 60, 74, 80, 103, 132, 135, 143, 154, 176, 200, 211; I Like America and	
174, 175	America Likes Me, 60	
Baselitz, Georg (Germany, b. 1938), 171	Bickerton, Ashley (U.S., b. 1959), 173	
Basquiat, Jean-Michel (U.S., 1960- 1988), 36, 121, 137, 138, 139, 171;	Bidlo, Mike (U.S., b. 1953), 69, 121 Biemann, Ursula (Switzerland), 250	
1988), 36, 121, 137, 138, 139, 171, Pakiderm, 122	Biennale de Paris, 85	259
,		-55

	Biennale of Young Artists, Paris, 23	Brack, John (Australia, b. 1920), 67, 69
	biennial exhibitions, 35, 41, 78, 85 , 145.	Brady, Robert (U.S., b. 1946), 89
	See also specific biennials	Brancusi, Constantin (Romania, 1876–
	Biggers, John (U.S., 1924–2001), 85	1957), 77
	Bill, Max (Switzerland, 1908–1994),	Brandon, Teena, 184
	106, 169	Brandt, Bill (Great Britain, 1904–1983),
	biomorphism, 56, 246	240
	Bioulès, Vincent (France, b. 1938), 99	Braque, Georges (France, 1882–1963),
	Birnbaum, Dara (U.S., b. 1946), 250	17, 64, 80, 94, 97, 107, 134, 146
	Bischoff, Elmer (U.S., 1916–1991), 82,	Brauntuch, Troy (U.S., 1954), 196
	83-84	Brazil: Neo-Concretism in, 168–69 ,
	Black Arts Movement, 85-87, 86	169, 248; Tropicalism in, 169, 248 -
	Blackman, Charles (Australia, b. 1928),	49 , 249
	67, 69	Brecht, George (U.S., 1926–2008), 74,
	Black Mountain College, N.C., 142	132
	Black Power Movement, 85	Breder, Hans, 146
	Bladen, Ronald (Canada, 1918–1988),	Brehmer, Klaus (Germany, 1938–1997),
	155	202
	Blair, David (U.S.), 182	Breton, André, 245–46
	Blake, Nayland (U.S., b. 1960), 61, 130,	Brice, William (U.S., 1921–2008), 53
	143	Bridge, Allan (U.S., 1945–1995), 231, 232
	Blake, William, 75	Brisley, Stuart (Great Britain, b. 1933),
	Blanchon, Robert (U.S., 1965–1999), 189	87, 192
	Der Blaue Reiter (The Blue Rider), 125	Broodthaers, Marcel (Belgium, 1924-
	Bleckner, Ross (U.S., b. 1949), 61, 63, 185	1976), 74, 143
	Block, René, Gallery, Berlin, 203	Brooklyn Museum of Art, 254
	Bloom, Barbara (U.S., b. 1951), 143	Brooks, Ellen (U.S., b. 1946), 236
	Bob and Bob (U.S.), 192 Bochner, Mel (U.S., b. 1940), 103	Brossa, Joan, 117
	body art, 53, 61, 87-89 , 88, 183, 192	Brown, Joan (U.S., b. 1938), 82, 84, 166; Lolita, 84
	Body Works (Chicago, 1975), 31	Brown, Kathan, 210
	Boetti, Alighiero (Italy, 1940–1994), 73	Brown, Roger (U.S., 1941–1997), 89, 91;
	Bogosian, Eric (U.S., b. 1953), 192, 194	Peach Light, 91
	Boltanski, Christian (France, b. 1944),	Brown, Tony (Canada, b. 1952), 143
	143	Die Brücke (The Bridge), 125
	Bömmels, Peter (Germany, b. 1951), 163,	Bruguera, Tania (Cuba, b. 1968), 226
	164	Brus, Günter (Austria, b. 1938), 59, 60
	Bond, Henry (Great Britain, b. 1966),	Bryant, Anita, 113
	226	Buchanan, Nancy (U.S., b. 1946), 74, 192
	Bontecou, Lee (U.S., b. 1931), 146, 147	Buchanan, Patrick, 112
	book art. See artists' books	Buchner, Charles (U.S.) and Mary (U.S.),
	Border Art Workshop (Mexico/U.S.),	231
	154, 200, 227	Bulatov, Eric (Russia, b. 1933), 229
	Borofsky, Jonathan (U.S., b. 1942), 143,	"Bulldozer" show (Moscow, 1974), 30,
	165, 166, 171, 174, 175, 217	230
	Bouguereau, Adolphe William, 59	Bulloch, Angela (Canada, b. 1966), 252
	Bourdin, Guy (France, 1933–1991), 126	Bunting, Heath (Great Britain), 182
	Bourgeois, Louise (U.S., 1911–2010), 80	Burden, Chris (U.S., b. 1946), 55, 87, 143,
	Bourriaud, Nicolas, 41	154, 192, 212
	Bowers, Harry (U.S., b. 1938), 236	Buren, Daniel (France, b. 1938), 103,
	Boyd, Arthur (Australia, b. 1920), 67	143, 145
	Boyd, David (Australia, b. 1924), 67	Burgess, Lowry (U.S.), 70, 232
60	Bo Yun (China, b. 1948), 238	

Burgin, Victor (Great Britain, b. 1941),	Carrión, Ulises (Mexico, b. 1940), 74, 151	
74, 103, 129, 200, 220	Cartier-Bresson, Henri (France, 1908–	
Burkhardt, Hans (U.S., 1904–1994), 53	2004), 126, 240	
Burkhart, Kathe (U.S., 1958), 61	Cartoon Art Museum, San Francisco, 99	
Burnham, Jack, 105	Carvão, Aluísio (Brazil, 1920–2001), 168	
Burri, Alberto (Italy, 1915–1995), 74	Casebere, James (U.S., b. 1953), 236	
Burson, Nancy (U.S., b. 1948), 61, 101 Burton, Scott (U.S., 1939–1989), 77, 192,	Castelli, Leo, Gallery, New York, 23, 221 Castle, Wendell (U.S., b. 1932), 112	
194, 212; Two-Part Chaise, 77	Castro, Amilcar de (Brazil, 1920–2002),	
Bury, Pol (Belgium, b. 1922), 147	168	9-9
Bush, Jack (Canada, 1909–1977), 97	Catlett, Elizabeth (U.S., 1915–2012), 85,	
Butler, Judith, 130	87	
Byars, James Lee (U.S., 1932–1997), 103	Cavellini, Guglielmo Achille (Italy,	
Byrne, David, 194	1914–1990), 151 Celant, Germano, 27, 73, 74	
С	censorship, 38, 40, 41, 63, 113, 183	
Cabaret Voltaire, Zürich, Switzerland,	Center for Advanced Visual Studies,	-
116	Massachusetts Institute of	
Café au Go Go, New York, 26, 250	Technology, Cambridge, 27, 71, 101,	
Cage, John (U.S., 1912–1992), 71, 74, 103,	233	14
141-42, 193, 231	Center for Land Use Interpretation, 92,	
Caldra Alexander (H.S. 2000, 2076)	95, 232	
Calder, Alexander (U.S., 1898–1976), 147, 165	Centre Georges Pompidou, Paris, 32, 36, 38, 44, 164, 224	
California College of the Arts, San	ceramic sculpture, 58, 89 , 90, 112, 135	
Francisco, 226	César (France, b. 1921), 146–47, 181	
California Institute of the Arts	Cézanne, Paul (France, 1839–1906), 49,	
(CalArts), 28, 129, 184, 196, 216, 227	78	
California School of Fine Arts. See San	Cha, Theresa Hak Kyung (U.S., 1951–	
Francisco Art Institute	1982), 192	
California State University, Fresno, 28,	Chadwick, Helen (Great Britain, 1953-	
129 Calle, Sophie (France, b. 1953), 143	1996), 127 Chamberlain, John (U.S., b. 1927), 80,	
Camargo, Sergio (Brazil, 1930–1990), 168	146, 165	
Cameron, Dan, 34	Chand, Nek (India, b. 1924), 188	
Camnitzer, Luis (Uruguay, b. 1939), 103	Chapman, Jake (Great Britain, b. 1966)	
camp, 149	and Dinos (Great Britain, b. 1962),	
Campbell, Colin (Canada, b. 1942), 166,	252, 254	
250	Charlesworth, Bruce (U.S., b. 1950), 166,	
Campbell, Jim (U.S.), 101	167, 236 Charlesworth, Sarah, 223	
Campus, Peter (U.S., b. 1937), 250 Camus, Albert, 124	Cheang, Shu Lea (U.S., b. 1954), 182;	
Cane, Louis (France, b. 1943), 99	Brandon, 184	
Canogar, Rafael (Spain, b. 1934), 123	Chia, Sandro (Italy, b. 1946), 171, 246	-
Capitalist Realism, 203. See also Pop Art	Chicago, Judy (U.S., b. 1939), 33, 127, 129,	
Capogrossi, Giuseppe (Italy, 1900–	131, 227; Car Hood, 131	-
1972), 235	Chicago Arts Club, 19, 72, 91	
Cardinal, Roger, 186	Chicago Imagism, 55, 72, 82, 89–92 ,	
Carleon Chostor F. 111	91, 136 Chihuly, Dale (U.S., b. 1941), 112	
Carlson, Chester F., 111 Carnegie Mellon, Pittsburgh, STUDIO	Chin, Mel (U.S., b. 1951), 226	
for Creative Inquiry, 233	China: '85 New Wave in, 51–53 , 52,	
Carré d'Art, Nîmes, France, 40	114; academic painting in, 51–52,	261

59; auction prices for art from, 47. 48; Beijing Olympics in, 47; Cynical Realism in, 113-15, 114, 200-201; first officially sponsored foreign exhibition of avant-garde art from, 45; graffiti art in, 138, 139; museum openings in, 48; Political Pop in, 114, 200-201, 202, 226; Rauschenberg's 1985 show in. 36, 201: Socialist Realism in, 176, 200, 226; Stars Group in, 33, 51, 238-40, 239 China Arts Gallery (now called National Art Museum of China), Beijing, 53, 201, 238, 239 China/Avant-Garde (Beijing, 1989), 38, 53, 114, 240 China's New Art, Post-1989 (Hong Kong, 1993), 40, 115, 201 Chinese United Overseas Artists Association, 240 Chirico, Giorgio de, 64 Chirino, Martin (Spain, b. 1925), 123 Chong, Ping (U.S., b. 1946), 192 Christian Coalition, 113 Christie's New York, 49 Christie's Hong Kong, 47 Christo (U.S., b. 1935), 31, 39, 120, 181, 227 Church, Frederic Edwin, 33 Cirlot, Juan Eduardo, 117 Cirrus Editions Limited, Los Angeles, 209 Clar, Richard (U.S.), 232 Clark, Ed (U.S., b. 1926), 85 Clark, Jonathan (Great Britain), 216 Clark, Larry (U.S., b. 1943), 224 Clark, Lygia (Brazil, 1920–1988), 168, 248 Clarke, John Clem (U.S., b. 1937), 194 Clegg & Guttmann (Michael Clegg, U.S., b. 1957; Martin Guttmann, U.S., b. 1957), 92, 223 Clemente, Francesco (Italy, b. 1952). 36, 64, 171, 246; Francesco Clemente Pinxit. 247 Close, Chuck (U.S., b. 1940), 194 Coates, Robert, 16, 57 Cobo, Chema (Spain, b. 1952), 171 CoBrA, 18, 19, 69, **92**, 93, 124 Coe, Sue (U.S., b. 1959), 166, 171, 172, 200; Woman Walks into Bar—Is Raped by 4 Men on the Pool Table—While 20 Men Watch, 168 Cohen, Harold (Great Britain, b. 1928), 101

Colescott, Robert (U.S., 1925-2009), 64, 82, 166 Colette (U.S.), 192 collaborative art. 92-95, 94 Collaborative Projects, Inc., 180 collage, 69, 80, **95-97**, 96, 107, 134, 146, 161. See also assemblage Collishaw, Mat (Great Britain, b. 1966). 252 Colo, Papo (U.S., b. 1946), 192 Cologne Art Fair, 40 Colony Room, London, 218 color-field painting (post-painterly abstraction; systemic painting), **97-99**, 98, 106, 143, 188, 198, 211, 220 combines, 170 comics art, **99-100** commodification, **100-101**, 103, 108-9, 117. See also art market; auctions computer art, 27, 101-3, 102, 161, 184 Conal, Robbie (U.S., b. 1941), 200, 243 Conceptual art, 27, 28, 29, 36, 65, 70, 84, 95, 100, 101, **103-5**, 105, 125, 133, 140, 162, 164, 175, 205, 207, 212, 224, 227, 244, 253; artists' books and, 76; Dada and, 116-17; documentation and, 104, 118; Düsseldorf School of Photography and, 118-19, 119; feminist, 129; installations and, 145; mail art and, 152; Neo-Conceptualism and, 105, 123, 217; neo-geometric (Neo-Geo), 36, 123, 132, **173**, 174, 203; online art and, 182-84; performance art and, 193-94; Pictures Generation and, 196–97; political art and, 200; print revival and, 210; reactions against, 82, 171, 174, 180; semiotics and, 220-21; sound art and, 28, 231–32. See also body art; earth art; video art Conceptual Art/Arte Povera/Land Art (Turin, 1970), 28 Concrete art, 56, 92, **106**, 160; Brazilian Neo-Concretism and, 168-69, 169, 248 Condé, Manuel, 123 Connelly, Arch (U.S., 1950–1993), 121 Conner, Bruce (U.S., b. 1933), 80, 97, 135, 167, 170 Constant (Netherlands, b. 1920), 223 Constructivism, 56, 58, 70, 92, **106-7**,

156, 160, 161, 169

Coleman, James (Ireland, b. 1941), 103

consumer culture, 147, 189, 199, 201,	Cultural Center of European Space	
203, 205, 206, 223, 245	Technologies (KSEVT), 234	
contemporary, use of term, 107-9	Cultural Revolution (China), 51, 114,	
Contemporary Arts Center, Cincinnati,	201, 238	
38	culture wars, 48, 112-13 , 165	
Contemporary Bay Area Figurative	Cumming, Robert (U.S., b. 1943), 166,	
Painting (Oakland, Calif., 1957), 22	236	
contemporary Indigenous Australian	Cunningham, Imogen (U.S., 1883–	
art, 40, 43, 109-10	1976), 240, 241	
Contemporary Jewish Museum, San	Curry, John Steuart, 215	
Francisco, 46	CutUp Collective (Great Britain), 243	
content, 110-11 ; form in relation to,	Cybernetic Serendipity: The Computer and	
111, 134; semiotics and, 221	the Arts (London, 1968), 27, 101	
Conwill, Houston (U.S., b. 1947), 212	Cynical Realism, 113-15 , 114, 200-201	-
cooperative gallery. See alternative	D	
space	D	_
copy art, 111 , 151	Dada, 19, 25, 60, 70, 88, 92, 100, 116-17 , 147, 161, 238; collage and, 95, 151;	
Corcoran Gallery of Art, Washington,	found objects and, 135; funk art	-
D.C., 38 Corneille (Netherlands, b. 1922), 92	and, 135; Happenings and, 141; junk	
Cornell, Joseph (U.S., 1903–1972), 80, 245	sculpture and, 146, 170; performance	-
correspondence art. See mail art	art and, 193; Pop art and, 203;	
Cottingham, Robert (U.S., b. 1935), 194	Surrealism and, 246; Xiamen Dada	-
Cotton, Paul (U.S., b. 1938), 192	group and, 53. See also Duchamp,	
Courbet, Gustave, 160, 215	Marcel; Neo-Dada	-
Cply (William Nelson Copley) (U.S.,	D'Agostino, Peter (U.S., b. 1945), 101,	
1919–1996), 82	182, 183, 250	
crafts-as-art, 77, 112, 161; feminist art	Dahl-Wolfe, Louise, 126	
and, 129, 130, 192. See also artists'	Dahn, Walter (Germany, b. 1954), 153,	
furniture; ceramic sculpture; Pattern	163, 164	
and Decoration	Dailey, Dan (U.S.), 112	
Crane, Margaret (U.S.), and Jon Winet	Dalí, Salvador (Spain, 1904–1989), 16,	
(U.S.), 92, 95, 182	56, 245, 246	
Crash (U.S., b. 1961), 137	Daniel, Bill (U.S., b. 1959), 158	
Craxton, John, 218	Daphnis, Nassos (Greece, 1914-2010), 97 Darboven, Hanne (Germany, b. 1941),	
Creative Time, 226	74, 103	
Crewdon, Grogory (U.S., b. 1932), 53	Darger, Henry (U.S., 1892–1973), 188	
Crewdson, Gregory (U.S., b. 1962), 196, 197–98, 236, 237; Untitled (Penitent	Darling, Lowell (U.S.), 151, 154	
Girl), 237	Dater, Judy (U.S., b. 1941), 127, 236	
Crimp, Douglas, 32, 196	Dau al Set, 117 , 123	
Crippa, Roberto (Italy, 1921–1972), 235	Daumier, Honoré, 99	
Critical Art Ensemble (U.S.), 200	Davidson, Bruce (U.S., b. 1933), 224	
Crown Point Press, San Francisco, 209,	Davies, Char (Canada), 101	
210	Davis, Brad (U.S., b. 1942), 191	
Crumb, Robert (U.S., b. 1943), 100	Davis, Douglas (U.S., b. 1933), 182, 183,	-
Cruz Azaceta, Luis (Cuban, active U.S.,	250	
b. 1942), 171	Davis, Gene (U.S., 1920–1985), 97	-
CUBA (U.S.), 158	Davis, Stuart (U.S., 1892–1964), 99, 200,	
Cubism, 74, 94, 97, 107, 126, 146, 161,	203	-
220, 238	Day With(out) Art, 38, 63	
Cucchi, Enzo (Italy, b. 1950), 64, 171, 246	Daze, 137	
Cuixart, Modest (Spain, b. 1925), 117	De Andrea, John (U.S., b. 1941), 195	263
		_

	Debord, Guy, 223, 224	Disney, Walt, Company, 39
	Decade Show, The (New York, 1990), 38, 164	di Suvero, Mark (Ü.S., b. 1933), 165, 212 Divola, John (Ü.S., b. 1949), 236
_	décollage, 97	Dix, Otto, 176
	deconstruction, 134, 196, 220–21, 254 decorative arts, 191. <i>See also</i> Pattern and	Documenta, Kassel, Germany, 21, 27, 29, 44, 85, 195
	Decoration	documentary photography, 241
	De Forest, Roy (U.S., b. 1930), 135 Degenerate Art (<i>Entartete Kunst</i>) (Los	documentation, 76, 87, 103–4, 118 , 120, 145
	Angeles, 1991), 39	Doesburg, Theo van, 106
	Deitch, Jeffrey, 244	Dokoupil, Jiří Georg (Germany, b. 1954),
	de Kooning, Willem (U.S., 1904–1997), 18, 33, 38, 56, 57, 209	163, 164 Dolla, Noël (France, b. 1945), 99
	Delaunay, Robert, 55	Donaldson, Jeff (U.S., b. 1932), 85
	de Lauretis, Teresa, 130	Donati, Enrico (U.S., b. 1909), 235
_	Demand for Artistic Freedom (Tokyo, 2000), 240	Dondi (U.S.), 137 Dotremont, Christian, 92
	De Maria, Nicola (Italy, b. 1954), 246	Douglas, Stan (Canada, b. 1960), 250
	De Maria, Walter (U.S., 1935–2013), 120, 143; Lightning Field, 118, 120	Dova, Gianni (Italy, 1925–1991), 235 Downes, Rackstraw (U.S., b. 1939), 194
	Denes, Agnes (U.S., b. 1931), 211	Downey, Juan (U.S., b. 1940), 250
	De Pillars, Murry (U.S., 1938–2008), 85	Dreva, Jerry (U.S.), 151
	Derain, André, 125 dérive (drift), 223	Dubuffet, Jean (France,1901–1985), 16, 19, 71–72, 91, 124, 137; Coffee Pot II, 72
_	DeSana, Jimmy (U.S., 1950–1990), 121	Duchamp, Marcel (France, 1887–1968),
	De Staebler, Stephen (U.S., b. 1933), 77, 89	25, 27, 70, 74, 75, 80, 88, 104, 116, 117,
	De Stijl, 169	134–35, 146, 147, 165, 170; A Bruit secret (With Hidden Noise), 231
_	détournement (diversion or	Dufy, Raoul, 125
	displacement), 223 Devade, Marc (France, 1943–1983), 99	Duncan, Michael, 49, 53, 55 Düsseldorf School of Photography,
	Dewasne, Jean (France, b. 1921), 106	118–19 , 119
_	de Young Museum, San Francisco, 46	Dyke Action Machine, 127, 130
	Dezeuze, Daniel (France, b. 1942), 99 Dia Art Foundation, 120	Dzubas, Friedel (U.S., 1915–1994), 97
	dialogical aesthetics. See social practice	E
_	Diamond, Jessica (U.S., b. 1957), 189 Diao, David (U.S., b. 1943), 69	Earls, Paul (U.S., b. 1934), 101, 231 earth art (environmental art), 27, 28, 31,
	Diaz, Al, 137	32, 100, 104, 120 , 121, 162, 209, 211,
	Dibbets, Jan (Netherlands, b. 1941), 103,	213; documentation and, 118; sound
_	120 Dickerson, Robert (Australia, b. 1924),	art and, 232 Earth Art (Ithaca, N.Y., 1968), 27
	67, 69	George Eastman House (Rochester,
	Diebenkorn, Richard (U.S., 1922–1993), 55, 82, 83	N.Y.), 111 East Village, 34, 65, 121–23 , 122, 173;
_	Difference: On Representation and	new wave and, 180. See also graffiti art
	Sexuality (New York, 1984), 35, 186	eBay, 183–84
	digital art, 41, 42. <i>See also</i> computer art; new media; online art	Eco, Umberto, 220 Eddy, Don (U.S., b. 1944), 194
	digital communication, 206	Edelson, Mary Beth (U.S., b. 1934), 127,
	digital mass media, 178	129
4	Dine, Jim (U.S., b. 1935), 141, 202 Ding Fang (China, b. 1956), 51	Edison, Thomas Alva, 111
- 1		

Editions M.A.T. (Multiplication Arts Transformable), 23, 165 Ehrenberg, Felipe (Mexico, b. 1943), 74 Eichbauer, Hélio (Brazil, b. 1941), 248 Eichelberger, Ethyl (U.S., 1945–1990), 192 18 Happenings in 6 Parts (New York, 1959), 23, 141 Eisenman, Nicole (U.S., b. 1963), 99, 217 Eisenman, Peter (U.S., b. 1932), 212 Eisner, Will (U.S., 1917–2005), 100 Eitel, Tim (Germany, b. 1971), 176 electrographic art. See copy art electronic art. See digital art Electrowork (Rochester, N.Y., 1979), 111 Eliasson, Olaffur (Denmark, b. 1967), 143 Elmgreen & Dragset (Michael Elmgreen, Denmark, b. 1961, and Ingar Dragset, Norway, b. 1969), 143 El Paso, 123 Emin, Tracey (Great Britain, b. 1963), 252; Everyone I Have Ever Slept With 1963–1995, 253, 254 Emshwiller, Ed (U.S., b. 1925), 101, 250 English, Ron (U.S., 1959), 243 English, Rose (Great Britain), 127 Eno, Brian (Great Britain, b. 1948), 231, 232 Enokura, Koji (Japan, 1942–1995), 161 Entartete Kunst (Degenerate Art) (Los Angeles, 1991), 39 environmental art. See earth art Equipo Crónica (Rafael Solbes, Spain, 1940–1981; Manuel Valdés, Spain, b. 1942), 92, 95, 202 Ericson, Kate (U.S., b. 1955), and Mel Ziegler (U.S., b. 1956), 92, 95 Erlebacher, Martha (U.S., b. 1937), 178 Ernst, Max (Germany, 1891–1976), 58, 64, 116, 245, 246	Experiments in Art and Technology (EAT) (U.S.), 26, 70–71 Exposição Nacional de Arte Concreta (São Paulo, 1956, and Rio de Janeiro, 1957), 169 expressionism, 58, 89, 92, 125, 153, 161, 163, 180, 188, 217; German, 56, 125, 161, 176, 238; gesturalism and, 137. See also Abject Expressionism; Abstract Expressionism Neo-Expressionism Extended Sensibilities: Homosexual Presence in Contemporary Art (New York, 1982), 34 Exter, Alexandra (Russia, 1882–1949), 106 Eyebeam Art + Technology Center, New York, 42, 103, 184 F Fab 5 Freddy (a.k.a. Freddy Brathwaite, U.S., b. 1958), 137 Fabre, Jan (Belgium, b. 1958), 192 fabricated photography, 236–37, 241 Fabro, Luciano (Italy, b. 1936), 73 Fahlström, Öyvind (Sweden, 1928–1976), 99, 166, 202 Fairey, Shepard (U.S., b. 1970), 243 Fairhurst, Angus (Great Britain, 1966–2008), 252 Family of Man, The (New York, 1955), 21 Fang Lijun (China, b. 1963), 51, 113, 114 Farm Security Administration (FSA), 229 Farocki, Harun (Czech Republic, b. 1944), 200 fashion aesthetic, 126–27, 127, 241 Fashion Moda, New York, 137, 180 Faucon, Bernard (France, b. 1950), 236 Fautrier, Jean (France, 1898–1964), 74 Fauvism, 125, 220, 238 Fecteau, Vincent (U.S., b. 1969), 189	
232		
Enokura, Koji (Japan, 1942–1995), 161		
essentialism, 130, 156 Estes, Richard (U.S., b. 1932), 194, 195;	Feher, Tony (U.S.), 217, 218	
Canadian Club, 195	Feingold, Ken (U.S., b. 1952), 101	
etching. See print revival	Feininger, Lyonel (U.S./Germany,	
Evans, Walker (U.S., 1903–1975), 197,	1871–1956), 99	
229, 240, 241	Feitelson, Lorser (U.S., 1898–1978), 142	
Evergon (Canada, b. 1946), 111	Feito, Luis (Spain, b. 1929), 123	
Everts, Connor (U.S., b. 1926), 53	Fekner, John (U.S., b. 1950), 243 Feldman, Ronald, Fine Arts, New York,	
existentialism, 55, 58, 82, 124 , 140, 186 Experimental Group, 92	231	
Experimental Group, 92 Experimental Workshop, San	feminism, 65, 134, 186	
Francisco, 209		265

feminist art, 28, 61, 63, 103, 127-30 ,	Fluxus, 24, 26, 59–60, 76, 104, 132–33 ,
128, 161, 207, 209, 220, 227;	133, 140, 146, 192, 231; Japanese anti-
appropriation and, 69-70; crafts and,	art and, 65; mail art and, 152
129, 192; performance art and, 192	folk art, 137, 188, 201
Feminist Art Program, 129	Fontana, Lucio (Italy, 1899–1968), 106,
Feminist Art Workers (U.S.), 127, 200	124, 221, 235–36; Spatial Concept, 235
Feng Mengbo (China, b. 1966), 200, 201,	
250; Long March: Restart, 202	Fontcuberta, Joan (Spain, b. 1955), 153
Feng Yidai, 240	Ford, Walton, 166
	Foreman, Richard, 146
Ferrara, Jackie (U.S., b. 1929), 212	forgeries, 16, 37, 222, 245
Ferrari, Leon (Argentina, 1920–2013),	form, in relation to content, 111, 134
200	formal/formalism, 97, 134 , 145, 161,
Festival d'Avignon, 31	188, 196, 220; Concrete art and, 106;
Festival of Britain, 19	reactions against, 103, 211
Fetting, Rainer (Germany, b. 1948), 164,	Foucault, Michel, 130, 207
171	Foulkes, Llyn (U.S., b. 1934), 53, 55;
figurative, use of term, 130	Made in Hollywood, 54
figurative artworks and imagery, 23,	found objects, 69, 134–35 , 146, 158, 161,
55, 64, 82, 87, 167, 215, 246. See also	170, 182, 217, 246; readymades and,
Abject Expressionism; Antipodean	80, 104, 116, 134–35; Xiamen Dada
Group; Bay Area figurative style;	group and, 53
Chicago Imagism; CoBrA; New	Fox, Connie (U.S., b. 1925), 111
Image; New Realism; School of	Fox, Terry (U.S., b. 1943), 87, 143, 192,
London	231, 250
figurative expressionism. See Abject	France: existentialism in, 124; School
Expressionism	of Paris in, 74, 220 ; Supports/Sur-
Filliou, Robert (France, 1926–1987), 74,	faces in, 99. See also Art Informel;
132, 151	Nouveau Réalisme
Finish Fetish (Los Angeles "look" or	Frank, Robert (Switzerland, active
L.A. Slick), 131, 131–32 , 150	U.S., b. 1924), 23, 224–25, 240; The
Finley, Karen (U.S., b. 1956), 127, 189, 192	Americans, 23
First Open Air Contemporary Sculpture	Frankenthaler, Helen (U.S., 1928–2011),
Exhibition (Kobe, 1968), 162	97, 98, 128, 211; Approach, 98
Fischer, Hervé (France), 151	
Fischer, R. M. (U.S., b. 1947), 77, 212	Freeze (London, 1988), 37, 253
Fischl Fric (IIS b 1049) 44 166 171	Frente Group (Brazil), 169
Fischl, Eric (U.S., b. 1948), 44, 166, 171,	Freud, Lucian (Great Britain, 1922–
215 Fischli and Woiss (Potor Fischli	2011), 178, 179, 218
Fischli and Weiss (Peter Fischli,	Freud, Sigmund, 60, 246
Switzerland, b. 1946; David Weiss,	Frey, Viola (U.S., b. 1933), 89
Switzerland, b. 1946), 92, 236	Fried, Howard (U.S., b. 1946), 103, 143
Fish, Janet (U.S., b. 1938), 178	Fried, Michael, 134, 145
Fisher, Vernon (U.S., b. 1943), 166	Friedlander, Lee (U.S., b. 1934), 224, 225,
Flack, Audrey (U.S., b. 1931), 194, 195	240; Mount Rushmore, South Dakota,
Flanagan, Bob (U.S., 1952–1997), and	225
Sheree Rose (U.S.), 87	Friedman, Benno (U.S., b. 1945), 153
Flavin, Dan (U.S., 1933–1996), 155;	Friedman, Ken (U.S., b. 1949), 132
Untitled (to Saskia, Sixtina, and	Frost, Terry (Great Britain, 1915-2003),
Thordis), 156	216
Fleischner, Richard (U.S., b. 1944), 212	Fry, Roger, 134
Fleming, Martha (Canada), and Lynn	Fuller, Buckminster, 71
Lapointe (Canada), 92	Fulton, Hamish (Great Britain, b. 1946),
Flint, Henry (U.S.), 103	74, 103, 120
,, (0.0.1, 103	Fulton, Jack (U.S., b. 1939), 153
	1 arcorr, jack (0.0., 0. 1939), 153

Fundación Ludwig de Cuba, Havana, 41 Fung, Richard (U.S., b. 1957), 250 Fun Gallery, New York, 34, 123 Funk (Berkeley, 1967), 27, 55, 135 funk art, 82, 92, 135-36, 136 furniture. See artists' furniture Füss, Adam (U.S., b. 1961), 236 Futura 2000, 137 Futurism, 70, 160, 231, 236 G Gablik, Suzi, 138 Gabo, Naum (Russia/U.S., 1890–1977), 106, 147 Galeria Civica, Modena, Italy, 34 Galerie Internationale d'Art Contemporain, Paris, 23 Galicia Center for Contemporary Art, Santiago de Compostela, Spain, 40 Galleria Civica d'Arte Moderna, Turin, Italy, 28 Gallery A/G, New York, 132 Gallizio, Pinot (Italy, 1902–1964), 223–24 Ganzeer (Mohamad Fahmy, Egypt), 200, 243 Gao Minglu, 42, 51, 53 Garabedian, Charles (U.S., b. 1923), 82 Gardner, Isabella Stewart, Museum, Boston, 38 Garouste, Gérard (France, b. 1946), 171 Gates, Jeff (U.S., b. 1949), 182, 184 Gates, Theaster (U.S., b. 1973), 226 Gaudí, Antoni, 117 Gaudy Art, 201 Gauguin, Paul (France, 1848–1903), 64, 208 Gehry, Frank (U.S., b. 1929), 42, 45, 77, 109 Gemini G.E.L. (Graphics Editions Limited), Los Angeles, 209, 210 gender, performative view of, 130 General Idea (Canada), 61, 74, 92, 103, 143, 151, 192 Geng Jianyi (China, b. 1962), 51 geometric abstraction, 56, 74, 92, 97, 106, 107. See also Minimalism Gerlovin, Valeriy (Russia, b. 1945), and Rimma Gerlovina (Russia, b. 1951), 92, 229	Germany: Capitalist Realism in, 203; Düsseldorf School of Photography in, 118–19, 119; Mülheimer Freiheit in, 163–64; New Leipzig School in, 176–77,177 gesture/gesturalism, 82, 89, 96, 97, 124, 136–37, 143, 171, 188, 217, 236; manipulated photography and, 153 Getty Research Institute, Los Angeles, 49, 54 Giacometti, Alberto (Switzerland, 1901–1966), 48, 111, 124 Gide, André, 124 Gil, Gilberto, 249 Gilbert & George (Gilbert, Great Britain, b. 1943; George, Great Britain, b. 1942), 61, 87, 92, 95, 192, 193–94; Life, from Death Hope Life Fear, 94 Gillespie, Gregory (U.S., b. 1936), 178 Gillette, Frank (U.S., b. 1941), 143, 250 Gilliam, Sam (U.S., b. 1933), 97, 211 Gillick, Liam (Great Britain, b. 1964), 226 Ginzel, Andrew (U.S., b. 1954), and Kristin Jones (U.S., b. 1956), 92 Gioli, Paolo (Italy, b. 1942), 153 Girouard, Tina (U.S., b. 1946), 191, 192 Glass, Philip (U.S., b. 1937), 31 globalism, 44, 85 Gober, Robert (U.S., b. 1954), 189 Godard, Jean-Luc, 180 Godwin, Francis, 234 Goeritz, Mathias (Germany, active Mexico, 1915–1990), 155 Gogh, Vincent van (Netherlands, 1853– 1890), 37, 38, 58, 78, 93, 125, 137, 208 Goings, Ralph (U.S., b. 1928), 194 Goldberg, Whoopi, 194 Golden, Judith (U.S., b. 1934), 153 Goldin, Nan (U.S., b. 1953), 61 Goldsmiths, London, 252 Goldstein, Jack (U.S., 1945–2003), 196, 198 Golub, Leon (U.S., 1922–2004), 89, 90, 91, 124, 166, 200; Mercenaries II, 199 Gómez-Peña, Guillermo (Mexico/U.S., b. 1955), 192, 200; El Aztec Vampire, 193	
Rimma Gerlovina (Russia, b. 1951), 92, 229	b. 1955), 192, 200; El Aztec Vampire, 193	
German Expressionism, 56, 125, 161, 176, 238	Gonzalez-Torres, Felix (U.S., 1957– 1996), 61, 226 Goode, Joe (U.S., b. 1937), 131	267
		207

Gordon, Douglas (Scotland, b. 1966),
226, 250
Gorky, Arshile (U.S., 1904–1948), 18,
200, 246
Gottlieb, Adolph (U.S., 1903–1974), 57
graffiti art, 31, 35, 123, 137-39 , 138, 158-
59, 209, 243, 244; new wave and, 180
Graham, Dan (U.S., b. 1942), 103, 143, 250
Grand, Toni (France, b. 1935), 99 Gran Fury (U.S.), 61, 63, 92, 154, 200,
243, 244
graphic novels, 100
Graves, Michael (U.S., b. 1934), 34
Graves, Nancy (U.S., 1940–1995), 171
Gray, Eileen, 48
Gray, Spalding, 194
Great Britain: Kitchen Sink School in,
215; punk art in, 224; Saint Ives paint-
ers in, 216–17 ; School of London in, 124, 218 , 219; Young British Artists
(YBAs) in, 37, 176, 252–55 , 253. See
also Young British Artists
Green, Brent (U.S., b. 1978), 143
Greenberg, Clement, 25, 57, 97, 134, 149,
188
Greenblat, Rodney Alan (U.S., b. 1960),
121 Greenwood, Nigel, Gallery, London,
29, 75
Greyson, John (Canada, b. 1960), 250
Griffith, Bill (U.S., b. 1944), 100
Grooms, Red (U.S., b. 1937), 82, 141, 145
Grosman, Tatyana, 22, 209–10
Groupe de Recherche d'Art Visuel
(GRAV), 23, 70
Group Kyushu, 65 Group Material (U.S.), 61, 92, 143, 154,
200
Guerrilla Girls (U.S.), 92, 154, 200
Guggenheim Foundation, 109, 184
Guggenheim, Solomon R., Museum,
New York, 21, 29, 97, 227
Guggenheim Museum Bilbao, Spain,
42,109
Guggenheim Museum Soho, New York, 41
Guinovart, Josep (Spain, b. 1927), 117
Gullar, Ferreira (Brazil, b. 1930), 168
Günther, Ingo (Germany, b. 1957), 143
Guo Wei (China, b. 1982), 113
Gursky, Andreas (Germany, b. 1955),
118, 119; New York Mercantile

Guston, Philip (U.S., 1913–1980), 57, 82, 174–75 Gutai, 20, 59, 67, 124, **139–41**, 162 Guttmann, Martin. *See* Clegg & Guttmann Gu Wenda (China, b. 1955), 51 Gysin, Brion (U.S., 1916–1986), 151

H

Haacke, Hans (Germany, active U.S., b. 1936), 29, 74, 103, 104, 143, 200, 211, 220; Condensation Cube, 212 Haas, Richard (U.S., b. 1936), 212, 213 Hainke, Wolfgang (Germany), 111 Hairy Who, 91 Halbreich, Kathy, 38 Hall, Doug (U.S., b. 1944), 250 Halley, Peter (U.S., b. 1953), 173, 223; Untitled 174 Hals, Frans, 137 Hambleton, Richard (U.S., b. 1954), 121 Hamilton, Richard (Great Britain, b. 1922), 97, 99, 202, 203; Just What Is It That Makes Today's Homes So Different, So Appealing?, 21, 96 Hammersley, Frederick (U.S., b. 1919), Hammond, Harmony (U.S., b. 1944), 127 Hammond, Jane (U.S., b. 1950), 165; Clown Suit, 166 Hammons, David (U.S., b. 1943), 143 Hamrol, Lloyd (U.S., b. 1937), 212 Hanart Gallery (Taipei and Hong Kong). Hansen, Al (U.S., 1927-1995), 141 Hanson, Duane (U.S., 1925–1996), 195 Happenings, 59, 132, 141-42, 145, 192, 231; Gutai and, 140. See also Action/ Actionism; Fluxus; performance art Happenings and Fluxus (Cologne, 1970). Hara Museum of Contemporary Art,

hard-edge painting, 22, 97, 107, 111, 142, 142-43, 188

Haring, Keith (U.S., 1958-1990), 36, 61, 102, 121, 137, 138-39

Harris, Ann Sutherland, 31

Harris, Lyle Ashton (U.S., b. 1965), 236

Harrison, Helen Mayer (U.S.) and Newton (U.S., b. 1932), 70, 92, 95, 143

Hart, Frederick, 213

Harbour of Life (Sydney, 2000), 43

Tokyo, 33

Exchange, 119

Hartigan, Grace (U.S., 1922–2008), 128	Hirshhorn Museum and Sculpture Garden, Washington, D.C., 32	
Hartmann, Sadakichi (U.S., 1867–1944), 241	Hirst, Damien (Great Britain, b. 1965),	
Hartung, Hans (France, 1904–1989), 74	47, 252, 253, 254	
Hartzell, Emily (U.S.), and Nina Sobell (U.S.), 182	Hispanic Art in the United States (Houston, 1987), 37	
Harvey, Marcus (Great Britain, b. 1963), 252, 254	history painting, 58–59, 167, 176, 207 Hitler, Adolf, 39, 63, 112, 199–200, 246	
Hatoum, Mona (Great Britain/ Palestinian, b. 1952), 143, 200	Hoberman, Perry (U.S., b. 1954), 101, 182 Höch, Hannah (Germany, 1889–1978),	
Havana Biennial, 35	116 Hockney, David (Great Britain, b. 1937),	
Hayes, Paula (U.S.), 217 Hayter, Stanley William, 209	97, 102, 202	
Hearn, Pat, 123	Hödicke, Karl (Germany, b. 1938), 164,	
Heckel, Erich (Germany, 1883–1970), 125	171, 202	
Heftige Malerei, 164	Höfer, Candida (Germany, b. 1944), 118	
Heisig, Bernard, 176, 177	Höller, Carsten (Germany, b. 1961), 226,	
Heizer, Michael (U.S., b. 1944), 49, 120,	227	
212	Hollis, Doug (U.S., b. 1948), 212, 231, 232	
Held, Al (U.S., 1928–2005), 142; Fly	Holt, Nancy (U.S., b. 1938), 120, 212	
Away, 210	Holzer, Jenny (U.S., b. 1950), 101, 154,	
Helfand, Glen, 44, 158	243	
Henderson, Mel (U.S., b. 1922), 135	Hompson, Davi Det (U.S., b. 1939), 132,	
Hendricks, Barkley (U.S., b. 1945), 85, 87	151	
Hendricks, Geoff (U.S., b. 1931), 132	Hong Kong, art fairs in, 78	
Henes, Donna, 118	Hong Kong Arts Centre, 115, 201 Hopper, Edward, 209	
Henri, Robert (U.S., 1865–1929), 229	Horn, Rebecca (Germany, b. 1944), 87,	
Hepworth, Barbara (Great Britain, 1903–1975), 216, 217	127, 192, 250	
Herms, George, 97	Horst, 126	
Heron, Patrick (Great Britain, b. 1920),	Huafang Studio, Beijing, 238	
216	Huang Rui (China, b. 1957), 238, 239	
Herrold, Georg (Germany, b. 1947), 189	Huang Yong Ping (China/France, b.	
Hershman Leeson, Lynn (U.S., b. 1941),	1954), 51, 53	
101, 127, 236	Hudnot, Joseph, 206	
Herzog & de Meuron, 46, 47	Hudson, Robert (U.S., b. 1938), 135	
Hesse, Eva (U.S., 1936–1970), 74, 157,	Huffman, Kathy Rae (Austria, b. 1943),	
211, 217	and Eva Wöhlgemuth (Austria), 182	
Heubler, Douglas (U.S., b. 1924), 103	Hughes, Robert, 104	
Hewicker, Scott (U.S., b. 1970), 189	Hugo, Pieter (South Africa, b. 1976), 236	
Higgins, Dick (U.S., b. 1938), 26, 74, 132,	Hultén, Pontus, 28	
145–46, 151 high art: craft forms and, 77, 89, 143;	Hume, Gary (Great Britain, b. 1962), 252, 254	
popular culture and, 100, 149, 205,	Hung Liu (China/U.S., b. 1948), 127–28	
207, 243	Hütte, Axel (Germany, b. 1951), 118	
Hill, Gary (U.S., b. 1951), 250	Huyghe, Pierre (France, b. 1962), 226	
Hill, Pati (U.S., b. 1921), 111	Hyper-Realism. See Photo-Realism	
Hiller, Susan (Great Britain, b. 1942), 153	/ F	
Hilton, Roger (Great Britain, 1911–1975),	I	
216	iconography, 216	
Hindley, Myra, 254	Idea art. See Conceptual art	
Hine, Lewis (U.S., 1874-1940), 240, 241	identity politics, 40, 85, 164	
	Imai, Norio (Japan, b. 1964), 139	

Immatériaux, Les (Paris, 1985), 36	T
Immendorff, Jörg (Germany, b. 1945),	, Jaar, Alfredo (Chile, b. 1956), 243
64, 166-67, 171	Jackson, Oliver (U.S., b. 1935), 171
Império, Flávio (Brazil, 1935–1985), 248	Jacob, Mary Jane, 39
Impressionism, 59, 125, 161	Jacobson, Bill (U.S., b. 1955), 61
In a Different Light (Berkeley, 1995), 130	Jameson, Fredric, 207
Independent Group, 19, 203	Janis, Sidney, Gallery, New York, 24, 35,
Indiana, Robert (U.S., b. 1928), 202	138, 203
Indigenous Australian art. See	Janowich, Ron (U.S., b. 1948), 221
contemporary Indigenous	Japan: anti-art in, 65-67 , 66; Gutai in,
Australian art	59, 67, 124, 139-41 , 162; Mono-ha in,
Information (New York, 1970), 28, 105	140, 157, 161-63 , 162
Inhibodress group (Australia), 104	Japanese Art after 1945: Scream Against
Inside Out: New Chinese Art (New York	the Sky (1994), 40
and San Francisco, 1998), 42	Jardim, Reynaldo (Brazil, 1926–2011),
installations, 40, 65, 85, 105, 143-45 ,	168
144, 150, 150-51, 161, 175, 207;	Jaudon, Valerie (U.S., b. 1945), 191, 192,
"artisco" trend of, at nightclubs, 36;	212
documentation of, 76; Mülheimer	Jawlensky, Alexei von, 125
Freiheit and, 163; narrative art and,	Jeanne-Claude (1935–2009), 31, 39, 118,
167; Neo-Conceptualism and, 105;	120, 227
Pattern-and-Decoration and, 192;	Jencks, Charles, 206
scatter art, 217–18; sound art and, 232; Tropicalism and, 248; videotapes	Jenkins, Paul (U.S., 1923–2012), 97 Jenney, Neil (U.S., b. 1945), 82, 174, 175,
in, 250. See also light-and-space art	178; Coat and Coated, 83
Institute of Contemporary Art (Boston),	Jess (Jess Collins) (U.S., 1923–2004), 97,
17, 108	99
Institute of Contemporary Arts,	Jet Propulsion Laboratory, 234
London, 17, 19, 21, 27, 101, 203	Jewish Museum, New York, 26, 28, 104,
Instituto Valenciana de Arte Moderna	157
(IVAM), Valencia, Spain, 37	Jiménez, Luis (U.S., b. 1940), 212
intermedia, 26, 142, 145-46 ; sound art	Johanson, Chris (U.S., b. 1968), 158, 243
and, 231–32	Johns, Jasper (U.S., b. 1930), 96, 99, 103,
International Association of Art Critics	135, 167, 170, 171, 182, 203
(AICA), 85	Johnson, Ray (U.S., 1927–1995), 132, 133,
International Istanbul Biennial, 164	151; Untitled, 152
International Museum of Photography,	Jonas, Joan (U.S., b. 1936), 127, 192,
Rochester, N.Y., 118	250-52, 252
International Style, 157 Internet, 182, 227. <i>See also</i> online art	Jones, Ben (U.S., b. 1941), 85
Irascibles, 18	Jones, Cleve, 63 Jones, John Paul (U.S., b. 1924), 53, 55
Ireland, David (U.S., b. 1930), 77, 143	Jones, Kristin (U.S., b. 1956), and
Ireland, Patrick (U.S., b. 1935), 143	Andrew Ginzel (U.S., b. 1954), 92
Irish Museum of Modern Art, Dublin,	Jones, LeRoi (a.k.a. Amiri Baraka), 26,
39	85, 86
IRWIN (Slovenia), 92, 143	Jones, Lois Mailou (U.S., 1905-1998),
Irwin, Bill, 194	85, 87
Irwin, Robert (U.S., b. 1928), 54, 70, 131,	Jorn, Asger (Denmark, 1914–1973), 92,
132, 143, 150–51, 212; Room with Twin	223
Skylights, Facing Wall Removed, 150	Juarez, Roberto (U.S., b. 1952), 171
Italy: Arte Povera in, 73, 73–74 , 120,	Judd, Donald (U.S., 1928–1994), 155, 157
140, 211, 224; Spatialism in, 235, 235 -	Judson Memorial Church, New York,
36 ; Transavantgarde in, 246-47 , 247	206

junk sculpture, 146-47 , 170, 182,	Klein, Astrid (Germany, b. 1951), 153	
187-88	Klein, Yves (France, 1928–1962), 23,	
Just Pathetic (1990), 189	59, 60, 88, 100, 104, 181, 182; Shroud	
,	Anthropometry 20—Vampire, 181	
K	Klier, Michael (Germany, b. 1943), 250	
Kabakov, Ilya (Russia, b. 1933), 143, 229	Klimt, Gustav, 46	
Kac, Eduardo (Brazil), 182	Kline, Franz (U.S., 1910–1962), 57	
Kahlo, Frida (Mexico, 1907–1954), 245	Klüver, Billy, 70	
Kanayama, Akira (Japan, 1924-2006), 139	Kngwarreye, Emily Kame (Aboriginal, 1910–1996), 109	
Kandinsky, Wassily, 55, 57, 125	Knowles, Alison (U.S., b. 1933), 74, 132	
Kaprow, Allan (U.S., 1927–2006), 104,	Kobe, Martin (Germany, b. 1973), 176	
140, 141, 145, 167, 170, 182, 232	Kodak, 111	
Kasten, Barbara (U.S.), 236	Kolbowski, Silvia (Argentina, active	
Katz, Alex (U.S., b. 1927), 178, 179	U.S., b. 1953), 127, 129	
Kauffman, Craig (U.S., b. 1932), 131	Kollwitz, Käthe, 238	
Kawamata, Tadashi (Japan, b. 1953), 143	Kölnischer Kunstverein (Cologne), 28	
Kawara, On (Japan, active U.S., b. 1933),	Komar and Melamid (Vitaly Komar,	
103, 151, 152	Russia, b. 1943; Alexander Melamid,	
Kazimir Passion Group (Russia), 229	Russia, b. 1945), 29, 59, 69, 92, 95, 229,	
Kearns, Jerry (U.S., b. 1943), 200	231; The Origin of Socialist Realism,	
Kellard, Adrian (U.S., 1959–1991), 61	230	
Kelley, Mike (U.S., 1954–2012), 189, 190;	Komisar, Milton (U.S., b. 1935), 101	
More Love Hours Than Can Ever Be	"Konzept"-Kunst (Basel, 1972), 29	
Repaid and The Wages of Sin, 190	Koolhaas, Rem, 47 Koons, Jeff (U.S., b. 1955), 39, 47, 49, 69,	
Kelly, Ellsworth (U.S., b. 1923), 97, 142,	70, 101, 173, 201	
143, 164, 221 Kelly, Joanne (U.S.), and Skip Sweeney	Kopystiansky, Igor (Russia, b. 1954), 69	
(U.S., b. 1946), 250	Korzhev, Geli (Russia, 1925–2012):	
Kelly, Mary (U.S., b. 1941), 127, 220	Raising the Banner, from the triptych	
Kelpra Studio, London, 210–11	Communists, 227	
Kepes, György (Hungary/U.S., b. 1906),	Kos, Paul (U.S., b. 1942), 103, 231, 250-52	
70,71	Koshimizu, Susumu (Japan), 161	
Kertész, André, 126	Koslapov, Alexander (Russia, b. 1943),	
Kever, Gerhard (Germany, b. 1956), 163	229	
Kiefer, Anselm (Germany, b. 1945), 64,	Kossoff, Leon (Great Britain, b. 1926), 218	
74, 171	Kostabi, Mark (U.S., b. 1960), 101	
Kienholz, Edward (U.S., 1927–1994), 26,	Kosuth, Joseph (U.S., b. 1945), 103, 144;	
53, 80, 103, 135, 145, 165, 170	One and Three Chairs, 221; One and	
Kienholz, Nancy Reddin (U.S., b. 1943),	Three Shovels, 105	
80 Wiles Managet (IJS 1007 2001)	Kounellis, Jannis (Greece/Italy, b. 1936),	
Kilgallen, Margaret (U.S., 1967–2001),	73, 211 Kowalski, Piotr (France, b. 1927), 70	
158, 159, 243 Kilimnik, Karen (U.S., b. 1955), 217	Kozloff, Joyce (U.S., b. 1942), 191, 192,	
kinetic sculpture, 70, 71, 101, 107, 147 ,	212, 213	
148	Kracke, Bernd (Germany), 101	-
Kirchner, Ernst, 125	Kramer, Hilton, 104	
Kirkeby, Per (Denmark, b. 1938), 171	Kramer, Margia (U.S., b. 1939), 74	
Kitaj, R. B. (U.S./Great Britain, 1932–	Kramlich, Pamela and Richard, 252	
2007), 202, 218	Krasner, Lee (U.S., 1908–1984), 57	
Kitchen Sink School, 215	Krauss, Rosalind, 134	
kitsch, 149 , 201	Kriesche, Richard (Austria, b. 1940),	-
Klee, Paul, 125, 209	103, 250	271

Krim, Mathilde, 62 Kruger, Barbara (U.S., b. 1945), 127, 130, 223, 224; untitled installation at the Mary Boone Gallery (New York, 1991), 128 Kubota, Shigeko (U.S., b. 1937), 250 Kupka, František, 55 Kusama, Yayoi (Japan, b. 1929), 77, 144 Kushner, Robert (U.S., b. 1949), 96, 191 Kwangju (South Korea) Biennial, 41 L Labowitz, Leslie (U.S., b. 1946), 127, 129, 154, 194 Lacan, Jacques, 186 Lacy, Suzanne (U.S., b. 1945), 103, 127, 129, 154, 200, 226, 227; The Crystal Quilt, 228, 228 Lady Pink (U.S.), 137 Lafontaine, Marie-Jo (Belgium, b. 1945), 250 Laib, Wolfgang (Germany, b. 1950), 144 Lamm, Leonid (Russia, b. 1926), 229 Land, Louise (U.S.), 196 Landfall Press (Chicago), 209 landscape painting, 59, 207 Lane, Abigail (Great Britain, b. 1967), 252 Lange, Dorothea (U.S., 1895–1965), 229, 240, 241 Langsner, Jules, 22, 143 Lanyon, Ellen (U.S., b. 1926), 89, 90, 91 Lanyon, Peter (Great Britain, 1918–1964), 216, 217 LAPD (Los Angeles Poverty	Leibowitz, Cary S. (a.k.a. Candy Ass) (U.S., b. 1963), 61, 189 Leipzig Academy of Art, 176, 177 Lemcke, Rudy (U.S.), 61 Leone & MacDonald (Hillary Leone, U.S.; Jennifer MacDonald, U.S.), 92, 95 Le Parc, Julio (Argentina, b. 1928), 70 Leslie, Alfred (U.S., b. 1927), 167, 178 Lettrist International, 223 Le Va, Barry (U.S., b. 1941), 87, 103 Leveton, N'ima (U.S.), 111 Levine, Les (U.S., b. 1935), 102, 103, 104, 154, 244, 250; Block God, 155, 155 Levine, Sherrie (U.S., b. 1947), 69–70, 127, 196, 197, 223; Fountain (Madonna), 68 Levinthal, David (U.S., b. 1949), 236 Lewis, Joe, 231 LeWitt, Sol (U.S., 1928–2007), 74, 103, 144, 155 Liberman, Alexander, 143 Lichtenstein, Roy (U.S., 1923–1997), 99, 134, 202, 203, 212 Liebeskind, Daniel, 46 Liebling, A.J., 155 light-and-space art, 70, 132, 150, 150– 51, 160–61 Ligon, Glenn (U.S., b. 1960), 144 Lin, Maya (U.S., b. 1959), 212; Vietnam Veterans Memorial, 213, 214 linearity, 188 Linhares, Judith (U.S., b. 1940), 82 Linker, Kate, 35, 186 Lipofsky, Marvin (U.S., b. 1938), 112
1964), 216, 217	Linker, Kate, 35, 186
LAPD (Los Angeles Poverty	Lipofsky, Marvin (U.S., b. 1938), 112
Department), 226	Lippard, Lucy, 129
Lapointe, Lynn (Canada), and Martha	Lipski, Donald (U.S., b. 1947), 80, 144, 145
Fleming (Canada), 92	Li Shan (China, b. 1942), 51, 200, 201
Laporte, Cati (France), 182	Li Shuang (China, b. 1957), 238
L.A. Raw (Pasadena, 2012), 49, 53, 54 L.A. Slick. See Finish Fetish Lawler, Louise (U.S., b. 1947), 69; Persimmon and Bottle, 197 Leaf, June (U.S., b. 1929), 89 LeBrun, Christopher (Great Britain, b. 1951), 171 Lebrun, Rico (U.S., 1900–1964), 53, 55 Leeson, Lynn Hershman (U.S., b. 1941),	Lissitzky, El (Russia, 1890–1941), 106 lithography. See print revival Li Tianyuan (China, b. 1965), 51 Littleton, Harvey K. (U.S., b. 1922), 112 Liu Fenghua (China, b. 1956), 200 Liu Wei (China, b. 1972), 113, 114 Liu Xiaodong (China, b. 1963), 51, 113 Li Xianting, 113–14, 200–201 Li Yelin (China), 51
100, 143, 236	Lobdell, Frank (U.S., b. 1921), 82
Le Gac, Jean (France, b. 1936), 167	Logue, Joan (U.S., b. 1942), 250
Léger, Fernand (France, 1881–1955), 58,	Lohse, Richard Paul (Switzerland,
61	1902–1988), 106
Legrady, George (Hungary/U.S., b.	Long, Richard (Great Britain, b. 1945),
1950), 101	103, 120

Longo, Robert (U.S., b. 1953), 171, 196, 198
Lord, Chip (U.S., b. 1944), 250
Los Angeles Artists Protest Committee,
26
Los Angeles County Museum of Art, 25,
26, 29, 31, 36, 39, 49, 97, 151, 188; Art
and Technology Program of, 71, 234
Los Angeles figurative style. See Abject
Expressionism
Los Angeles "look." See Finish Fetish
Louis, Morris (U.S., 1912–1962), 97, 98
Louvre Abu Dhabi, 48
Loving, Al (U.S., 1935–2005), 85
low art, 205; kitsch and, 149, 201. See
also popular culture Lozano-Hemmer, Rafael (Mexico, b.
1967), 144
Lucas, Sarah (Great Britain, b. 1962),
252, 254
Lucier, Alvin (U.S., b. 1931), 231
Lucier, Mary (U.S., b. 1944), 250–52
Ludwig, Peter, 41
Ludwig Museum, Beijing, 41
Lueg, Konrad (Germany, b. 1939), 202
Luna, James (U.S., b. 1950), 144
Luo Brothers (China), 200, 201
Lüpertz, Markus (Germany, b. 1941), 171
Lybke, Gerd Harry, 176
Lyons, Joan (U.S., b. 1937), 111
Lyotard, Jean-François, 36
lyrical abstraction. See color-field
painting
N/I
MacConnel Vira (IIS h 1016) 77 06

MacConnel, Kim (U.S., b. 1946), 77, 96, 191, 192 MacDonald, Jennifer. See Leone & MacDonald Machine as Seen at the End of the Mechanical Age, The (New York, 1968), 27 Maciunas, George (U.S., 1931-1978), 24, 74, 132, 151 Macke, August, 125 MacKenzie, Alexander (Great Britain), MacLow, Jackson (U.S., b. 1932), 132 Ma Desheng (China, b. 1952), 238 Maenz, Paul, Galerie (Cologne), 164 Magiciens de la terre, Les (Paris, 1989), 38, 164 Magnelli, Alberto (Italy, 1888–1971), 106

Magnuson, Ann, 194

Magritte, René (Belgium, 1898-1967), mail art, 104, 133, 151-52, 152 Mailer, Norman, 137-38 Main and Main (U.S.), 77 Majore, Frank (U.S., b. 1948), 126 Malangi, David (Aboriginal, 1927-1999), 109 Malcolm X, 26, 86 "male gaze," 129 Malet, Leo, 97 Malina, Frank J., 232 Maloof, Sam (U.S., 1916-2009), 112 Malpede, John (U.S.), 226 Mandel, Mike (U.S., b. 1950), and Larry Sultan (U.S., b. 1946), 154, 236 Manet, Édouard (France, 1832–1883), 69, 137, 160 Mangold, Robert (U.S., b. 1937), 155, 157 Mangold, Sylvia (U.S., b. 1938), 178 Manifesto Neoconcreto, 168–69 manipulated photography, 153, 153-54, Manzoni, Piero (Italy, 1933-1963), 59, 60,88,104 Mao Lizi (China, b. 1950), 238 Mao Xuhui (China, b. 1956), 51 Mapplethorpe, Robert (U.S., 1946– 1989), 38, 48, 61, 63, 113, 126 Marc, Franz (Germany, 1880–1916), 125 Marcel Duchamp: A Retrospective Exhibition (Pasadena, 1963), 25 Marden, Brice (U.S., b. 1938), 155, 157 Mariani, Carlo Maria (Italy, b. 1931), 69 Marin, John (U.S., 1870–1953), 209 Marina Abramović: The Artist Is Present (New York, 2010), 88-89 Marioni, Tom (U.S., b. 1937), 28, 87, 103, 104, 144, 151, 152, 231; Handcuff, 88 Marisol (U.S., b. 1930), 80 Marroquin, Raul (Netherlands, b. 1948), Marshall, Richard, 174 Marshall, Stuart (Great Britain, d. 1993), 250 Martin, Agnes (U.S., 1912–2004), 155, Maruyama, Hirotaka (Japan), 111 Mason, John (U.S., b. 1927), 89 Massachusetts Institute of Technology (MIT), Cambridge, Center for Advanced Visual Studies, 27, 71, 101, 233 mass culture. See popular culture

Meyerowitz, Joel (U.S., b. 1938), 224 Michals, Duane (U.S., b. 1932), 61, 167 Michelangelo, 25 Middendorf, Helmut (Germany, b. 1953), 64, 164, 171 Millares, Manolo (Spain, 1926–1972), 123 Millennium Park, Chicago, 45
Michelangelo, 25 Middendorf, Helmut (Germany, b. 1953), 64, 164, 171 Millares, Manolo (Spain, 1926–1972), 123
Michelangelo, 25 Middendorf, Helmut (Germany, b. 1953), 64, 164, 171 Millares, Manolo (Spain, 1926–1972), 123
Middendorf, Helmut (Germany, b. 1953), 64, 164, 171 Millares, Manolo (Spain, 1926–1972), 123
1953), 64, 164, 171 Millares, Manolo (Spain, 1926–1972), 123
Millares, Manolo (Spain, 1926–1972), 123
123
Miller, John (U.S., b. 1954), 189
Miller, Tim (U.S.), 192 Milwaukee Art Museum, 44
Minimalism, 26, 89, 100, 107, 132, 155 -
57 , 156, 161, 198, 207, 220; primary
structures in, 26, 143, 157, 221; reac-
tions against, 82, 88, 103, 145, 171, 174,
192, 211; shaped canvases and, 221
Minter, Marilyn (U.S., b. 1948), 121
Minton, John, 218
Mirakami, Saburo, 139
Miralda, Antoni (Spain, b. 1942), 103
Miró, Joan (Spain, 1893–1983), 58, 89,
99, 117, 245, 246
Mir space station, 234
Mirza, Haroon (Great Britain, b. 1977),
231
Miss, Mary (U.S., b. 1944), 120, 212
Mission School, 44, 158-59 , 159
Miyajima, Tatsuo (Japan, b. 1957), 101
mobiles, 147
modern. See contemporary
modernism, 56, 64, 103, 108, 112,
116, 117, 123, 130, 160-61 , 167, 178,
185, 204, 205, 213, 215, 220, 223;
formalism and, 134, 145; literary
content and, 167; Minimalism and,
156; postmodernism compared
to, 206–8; primitivism and, 160,
161, 188, 208; progress notion and,
188, 198; reactions against, 69, 95,
145–46, 149, 169, 171, 189, 215, 229
(see also postmodernism); straight
photography and, 241. See also
specific groups and styles
Moffett, Donald (U.S., b. 1955), 61
Moholy-Nagy, László, 147
Mondrian, Piet (Netherlands, 1872–
1944), 58, 69
Monk Moradith (IIC h 1040) 100 100
Monk, Meredith (U.S., b. 1942), 128, 192
Mono-ha, 140, 157, 161–63 , 162
Mono-ha, 140, 157, 161–63 , 162 Monro, Niall (Great Britain), 111 Monster Roster, 91
Mono-ha, 140, 157, 161–63 , 162 Monro, Niall (Great Britain), 111 Monster Roster, 91 Montano, Linda (U.S., b. 1942), 87, 128,
Mono-ha, 140, 157, 161–63 , 162 Monro, Niall (Great Britain), 111 Monster Roster, 91

	onte, James, 211	Museum of Conceptual Art, San	
	oore, Frank (U.S., 1953–2002), 61	Francisco, 28, 104, 232	-
	oore College of Art, Philadelphia, 30,	Museum of Contemporary Art,	
	75	Bordeaux, France, 41 Museum of Contemporary Art,	
1010	oorman, Charlotte (U.S., 1933–1991), 132; TV Bra for Living Sculpture,	Chicago, 31	
	132–33, 133	Museum of Contemporary Art, Los	
	orimura, Yasumasa (Japan, b. 1951),	Angeles, 35, 244	
	236	Museum of Contemporary Art, Niterói,	
Mo	orley, Malcolm (Great Britain, b.	Brazil, 41	
	1931), 194, 195	Museum of Contemporary Art, Tokyo,	
Mo	orphesis, Jim (U.S., b. 1948), 53	41	_
	orris, Robert (U.S., b. 1931), 74, 103,	Museum of Contemporary Crafts, New	
1	104, 120, 155, 157, 171, 211, 217	York, 28, 232	
	oskowitz, Robert (U.S., b. 1935), 174,	Museum of Contemporary Hispanic	
	175 otherwell, Robert (U.S., 1915–1991),	Art, New York, 164 Museum of Fine Arts, Houston, 37	
	19, 57, 124	Museum of Modern Art, Frankfurt, 39	
	otonaga, Sadamasa (Japan, b. 1922),	Museum of Modern Art, New York, 20,	
	139	21, 23, 24, 26, 28, 29, 30, 33, 41, 45, 55,	
	oufarrege, Nicolas (U.S., 1948–1985),	75, 80, 88–89, 100, 104, 108, 147, 185	-
	121	Museum of Modern Art, Rio de Janeiro,	
Mo	ovement for an Imaginist Bauhaus,	248	
	223	Museum of Old and New Art, Hobart,	
	ieck, Ron (Australia, b. 1958), 252	Tasmania, 49	
	ihl, Otto (Austria, b. 1925), 59, 60 ıkai, Shuji (Japan, b. 1939), 139	Muxart, Jaume (Spain, b. 1922), 117 Myers, Forrest (U.S., b. 1941), 232, 233	
	ilheimer Freiheit, 163-64	Myers, Porrest (0.3., b. 1941), 232, 233	
	ıller, Grégoire (Switzerland, b. 1947),	N	
	167	Nagle, Ron (U.S., b. 1939), 89	
mu	ılticulturalism, 38, 63, 65, 87, 164-65	Nagy, Peter (U.S., b. 1959), 121	
mu	ıltiples, 23, 165 , 166	naive art. See Art Brut; outsider art	
	ınari, Bruno (Italy, 1907–1998), 111	Namatjira, Albert (Aboriginal, 1902–	
	ınch, Edvard, 45	1959), 109	
	intadas, Antonio (Spain, b. 1942), 40,	NAMES Project–AIDS Memorial Quilt,	
	103, 144, 154, 182, 183, 250; The File	37, 62-63	
	Room, 40, 183, 183 inter, Gabriele, 125	Napangardi, Dorothy (Aboriginal, early 1950s–2013), 109	-
	ırakami, Saburo (Japan, 1925–1996),	Napier, Mark, 183	
	139, 140	Narita, Katsuhiko (Japan), 161	
	ırray, Elizabeth (1940–2007), 221	narrative art, 76, 82, 130, 166-67 , 168;	
Mu	ısée du Quai Branly, Paris, 110	allegory and, 64, 171	
	iseo de Arte Contemporáneo	NASA (National Aeronautics and Space	
	Monterrey, Monterrey, Mexico, 39	Administration), 234	
	iseo Nacional Centro de Arte Reina	Naschberger, Gerhard (Germany, b.	
	Sofia, Madrid, 36 Iseo Thyssen-Bornemisza, Madrid,	1955), 163	
	iseo Inyssen-Bornemisza, Madrid, 39	Nathan, Piotr (Poland/Germany, b. 1956), 61	
	seu d'Art Contemporani, Barcelona,	National Art Museum of China	
	‡1	(formerly called China Arts Gallery),	
	iseum Boijmans Van Beuningen,	Beijing, 53, 201, 238, 239	
F	Rotterdam, 35, 138	National Association of Artists'	_
Mu	seum Ludwig, Cologne, 36	Organizations (NAAO), 65	275

	National Endowment for the Arts	new media, uses of term, 178
-	(NEA), 26, 27, 40, 41, 65, 113, 213	New Museum of Contemporary Art,
	National Endowment for the	New York, 32, 34, 35, 36, 82, 164, 186,
-	Humanities (NEH), 26	231
	National Gallery, Berlin, Contemporary	New Objectivity (Neue Sachlichkeit),
_	Art Museum, 41	215
	National Gallery of Art, Washington,	New Realism, 24, 64, 89, 167, 178-79 ,
	D.C., 32	179, 215; as name for Pop Art, 178, 182,
	National Gallery of Australia, Canberra,	203; Nouveau Realisme and, 181–82
_	37, 110	New Realists, The (New York, 1962), 24,
	National Gallery of Canada, Ottawa, 37	203
	National Portrait Gallery, Washington,	New School for Social Research, New
	D.C., 48	York, 142
	naturalism, 215, 217 Nauman, Bruce (U.S., b. 1941), 87, 103,	New Sensations prize, 254
	144, 150, 231–32, 250	New Spirit in Painting, A (London, 1981),
_	Navarro, Miquel (Spain, b. 1945), 144	Newton, Helmut (Australia, 1920–
	Nechvatal, Joseph (U.S., b. 1951), 182	2004), 126
_	Neel, Alice (U.S., 1900–1984), 178;	New Topographics (Rochester, N.Y.,
	Randall in Extremis, 179	1975), 118
	neo-, use of prefix, 206	new wave, uses of term, 180
	Neo-Conceptualism, 105, 123, 217	New Wave art, 33, 180. See also '85 New
_	Neo-Concretism, 168–69 , 169, 248	Wave
	Neo-Dada, 22, 135, 170-71 , 182, 203; in	New York Art Now (London, 1987), 173
_	Japan, 65	New York Correspondance School, 151
	Neo-Expressionism (Neo-Ex), 34, 123,	New York New Wave (New York, 1981),
_	125, 137, 157, 164, 171-72 , 172, 177, 180,	180
	198, 205; Transavantgarde and, 247	New York School, 134, 216, 220
_	Neo-Geo, 36, 123, 132, 173 , 174, 203	New York World's Fair (1964), 25
	Neo-Image Exhibitions (China), 52–53	Nice Style—the World's First Pose Band
_	Nerdrum, Odd (Norway, b. 1944), 167	(Great Britain), 192
	Neri, Manuel (U.S., b. 1930), 82, 84	Nicholson, Ben (Great Britain, 1894–
_	Neri, Ruby (U.S., b. 1970), 158, 159	1982), 216, 217
	Nesbitt, Esta (U.S.), 111	Ni Haifeng (China, b. 1964), 51
_	Neshat, Shirin (Iran/U.S., b. 1957), 200,	Nilsson, Gladys (U.S., b. 1940), 89, 90,
	250	91, 136
	Neto, Torquato, 249	Nine Evenings (New York, 1966), 71
	Neue Sachlichkeit (New Objectivity),	9/11 terrorist attacks (2001), 44, 227
_	215 Neue Staatsgalerie, Stuttgart, 35	Nitsch, Hermann (Austria, b. 1938), 59, 60
	Neue Wilde, 164	Nixon, Nicholas (U.S., b. 1947), 61
_	Neuhaus, Max (U.S., b. 1939), 212, 213,	Noble Savage, 208
	231, 232	Nochlin, Linda, 31
_	Nevelson, Louise (U.S., 1899–1988), 80	Noël, Ann (Great Britain), 111
	New Art Trust, 252	Noggle, Anne (U.S., 1922–2005), 128
_	New Image, 32, 174-76 , 175	Noguchi, Isamu (U.S., 1904–1988), 77,
	New Image Painting (New York, 1978),	165, 212, 213
_	32, 174	Noland, Cady (U.S., b. 1956), 144, 189
	New Images of Man (New York, 1959),	Noland, Kenneth (U.S., 1924–2010), 97,
_	23, 55	102, 142, 143, 221
	New Leipzig School, 176-77 , 177	nonobjective. See abstract/abstraction
_	Newman, Barnett (U.S., 1905–1970), 57,	nonrepresentational. See abstract/
6	98, 124, 156	abstraction

Nordman, Maria (U.S., b. 1943), 144, 150 Northern Artists Group, 51–52 Nouveau Réalisme, 23, 97, 167, 171, 178, 181, **181–82**, 203 Nutt, James (U.S., b. 1938), 89, 90, 91, 136

0

Oakland Museum, 22 O'Banion, Nance (U.S., b. 1949), 112 Öffentliche Kunstsammlung, Basel, Switzerland, 29 Ofili, Chris (Great Britain, b. 1968), 252, O'Grady, Lorraine (U.S.), 144 O'Hara, Morgan (U.S., b. 1941), 103, 105 OHO group (Slovenia), 104 Oiticica, Hélio (Brazil, 1937-1980), 106, 144, 168, 186, 200, 248-49; Tropicália installation, 249 O'Keeffe, Georgia, 56 Olbrich, Jurgen (Germany), 111 Oldenburg, Claes (U.S., b. 1929), 141, 145, 165, 202, 203, 212, 233 Olitski, Jules (U.S., 1922–2007), 97 Oliva, Achille Bonito, 247 Oliveira, Nathan (U.S., 1928-2005), 55, Oliveros, Pauline (U.S., b. 1932), 231 Olson, Richard (U.S., b. 1938), 74 Olympic Games, 43, 45, 47 online art, 40, 71, 103, 182-84, 183 Ono, Yoko (U.S., b. 1933), 132, 151 Ontani, Luigi (Italy, b. 1943), 192 On the Passage of a Few People Through a Rather Brief Moment in Time (Paris, 1989), 38, 224 Op art (perceptual abstraction; retinal art), 25, 26, 106, 184-85, 185 "Open Circuits" (New York, 1974), 30 Oppenheim, Dennis (U.S., b. 1938), 39, 87, 103, 120, 167, 231 Oppenheim, Meret (Switzerland, 1913-1985), 245 organic abstraction, 56 Orientalism, 186 Origin Point (Beijing, 2007), 240 Orozco, José Clemente (Mexico, b. 1933), 64, 229 Orr, Eric (U.S., b. 1939), 150, 151 Osorio, Pepón (U.S., b. 1955), 144 the Other, 130, 164, 186 Otis Art Institute, Los Angeles, 20, 89 Otolith Group (Great Britain), 200

Otterness, Tom (U.S., b. 1952), 180, 212 Oursler, Tony (U.S., b. 1957), 250 Outcault, Richard, 99 outsider art, 92, 137, **186–88**, 187, 209 Outterbridge, John (U.S., b. 1933), 53, 55, 80 Overstreet, Joe (U.S., b. 1933), 85

P Pacific Standard Time: Art in L.A. 1945-1980 (Southern Calif., 2011–12), 49, 54 Pagès, Bernard (France, b. 1940), 99 Paglen, Trevor (U.S., b. 1974), 232; The Last Pictures Artifact, 233, 234 Paik, Nam June (South Korea, 1932-2006), 25, 26, 70, 101, 132, 144, 231, 250; TV Bra for Living Sculpture, 132-33, 133 painterly, use of term, 188. See also gesture/gesturalism paint systems, 102-3 Paladino, Mimmo (Italy, b. 1948), 171, 246 Paley, Albert (U.S., b. 1944), 112, 212 Pane, Gina (France, b. 1939), 87, 192 Paolini, Giulio (Italy, b. 1940), 73 Paolozzi, Eduardo (Great Britain, b. 1924-2005), 146, 202 Pape, Lygia (Brazil, 1927–2004), 168, 248 papier collé. See collage parallel gallery. See alternative spaces Parasol Press Ltd., New York, 209 Pardo, Jorge (U.S./Cuba, b. 1963), 226 Park, David (U.S., 1911-1960), 82, 83 Parr, Mike (Australia, b. 1945), 87, 103, Parreno, Philippe, 226 participatory art. See social practice Pasadena Museum of California Art, 25, 49, 53 Paschke, Ed (U.S., b. 1939), 89, 91, 171 Paterson, Carrie (U.S.), 232 pathetic art, 55, 189-90, 190 Pattern and Decoration, 34, 96-97, 129, 176, 191, **191-92**, 245 Pauline, Mark, 147 Pearlstein, Philip (U.S., b. 1924), 178 Luigi Pecci Center of Contemporary Art, Prato, Italy, 37 Pederson, Carl Henning (Denmark, 1913-2007), 92 Pei, I. M., 32 Peljhan, Marko (Slovenia, b. 1969), 232 Pellicer, Alexandre Cirici, 117

Penck, A. R. (Germany, b. 1939), 171 Penn, Irving (U.S., 1917–2009), 126 Penone, Giuseppe (Italy, b. 1947), 73 Pentagon Papers, 67 Peppermint, Cary (U.S., b. 1970), 182, 183–84 percent-for-art programs, 213 perceptual abstraction. See Op art Perceval, John (Australia, 1923–2000), 67 performance art, 31, 65, 104, 145, 161, 167, 178, 180, 192–194, 193, 205, 207, 209, 211; documentation of, 76, 118; in East Village, 121; feminist, 129, 130; precursors of, 59–61, 87, 116, 132–33; sound art and, 231; videotapes in, 250. See also Action/Actionism; Fluxus; Happenings personifications, 64 perspective, 196 Pettibon, Raymond (U.S., b. 1957), 100, 189 Pevsner, Antoine (France, 1886–1962), 106 Pfaff, Judy (U.S., b. 1946), 144, 145, 212; Deep Water, 144 Philadelphia Museum of Art, 27 Phillips, Donna-Lee (U.S., b. 1943), 128 Phillipsz, Susan (Scotland, b. 1965), 231 Phillpot, Clive, 76 Phoenix Art Museum, 100 photography: documentary, 241; Düsseldorf School, 118–19, 119; fabricated, 236–37, 241; fashion aesthetic and, 126–27, 127, 241; manipulated, 153, 153–54, 241; Photo-Realism and, 29, 194–195, 195; postmodern, 241; snapshot aesthetic in, 23, 224–25, 225, 241; Social Realist, 229; staged, 197–98, 236–37, 237; straight, 154, 225, 240–41, 242 photomontage, 96 Photo-Realism, 29, 194–195, 195	picture plane, 97, 161, 196 Pictures (New York, 1977), 32, 196 Pictures Generation, 32, 196–98 , 197 Piene, Otto (Germany, b. 1928), 70, 101 Pierre et Gilles (Pierre Commoy, France, b. 1950; Gilles Blanchard, France, b. 1953), 92 Pierson, Jack (U.S., b. 1960), 217 Pietronigro, Frank (U.S.), 232 Pinceman, Jean-Pierre (France, 1944–2005), 99 Pincus-Witten, Robert, 29, 157 Pindell, Howardena (U.S., b. 1943), 97, 250 Piper, Adrian (U.S., b. 1948), 103, 144, 250 Pistoletto, Michelangelo (Italy, b. 1933), 73, 144; Wall of Rags, 73 Pitts, Bradley (U.S., b. 1978), 232 Places with a Past (Charleston, S.C., 1991), 39 Plasma, Dan (U.S.), 158 "plop art," 213 pluralism, 65, 198 Poirier, Anne (France, b. 1942) and Patrick (France, b. 1942), 92, 95 political art, 199, 199–200 political correctness. See culture wars Political Pop, 114, 200–201 , 202, 226 Polke, Sigmar (Germany, 1941–2010), 69, 202 Pollock, Jackson (U.S., 1912–1956), 18, 46, 57, 58, 74, 98, 137, 140, 143, 193, 199, 211; No. 1, 1949, 57 Pomeroy, Jim (U.S., 1945–1992), 231 Ponç, Joan (Spain, b. 1927), 117 Poons, Larry (U.S., b. 1937), 97, 184 Pop art, 19, 21, 22, 24, 27, 70, 89, 100, 108, 134, 142, 161, 165, 167, 171, 173, 182, 198, 202–3 , 204, 205, 215, 220, 229, 231, 245; appropriation and, 69; Chinese Cynical Realism and Political Pop and, 114, 201; Finish Fetish and, 132; kitsch and, 149; New
	199, 211; No. 1, 1949, 57
	182, 198, 202-3 , 204, 205, 215, 220,
Photo-Realism, 29, 194–195 , 195	
Photoshop, 154	Realism and, 178; Photo-Realism
Picabia, Francis (France, 1879–1953),	and, 195; postmodernism and, 134,
70, 116 Picasso, Pablo (Spain, 1881–1973), 20,	203, 207; snapshot aesthetic and, 225 popular culture, 103, 130, 135, 203,
33, 34, 41, 48, 56, 64, 69, 77, 80, 89, 93,	204–5 , 207, 216, 223, 241; comics
94, 95, 97, 106, 107, 117, 134, 146, 188,	art and, 99–100; fashion aesthetic
199, 208, 238, 245	and, 126–27; high art and, 100, 149,
Picasso and Portraiture (New York, 1996), 41	205, 207, 243; kitsch and, 149, 201;
Pictorialism, 241	Transavantgarde and, 247. See also media art
* 10000000	

Pugh, Clifton (Australia, 1924–1990), Porter, Fairfield (U.S., 1907–1975), 178 Porter, Liliana (Argentina, b. 1941), 151 67,69 Portland (Oreg.) Municipal Services Puig, Arnau, 117 Pulitzer Foundation for the Arts, 226 Building, 34 punk art, British, 224 post-, use of prefix, 205-6 Purifoy, Noah (U.S., 1917–2004), 85 postal art. See mail art Puryear, Martin (U.S., b. 1941), 212 Post-Graffiti (New York, 1983), 35, 138 Pussy Riot (Russia), 49, 128 Post-Impressionism, 161, 206 Pwerle, Minnie (Aboriginal, c. 1920-Post-Minimalism, 29, 157 2006), 109 postmodernism, 23, 26, 33, 34, 36, 64, 77, 108, 130, 203, **206-8**, 243, 255; academic painting and, 59; appro-Q Qi Zhilong (China, b. 1962), 200 priation and, 69–70; kitsch and, 149; Queens Museum of Art, New York, 226 Neo-Expressionism and, 125, 171; Queer Nation, 130 New Image and, 175–76; photograqueer theory, 130 phy and, 241; Pop art and, 134, 203, Quinn, Marc (Great Britain, b. 1964), 252 207; popular culture and, 205; Sots Quinones, Lee (U.S., b. 1960), 137 art and, 231 post-painterly abstraction. See color-Qu Leilei (China, b. 1951), 238 field painting Post-Painterly Abstraction (Los Angeles, R 1964), 25, 97, 188 Raad, Walid (Lebanon, b. 1967), 250 Rae, Fiona (Great Britain, b. 1963), 252 Powers, Hiram, 113 Prater, Chris, 211 Raffael, Joseph (U.S., b. 1933), 178 Rainer, Arnulf (Austria, b. 1929), 59, 153 Pre-Raphaelites, 59 Rainer, Yvonne (U.S., b. 1934), 71, 128, Presence of the Past, The (Venice, 1980), 33 Price, Ken (U.S., 1935–2012), 89, 131 Arnulf Rainer Museum, New York, 40 primary market, 78. See art market primary structures, 26, 143, 157, 221 Ramírez, Martín (Mexico, 1895-1963), Primary Structures (New York, 1966), Rammellzee (U.S., 1960-2010), 137 26, 157 Ramos, Mel (U.S., b. 1935), 202 primitivism, 90, 92, 125, 163, 208-9; modernism's fascination with, 160, Raphael, 69 Rapoport, Sonya (U.S., b. 1923), 101 161, 188: multiculturalism and, 164; Rasdjarmrearnsook, Araya (Thailand, Tropicalism and, 248 Prince, Richard (U.S., b. 1949), 69, 74, b. 1957), 250 Rat, Blek le (France, b. 1952), 243 196, 197, 223, 224 print revival, 22, 76, 165, **209-11**, 210 Rath, Alan (U.S., b. 1959), 101 Rauch, Neo (Germany, b. 1960), 176, Prinzhorn, Hans, 71 177; Abstraktion, 177 Prisbrey, Grandma (U.S.), 188 Rauschenberg, Robert (U.S., 1925-Probing the Earth (Washington, D.C., 2008), 25, 36, 70, 80, 97, 146, 165, 170, 1977), 32 171, 182, 201, 210 Procedures/Materials (New York, 1969), 28, 211 Rauschenberg Overseas Cultural Interchange (ROCI), 201 process art, 18, 74, 100, 120, 162, 211, Rawanchaikul, Navin (Thailand, b. 212, 217 progress: impact on environment of, 1971), 144 206-7; modernist notion of, 188, 198 Ray, Man (U.S., 1890–1976), 116, 165, 245 readymades, 80, 104, 116, 134-35 P.S. 1 (New York), 180 realism, 215; Chinese Cynical Realism PTW Architects, 47 and, 113-15, 114, 200-201; Photopublic art, 23, 38, **212-14**, 214; about Realism and, 29, **194–195**, 195. See AIDS, 62-63; "outlaw," 158-59

also New Realism

279

public practice. See social practice

Redon, Odilon, 64 Red Ribbon, 63 Reese, Marshall (U.S.), 154 regionalism, 58, 215-16 Reichardt, Jasia, 101 Reinhardt, Ad (U.S., 1913–1967), 82, 143, 156 Reiring, Janelle, 196 relational art, 227. See also social practice Rembrandt, 94 Renaissance, 93, 99, 108, 119, 165, 167, 196, 221 René, Denise, 165 Renger-Patzsch, Albert (Germany, 1897–1966), 240 Renoir, Pierre-Auguste, 38 Ren Sihong (China, b. 1967), 200 representation, 56, 216 ; elimination of, in Minimalism, 156, 157; figurative and, 130 resale rights laws, 78 Responsive Eye, The (New York, 1965), 26, 185 Restany, Pierre, 23, 181 retinal art. See Op art Reuben Gallery, New York, 23, 141 Reynolds, Hunter (U.S., b. 1959), 61 Rhein, Eric (Germany, 1902–1956), 61 Rhodes, Rod, 61 Ricard, René, 180 Rich, Adrienne, 130 Richon, Olivier (Great Britain, b. 1956), 236 Richter, Gerhard (Germany, b. 1932), 69, 202, 203 Rickey, George (U.S., 1907–2002), 25, 147, 184 Rigo 23 (Portugal, b. 1966), 158, 243 Riley, Bridget (Great Britain, b. 1931), 128, 184 Rinder, Lawrence, 130 Ringgold, Faith (U.S., b. 1930), 112, 128, 167 Rink, Arno, 177 Rinke, Klaus (Germany, b. 1939), 87, 250 Ripps, Rodney (U.S., b. 1950), 191	Robinson, Walter (U.S., b. 1950), 121 Rockburne, Dorothea (U.S., b. 1921), 155 Rockefeller, Nelson, 104 Rockefeller Center, New York, 44 Rodan, Don (U.S., b. 1950), 236 Rodchenko, Alexander (Russia, 1891–1956), 106, 107 Rodia, Simon, 187 Rogers, Bryan (U.S., b. 1941), 70 Rojas, Clare (U.S., b. 1976), 158 Rollins, Tim (U.S., b. 1955), + K.O.S., 92, 95 Romeo Void, 180 Rose, Barbara, 156 Rose, Sheree (U.S.), and Bob Flanagan (U.S., 1933–1997), 87 Rosenbach, Ulrike (Germany, b. 1943), 128, 192, 250 Rosenberg, Harold, 19, 57, 58, 161 Rosenquist, James (U.S., b. 1933), 202 Rosenthal, Rachel (U.S., b. 1926), 192 Rosler, Martha (U.S., b. 1943), 74, 128, 154, 200, 250 Rosofsky, Seymour (U.S., b. 1924), 89, 91 Ross, David, 38 Rotella, Mimmo (Italy, 1918–2006), 97, 181 Roth, Dieter (Switzerland, b. 1930), 74, 75, 103 Roth, Moira, 129 Roth, Tim Otto (Germany, b. 1974), 232 Rothenberg, Susan (U.S., b. 1945), 174, 175; Hector Protector, 175 Rothko, Mark (U.S., 1903–1970), 57, 58, 82, 98, 209 Rousseau, Henri (France, 1844–1910), 188 Rousseau, Jean-Jacques, 208 Royal Academy of Arts, London, 34, 58–59 Rozanova, Olga (Russia, 1886–1918), 106 rubber-stamp art, 151, 152 Rubell, Don and Mera, 176 Rubens, Peter Paul, 69, 94, 208 Ruckhäberle, Christoph (Germany, b. 1972), 176 Ruff, Thomas (Germany, b. 1958), 118
Rink, Arno, 177 Rinke, Klaus (Germany, b. 1939), 87, 250	Ruckhäberle, Christoph (Germany, b. 1972), 176
Robert, Marie-Hélène (France), 111	Every Building on the Sunset Strip, 76

Scharf, Kenny (U.S., b. 1958), 121, 149 Ruskin, John, 217 Russia. See USSR Scher, Julia (U.S., b. 1954), 144, 182 Schilling, Alfons (Austria, b. 1934), 59, Russian Constructivism, 107 Russolo, Luigi (Italy, 1883-1947), 231 60-61 Rustic Realism, 240 Schmidt, Angelika (Germany), 151 Schmidt-Rottluff, Karl, 125 Ryman, Robert (U.S., b. 1930), 155, 157 Schnabel, Julian (U.S., b. 1951), 36, 69, 70, 171–72; Self-Portrait in Andy's Shadow, 172 Saad-Cook, Janet (U.S.), 232 Schneemann, Carolee (U.S., b. 1939), 44, Saar, Betye (U.S., b. 1926), 85, 87, 97; Mti. 86 87, 128, 141, 146 Schnell, David (Germany, b. 1971), 176 Saatchi, Charles, 176, 253, 254 Saatchi Gallery, London, 173, 252, 254 Schöffer, Nicolas (France, 1912–1992), Safdie, Moshe, 37 70,147 School of London, 124, **218**, 219 Said, Edward, 186 Saint Ives painters, 216-17 School of London: Six Figurative Painters, Saint Phalle, Niki de (France, b. 1930), A (London, 1987), 218 School of Paris, 74, 220 181, 212 School of the Art Institute (Chicago), 91 Saito, Ryoei, 38 Schulze, Franz, 91 Sakoguchi, Ben (U.S., b. 1938), 53 Schutz, Dana (U.S., b. 1976), 167 Sale, Gregory (U.S.), 226 Salle, David (U.S., b. 1952), 69, 70, 171 Schuyff, Peter (U.S., b. 1958), 69, 121 Salomé (Germany, b. 1954), 164, 171 Schwarzkogler, Rudolf (Austria, 1940-Salon. See academic art 1969), 59, 60 Salvadori, Remo (Italy, b. 1947), 246 Schwitters, Kurt (Germany, 1887-1948), Samaras, Connie (U.S.), 232, 234 99, 116, 146, 151, 170 Samaras, Lucas (U.S., b. 1936), 97, 153; Scott, Jill (Australia, b. 1950), 87, 101, Photo-Transformation, 153 192, 231-32, 250-52 Scott, Judith (U.S., 1943-2005), 188 Samo (Basquiat and Al Diaz), 137 Scull, Robert and Ethel, 30, 100, 108 San Francisco Art Institute (formerly California School of Fine Arts), Seawright, James (U.S., b. 1936), 70, 101 secondary market, 78. See art market 82-83, 159, 180 Sedgwick, Eve Kosofsky, 130 San Francisco Bay Area: funk art in, Seid, Dui (b. 1945), 61 82, 92, **135–36**, 136; Mission School Seitz, William, 24, 26, 80, 184 in, 44, **158–59**, 159. See also Bay Area Sekine, Nobuo (Japan, b. 1942), 155, 161, figurative style San Francisco Museum of Modern Art, 162–63; Phase–Mother Earth, 162, 162 Selz, Peter, 23, 24, 55, 80, 135, 184 33, 42, 108 São Paulo Bienal, 19, 20, 43, 85 semiotics, 103, 134, 203, 220-21, 222, Sartre, Jean-Paul, 22, 124 Sensation! Young British Artists from the Sasson, Danielle (Italy), 111 Saatchi Collection (London, Berlin, Saura, Antonio (Spain, b. 1930), 123 and New York, 1997), 254 Saussure, Ferdinand de, 220 Saville, Jenny (Great Britain, b. 1970), Serra, Richard (U.S., b. 1939), 38, 155, 157, 211, 212, 213-14, 217, 250 252 Saytour, Patrick (France, b. 1937), 99 Serrano, Andres (U.S., 1950), 113 set-up photography. See staged Scanavino, Emilio (Italy, 1922–1986), 235 Scar Art, 240 photography Shafrazi, Tony (Iran/U.S., b. 1944), 243 scatter art, **217-18** Shahn, Ben (U.S., 1898–1969), 229 Schamberg, Morton (U.S., 1881–1918), Shao Fei (China, b. 1954), 238 Schapiro, Miriam (U.S., b. 1923), 96, 112, shaped canvas, 23, **221**, 222

128, 129, 191, 192, 227; Black Bolero, 191

Shapiro, Joel (U.S., b. 1941), 174

Sharp-Focus Realism. See Photo-Realism Shaw, Richard (U.S., b. 1931), 89, 135 Sheng Qi (China, b. 1965), 200 Sheridan, Sonia (U.S., b. 1925), 111 Sherk, Bonnie (U.S., b. 1945), 227 Sherman, Cindy (U.S., b. 1954), 128, 129, 196, 198, 236, 237 Shimamoto, Shozo (Japan, b. 1928), 139 Shiraga, Kazuo (Japan, 1924–2008), 139, 140 Shire, Peter (U.S., b. 1947), 77 Shonibare, Yinka (Great Britain, b. 1962), 144, 250 Shore, Stephen (U.S., b. 1947), 118 Shu Qun (China, b. 1958), 51 Sicilia, José Maria (Spain, b. 1954), 171 Seth Siegelaub Gallery, New York, 28 Silence=Death, 63 Simmons, Laurie (U.S., b. 1949), 196, 198, 236 Simon, John (U.S.), 182 Simpson, Lorna (U.S., b. 1960), 144 simulacrum, 222–23 simulation, 173, 222–23 Singer, Michael (U.S., b. 1945), 120 site-specific artworks, 211. See also installations Situationism, 22, 223–24 Situationist International, 22, 223, 224 Skoglund, Sandy (U.S., b. 1946), 144, 236 Slanguage (U.S), 226	Socialist Realism, 176, 200, 226 , 227 social practice, 39, 200, 226–28 , 228 Social Realism, 58, 229 Software (New York, 1970), 28, 105 Softworlds (Janine Cirincione, Michael Ferraro, and Brian D'Amato), 101; The Imperial Message, 102 Sokov, Leonid (Russia, b. 1941), 229 Solbes, Rafael. See Equipo Crónica Solomon, Holly, 192 Solomon, Rosalind (U.S., b. 1930), 61 Sonfist, Alan (U.S., b. 1946), 120, 212 Song Yonghong (China, b. 1966), 51, 113 Song Yongping (China, b. 1961), 51 Sonnabend Gallery, New York, 36, 173, 194 Sonnier, Keith (U.S., b. 1941), 211, 231 Sontag, Susan, 32, 149 Sotheby's London, 47 Sotheby's New York, 46, 100 Soto, Jesús Rafael (Venezuela, 1923–2005), 147, 184 Sots art, 29, 226, 229–31 , 230 Sots Art (New York, 1986), 36, 231 Soulages, Pierre (France, b. 1919), 74 Sound (New York, 1969–70), 28 sound art, 28, 145, 213, 231–32 Sound Sculpture As (San Francisco, 1970), 28 Southern Artists Group, 51–53 South of Market Cultural Center, San Francisco, 158
Skoglund, Sandy (U.S., b. 1946), 144, 236	South of Market Cultural Center, San
Smith, Alexis (Ü.S., b. 1949), 144, 167 Smith, Barbara (U.S., b. 1931), 111, 128 Smith, Bernard, 67	Southwest Artists Group, 52–53 Soviet Union. See USSR space art, 71, 232–34 , 233
Smith, David, 156, 199 Smith, Keith (U.S., b. 1938), 111	Spain: Dau al Set in, 117 ; El Paso painters in, 123
Smith, Kiki (U.S., b. 1954), 144, 189 Smith, Leon Polk (U.S., 1906–1996), 143, 221	Spanudis, Theon (Brazil), 168 SPARC (Social Practice Arts Research Center) (Santa Cruz), 226
Smith, Owen, 146 Smith, Patti, 48 Smith, Richard (Great Britain, b. 1931),	Spatialism, 124, 235, 235–36 Spero, Nancy (U.S., 1926–2004), 128, 144 Spiegelman, Art (U.S., b. 1948), 100 Spiritual in Art: Abstract Painting, The,
Smith, Tony (U.S., 1912–1980), 155, 212 Smithson, Robert (U.S., 1938–1973), 120; Spiral Jetty, 120, 121	1890–1985 (Los Angeles, 1986), 36 Spoerri, Daniel (Switzerland, b. 1930), 23, 132, 165, 181, 182
Smyth, Ned (U.S., b. 1948), 191, 192, 212 snapshot aesthetic, 23, 224–25 , 225, 241 Snow, Michael (Canada, b. 1929), 103, 250 Snyder, Huck (U.S., d. 1993), 121 Sobell, Nina (U.S.), and Emily Hartzell	Sprinkle, Annie, 130 Spur Group (Germany), 223, 224 Staël, Nicolas de (Belgium, 1914–1955), 74 staged photography (set-up photo-
(U.S.), 182	graphy), 197-98, 236-37 , 237

stain painting, 97-98, 211 Staley, Earl (U.S., b. 1938), 82, 167, 171 Staller, Eric (U.S., b. 1947), 101 Stamos, Theodoros (U.S., 1922-1997), 97 Stanczak, Julian (Poland/U.S., b. 1928), Stankiewicz, Richard (U.S., 1922–1983), 80.146 Starn, Doug (U.S., b. 1961) and Mike (U.S., b. 1961), 92 Stars Group, 33, 51, 238-40, 239 Steers, Hugh (U.S., 1962-1995), 61; Blue Towel, Red Tank, 62 Steichen, Edward (U.S., 1879-1973), 126 Steinbach, Haim, 135, 173 Steir, Pat (U.S., b. 1940), 174, 176 Stelarc (Australia), 87, 182, 183, 192 Stella, Frank (U.S., b. 1936), 23, 155, 221; Kufa Gate II, 222 Stevens, May (U.S., b. 1924), 128, 200 Stewart, Michael, 139 Stieglitz, Alfred (U.S., 1864–1946), 225, 240, 241 Still, Clyfford (U.S., 1904–1980), 57, 82 Stockholder, Jessica (U.S., b. 1959), 217, 218 story art. See narrative art Stoschek, Julia, 252 straight photography, 154, 225, 240-41, Strand, Paul (U.S., 1890-1976), 240 street art, 158, 243-44 Struth, Thomas (Germany, b. 1954), 118 STUDIO for Creative Inquiry, Carnegie Mellon, Pittsburgh, 233 Studio Museum of Harlem, New York, Sturgeon, John (U.S., b. 1946), 250 Sturtevant, Elaine (U.S., b. 1930), 69 style, **245**; pluralism and, 198 subject, 110 Suga, Kishio (Japan, b. 1944), 155, 161 Sultan, Donald (U.S., b. 1951), 171, 174 Sultan, Larry (U.S., b. 1946), and Mike Mandel (Ú.S., b. 1950), 154, 236 Sumi, Yasuo (Japan, b. 1925), 139 Sun Liang (China, b. 1957), 51 Sun Ra, 87 Superflex (Denmark), 226 Supports/Surfaces, 99 Surrealism, 89, 116, 117, 135, 161, 163, 215, 220, 236, 238, **245-46**; collage

and, 95–96; Dau al Set and, 117, 123; Situationism and, 223 Survival Research Laboratory, 147 Sweeney, Skip (U.S., b. 1946), and Joanne Kelley (U.S.), 250 symbol, allegory vs., 64 synesthesia, 56 systemic painting. See color-field painting Systemic Painting (New York, 1966), 97 Sze, Sarah (U.S., b. 1969), 144 Szeeman. Harold, 211

Taaffe, Philip (U.S., b. 1955), 185 Tachisme, 74, 182, 236 tactical media, 155 Takayama, Noboru (Japan), 161 Taki 183, 137 Takis (Greece, b. 1925), 70 Talking Heads, 180 Tamarind Lithography Workshop, Albuquerque (formerly Los Angeles), 23, 55, 209-10 Tanaka, Atsuko (Japan, 1932-2005), 139, 140 Tanaka, Janice (U.S., b. 1940), 250 Tanguy, Yves (France, 1900–1955), 245 Taniguchi, Yoshio, 45 Tansey, Mark (U.S., b 1949), 167 Tapié, Michel, 19, 58, 74 Tàpies, Antoni (Spain, 1923–2012), 74, 117, 137 Tatlin, Vladimir (Ukraine, 1885–1953), 55, 106, 107 Taussig, H. Arthur (U.S.), 111 Technische Hochschule (Stuttgart, Germany), 101 technology. See art and technology Télémaque, Hervé (France, b. 1937), 97, television, video art and, 250 Teraoka, Masami (Japan, b. 1936), 61 Teske, Edmund (U.S., 1911–1996), 53 Tharrats, Joan-Josep (Spain, 1918– 2001), 117 Thater, Diana (U.S., b. 1962), 250 Thiebaud, Wayne (U.S., b. 1920), 202 This Is Tomorrow (London, 1956), 203 Thomas, Rover (Aboriginal, 1926– 1998), 109 Tillers, Imants (Australia, b. 1950), 103

Tilson, Joe (Great Britain, b. 1928), 165

time-based art, 178 Times Square Show (New York, 1980), 33, 144, 150, 151 137, 180-81 Timms, Freddie (Aboriginal, b. ca. 1946), 109 Tinguely, Jean (Switzerland, 1925–1991), 23, 146, 147, 165, 181; Dissecting Machine, 148 Tzara, Tristan, 116 Tiravanija, Rirkrit (Thailand, b. 1961), 226, 227 Tisdale, Danny (U.S.), 144 Tivey, Hap (U.S., b. 1947), 150 Tjakamarra, Michael Nelson, 110 Tjapaltjarri, Clifford Possum (Aboriginal, 1932-2002), 109 Beijing, 47 Tobey, Mark (U.S., 1890–1976), 57 Today Art Museum, Beijing, 240 Tokyo Fluxus, 65 Tokyo Gallery, 240 Töppfer, Rodolphe, 99 Torres, Francesc (U.S., b. 1948), 144 Tortosa, Ruben (Spain), 111 Traffic (Bordeaux, France, 1996), 41 Transavanguardia, Italia-America: Mostra (Modena, 1982), 34 Transavantgarde, **246-47**, 247 transmedia. See intermedia Trasov, Vincent (Canada, b. 1947), 151 Traylor, Bill (U.S., c. 1854–1949): Berkeley, 55 Untitled (Figures and Construction with Blue Border), 187 Treasures of Tutankhamen, The (U.S. tour, 1977), 32 Trecartin, Ryan (U.S., b. 1981), 250 Treiman, Joyce (U.S., 1922–1991), 53 Tribe, Mark (U.S., b. 1966), 182, 192 Trieste Constructivist Cabinet (Slovenia), 232 Trockel, Rosemarie (Germany, b. 1952), "unofficial" art from, exhibited in West, 37. See also Constructivism 128 trompe-l'oeil, 215 Tropicalism, 169, 248-49, 249 Truffaut, François, 180 Vaisman, Meyer (U.S., b. 1960), 121, 173 T. R. Uthco (U.S.), 250; The Eternal Frame, 251, 252 Tsai, Wen-ying (China, b. 1928), 101, 231 Tsang Tsou Choi (China, 1921-2007), Tuchman, Maurice, 36 Tucker, Marcia, 32, 82, 211 1987), 137 Tunick, Spencer, 47 Turbeville, Deborah (U.S., b. 1938), 126, 153

Turrell, James (U.S., b. 1941), 70, 120, Tuttle, Richard (U.S., b. 1941), 103 Tuymans, Luc (Belgium, b. 1958), 189 Twombly, Cy (U.S., 1928-2011), 137, 170 Tyler Graphics, Ltd., Mount Kisco, N.Y., Ufan, Lee (Korea, b. 1936), 161, 163 Ulay (Germany, b. 1943), 87, 89 Ullens, Baron Guy and Myriam, 47 Ullens Center for Contemporary Art, UnInked (Phoenix, 2007), 100 United Graffiti Artists, 137 United States Holocaust Memorial Museum, Washington, D.C., 40 Universal Limited Art Editions (USLA), West Islip, N.Y., 22, 209-10 University at Buffalo (SUNY Buffalo), University of California, Berkeley, 87, 89 University of California, Davis, 136 University of California, Santa Cruz, University of California Art Museum, University of Iowa, 146 University of Maine, 146 urbanisme unitaire (integrated city life), Uslé, Juan (Spain, b. 1954), 171 USSR (Soviet Union): political art in, 199, 200; Socialist Realism in, 226, 227; Sots art in, 29, 226, **229-31**, 230; "space race" between U.S. and, 232;

Valdés, Manuel. See Equipo Crónica Valensi, André (France, b. 1947), 99 Valentine, DeWain (U.S., b. 1936), 131, Vallance, Jeffrey (U.S., b. 1955), 189 Vallauri, Alex (Ethiopia/Brazil, 1949– Vandenberge, Peter (U.S., b. 1935), 89 Vanderbeek, Stan (U.S., 1927–1984), 101, 250

Wang Jinsong (China, b. 1963), 113, 115 Vanderlip, Dianne, 30, 75 Wang Jonson (China), 51 Vargas, Kathy (Mexico, b. 1941), 61 Wang Keping (China, b. 1949), 238; Idol, Varo, Remedios (Spain, active Mexico, 1908-1966), 245 239, 239 Vasarely, Victor (Hungary, 1908–1997), 165, 184; Ond S.J., 185 Vasulka, Steina (Iceland, active U.S., b. 1940), 250 Vasulka, Woody (b. 1937), 250 c. 1925-2001), 109 Vautier, Ben (France, b. 1935), 132 Ware, Chris (U.S., b. 1967), 100 Velázquez, Diego, 69, 137 Velde, Bram van (Netherlands, 1895– 1981), 74 Veloso, Caetano, 249 Venet, Bernar (France, b. 1941), 103 Venice Biennale, 17, 18, 25, 33, 41, 43, 85, 159, 244 Venturi, Robert, 26, 207 Vermeer, Jan, 16, 245 209-10 Verne, Jules, 232 Viallat, Claude (France, b. 1936), 99 1963), 250, 252 Victoria, Ted (U.S., b. 1944), 101 Victorian art, 209, 217 Victorian Artists' Society (Australia), 67 video art, 26, 30, 65, 104, 161, 167, 178, 182, 184, 205, **250-52**, 251; sound art 236, 237, 250 and, 232 video games, 201 Viola, Bill (U.S., b. 1951), 144, 250–52 Viola, Manuel (Spain, 1916–1987), 123 176 Visual AIDS, 38, 63 Vitiello, Stephan (b. 1964), 231 Vlaminck, Maurice de, 125 1911-2005), 168 Vogel, Susan Kaiser (U.S.), 150 Vostell, Wolf (Germany, b. 1932), 132, 151, 202 Voulkos, Peter (U.S., 1924–2002), 20, 58, 89,112 W Wachtel, Julie, 149 Wada, Yoshi (U.S., b. 1943), 231 80, 89, 90, 91 the Waitresses (U.S.), 192

Waldvogel, Christian (Switzerland), 232 Walker Art Center, Minneapolis, 38 Wallinger, Mark (Great Britain, b. 1959), 252 wall sculptures, 173 Walsh, David, 49 Wangenheim, Chris von (U.S./ Germany, b. 1942), 126 Wang Guangyi (China, b. 1957), 51, 200 Wang Jianwei (China, b. 1958), 250

Wang Xingwei (China, b. 1969), 200 Wang Ziwei (China, b. 1963), 200 WAR (Women Artists in Revolution), Warangkula, Johnny (Aboriginal, Warhol, Andy (U.S., 1928–1987), 25, 27, 36, 37, 69, 94, 99, 101, 108, 122, 137, 138, 145, 154, 199, 201, 202, 203, 233 Warhol, Andy, Museum, Pittsburgh, 40 Watson, Judy (Aboriginal, b. 1959), 109 Watts, Robert (U.S., 1923–1988), 132 Wayne, June (U.S., 1918–2011), 23, 53, 55, Wearing, Gillian (Great Britain, b. Webb, Boyd (New Zealand, b. 1947), 236 Weber, Bruce (U.S., b. 1946), 126 Weems, Carrie Mae (U.S., b. 1953), 144 Wegman, William (U.S., b. 1943), 167, Wei Guangqing (China, b. 1963), 51 Weil, Brian (U.S., 1954–1996), 61 Weiner, Lawrence (U.S., b. 1942), 103 Weischer, Matthias (Germany, b. 1973), Weiss, David. See Fischli and Weiss Weissmann, Franz (Austria/Brazil, Welliver, Neil (U.S., b. 1929), 178 Wells, John (Great Britain, 1907–2000), Wells, Lynton (U.S., b. 1940), 153 Wesselmann, Tom (U.S., 1931-2004), Westermann, H. C. (U.S., 1922–1981), Weston, Edward (U.S., 1886–1958), 69, 70, 225, 240 Wheeler, Doug (U.S., b. 1939), 150 When Attitudes Become Form (Bern, 1969), 28, 211 White, Charles (U.S., 1918–1979), 53 White Museum (Ithaca, N.Y.), 27 Whiteread, Rachel (Great Britain, b. 1963), 212, 252 Whitman, Robert (U.S., b. 1935), 141

Whitney Museum of American Art, New York, 28, 32, 38, 40, 85, 151, 174, Whitten, Jack (U.S., b. 1939), 85, 87 Wiley, William T. (U.S., b. 1937), 135; Nomad Is an Island, 136 Wilhite, Robert (U.S.), 77 Wilke, Hannah (U.S., 1940–1993), 128 Williams, Emmett (U.S., 1925–2007), 111 Williams, Sue (U.S., b. 1954), 99, 128 Williams, William T. (U.S., b. 1942), 85, Wilmarth, Christopher (U.S., 1943-1987), 112 Wilson, Fred (U.S., b. 1954), 144 Wilson, Robert (U.S., b. 1941), 31, 77, 146, Wilson, S. Clay (U.S., b. 1941), 100 Elga Wimmer PCC, New York, 44 Winer, Helene, 196 Winet, Jon (U.S.), and Margaret Crane (U.S.), 92, 95, 182 Winn, Albert (U.S.), 61 Winogrand, Garry (U.S., 1928–1984). 224, 225, 240; Park Avenue, New York. 242 Howard Wise Gallery, New York, 101 Witkin, Joel-Peter (U.S., b. 1939), 153 Witten, Andrew (Zephyr) (U.S.), 137 Wittgenstein, Ludwig, 220 Wodiczko, Krzysztof (Poland, b. 1943), Wöhlgemuth, Eva (Austria), and Kathy Rae Huffman (Austria, b. 1943), 182 Wojnarowicz, David (U.S., 1954–1992), 48, 61, 63, 121, 243 Wölfflin, Heinrich, 188 Wolfsonian, Miami Beach, 41 Wols (Germany, 1913–1951), 74 Women Artists: 1550–1950 (Los Angeles, 1976). 31 Wong, Martin (U.S., b. 1946), 121 Wong, Paul (Canada, b. 1954), 250 Wonner, Paul (U.S., 1920–2008), 82 Wood, Grant, 215 Woodruff, Thomas (U.S., b. 1957), 61 Woods, Arthur (U.S., b. 1948), 232, 234 Wooster Group, 146 Work of Art in the Age of Mechanical Reproduction, The (New York, 1969). World War I, 92, 116

World War II, 92, 124, 146; contemporary term and, 108 World Wide Web. See online art Wortzel, Adrianne (U.S., b. 1941), 182 Wright, Frank Lloyd, 21 Wu Shanzhuan (China, b. 1960), 51 Wynter, Bryan (Great Britain, 1915-1975), 216

X

xerography, 16, 22, 111. See also copy art Xerox Corporation, 22, 111 Xiamen Dada, 53 Xiao Lu (China, b. 1962), 51, 53 The Xijing Men (Asia), 250 Xing Danwen (China, 1967), 167 Xu Bing (China, b. 1955), 51; Book from the Sky, 52 Xu Tan (China, b. 1957), 51

Yamamoto, Tarsua (Japan), 103 Yamazaki, Tsuruko (Japan, b. 1925), 139 Yang Shaobin (China, b. 1963), 113 Yang Yiping (China, b. 1947), 238 Yan Li (China, b. 1954), 238 Yerba Buena Center for the Arts. San Francisco, 40, 158 Yes Men (U.S.), 182 Ye Yongqing (China, b. 1958), 51 Yin Guangzhong (China, b. 1942), 238 Yonemoto, Bruce (U.S., b. 1949) and Norman (U.S., b. 1946), 167, 250 Yoshida, Katsuro (Japan, b. 1943), 155 Yoshida, Minoru (Japan), 139 Yoshihara, Jiro (Japan, 1905–1972), 20, 124, 139-40, 141 Yoshihara, Michio (Japan, b. 1933), 139 Young, La Monte (U.S., b. 1935), 132 Young Art of Progressive China, The (Beijing, 1985), 53 Young British Artists (YBAs), 37, 176, **252-55**, 253 Youngerman, Jack (U.S., b. 1926), 142 YouTube, 182, 250 Yuanmingyuan Artist Village, near Beijing, 115 Yue Minjun (China, b. 1962), 113, 114, 115; The Execution, 114 Yu Hong (China, b. 1966), 51, 113 Yulikov, Alexander (Russia, b. 1943),

Yu Youhan (China, b. 1943), 200, 201

Z

Zajac, Jack (U.S., b. 1929), 53 Zakanitch, Robert (U.S., b. 1936), 191-92 Zeisler, Claire (U.S., 1903-1991), 112 Zeitgeist, 255 Zelevansky, Paul (U.S.), 74 Zeng Fanzhi (China, b. 1964), 47, 51 Zephyr (a.k.a. Andrew Witten) (U.S.), 121, 137 ZERO group, 22, 70, 236 Zhang Dali (a.k.a. AK-47 and 18k) (China, b. 1963), 137, 139; Demolition: Forbidden City, 138 Zhang Hongtu (China, b. 1943), 200 Zhang Peili (China, b. 1957), 51, 250 Zhang Xiaogang (China, b. 1958), 47, 51, 113, 114, 115

Zhao Bandi (China, b. 1966), 51 Zheng Fanzhi (China, b. 1964), 113 Zhong Acheng (a.k.a. Ah Cheng) (China, b. 1949), 238 Zhou Chunya (China, b. 1955), 51 Ziegler, Mel (U.S., b. 1956), and Kate Ericson (U.S., b. 1955), 92, 95 Ziranek, Sylvia (Great Britain, b. 1952), Zixin Road Primary School, Beijing, 240 ZKM (Zentrum für Kunst und Medientechnologie, or Center for Art and Media Technology), Karlsruhe, Germany, 42, 103, 184 Zorio, Gilberto (Italy, b. 1944), 73 Zucker, Joe (U.S., b. 1941), 174 Zwillinger, Rhonda (U.S.), 121

Photography Credits

The photographers and sources of photographic material other than those indicated in the captions are as follows:

p. 16: Office of the U.S. Chief of Counsel for the Prosecution of Axis Criminality/ Still Picture Records LICON, Special Media Archives Services Division (NWCS-S); p. 17: Bob Sandberg, Look magazine photograph collection (Library of Congress); p. 18: from Quotations from Chairman Mao; p. 19: Roger Higgins, New York World-Telegram and Sun Newspaper Photograph Collection (Library of Congress); p. 20: www.defenseimagery.mil; p. 21: Library of Congress; p. 22: National Aeronautics and Space Administration; p. 24: Cecil W. Stoughton, White House Press Office; p. 29: Oliver F. Atkins, White House Photo Office; p. 30: Robert L. Knudsen, National Archives and Records Administration; p. 31: U.S. Department of Defense; p. 32: © sajed.ir, used under a Creative Commons Attribution-ShareAlike license; p. 35: Staff Sergeant Robert E. Kline, U.S. Marine Corps; p. 36: National Aeuronautics and Space Administration; p. 37: © 1988 Mikhail Evstafiev, used under a Creative Commons Attribution-ShareAlike license; p. 40: © 2009 Toni Barros, used under a Creative Commons Attribution-ShareAlike license; p. 41: © Paul Weinberg, used under a Creative Commons Attribution-ShareAlike license; p. 42: Al Jenny, U.S. Department of Agriculture; p. 45: Michael L. Bak, U.S. Department of Defense; p. 46: NyxoLyno Cangemi, U.S. Coast Guard; p. 52: courtesy Xu Bing Studio; p. 54: courtesy Kent Fine Art; p. 57: photo by Squidds and Nunns; p. 60: photo by Caroline Tisdall; p. 66: © Akasegawa Genpei/photo courtesy SCAI THE BATHHOUSE and Nagoya City Art Museum; p. 68: © Sherrie Levine/photo courtesy Simon Lee Gallery; p. 72: © 2013 Artists Rights Society (ARS), New York / ADAGP, Paris; p. 73: photo by P. Pellion; p. 77: © 2013 Estate of Scott Burton/Artist Rights Society (ARS), New York; p. 81: © 2013 Artists Rights Society (ARS), New York/ADAGP, Paris; p. 84: courtesy John Berggruen Gallery, San Francisco; p. 86: courtesy Michael Rosenfeld Gallery LLC, New York; p. 88:

photo by Minette Lehmann; p. 90: courtesy Foster Goldstrom, New York; p. 91: © The School of the Art Institute of Chicago and the Brown family; p. 93: © 2013 Artists Rights Society (ARS), New York/Pictoright, Amsterdam; p. 94: courtesy the artist and Lehmann Maupin, New York and Hong Kong; p. 96: © R. Hamilton/all rights reserved, DACS and ARS 2013; p. 98: © 2013 Estate of Helen Frankenthaler/ Artists Rights Society (ARS), New York; p. 102: courtesy the artists; p. 105: © 2013 Joseph Kosuth/Artists Rights Society (ARS), New York/photo by Jason Wyche, New York, courtesy Sean Kelly Gallery, New York; p. 114: courtesy Pace Beijing; p. 119: © 2013 Andreas Gursky/Artists Rights Society (ARS), New York/VG Bild-Kunst, Bonn/courtesy Gagosian Gallery and Sprüth Magers Berlin London; p.121: photo by Gianfranco Gorgoni, courtesy John Weber Gallery, New York; p. 128: courtesy Mary Boone Gallery, New York; p. 131: © 2013 Judy Chicago/Artists Rights Society (ARS), New York; p. 133: courtesy Holly Solomon Gallery/photograph © 1969 Peter Moore; p. 138: © Zhang Dali, courtesy Eli Klein Fine Art; p. 144: photo by Julius Kozlowski; p. 150: © 2013 Robert Irwin/Artists Rights Society (ARS), New York/photo by Peter Lake, courtesy Pace Gallery; p. 152: © Ray Johnson Estate, courtesy Richard L. Feigen & Co.; p. 153: courtesy Pace MacGill Gallery and Pace Gallery; p. 155: © 1985 Les Levine; p. 156: © 2009 Stephen Flavin/Artists Rights Society (ARS), New York/photo by Nic Tenwiggenhorn, courtesy David Zwirner, New York/London; p. 159: courtesy the artist and Roberts & Tilton, Culver City, California; p. 162: courtesy the artist and Blum & Poe, Los Angeles/photo by Joshua White; p. 168: courtesy Werner and Elaine Dannheiser; p. 170: © Cildo Meireles/courtesy Galerie Lelong, New York; p. 172: © 2013 Julian Schnabel/ Artists Rights Society (ARS), New York; p. 177: © 2013 Artists Rights Society (ARS). New York/courtesy Galerie EIGEN + ART Leipzig/Berlin and David Zwirner, New York/London; p. 179: courtesy David Zwirner, New York/London; p. 183: photo by Paul Brenner, Randolph Street Gallery, Chicago; p. 185: © 2013 Artists Rights Society (ARS), New York/ADAGP, Paris; p. 190: photo © 1997 Whitney Museum of American Art, New York; p. 195: courtesy the artist and Marlborough Gallery, New York; p. 197: courtesy the artist and Metro Pictures; p. 202: courtesy the artist and Chambers Fine Art; p. 210: © 2013 Al Held Foundation, Inc./licensed by Artists Rights Society (ARS), New York; p. 214: photo by Fred W. Baker III, U.S. Department of Defense; p. 222: © 2013 Frank Stella/Artists Rights Society (ARS), New York; p. 227: Scala/Art Resource, New York; p. 230: courtesy Ronald Feldman Fine Arts, New York, www.feldmangallery.com, photo by D. James Dee; p. 233: courtesy the artist and Metro Pictures, New York/Altman Siegel Gallery, San Francisco/Galerie Thomas Zander, Cologne; p. 235: © 2013 Artists Rights Society (ARS), New York/ SIAE, Rome; p. 237: @ Gregory Crewdson/courtesy Gagosian Gallery; p. 239: courtesy 10 Chancery Lane Gallery, Hong Kong; p. 249: photo by César Oiticica Filho; p. 253: © 2013 Tracey Emin, all rights reserved/DACS, London/Artists Rights Society (ARS), New York